The Landscape Paintings of Thomas Gainsborough
Volume Two

# The Landscape Paintings of Thomas Gainsborough

A Critical Text and Catalogue Raisonné

Volume Two
## *Catalogue Raisonné*

John Hayes

Cornell University Press
Ithaca, New York

First published 1982 by Cornell University Press

Designed and produced for
Cornell University Press, New York,
and Sotheby Publications, London,
by Philip Wilson Publishers Limited,
Russell Chambers, Covent Garden, London WC2E 8AA.

International Standard Book Number 0-8014-1528-4
Library of Congress Catalog Card Number 82-70753

Designed by Graham Johnson and Cathryn O'Neill

Printed in Great Britain by BAS Printers Limited, Over Wallop, Hampshire
and bound by Woolnough Bookbinders Limited, Wellingborough, Northamptonshire

# Contents

## Volume Two

# Introduction

From the point of view of the history of art, the landscape paintings are by far the most important of Gainsborough's works. They were also the works from which the artist himself derived the deepest personal satisfaction: in one of his most poignant and vividly phrased letters, he exclaimed to his friend William Jackson, 'I'm sick of Portraits and wish very much to take my Viol da Gam and walk off to some sweet Village where I can paint Landskips and enjoy the fag End of Life in quietness & ease . . . I hate . . . being confined *in Harness* to follow the track, whilst others ride in the Waggon, under cover, stretching their Legs in the straw at Ease, and gazing at Green Trees & Blue skies without half my *Taste*.'[1]

Yet Gainsborough's landscapes have always been the least fully studied of his works, though for this there are a number of practical reasons. There is no large concentration of the landscapes in a single place, as there is for Wilson, Constable, Crome or Turner; indeed, they are unusually widely scattered, in collections all over the British Isles and the United States, with some in South Africa, Brazil and Australia. Moreover, the majority of them still remain in private hands, and are thus less easily, or frequently, accessible to students. Nor is documentary and first-hand evidence about the landscapes any easier to seek than the pictures themselves. Gainsborough himself left very little of value to the historian. He rarely signed, and scarcely ever dated, his pictures; kept no accounts (or sitter books for his portraiture); used the services of a bank as little as was necessary[2]—though he was intimate with several prominent banking families; and seems to have thrown away letters. He had no studio assistants that we know of except, in the latter part of his life, his nephew, Gainsborough Dupont—and Dupont died young, having, unfortunately, recorded hardly anything for posterity about his uncle's work.[3] Only a handful of receipts, or other documents, survives for landscape payments, and so far no transactions which could be connected with landscape purchases have been discovered in patrons' banking accounts or in trading accounts with banks.

What is known about the landscapes at first hand comes chiefly from the columns of contemporary newspapers, notably those of the *Morning Herald*, whose proprietor, the Rev. Henry Bate-Dudley, was a close friend of Gainsborough and kept the public informed about the progress of most of the important pictures produced during the last decade of the artist's career. Even in this field, however, the task of research is not wholly rewarding, as, after all the files of the *Morning Herald* preserved in British and American libraries have been consulted,[4] the proportion of missing issues remains tantalizingly large.

The first attempt at a Gainsborough catalogue was incorporated in the *Life of Thomas Gainsborough, R.A.* (1856) by George Williams Fulcher, a poet and miscellaneous writer who owned a bookselling and printer's business in Sudbury, Gainsborough's birthplace. This was based largely on British Institution catalogues, local sources and information supplied by correspondents, and was in no sense a critical catalogue, but it remains valuable, nonetheless, for the accounts handed down by tradition, relating to a number of Gainsborough's pictures, which it rescued from oblivion; the second edition, published in the same year, included a little more information.

Sir William Armstrong's catalogue, included in his *Gainsborough & his Place in English Art* (1898), and extended in the popular edition of that work which appeared in 1904, was a more pretentious, but unfortunately far less useful, publication; wholly uncritical in approach, taking over a good many entries from Fulcher with the names of the owners unchanged, and including a high percentage of pictures which can never have been carefully examined,[5] it gave the cachet of a distinguished name in the art world of the day to numerous landscapes which have nothing whatsoever to do with Gainsborough, and handed down a totally misleading idea of his *oeuvre*.[6]

Partly, no doubt, as a result of Armstrong, both the 1927 Bicentenary Exhibition at Ipswich and the 1936 exhibition at no. 45, Park Lane, organized by Sir Philip Sassoon, included (and illustrated in the catalogues) many landscapes not by Gainsborough, and it was not until more recently, with the publication in 1958 of the third, more critical, Gainsborough catalogue, by Sir Ellis Waterhouse, that much of the damage caused by Armstrong was finally undone.

Problems of attribution still, however, present difficulties, as very few of the landscapes have a secure provenance, and the work of Gainsborough Dupont, whose career has never been investigated before, had always been an unknown quantity. Unravelling the style of Dupont is the most crucial problem on the periphery of Gainsborough studies, and a tentative catalogue of his landscapes, and account of his development, is given in Appendix One.

The present catalogue sets out to provide as reliable a canon as possible of Gainsborough's landscapes by including none which can reasonably be questioned (pictures which it has not been possible to study in the original are marked with an asterisk). Those works included which have required particular scrutiny—and to which the critical attention of students is especially drawn—are the repetitions (cat. nos 106, 145, 147), the copies after old masters (cat. nos 92, 93, 187), the group of works in mixed media of which the first is cat. no. 99, and (because of condition or other factors) cat. nos 8, 16, 30, 53, 65, 66, 76, 152, 164, 168, 170, 178, 180, 181).

The catalogue includes the oils on glass which Gainsborough made for his peep-show box and also the larger oils, or works in mixed media, on paper 25 × 30 inches in size and upwards. The smaller landscapes on paper in which Gainsborough used oil are usually in a mixture of media and are more satisfactorily classified as drawings; these were catalogued in my *Drawings of Thomas Gainsborough*, published in 1970 (one exception is cat. no. 45, omitted from the *Drawings* catalogue as it was then thought to have been executed, rather than mounted, on canvas). Untraced landscapes are not included unless their appearance is recorded by photograph, engraving or copy. Some paintings—such as *The Mall* (Frick Collection), the *Diana and Actaeon* (Royal Collection), *Hounds coursing a Fox* (Iveagh Bequest, Kenwood) and *Hagar and Ishmael* (National Museum of Wales)—which are properly subject, mythological, sporting or religious pictures respectively, are included in the catalogue because they are substantially landscapes, but they will also find a relevant place in the catalogues of Gainsborough's work which remain to be done—namely, those of the portraits, the 'fancy' and other subject pictures, the animal paintings and the copies after old masters.

All studies and closely related drawings are listed under the appropriate entries and are reproduced. The principal replicas and copies of the landscapes are also listed: further discussion of these will be found in Appendix Two. Engravings of the landscapes subsequent to about 1830 are not normally noted, unless they are relevant to establishing authenticity or provenance. Few x-ray photographs have been made of Gainsborough's landscapes; those which reveal significant alterations in composition are noted, and the more important are reproduced. The technical analysis of painting is a highly skilled task and more properly undertaken for the benefit of museum catalogues than in an *oeuvre* catalogue, which is

fundamentally art-historical; remarks on pigments, condition and such restorations as may have been carried out have, therefore, not been included except very occasionally, when a detailed conservation report has been available and the results have been of special significance. Remarks on condition without the benefit of technical examination are notoriously unreliable, and, where it has been felt necessary to make them, have been confined to the obvious. Details of provenance, exhibitions and bibliography have, as far as possible, all been checked from the original sources; the exhibition and bibliographical references do not claim to be exhaustive—many of the latter have been superseded or are else too insignificant to include—but it is hoped that none of the more important, and notably the earlier, have been missed, and that, through the mere listing of references, some indication emerges of accessibility or the vagaries of taste: for example, it is apparent that, during the period 1880–1910, writers were disarmingly repetitive in their discussion and reproduction of a limited number of works, among them landscapes such as those in the Tate Gallery (cat. no. 75) and at Philadelphia (cat. no. 79), less reproduced in more recent years. Erroneous datings in the references of this period have not been noted since this was common: until documentary information was discovered even a masterpiece such as *The Watering Place* (cat. no. 117), exhibited RA 1777, could be variously dated *c.* 1767–8 (Bell) and late Bath period (Armstrong), or *The Market Cart* (cat. no. 183) of 1786 ascribed to twenty years earlier (Bell). Measurements are given in inches, followed by centimetres, height preceding width.

The arrangement is as far as possible chronological. However, very few of the landscapes are precisely datable, especially in the early and middle years of Gainsborough's career, and, even after the minutest comparison of variations in style and technique, combined with a study of the portraits with landscape backgrounds (increasingly an unsure guide in Gainsborough's later career, since his intentions were different and the handling correspondingly broader) and of the few datable landscape drawings, an exact chronology is impossible to sustain without the aid of much more documentary evidence than is available. The entries have, therefore, been grouped round those pictures which can be securely dated, and no attempt is made to suggest more than fairly loose date brackets. Even so, the charting of the first decade of Gainsborough's career as a painter, especially the years between 1748 and 1755, remains unsatisfactory in detail. Each entry for an undated work contains stylistic and technical comparisons which are as detailed as seemed proper, given the varying condition and extent of discolouration of the pictures compared; the terms 'identical with', 'closely related to' and 'related to' are formulae devised to indicate differing degrees of similarity.

For the sake of greater clarity and for the convenience of students, the catalogue is preceded by two lists of datable landscapes, identified and unidentified respectively, followed by a summary of the rationale for establishing the chronology proposed. At the risk of repetition, the full evidence for dating is cited both in the first of these lists and in the relevant catalogue entries. Where this evidence is provided by contemporary descriptions of exhibited pictures, the identification has been controlled by stylistic analysis, but necessarily it has been assumed also that pictures which might equally well fit the description and date are not still awaiting discovery—in the case of important exhibited pictures, such a possibility must now be exceedingly remote.

# List of Abbreviations

The following abbreviations have been employed in the Catalogue Raisonné and (in a few cases) in the remaining sections of this Introduction:

| | |
|---|---|
| Armstrong, 1894 | Walter Armstrong, *Thomas Gainsborough*, London, 1894 |
| Armstrong, 1898 | Sir Walter Armstrong, *Gainsborough & his Place in English Art*, London, 1898 |
| Armstrong, 1904 | Sir Walter Armstrong, *Gainsborough & his Place in English Art*, London, 1904 |
| Armstrong, 1906 | Sir Walter Armstrong, *Thomas Gainsborough*, London, 1906 |
| Arts Council, 1949 | 'Thomas Gainsborough', Arts Council exhibition (Bath, Ipswich, Worcester, York, Bolton and Darlington), May–October 1949 |
| Arts Council, 1953 | 'Thomas Gainsborough', exhibition, Tate Gallery, summer 1953 |
| Bath, 1951 | 'Paintings and Drawings by Thomas Gainsborough', exhibition, Victoria Art Gallery, Bath, May–June 1951 |
| Bell | Mrs Arthur Bell, *Thomas Gainsborough: A Record of his Life and Works*, London, 1897 |
| Boulton | William B. Boulton, *Thomas Gainsborough: His Life, Work, Friends and Sitters*, London, 1905 |
| BI | British Institution |
| BI, 1814 | 'Pictures by the late William Hogarth, Richard Wilson, Thomas Gainsborough and J. Zoffani', exhibition, British Institution, 5 May–20 August 1814 |
| BI, 1817–63 | 'The Works of Ancient Masters and Deceased British Artists' (annual exhibitions at the British Institution) |
| BM, 1978 | Timothy Clifford, Antony Griffiths and Martin Royalton-Kisch, 'Gainsborough and Reynolds in the British Museum', exhibition, London, 1978 |
| Chamberlain | Arthur B. Chamberlain, *Thomas Gainsborough*, London, n.d. [1903] |
| Cincinnati, 1931 | 'Paintings and Drawings by Thomas Gainsborough, R.A.', exhibition, Cincinnati Art Museum, May 1931 |
| Fulcher | George Williams Fulcher, *Life of Thomas Gainsborough, R.A.*, London, 1856 (2nd ed., revised, also 1856) |
| Gatt | Giuseppe Gatt, *Gainsborough*, London, 1968 |
| Gower | Lord Ronald Sutherland Gower, *Thomas Gainsborough*, London, 1903 |
| Grand Palais, 1981 | 'Gainsborough', exhibition, Grand Palais, Paris, February–April 1981 |
| GG, 1885 | 'The Works of Thomas Gainsborough, R.A.', exhibition, Grosvenor Gallery, winter and spring 1885 |
| Hayes, *Drawings* | John Hayes, *The Drawings of Thomas Gainsborough*, 2 vols, London and New Haven, 1970 |
| Hayes, *Printmaker* | John Hayes, *Gainsborough as Printmaker*, London, 1971 |
| Hayes | John Hayes, *Gainsborough: Paintings and Drawings*, London, 1975 |

| | |
|---|---|
| Herrmann | Luke Herrmann, *British Landscape Painting of the Eighteenth Century*, London, 1973 |
| Ipswich, 1927 | 'Bicentenary Memorial Exhibition of Thomas Gainsborough, R.A.', Ipswich Museum, October–November 1927 |
| Lindsay | Jack Lindsay, *Thomas Gainsborough: His Life and Art*, London, 1981 |
| Menpes and Greig | Mortimer Menpes and James Greig, *Gainsborough*, London, 1909 |
| Millar | Oliver Millar, *Thomas Gainsborough*, London, 1949 |
| Nottingham, 1962 | 'Landscapes by Thomas Gainsborough', exhibition, Nottingham University Art Gallery, November 1962 |
| Pauli | Gustav Pauli, *Gainsborough*, Bielefeld and Leipzig, 1904 |
| Paulson | Ronald Paulson, *Emblem and Expression: Meaning in English Art of the Eighteenth Century*, London, 1975 |
| RA | Royal Academy of Arts |
| RA, 1871–1910 | 'Works by the Old Masters and by Deceased Masters of the British School' (annual winter exhibitions at the Royal Academy) |
| SA | The Society of Artists |
| Sassoon, 1936 | 'Gainsborough', exhibition, no. 45, Park Lane, London, February–March 1936 |
| Tate Gallery, 1980–81 | 'Thomas Gainsborough', exhibition, Tate Gallery, October 1980–January 1981 |
| Thicknesse | Philip Thicknesse, *A Sketch of the Life and Paintings of Thomas Gainsborough, Esq.*, London, 1788 |
| Waterhouse | Ellis Waterhouse, *Gainsborough*, London, 1958 |
| Whitley | William T. Whitley, *Thomas Gainsborough*, London, 1915 |
| Woodall, *Drawings* | Mary Woodall, *Gainsborough's Landscape Drawings*, London, 1939 |
| Woodall | Mary Woodall, *Thomas Gainsborough: His Life and Work*, London, 1949 |
| Woodall, *Letters* | Mary Woodall, ed., *The Letters of Thomas Gainsborough*, London, 2nd ed., rev., 1963 |

# Datable Landscapes

1747. Cat. no. 22. *Wooded Landscape with Peasant resting beside a Winding Track, Figures and Animals*. 40⅛ × 58 inches. Signed and dated bottom left: *Gainsbro:/1747*. Philadelphia Museum of Art, Philadelphia.

1748. Cat. no. 17. *Wooded Landscape with Woodcutter, Figures, Animals, Pool and Distant Village (Gainsborough's Forest)*. 48 × 61 inches. National Gallery, London. This painting was bought by Josiah Boydell at Richard Morrison's sale at Greenwood's, 8 March 1788, lot 78, and was the subject of one of Gainsborough's most famous letters, later published in the *Morning Herald*. 'It is in some respects,' he wrote, 'a little in the *schoolboy* stile—but I do not reflect on this without a secret gratification; for—as an early instance how strong my inclination stood for LANDSKIP, this picture was actually painted at SUDBURY, in the year 1748: it was begun *before I left school*;—and was the means of my Father's sending me to London.'[7] The statement that the picture was begun before leaving school and being sent to London, which can only mean before 1740–41, has never been satisfactorily explained. As the canvas shows no sign of having been reworked (compare the x-ray photographs specially made by the National Gallery) and since it is unlikely in any case that Gainsborough was capable of managing a composition of this size at so early an age (all the early works are on a small scale), the most obvious explanation is that he had made drawings and sketches of the scene when he was still a schoolboy and only took them up again several years later. Most of the very early drawings are, in fact, of woodland scenery. There are stylistic reasons for believing that, at a distance of forty years, Gainsborough's memory may have played him false in giving the date of execution so exactly as 1748 (see cat. no. 17).

1748. Cat. no. 23. *The Charterhouse*. Roundel, 22 inches in diameter. Thomas Coram Foundation for Children, London. Presented to the hospital by the artist in 1748. The following resolution is recorded in the Committee's minutes for 11 May 1748: 'Mr. Monamy, Mr. Whale [sic], and Mr. Gainsborough; having presented pictures to this Hospital. Resolved—That the Thanks of this Committee be returned them for the same, and that Mr. White be desired to acquaint them therewith.'[8]

1753. Cat. no. 37. *View of Landguard Point and Fort and the River Orwell, with Gentleman Reclining, Figures, Animals, Country Cart and Shipping (Landguard Fort)*. Destroyed, and now known only from the engraving by Thomas Major published in 1754. Commissioned by Philip Thicknesse, who took up his post as Lieutenant-Governor of Landguard Fort in February 1753. The picture must have been executed for him during the spring or summer of that year, as Thicknesse tells us that he took it to be engraved 'in the following winter',[9] which, from the date of the engraving, 1754, must be that of 1753–4.

1755. Cat. no. 50. *Wooded Landscape with Woodcutter courting a Milkmaid, White Cow, Plough Team, Figures and Donkeys on a Hillock, and Distant Village*. 42 × 50½ inches. The Marquess of Tavistock and the Trustees of the Bedford Settled Estates, Woburn Abbey. Gainsborough's receipt for payment, dated 17 November 1755, is preserved in the archives at Woburn: he rendered his account on 24 May 1755.[10]

1755. Cat. no. 51. *Wooded Landscape with Peasant Boy Mounted and Two Horses, Pond with Ducks, Haymakers and Haycart, and Church Tower among Trees*. 36¼ × 40¼ inches. The Marquess of Tavistock and the Trustees of the Bedford Settled Estates, Woburn Abbey. Gainsborough's account for this picture was rendered on 24 July 1755; his receipt for payment, dated 17 November 1755, is preserved in the archives at Woburn.[11]

1766. Cat. no. 87. *Wooded Landscape with Country Waggon, Milkmaid and Drover*. 57 × 47 inches. Private collection, England. Exhibited SA, 1766 (53, 'A large landscape with figures') and bought by Sir William St Quintin, ancestor of the present owner. The frame of the picture is dated 1766, and the following entry was made by Sir William in his account book under the year 1766: 'Gainsborough. 1 picture. £43.11.6.'[12] This evidence makes it certain that this was the landscape which Gainsborough sent up to the Society of Artists in 1766, as no other picture datable to the 1760s fits the contemporary comments on SA, no. 53. Horace Walpole noted in his catalogue, 'A milkmaid and clown,'[13] and an anonymous reviewer wrote, 'In this picture there is much to be commended, the figures are in a fine taste, the cart-horses and foreground are extremely fine and well painted, but the trees are too blue and hard.'[14]

1767. Cat. no. 88. *Wooded Landscape with Peasants in a Country Waggon, Drover holding a Horse while a Woman is helped in, and Distant Hill (The Harvest Waggon)*. 47½ × 57 inches. Barber Institute of Fine Arts, Birmingham. Exhibited SA, 1767 (61, 'A landskip and figures') and given to Walter Wiltshire by the artist in 1774. No other picture painted before 1774 fits Horace Walpole's note on SA 1767 (61): 'This landscape is very rich, the group of figures delightfully managed, and the horses well drawn, the distant hill is one tint too dark.'[15] An anonymous reviewer commented, 'The trees are hard, and the sky too blue.'[16] Supporting evidence that *The Harvest Waggon* was a publicly exhibited picture comes from the fact that Francis Wheatley used the composition for a picture of his own, dated 1774, now in the Nottingham City Art Gallery (pl. 27). Evidence that *The Harvest Waggon* may have been exhibited RA 1771 is considered in the entry for cat. no. 88.

1773. Cat. no. 107. *Open Landscape with Mounted Peasants going to Market, a Woman with Two Children resting beside a Sedgy Pool, and Sheep on a Bank*. 48 × 58 inches. Royal Holloway College, Egham. Presumably identifiable with 'Gainsborough's picture' for which Henry Hoare paid eighty guineas on 6 July 1773.[16A]

1777. Cat. no. 117. *Wooded Landscape with Peasants beside a Pool, Mounted Herdsman with Cattle and Goats watering and Distant Hills (The Watering Place)*. 58 × 71 inches. National Gallery, London. Exhibited RA, 1777 (136, 'A large landscape') and presented to the National Gallery in 1827 by Lord Farnborough (Charles Long). There are several contemporary descriptions of RA 1777 (136), which was recognized at once as a picture of outstanding quality and importance. Horace Walpole noted, 'In the Style of Rubens, & by far the finest Landscape ever painted in England, & equal to the great Masters.'[17] The critic of the *Morning Chronicle* commented that the picture was 'one of the best of its kind that has been exhibited for many years. The red cow and the perspective light, with the broken bank and the lucid water, are all fine parts of the picture.'[18] A visiting Italian artist wrote about it even more enthusiastically, 'His large landscape, No. 136, is inimitable. It revives the colouring of Rubens in that line. The scene is grand, the effect of light is striking, the cattle very natural. But what shall I say of the pencilling? I really do not know; it is so new, so original, that I cannot find words to convey any idea of it. I do not know that any aritsts, living or dead, have managed their pencils in that manner and I am afraid that any attempt to imitate it will be attended with ill success.'[19] Bate-Dudley, whose review of this year's Royal Academy in the *Morning Post* was his first notice of Gainsborough, wrote simply, 'A rural scene from nature, which discovers Mr. Gainsborough's superior taste and execution in the landscape way', adding, 'it is confessedly a masterpiece of its kind, but is viewed to every possible disadvantage from the situation in which the directors have thought proper to place it.'[20] The connection between these descriptions and *The Watering Place* is confirmed by the note which Joseph Farington later made against no. 136 in

his catalogue: 'Mr Charles Long's.'[21]

1780. Cat. no. 123. *Wooded Landscape with Peasant Family at a Cottage Door and Footbridge over a Stream (The Cottage Door)*. 58 × 47 inches. Henry E. Huntington Library and Art Gallery, San Marino, California. Exhibited RA, 1780 (62, 'Landscape'). Identifiable from the description given by an anonymous reviewer: 'The Artist seems to have neglected his Landscape to display the whole force of his genius in a beautiful groupe [sic] of children and their mother.'[22] Noted by Horace Walpole as 'charming'.[23] There are a number of copies of this composition, all but one—which could be a replica—greatly inferior to the Huntington picture, which is unquestionably the original. The other possible candidate for RA 1780 (62), the horizontal *The Cottage Door* at Cincinnati (cat. no. 121), has adults as well as children in the rather loose grouping of figures outside the cottage, and lacks the harmonious quality of the arrrangement in the Huntington picture, which seems to have been what caught the attention of the reviewer: moreover, it does not fit so well for date on the evidence of style, and it seems likely that it can now be identified with RA, 1778 (120) (see p. 320).

1780. Cat. no. 124. *Rocky Wooded Landscape with Mounted Drover, Horses watering at a Trough and Distant Village and Mountain*. 48½ × 39 inches. British Rail Pension Fund (on indefinite loan to the Iveagh Bequest, Kenwood). Exhibited RA, 1780 (74, 'Landscape'). Identifiable from the description given by an anonymous reviewer: 'A rocky, woody Scene, from whence a fall of water issues. Two horses and a dog are drinking at the fall, and with the Countryman who is upon one of the horses, form a groupe [sic] which is inimitably fine. We esteem this to be his best Landscape, this year.'[24] Horace Walpole's comment was 'very spirited'.[25] Other representations of this composition exist, notably one at Southill (see Appendix Two, pl. 338 and p. 281), but none of these is at all comparable in quality with the picture now on loan at Kenwood, which is certainly the original.

1780. Cat. no. 125. *Wooded River Landscape with Rustic Lovers examining a Tombstone in a Graveyard, Ruined Church, Goats, Shepherd and Sheep (The Country Churchyard)*. This canvas was mutilated at an early date, and the complete composition is now known only from the aquatint by M. C. Prestal published in 1790. Two fragments survive: *Shepherd and Peasant Girl examining a Tombstone* (11½ × 9 inches; last recorded with Parsons, 1911) and *Wooded Landscape with Shepherd and Sheep and Distant Hills* (18¾ × 26⅜ inches; private collection, London). Exhibited RA, 1780 (319, 'Landscape'). Identifiable from the description given by an anonymous reviewer: 'This represents part of the ruins of a Gothic Church; the whole scene overgrown with moss. There is a deal of nature in the simplicity of the boor, and in the girl's labouring to read the inscription.'[26]

1781. Cat. no. 126. *Rocky Coastal Scene with Ruined Castle, Sailing and Rowing Boats, Fishermen dragging Nets and Boy filling a Basket*. 41 × 50½ inches. National Trust, Anglesey Abbey (Fairhaven Collection). Exhibited RA, 1781 (77, 'Landscape'). Two of the 'Landscapes' exhibited in 1781 were actually seascapes, as we know from Bate-Dudley, who described them as his 'first attempts in that line'.[27] Identified as one of these two seascapes by an anonymous reviewer: 'It is impossible for the art to produce any work more complete and pleasing than this Landscape and its companion. The pellucid pencilling of the water, the etherial clearness of the sky, the unaffected composition, and the just reality of colour, renders these pictures admirable to every eye conversant with Nature, whether learned, or unlearned.'[28] Established as the Fairhaven seascape by the critic of the *Gazetteer*, who wrote, 'There is a great breadth of light and shadow in this picture, and the graduation from the dark building to the principal light upon the rock is depicted so insensibly as to produce a very natural and pleasing effect. An

Identifiable from Bate-Dudley's description in the *Morning Herald*: 'The largest of these landscapes displays a romantic scene. Broken ground, water, sloping trees, and an extended upland. In the foreground, near a cottage, three horses are seen with pack-saddles on them, one is laid down to rest, and the whole seem as if weary. The driver [sic] appears near at hand, and some cottagers complete the number of figures. The sky of this piece is painted with the most exquisite touches, and the clouds marked with uncommon brightness and serenity.'[48]

1786. Cat. no. 163. *Upland Landscape with Shepherd and Sheep, Cow on a Bank, and Distant Cottage.* $11\frac{13}{16} \times 13\frac{7}{8}$ inches. City Art Gallery, Manchester. Exhibited by the artist at Schomberg House, April 1786. Identifiable from Bate-Dudley's description in the *Morning Herald*: 'Two subjects of a lesser size, are excellent companions. One of them discovers a *Shepherd* playing with his *Dog*, his sheep lie in scattered parcels. A cow is described grazing on a rising bank. Trees in verdure, and decayed trunks, water and other images fill up the perspective.'[49]

1786. Cat. no. 164. *Wooded Landscape with Two Cows near a Pool.* $11\frac{7}{8} \times 14\frac{1}{8}$ inches. Private collection, England. Exhibited by the artist at Schomberg House, April 1786. Identifiable from Bate-Dudley's description in the *Morning Herald*: 'The companion [to cat. no. 163, described above] represents cows on a common, a sedgey brook, with trees, and hills in the distance.'[50]

1786. Cat. no. 165. *Open Landscape with Couple in a Country Cart and Peasants resting.* Private collection, Newcastle, Australia. Exhibited by the artist at Schomberg House, April 1786. Identifiable from Bate-Dudley's description in the *Morning Herald*: 'The seventh view consists of a rising ground, with a country cart-team, etc. and other rural representations.'[51]

1786. Cat. no. 174. *Wooded Landscape with Mother and Child and Housemaid outside a Cottage, Girl with Three Pigs at the Foot of the Steps, Cows, Shepherd and Scattered Sheep near a Pool, and Distant Buildings.* $38\frac{3}{4} \times 48\frac{3}{4}$ inches. Mrs Henrietta Scudamore, London (on indefinite loan to the Victoria and Albert Museum). Painted in the summer of 1786, and bought by Wilbraham Tollemache. Identifiable from Bate-Dudley's description in the *Morning Herald*: 'Mr. *Gainsborough* is, at this time, engaged in painting a beautiful landscape, in the foreground of which the *trio* of pigs, that are so highly celebrated by the connoisseurs, are introduced; together with the little girl, and several other rustic figures.'[52] This identification is confirmed by his reference in August to the purchaser: 'Mr. *Gainsborough*'s last delightful landscape, in which his celebrated group of pigs was introduced, is finished, and deposited in the cabinet of that spirited encourager of merit, Mr. *Tollemache*.'[53]

1786. Cat. no. 183. *Wooded Landscape with Peasants in a Country Cart accompanied by Two Children, a Woodgatherer, Peasants resting, and Distant Mountain (The Market Cart).* $72\frac{1}{2} \times 60\frac{1}{4}$ inches. Tate Gallery, London. Painted in the latter months of 1786 and completed by December. Identifiable from Bate-Dudley's description in the *Morning Herald*:

> In departing from the portraits, the eye cannot dwell too long on a beautiful landscape that Mr. *Gainsborough* has finished within these few days. It is a representation of a wood, through which a road appears. A loaded market cart, with two girls seated on top, is passing along; and beside the road, some weary travellers are resting. The foliage of the trees, is in a rich variation of hues, expressive of autumn:—here the trees are verdant—a browner aspect there prevails—and all the varied greens and yellows of the season, temper the scene, and exhibit a pleasing harmony. The interior recesses of the wood, afford charming invitations to the eye; the distances are exquisitely soft; and some broken clouds, diffused over the trees, and through the branches, give a delightful aspect to the whole.[54]

Two days later, he referred to the picture again: 'In addition to what has been said of Mr. *Gainsborough*'s new landscape, we must observe, that the figures are finished in a high stile of penciling [sic]: and an object of considerable interest in the picture, is a *woodman*, tying together a heap of sear branches. Through some vistas of the wood, partial gleams of light fall; which tend to diversify still more, the autumnal variation of the foliage; and add to the richness of the scene.'[55]

1787. Cat. no. 184. *Open Landscape with Two Woodcutters loading a Donkey with Faggots, and Distant Sheep*. $39\frac{1}{2} \times 49$ inches. National Trust, Stourhead. Painted in the autumn of 1787, and bought by Lady Hoare at the Gainsborough sale in March 1789. Identifiable with a picture seen in Gainsborough's studio by Bate-Dudley in November 1787 from his description of it in the *Morning Herald*: 'The PEASANTS and DOG, with the Ass laden with fire-wood, is most to be admired for its finely painted back-ground; the light is well distributed, & the effect striking'.[56]

1788. Cat. no. 185. *Wooded Landscape with Family grouped outside a Cottage, Mounted Peasants and Pack-horses, and Distant Mountain (Peasant smoking at a Cottage Door)*. $77 \times 62$ inches. University of California at Los Angeles, Los Angeles. Painted in the spring of 1788. Identifiable from Bate-Dudley's description of it in the *Morning Herald*. In May he wrote that Gainsborough 'has painted, during his quiet intervals [the painter was already gravely ill at this time, with his doctors constantly in attendance], a beautiful little *Landscape*,' and continued, 'Another *Landscape*, of larger dimensions, was finished a few weeks since by Mr. GAINSBOROUGH, and exhibits one of those sweet recesses, where the mind never fails to find a source of enjoyment:—'Tis reading *Poetry*, and compressing all its enchantments to the *glance* of the eye.'[57] In August he described this as 'one of the last pictures Mr. *Gainsborough* painted'[58] and later as 'the finest landscape ever produced, with its rich scenery of a summer evening unsurpassed by the fervid glow of Claude.'[59]

Out of almost 190 known landscapes, only the thirty pictures described above are exactly datable (and the date of one of these can be contested), and of these all but ten were painted in the last decade of Gainsborough's life. A number of other exhibited landscapes, some of them fully described in contemporary reviews, cannot be identified at present, at any rate with certainty, and these are listed below.

# Exhibited and other Recorded and Datable
# Landscapes at present Unidentified

SA 1763 (43, 'A large landskip'). By far the most ambitious and important landscape painted by Gainsborough in his early years at Bath was *Mountainous Wooded Landscape with Horse drinking, Flock of Sheep descending an Incline, Milkmaid crossing a Footbridge and Cows* (cat. no.80; Worcester Art Museum, Worcester, Mass.), and this was very probably the picture exhibited in 1763.

RA 1769 (37, 'A large landscape').

RA 1770 (88, 'A landscape and figures').

RA 1771 (79, 'A landscape and figures', and 80, 'A landscape and figures'). These two works were described by Horace Walpole as 'very good, but too little finished',[60] and a reviewer commented, 'The two large landscapes by this painter are very good. They are executed with a masterly hand, and in an excellent *gout* of colouring.'[61] Gainsborough himself described them in a letter as 'two large Landskips which will be in two handsome frames . . . the best I ever did, & probably will be the last I shall live to do.'[62] This comment is tantalizing. Evidence that one of the landscapes was *The Harvest Waggon* is considered in the entry for cat. no.88.

RA 1772 (98 and 99, 'Two landscapes, drawings, in imitation of oil painting'). The critic of the *London Chronicle* wrote, 'correctly drawn, handled with a *sportive* pencil, and shew the *versatility* of Mr. Gainsborough's genius,'[63] and Horace Walpole commented, 'very great effect, but neat, like needlework.'[64] Probably identifiable with two of the large pictures done on six pieces of paper joined together (of which cat. no. 102 is the most important), since these fit the description given and are closely related stylistically to the background of *Lady Margaret Fordyce* (private collection, Great Britain), also exhibited in 1772.

RA 1778 (119, 'A landscape with cows'). Bate-Dudley wrote in the *Morning Post*, 'a most inimitable performance,—the cows in this piece seem to have a force that detach them from the canvas,'[65] but Horace Walpole commented that it was 'too rough & unfinished'.[66] The critic of the *General Advertiser* enthused in a lengthy paragraph:

The design of this piece is beautiful to excess. The story is taken from the following elegant stanza of Shenstone's School-mistress:

But now Dan Phoebus gains the middle sky,
And liberty unbars her prison door;
And like a rushing torrent out they fly,
And now the grassy cirque have cover'd o'er.
With boisterous revel-rout and wild uproar,
A thousand ways in wanton rings they run:
Heaven shield their short-liv'd pastimes I implore,
For well may Freedom, erst so dearly won,
Appear to British elf more gladsome than the fun.

The descriptive part of this stanza has formed a most exuberant subject, and he has wrought it into a most advantageous effect. The disposition is beautiful, and the keeping correct and masterly. It is in such performances as these, that the genius of Gainsborough is apparent. He gives his landscapes a warmth and beauty of colouring superior to most of his competitors; and we confess, we would forego the portion of pleasure we experience in viewing his portraits, for the ineffable delight we receive from his landscapes; and wish that

he also would leave the one for the other.[67]

However, it is difficult to reconcile this description in the *General Advertiser* with the title of the picture and the comments made by Walpole and Bate-Dudley, so that it seems more than probable that the writer had confused the numbers and intended these remarks to apply to RA 1778 (120), the companion picture (see below). If this could be assumed to be the case, RA 1778 (120) would almost certainly be identifiable with *Hilly Landscape with Peasant Family at a Cottage Door, Children playing and Woodcutter returning* (cat. no. 121; Cincinnati Art Museum, Cincinnati), and RA 1778 (119) perhaps with *Wooded Landscape with Rustic Lovers, Cows and Flock of Sheep* (cat. no. 120; Duke of Rutland, Belvoir Castle).

RA 1778 (120, 'A landscape: its companion'). The critic of the *General Advertiser* wrote, '*The keeping* and *costume* of this piece are admirable. The *distances* are judiciously managed, and the *light* is beautifully disposed. Such an union of strength and lightness is rarely found. The foreground is highly enriched, and the whole print [sic] is full of nature.'[68] These comments were probably meant to apply to RA 1778 (119) (see the argument above). Bate-Dudley wrote in the *Morning Post*, 'only to be exceeded by the preceding,'[69] and Horace Walpole noted it as 'good'.[70]

RA 1779 (103, 'A landscape'). Horace Walpole noted this picture as 'most natural, bold & admirable!',[71] but the critic of the *St James's Chronicle* was not impressed: 'Though it be the *Ton* to admire the Richness and Embroidery of Mr. Gainsborough's Landscapes, they are not to our Taste.'[72]

RA 1780 (1, 'A Landscape'). An anonymous reviewer commented, 'A romantic Scene, in which are introduced a Shepherd and his Flock; the shapes are beautiful, and produce a strong effect of sunshine, but the Artist has not taken much pains in the finishing;'[73] and the critic of the *London Courant* wrote, 'A most enchanting landscape, by *Gainsborough*, touched with infinite spirit and taste: the gleam of sunshine on the distant hill has a most delightful effect.'[74] Horace Walpole simply noted, 'very good.'[75]

RA 1780 (197, 'Landscape'). An anonymous reviewer wrote, 'A groupe [sic] of horses and cattle is well disposed, but the Artist has left a good deal for the spectator to finish.'[76] Horace Walpole noted, 'as admirable as the great Masters.'[77] Possibly identifiable with *Open Landscape with Herdsman sleeping and Horses and Cows at the Edge of a Wood (Repose)* (cat. no. 119; William Rockhill Nelson Gallery of Art, Kansas City), the only Gainsborough landscape known in which both horses and cattle are included, and a picture more than worthy of Horace Walpole's praise.

RA 1780 (368, 'Landscape'). Noted by Horace Walpole as 'too cold'.[78]

Free Society 1783 (128, 'A landscape'). Noted by Horace Walpole as 'very natural & pretty'.[79]

Free Society 1783 (232, 'A landscape').

Schomberg House 1786 ('A Herdsman driving Cattle to a Watering Place, with Cottage, Sheep, etc'). This and the series of small landscapes following were carefully described by Bate-Dudley in the *Morning Herald*: 'The next Picture [to cat. no. 162, described on pp. 316–17], in point of dimensions, is a representation of a woody country, the face of which is covered with variety; distant thickets, jutting head-lands, trees rich with foliage of the most spirited pencilling, and here and there diversified with the yellow of Autumn. On a sunny bank, kept at a proper distance, sheep are browsing; a cottage is seen near, and in the fore ground a herdsman is driving cattle to a sedgy watering place. The light and shade of this picture diffuse a fine effect over the scene, and a sky, rich with fervid clouds, adds to the beauty of the landscape.'[80] Possibly identifiable with *Extensive Wooded Upland Landscape with Herdsman and Cows crossing a*

# Catalogue Raisonné

# Summary of the Chronology Proposed

Gainsborough's earliest documented picture is the small portrait of a bull terrier with a landscape background in an English private collection, which bears the following inscription on the relining canvas (presumably copied from an original in the artist's own hand): *Tho^s Gainsborough/Pinxit Anno/1745/'Bumper'/A Most Remarkable Sagacious/Cur.'* The landscape background of this picture is the only evidence surviving for the reconstruction of Gainsborough's really youthful work as a landscape painter, when he was in his 'teens and just starting out on his own after the years of working for Gravelot. Over half a dozen landscapes, all of them small, can be linked with *Bumper* on stylistic grounds, and may be dated *c.* 1744–6 (cat. nos 1–8).

In 1747 Boydell published a series of four landscape engravings (republished as nos 89–92 in John Boydell, *A Collection of Views in England and Wales*, London, 1790; nos 20–23 in the 1794 edition) after drawings by Gainsborough, drawings which unfortunately do not survive. Eight landscapes, still for the most part very small in size, can be grouped round these very contrived compositions, and may be dated *c.* 1746–7 (cat. nos 9–16).

Two pictures can be associated with the most important of Gainsborough's early works, the large woodland landscape in the National Gallery, recorded as painted in 1748 (cat. no. 17), but here argued as somewhat earlier, and these also may be dated to *c.* 1746–7 (cat. nos 17–19).

Two pictures can be closely linked with Gainsborough's only fully signed and dated landscape, the painting at Philadelphia dated 1747 (cat. no 22), and can thus be dated *c.* 1747 (cat. nos 20–22).

Only one picture can be linked with the view of the Charterhouse documented 1748 (cat. no. 23), and may be dated *c.* 1748 (cat. nos 23–24).

The landscapes of the late 1740s and early 1750s must be grouped round the view of Landguard Fort painted in 1753 (cat. no. 37), unfortunately known only from the engraving. The only closely datable pictures containing landscape painted between 1748 and 1755 are the double portrait of Mr and Mrs Andrews (National Gallery) of *c.* 1748–9 and the group portrait of Mr and Mrs Browne with their daughter (Marchioness of Cholmondeley) of *c.* 1754–5, so that this period is extremely difficult to reconstruct adequately. This group of pictures, over twenty in number, can only be dated very loosely, therefore, *c.* 1748–55, though some are clearly closer to 1748 and others to 1753–5 (cat. nos 25–48).

A small group of pictures can be associated with the two landscapes for the Duke of Bedford paid for in 1755 (cat. nos 50, 51), and may be dated *c.* 1754–6 (cat. nos 49–57).

No datable landscapes or portraits with landscape backgrounds exist for the years 1755–60. However, a number of pictures which are still fairly closely related to the two Woburn landscapes, but link also with the paintings of the end of the 1750s, can be grouped round the landscape owned by Earl Howe (cat. no. 62), which was first recorded in the collection of Charles Jennens in 1761. These may be dated *c.* 1755–7 (cat. nos 58–68).

The remaining Suffolk landscapes are generally rather looser in handling than the pictures of the mid-1750s, in the same way as the portraits painted at the end of this decade. These can be grouped round the picture at Toledo painted for the Edgar family (cat. no. 69), and may be dated *c.* 1757–9 (cat. nos 69–73).

As in the case of the later 1750s, there are no datable landscape paintings from the early 1760s, and the earliest pictures of this period can only be grouped round the finished watercolour of beech trees at Foxley now in the Whitworth Art Gallery, Manchester, which

has pasted on the back of the frame a fragment of paper bearing the inscription (in the artist's hand): *Tho: Gainsborough/del 1760*. Three landscapes may be associated with this watercolour, and dated *c.* 1759–62 (cat. nos 74–76).

The remaining landscapes of the early 1760s can be grouped with the portraits of Dr Charlton (Holburne of Menstrie Museum, Bath) and The Byam Family (Marlborough College), both of which were painted *c.* 1763–4 and have substantial landscape backgrounds. This group may be dated *c.* 1762–5 (cat. nos 77–85).

Only one of the undated landscapes of the 1760s (cat. no. 86) can usefully be grouped with the St Quintin picture of 1766 (cat. no. 87), which links most closely in style and technique with the Worcester landscape (cat. no. 80), but is firmer and more finished (cat. nos 86, 87).

Some of the landscapes of the later 1760s can be grouped round *The Harvest Waggon* (cat. no. 88), exhibited at the Society of Artists in 1767, and may be dated *c.* 1767–8 (cat. nos 88–91).

Another group of landscapes, still related to the style of *The Harvest Waggon*, can be more closely associated with the series of drawings which Gainsborough gave to Lord Bateman in 1770 and to the landscape in the background of *The Cruttenden Sisters* (private collection, England), painted in the late 1760s. These may be dated *c.* 1768–71 (cat. nos 92–97).

In 1772 Gainsborough exhibited 'Two landscapes, drawings, in imitation of oil painting' at the Royal Academy, of which one was probably the Faringdon picture (cat. no. 102). Six landscapes can be linked with this picture, and with the background of *Lady Margaret Fordyce* (private collection, Great Britain), also sent to the Academy in 1772. These may be dated *c.* 1771–2 (cat. nos 98–104).

The remaining landscapes of the Bath period can be associated with the background of *Master John Heathcote* (National Gallery of Art, Washington), painted in 1772–3, and the Royal Holloway College landscape (cat. no. 107), paid for in 1773. These may be dated *c.* 1772–4 (cat. nos 105–114).

The landscapes of the mid- and late 1770s can only be grouped round *The Watering Place* (cat. no. 117), sent to the Royal Academy in 1777, and must be dated, within a wide bracket, *c.* 1774–80 (cat. nos 115–122).

The chronology of the last eight years of Gainsborough's life is much easier to chart, since there are many more closely datable landscapes to serve as fixed points.

A number of pictures can be linked with those exhibited at the Royal Academy 1780–82, and may be dated *c.* 1780–82 (cat. nos 123–135).

A larger group of landscapes can be linked with the pictures of 1783, and may be dated *c.* 1782–4 (cat. nos 136–155).

Several landscapes can be grouped round *The Harvest Waggon* at Toronto (cat. no. 157), painted in the winter of 1784–5, and may be dated *c.* 1784–5 (cat. nos 156–161).

A large group of pictures can be linked with the landscapes painted in 1786, and may be dated *c.* 1786 (cat. nos 162–181).

A small group of pictures can be linked with *The Market Cart* (cat. no. 183) and the landscapes painted in 1787–8. These may be dated *c.* 1786–8 (cat. nos 182–187).

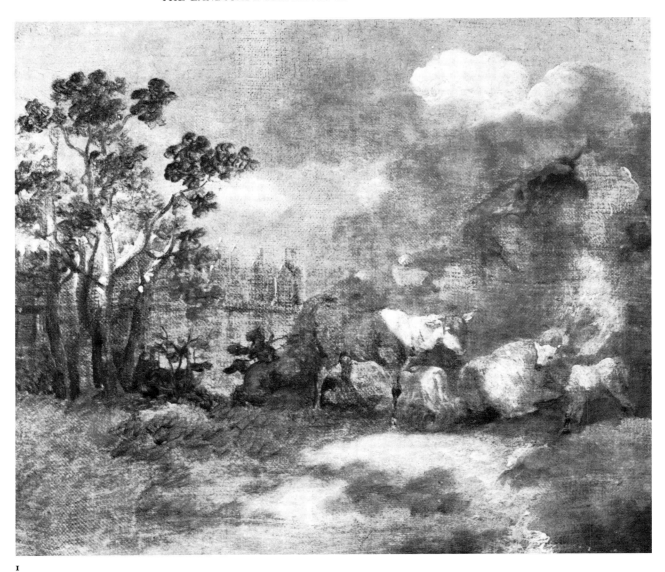

I

## 1 Landscape with Sheep, Lambs, Fence and Hillock

Canvas. $8\frac{9}{16} \times 9\frac{13}{16}$ 21.7 × 24.9
Painted *c*. 1744–5

Mr and Mrs Paul Mellon, Oak Spring, Virginia

PROVENANCE With Colnaghi, from whom it was purchased by the Master of Kinnaird, 1955; purchased by Mr and Mrs Paul Mellon, 1961; Paul Mellon Collection sale, Sotheby's, 18 November 1981, lot 42 (repr. col.) (withdrawn).

EXHIBITIONS 'Painting in England 1700–1850: Collection of Mr and Mrs Paul Mellon', Virginia Museum of Fine Arts, Richmond, 1963 (32, repr.).

BIBLIOGRAPHY Waterhouse, no. 885.

An early landscape by Gainsborough which is primarily a study of animals is a rarity, and the picture links closely in intention with the portrait of the dog *Bumper* (1a), inscribed as having been signed and dated 1745. We are

reminded also that Gainsborough 'made his first essays in the art by modelling figures of cows, horses, and dogs, in which he attained very great excellence. . . .' (*Morning Chronicle*, 8 August 1788.) The composition is flat and naïve, confined to a single plane, with no view into distance; the hillock on the right completely lacks modelling. But the handling of paint is fresh and sensitive, and Gainsborough's lifelong preoccupation with dramatic effects of light is already apparent. Also mentioned on p. 43.

DATING The light, fawn priming and pale tone are characteristic of all Gainsborough's very early works, including his portrait of *Bumper*. The picture is identical with *Bumper* in the fresh, liquid handling of the foliage, the loose touches of yellowish impasto in the foreground, the rather stiff delineation of the tree-trunks, the flat, restricted conception of the composition (deliberately avoiding spatial development) and the immaturity of the relationship between its various elements; the attempt at modelling the shape of the hillock on the right

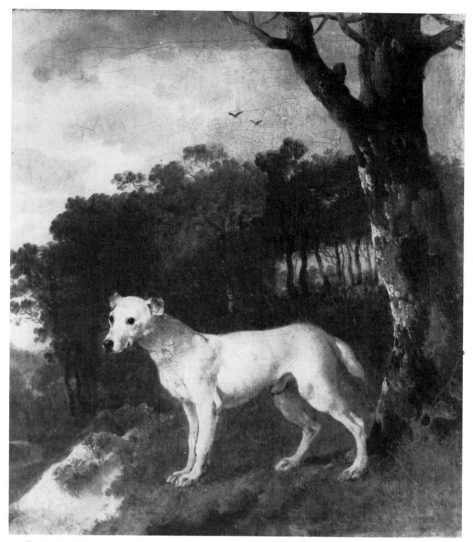

**1a** Portrait of 'Bumper'. Canvas. $13\frac{3}{4} \times 11\frac{3}{4}$ / 34.9 × 29.8. Original signature and date 1745 transcribed on the relining canvas. Private collection, England.

is considerably less effective than the execution of the sandy bank in *Bumper*, and suggests a date slightly earlier than that work.

## 2 Extensive River Landscape with Herdsman mounted on a Donkey, Animals and Cottage on a Hillock, Bridge and Distant Village

Canvas. $12\frac{3}{4} \times 14\frac{1}{8}$  32.4 × 35.9
Painted *c.* 1744–5

National Trust, Upton House, Edgehill (Bearsted Collection)

PROVENANCE Joshua Kirby (1716–74); by descent to the Rev. Henry Scott Trimmer; Trimmer sale, Christie's, 17 March 1860, lot 93, bt Rutley; G. A. F. Cavendish Bentinck; Cavendish Bentinck sale, Christie's, 8–17 July 1891, 4th day (11 July), lot 551, bt Martin Colnaghi; Mrs Martin Colnaghi sale, Robinson and Fisher's, 19–20 November 1908, 2nd day, lot 183, bt Banks; Walter, 2nd Viscount Bearsted; presented to the National Trust with the contents of Upton House, 1948.

EXHIBITIONS GG, 1885 (58); RA, 1890 (5); 'Selection of Works by French and English Painters of the Eighteenth Century', Corporation of London Art Gallery, 1902 (67); 'Illustrating Georgian England', Whitechapel Art Gallery, March–May 1906 (Upper Gallery: 14); Nottingham, 1962 (1); Tate Gallery, 1980–81 (72, repr.).

BIBLIOGRAPHY Armstrong, 1898, p. 205; Armstrong, 1904, p. 286; Waterhouse, no. 877; John Hayes, 'Gainsborough's Early Landscapes', *Apollo*, November 1962, p. 671, repr. fig. 8; Mary Woodall, 'Gainsborough Landscapes at Nottingham University', *Burlington Magazine*, December 1962, p. 562; *Upton House: The Bearsted Collection: Pictures*, National Trust, 1964, no. 24, p. 15: Herrmann, p. 92; John Ingamells, 'Thomas Gainsborough', *Burlington Magazine*, November 1980, p. 779, repr. fig. 97.

The device of the framing tree, with its branches

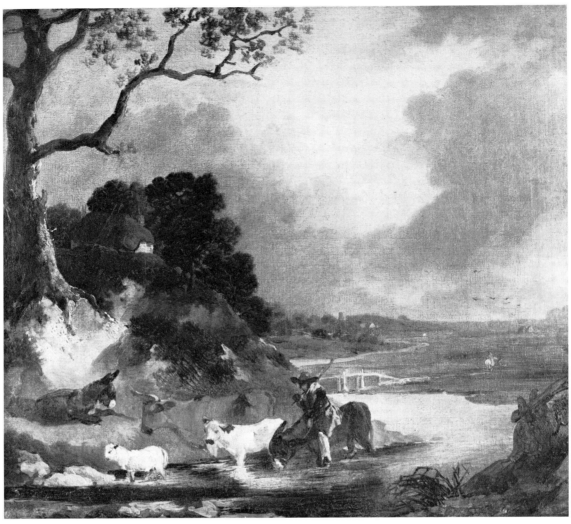

2

spreading across the picture plane, was constantly used by Gainsborough and one with which he found it hard to dispense; the *repoussoir* tree-trunk in the right foreground is a similarly recurrent feature found right up to the end of his career. The awkwardly modelled bank on the left is balanced by the dark-grey clouds on the right. The cottage, shown in the process of being thatched, is characteristic of the 'naturalistic' vignettes included in much contemporary English landscape painting. The relationship of sky to landscape is Dutch in character, but the feeling for atmosphere in the distance (treated in zones of green and then grey) is entirely personal. Also mentioned on pp. 41, 43, 47; a detail is repr. pl. 44.

DATING Identical with *Bumper* (1a) in the use of a light, fawn priming, the pale tonality, the soft handling of the grey clouds, with richly worked white impasto in the lights, the freshly painted, generalized foliage, the modelling of the tree-trunk in short, precise touches, the motif of the framing tree, the somewhat brittle de-lineation of the branches spreading across the surface of the picture, and the unbalanced composition. Certain features, however, such as the harsh, dramatic lighting of

the chalky bank, the painting of the hillock behind the broad areas of grey and brown, without much feeling for structure, and the modelling of the sheep and calf are more closely related to cat. no. 1.

## 3 Open Landscape with Cottage at the Edge of a Wood

Canvas. $11\frac{3}{4} \times 13\frac{3}{4}$   29.8 × 34.9
Painted *c.* 1744–5

Hove Museum of Art, Hove

INSCRIPTIONS Labels on the back are inscribed: *T. Gainsborough. R.A./A Landscape: study from/nature.* and *Bought/March. 20. 1874 at Ch . . . /from the collection of Tho . . ./Green of Ipswich, J. P. Heseltine 1878.*

PROVENANCE George Frost (d. 1821); Thomas Green; Green sale, Christie's, 20 March 1874, lot 113, bt Mrs N.; J. P. Heseltine, 1878; Heseltine sale, Sotheby's, 27–29 May 1935, 1st day, lot 38 (repr.), bt Gooden and Fox for Ernest Cook; bequeathed to Hove Museum of Art through the National Art Collections Fund, 1955.

3

EXHIBITIONS RA, 1878 (124); GG, 1885 (51); Fine Art Club, Ipswich, 1887 (172A or 174); 'Loan Collection of Pictures', Corporation of London Art Gallery, 1892 (119); Nottingham, 1962 (2); 'The Origins of Landscape Painting in England', Iveagh Bequest, Kenwood, summer 1967 (7).

BIBLIOGRAPHY Fulcher, p. 237; William Martin Conway, *The Artistic Development of Reynolds and Gainsborough*, London, 1886, p. 77; Armstrong, 1898, p. 205; Armstrong, 1904, p. 287; Waterhouse, no. 880; Mary Woodall, 'Gainsborough Landscapes at Nottingham University', *Burlington Magazine*, December 1962, p. 562.

Unfinished (the trees on the right are no more than laid in in a brown dead colour). The absence of figures or other staffage is unusual in a Gainsborough landscape (other examples are the Beit and Fitzwilliam pictures, cat. nos 4 and 18). The somewhat stiff tree on the left is Gaspardesque, and the carefully placed logs are a compositional device, derived from Ruisdael, which Gainsborough continued to use throughout his career. The compositional rhythms are, however, wholly rococo. Two copies on panel are in existence, both of them roughly the same size as the original; one is a straight copy, but in the other, formerly owned by P. M. Turner and exhibited in Ipswich in 1927 (no. 36), the left of the composition has been altered and a figure, laden donkey and dog have been added. The former may be by George Frost (see pl. 319 and p. 268), the original owner of the Gainsborough; the latter is by Ibbetson (see pl. 281 and p. 243). Also mentioned on pp. 47, 55–7.

DATING Closely related to *Bumper* (1a) in the use of a light fawn priming, the pale tonality and exceptionally pale-blue tints in the sky, the handling of the clouds, the fresh, generalized handling of the foliage in the distant trees, the tight modelling of the stiffly painted tree-trunk on the left, and the flatness of the composition. Although effective transitions between the different planes are still lacking, the modelling of the mounds in the foreground is more successful, and the tree is more firmly related to the ground, than in cat. no. 2.

4

## 4 Wooded Landscape with Winding Path

Canvas. $13\frac{1}{2} \times 10\frac{1}{4}$   $34.3 \times 26$
Painted $c$. 1745–6

Sir Alfred Beit, Bt, Russborough.

PROVENANCE Joshua Kirby (1716–74); by descent to the Rev. Henry Scott Trimmer; Trimmer sale, Christie's, 17 March 1860, lot 85, bt Rutley; G. A. F. Cavendish Bentinck; Cavendish Bentinck sale, Christie's, 8–17 July 1891, 4th day (11 July), lot 550, bt Agnew; Alfred (later Sir Alfred) Beit; thence by descent.

EXHIBITIONS RA, 1890 (6); Nottingham, 1962 (3); Tate Gallery, 1980–81 (73, repr.); Grand Palais, 1981 (13, repr.).

BIBLIOGRAPHY Armstrong, 1904, p. 285; either this or cat. no. 84 listed Menpes and Greig, p. 175; Waterhouse, no. 876; John Hayes, 'Gainsborough's Early Landscapes', *Apollo*, November 1962, p. 667, repr. fig. 2; Mary Woodall, 'Gainsborough Landscapes at Nottingham University', *Burlington Magazine*, December 1962, p. 562, repr. fig. 43; Herrmann, p. 92; Hayes,

p. 201, repr. pl. 2.

Unfinished (the foliage on the left is only laid in in dead colour, and the foreground and middle distance on the right are very sketchily handled in comparison with the left of the canvas). The fluidly painted branches and fresh handling of the foliage in the centre trees are comparable with passages in such Watteaus as *Le Mezzetin*, in the Metropolitan Museum (pl. 70), and the freshness of tone throughout is very French in quality. As in the case of the Hove landscape (cat. no. 3), the absence of figures is exceptional. Also mentioned on p. 55; a detail is repr. pl. 69.

DATING Closely related to *Bumper* (1a) in the use of exceptionally pale-blue tints in the sky, the handling of the clouds—in soft greys and mauves, with richly worked white impasto in the lights—and the fresh, liquid and generalized handling of the foliage throughout. However, both the tree-trunks and the sandy bank are more subtly and convincingly modelled than in *Bumper*, and the composition is conceived a little less flatly, with some suggestion of the depth and recesses of the wood.

5

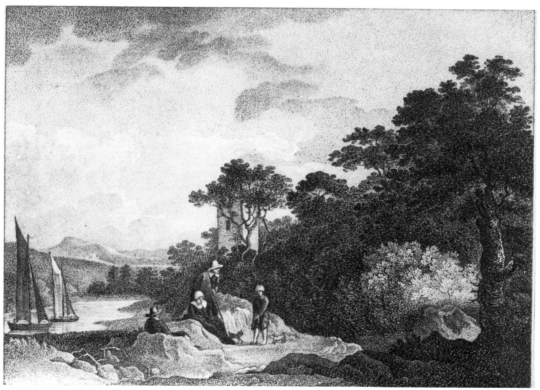

**5a** Engraving of cat. no. 5 by William Birch, published 1 October 1788.

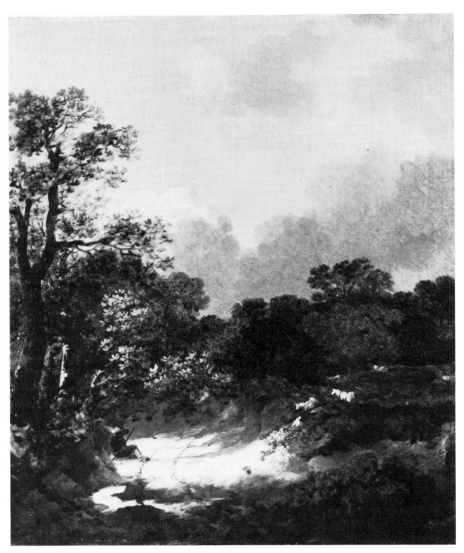

6

## 5* Wooded River Landscape with Peasants resting and Church Tower

Canvas. $9\frac{1}{4} \times 12\frac{1}{4}$   $23.5 \times 31.1$
Painted *c*. 1745–6

Ownership unknown

ENGRAVING Engraved and published by William Birch as *View at Wolverstone, Suffolk*, 1 October 1788.

PROVENANCE Colonel James Hamilton (1746–1804), by 1788; by descent to Colonel Robert Lloyd-Anstruther, Hintlesham Hall, Suffolk, 1887; with Colnaghi, 1895; 'An Eastern Art Museum' sale, Parke-Bernet's, New York, 2 February 1950, lot 16 (repr.), bt Austen.

EXHIBITION Fine Art Club, Ipswich, 1887 (184).

BIBLIOGRAPHY Waterhouse, no. 884.

The composition originally included two sailing boats on the left: it is not known when they were painted out, but this was evidently subsequent to 1788, as they appear in Birch's engraving of that year (5a). They remain very clearly visible in the photograph. The coulisse arrangement on the right, with alternating planes of dark and light in which the foliage is merged, is derived from the practice of Dutch landscape painting, as are the motifs of the church tower picturesquely shrouded by trees and the group of peasants resting by the roadside. Woolverstone, in Suffolk, is on the banks of the River Orwell, which helps to account for the title given to the picture by Birch, but the church is not St Michael's and there is no topographical evidence for the supposition that the scene is an actual view. Also mentioned on pp. 37, 48.

DATING Appears to be closely related to *Bumper* (1a) in the handling of the sky, clouds and foliage, the precise highlighting of the tree on the right and the flatness of the composition. The treatment of the figures and the very free painting of the distances seem to be similar to cat. no. 2, but the composition, though falling away to the left, is more integrated and would have appeared even more so before the boats were painted out (compare Birch's engraving).

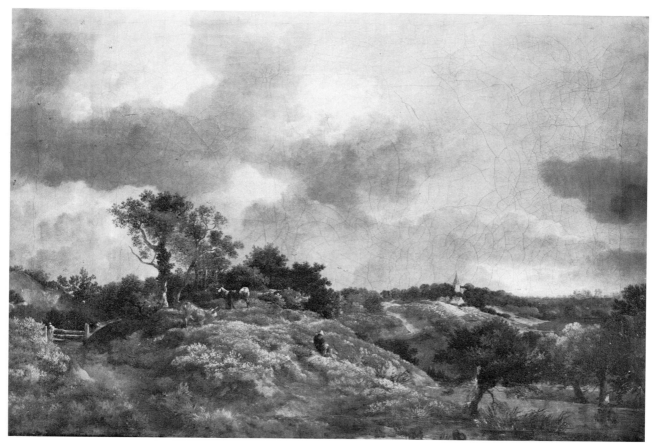

11

PROVENANCE The Rev. Thomas Rackett (1757–1841), rector of Spetisbury with Charlton Marshall, Dorset; thence by descent through his daughter, Dorothea Solly.

EXHIBITIONS Arts Council, 1949 (1); Bath, 1951 (6), p. 5.

BIBLIOGRAPHY Waterhouse, no. 869.

The relationship of sky to landscape derives from Dutch painting, but the changing lights playing over the distance are thoroughly English in character. The arrangement of the landscape in overlapping planes is more successfully contrived than hitherto, but the seated figure and cows are visually unrelated to each other. The handling is very precise and particularized throughout. Thomas Rackett, the first recorded owner of this picture and of cat. no. 12, who was taught drawing by Paul Sandby, was a man of wide learning and an avid collector, mainly of ancient seals and coins; he was a friend of J. T. Smith and one of Garrick's executors. Also mentioned on p. 48.

DATING Similar to the engravings of the drawings (now lost) Gainsborough executed for publication by John Boydell in 1747 (see Boydell, *A Collection of Views in England and Wales*, London, 1790, pls 89–92) in the arrangement of the composition in overlapping planes, while the crisp, nervous highlighting of the figure, cows and foreground detail is identical with cat. no. 9.

## 12 Open Landscape with Country Waggon travelling along an Undulating Track

Canvas. 19 × 23¼  48.3 × 60.3
Painted *c.* 1746–7

Private collection, England

PROVENANCE The Rev. Thomas Rackett (1757–1841), rector of Spetisbury with Charlton Marshall, Dorset; thence by descent through his daughter, Dorothea Solly.

ENGRAVING Mezzotinted by William Giller (*c.* 1805– after 1868).

EXHIBITIONS Art Council, 1949 (2); Bath, 1951 (5), p. 5, repr. facing p. 12; Tate Gallery, 1980–81 (76, repr.).

BIBLIOGRAPHY William Martin Conway, *The Artistic Development of Reynolds and Gainsborough*, London, 1886, repr. facing p. 78; Woodall, *Drawings*, p. 15, repr. pl. 7; Waterhouse, no. 867; John Hayes, 'Gainsborough's Early Landscapes', *Apollo*, November 1962, pp. 668, 671, repr. fig. 6.

Both the dark-grey, threatening clouds dominating the scene and the concept of the undulating track taking the eye into distance, skilfully solving the problem of relating the different planes of the landscape, are influenced by the example of Dutch landscape. The clouds are somewhat artificial in character. The motif of

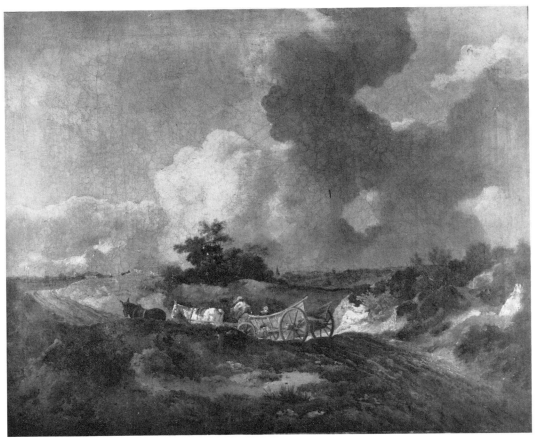

12

the country waggon, first featured in the Gardner landscape (cat. no. 7), now makes its appearance as a principal subject. Two copies on panel are in existence, one roughly the same as the original (Waterhouse, no. 868), the other somewhat smaller. The first may be attributed to Ibbetson (see pl. 278 and p. 243); the second may also be by the same artist. Also mentioned on p. 48.

DATING Identical with cat. no. 11 in the dominance, flat pattern and handling of the dark-grey clouds, the treatment of the foliage, the crisp highlighting of the figures and animals, and the scratchy, broken modelling of the sandy banks on the right. Although the composition is still organized in clearly separated planes, the arrangement is far more skilful than in earlier pictures, the divisions being masked by the flowing silhouettes of the foreground and middleground banks and by the swing of the waggon and the track.

### 13  Extensive Landscape with Chalky Banks, Winding Track, Figures and Animals

Canvas. $18\frac{1}{2} \times 24$   $47 \times 61$
Painted $c$. 1746–7

National Gallery of Ireland, Dublin (191)

PROVENANCE J. H. Reynolds; by descent to F. W. Reynolds; Reynolds sale, Christie's, 10 April 1883, lot 109, bt Doyle for the National Gallery of Ireland.

EXHIBITIONS 'Thomas Gainsborough Bicentenary Exhibition', National Gallery of Ireland, Dublin, 1927; 'British Art', City Art Gallery, Manchester, April–May 1934 (43); 'British Art', RA, 1934 (310); 'Twee Eeuwen Engelsche Kunst', Stedelijk Museum, Amsterdam, July–October 1936 (39); 'La Peinture Anglaise: XVIII$^e$ & XIX$^e$ Siècles', Louvre, Paris, 1938 (45, repr. *Souvenir*); 'English Masters from the National Gallery of Ireland, Dublin', Belfast Museum and Art Gallery, May–August 1960 (4); Nottingham, 1962 (4); 'National Gallery of Ireland Centenary Exhibition', Dublin, October–December 1964 (157); 'The Origins of Landscape Painting in England', Iveagh Bequest, Kenwood, summer 1967 (8, repr.); Tate Gallery, 1980–81 (77, repr.); Grand Palais, 1981 (14, repr.).

BIBLIOGRAPHY Armstrong, 1894, p. 76; Armstrong, 1898, pp. 38, 67, 69, 206, repr. facing p. 12; Chamberlain, p. 36; Armstrong, 1904, pp. 49, 88, 90–91, 287, repr. facing p. 20; Boulton, pp. 47, 48, 62; Armstrong, 1906, pp. 189–90; Gabriel Mourey, *Gainsborough*, Paris, n.d. [1906], repr. facing p. 80; Menpes and Greig, p. 48; 'Catalogue of Pictures in the National Gallery of Ireland', Dublin, 1928, no. 191, p. 43; C. H. Collins Baker, *British Painting*, London, 1933, repr. pl. 76; *Royal*

**13**

*Academy of Arts Commemorative Catalogue of the Exhibition of British Art, 1934*, Oxford, 1935, no. 178, repr. pl. LXIII (top); Mary Woodall, 'A Note on Gainsborough and Ruisdael', *Burlington Magazine*, January 1935, p. 45; Woodall, *Drawings*, p. 15; Millar, p. 6, repr. pl. 10; Woodall, p. 26, repr. p. 25; George Furlong, 'The National Gallery of Ireland', *Studio*, August 1949, repr. p. 41; Waterhouse, no. 870; Mary Woodall, 'Gainsborough Landscapes at Nottingham University', *Burlington Magazine*, December 1962, p. 562; Hayes, *Drawings*, p. 136; Mahonri Sharp Young, 'British Paintings in the National Gallery of Ireland', *Apollo*, February 1974, repr. fig. 26; Hayes, p. 201, repr. pl. 5; *The Genius of British Painting*, ed. David Piper, London, 1975, p. 186, repr. p. 187; Jeffery Daniels, 'Gainsborough the European', *Connoisseur*, February 1981, p. 111; Lindsay, pp. 22–3.

This landscape marks the beginning of a phase in which Gainsborough is using more sophisticated means to map out an extensive space. Again the inspiration is Dutch. The dark, threatening clouds, echoing the silhouette of the landscape, the rutted track, receding into distance through a pool, and the scraggy, windswept trees all derive from Ruisdael, though the clouds cascade across the painting as they might in Fragonard. The numerous scattered motifs, characteristic of the lesser Dutch landscapists, are typical of early Gainsborough. Also mentioned on pp. 47, 48, 57, 164, 167.

DATING Identical with cat. no. 12 in the dominant grey clouds, richly worked in the lights, the pale tonality, the crisp highlighting in the modelling of the banks, the broken chiaroscuro, and the use of flowing silhouettes and of a track receding into distance to link together the different planes of the composition. The modelling of the banks is more subtle and rococo than in earlier pictures, and the flat shapes of the clouds are now used to echo the silhouette of the horizon.

### 14  Wooded Landscape with Mother carrying a Baby and Reclining Peasant

Canvas. $14 \times 12\frac{1}{16}$   35.6 × 30.6
Painted *c.* 1746–7

Private collection, England

PROVENANCE L. Harper; Harper sale, Sotheby's, 13 December 1972, lot 84 (repr.), by Colnaghi; with Herner Wengraf; with Colnaghi, from whom it was purchased.

EXHIBITIONS 'Exhibition XX', Herner Wengraf's, 1974 (20, repr.); 'English Drawings, Watercolours and Paintings', Colnaghi's, September–October 1976 (8), repr. pl. II; Tate Gallery, 1980–81 (78, repr.).

BIBLIOGRAPHY Theodore Crombie, 'Buying British' ('Round the Galleries'), *Apollo*, March 1975, p. 231, repr. fig. 2.

14

The motif of the woman carring a baby is unique in Gainsborough's early work. She is, however, somewhat out of scale with the burdock leaves and the peasant on the right. The peasant seated in the shade of a tree is to become a familiar Gainsborough motif. The stiff tree-trunk harks back to the Hove landscape (cat. no. 3). The composition, still constructed in carefully demarcated planes, is dominated by an undulating lateral rhythm. Also mentioned on p. 57

DATING Closely related to cat. no. 12 in the pale-blue tints in the sky, the richly worked, creamish-white highlights in the clouds, the highlights in the foliage, the treatment of the distance, the spatial structure in carefully demarcated planes and the undulating composition. The soft handling and highlighting of the foliage are similar to cat. no. 7, and the crisp treatment of the foreground plants is similar to cat. no. 11.

## 15* Wooded Landscape with Figures, Cows and Distant Flock of Sheep

Canvas. $28\frac{1}{4} \times 36\frac{3}{4}$   $71.7 \times 93.3$
Painted *c.* 1746–7

Ownership unknown

PROVENANCE William Garnett, 1888; with Agnew, 1921; with Knoedler; with John Levy Galleries, New York; Robert Cluett, New York; Cluett sale, American Art Association, New York, 26 May 1932, lot 90 (repr.), bt L. Miller.

EXHIBITIONS GG, 1888 (302); 'First Loan Collection of Pictures', Storey Institute, Lancaster, October 1891 (112).

BIBLIOGRAPHY Waterhouse, p. 40, no. 846; *European Paintings in the Collection of the Worcester Art Museum*, Worcester, Mass., 1974, pp. 33–4; Martin Butlin and Evelyn Joll, *The Paintings of J. M. W. Turner*, New Haven and London, 1977, pp. 27–8.

This is the earliest known Gainsborough landscape of

15

any size. The carefully delineated view into distance, an extension of the compositional principles first developed in the Cincinnati landscape (cat. no. 9), is framed between the masses of trees, almost as though one were seeing it through a window. The flock of sheep enlivening this distant scene is paralleled in the background of *Mr and Mrs Andrews* (pl. 78). As in the early Solly landscape (cat. no. 11), the figures and animals are visually unrelated, and the handling of the foreground and middleground detail is exceptionally tight. A copy, probably by John Crome, is in the Worcester Art Museum (1940.53) (see pl. 318 and pp. 266–7); of much greater interest is a copy by Turner in the Tate Gallery (5489), an entirely free version, with the right half of the composition completely altered (see pl. 296 and pp. 254–7). Both are roughly the same size as the original, though the Worcester picture is truncated at the bottom. Also mentioned on pp. 45–6.

DATING Appears to be closely related to cat. no. 13 in the handling of the foliage, the highlighting of the scattered figures and animals, the scratchy modelling of the chalky

bank, the tight and rather fussy handling of the foreground detail, the use of the foreground bank as a *repoussoir* which is successfully linked visually with the middleground planes, and the arrangement of the clouds, echoing the silhouette of the trees. The composition is similar to cat. no. 9, but, instead of being organized on a narrow stage, is developed in depth and with far greater amplitude. The same tall, slender trees are evident, but the woodland seems to be more naturalistic, and the foliage denser and more plastic.

## 16  Wooded Landscape with Figure on a Winding Track

Canvas. $8\frac{3}{4} \times 7\frac{1}{16}$   22.2 × 17.9
Painted *c.* 1746–7

Tate Gallery, London (1485)

PROVENANCE Bequeathed by Mrs Gainsborough to her daughter, Margaret, who gave it to Henry Briggs (undated and unwitnessed codicil to her deed of gift, 23 May 1818); Richard Lane; by descent to the Misses Lane,

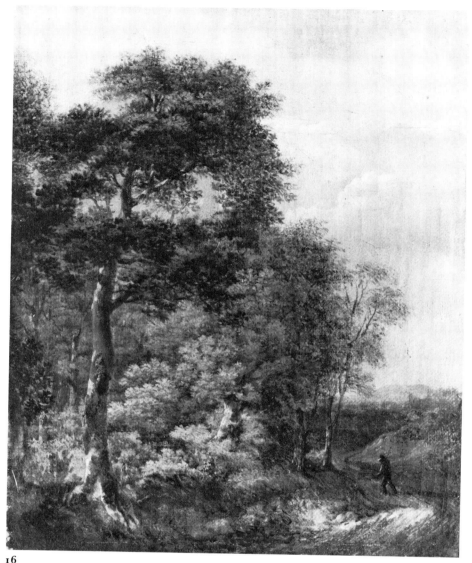

16

who presented it to the National Gallery, 1896; transferred to the Tate Gallery, 1919.

EXHIBITIONS BI, 1859 (165); RA, 1887 (5).

BIBLIOGRAPHY Armstrong, 1898, pp. 72, 206, repr. p. 113; Armstrong, 1904, pp. 95–6, 287; Pauli, p. 96, repr. pl. 79; Boulton, pp. 49, 51, 63–4; Menpes and Greig, p. 49; Myra Reynolds, *The Treatment of Nature in English Poetry*, Chicago, 1909, p. 305; Mary Woodall, 'A Note on Gainsborough and Ruisdael', *Burlington Magazine*, January 1935, p. 45; Waterhouse, no. 893; Dillian Gordon, *Second Sight: Rubens: The Watering Place/ Gainsborough: The Watering Place*, National Gallery, London, 1981, p. 17.

Companion, from after Gainsborough's death, to the wooded landscape of the same size in the Tate Gallery (cat. no. 8). The winding track on the right, leading to a hilly distance, seems to have been largely repainted. The composition is broadly similar to the left side of *Gainsborough's Forest* (cat. no. 17).

DATING Appears to be closely related to cat. no. 15 in the handling of the tall, slender tree-trunk and of the foliage.

### 17 Wooded Landscape with Woodcutter, Figures, Animals, Pool and Distant Village (Gainsborough's Forest)

Canvas. 48 × 61   121.9 × 154.9
Recorded as painted in 1748, but here suggested as painted *c.* 1746–7

National Gallery, London (925)

ENGRAVING Aquatinted in reverse by M. C. Prestal, with the title *Gainsborough's Forest*, and published by J. and J. Boydell as in the collection of Alderman Boydell, 1 January 1790.

PROVENANCE Said by Gainsborough in March 1788 to have been 'in the hands of twenty picture dealers' since its execution, and to have been bought by himself 'during that interval for *Nineteen Guineas*'; Richard

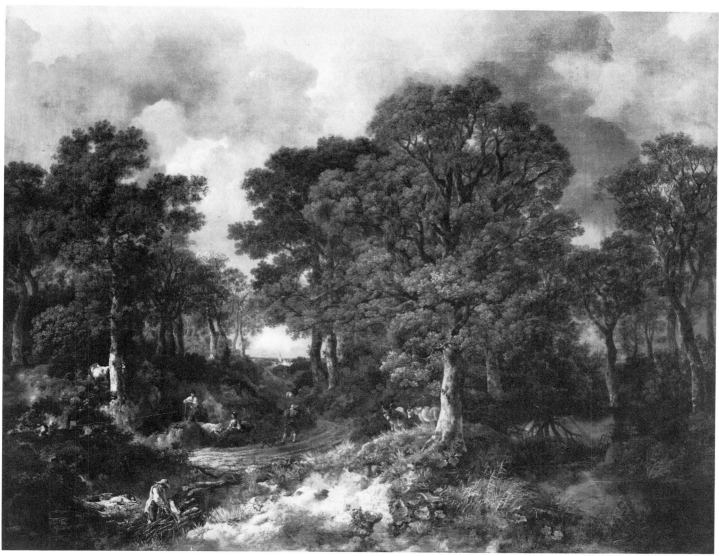

**17**

Morrison; Morrison sale, Greenwood's, 8 March 1788, lot 78, bt Alderman John Boydell; Josiah Boydell, 1808; David Pike Watts, 1814; by descent to his daugher, Jesse Watts Russell; Watts Russell sale, Christie's, 3 July 1875, lot 32, bt Burton for the National Gallery.

EXHIBITIONS The Shakespeare Gallery, Pall Mall, 1790; BI, 1814 (16); BI, 1843 (176); 'Art Treasures of the United Kingdom', Manchester, 1857 (Saloon D, 95); 'Cleaned Pictures', National Gallery, 1947 (82); 'Shock of Recognition: The Landscape of English Romanticism and the Dutch Seventeenth-century School', Maurits-huis, The Hague, November 1970–January 1971, and Tate Gallery, January–February 1971 (30, repr.); 'Landscape in Britain *c.* 1750–1850', Tate Gallery, November 1973–February 1974 (51, repr.).

BIBLIOGRAPHY *Morning Herald*, 12 March 1788, 23 April 1789; *Norwich Mercury*, 27 March 1790; *Gazetteer*, 6 May 1790; Farington Diary, 26 March 1808 (typescript, p. 4018); *Morning Post*, 19 May 1814; anon. [William Hazlitt], 'On Gainsborough's Pictures', *Champion*, 31 July 1814, p. 247; *Ilam Gallery Catalogue 1827*, 1828, no. 14; anon., *The History and Topography of Ashbourn*, Ashbourn, 1839, p. 181; Fulcher, pp. 10, 197; J. Beavington-Atkinson, 'Thomas Gainsborough' (article in Robert Dohme, *Kunst und Künstler des Mittelalters und der Neuzeit*, Leipzig, 1880, vol. 6), pp. 40–54; George M. Brock-Arnold, *Gainsborough*, London, 1881, p. 21; Armstrong, 1894, pp. 15, 50, 76, repr. facing p. 14; Bell, pp. 22–3; Armstrong, 1898, pp. 39, 63, 67, 70–73, 163, 206, 207, repr. p. 61; Mrs Arthur Bell, *Thomas Gains-borough, R.A.*, London, 1902, p. 32; Chamberlain, pp. 34–6, 144, 145, repr. p. 3; Gower, pp. vi, 7, 43, 112; Armstrong, 1904, pp. 50, 83, 89, 92–4, 95, 96, 283, 289, repr. facing p. 72; A. E. Fletcher, *Thomas Gainsborough, R.A.*, London, 1904, p. 185, repr. facing p. 144; Boulton, pp. 49–51, 62, 63, repr. facing p. 49; Armstrong, 1906, pp. 39, 128, 190, repr. facing p. 40; Gabriel Mourey, *Gainsborough*, Paris, n.d. [1906], pp. 51, 99–100; Menpes and Greig, pp. 35, 49, 91, 160–61; Myra Reynolds, *The*

*Treatment of Nature in English Poetry*, Chicago, 1909, p. 305; Whitley, pp. 4, 296–302, 333, 334, and repr. facing p. 298; E. Rimbault Dibdin, *Thomas Gainsborough*, London, 1923, pp. 15, 18, 26, 35, repr. p. 13 (col.); Farington Diary, ed. James Greig, London, vol. v, 1925, pp. 41–2, note, repr. facing p. 40; Hugh Stokes, *Thomas Gainsborough*, London, 1925, pp. 11–12, 137–8, repr. facing p. 12; William T. Whitley, 'An Eighteenth-century Art Chronicler: Sir Henry Bate Dudley, Bart', *The Walpole Society*, vol. XIII, Oxford, 1925, p. 59; William T. Whitley, *Artists and their Friends in England 1700–1799*, London, 1928, vol. I, p. 103; William T. Whitley, *Art in England 1821–1837*, Cambridge, 1930, pp. 56, 58, 135; Charles Johnson, *English Painting from the Seventh Century to the Present Day*, London, 1932, pp. 129–30; C. H. Collins Baker, *British Painting*, London, 1933, pp. 106, 150; Roger Fry, *Reflections on British Painting*, London, 1934, p. 72; Charles Johnson, *A Short Account of British Painting*, London, 1934, pp. 48–9; Mary Woodall, 'A Note on Gainsborough and Ruisdael', *Burlington Magazine*, January 1935, p. 45, repr. p. 41, pl. A; Woodall, *Drawings*, pp. 12–15, 24, 28–31, 33, 35, 36, 37, 39, 45, 46, 47, 86–7, 88, repr. pl. 6; Kenneth Clark, *More Details from Pictures in the National Gallery*, London, 1941, pl. 63 (detail); Millar, pp. 5–6, 10, 13, repr. pl. 1 (col.); Woodall, pp. 12–13, 26, 28, 29, 30, 106, repr. p. 23; Basil Taylor, *Gainsborough*, London, 1951, p. 4; Ernest Short, *A History of British Painting*, London, 1953, p. 173; Ellis Waterhouse, *Painting in Britain 1530–1790*, Harmondsworth, 1953, pp. 183–4, repr. pl. 151; Waterhouse, p. 12, no. 828, repr. pl. 22; Martin Davies, *The British School*, National Gallery, London, 2nd ed., rev., 1959, pp. 36–7; John Woodward, *British Painting: A Picture History*, London, 1962, p. 65 (repr. detail); John Hayes, 'Gainsborough's Early Landscapes', *Apollo*, November 1962, pp. 671, 672, repr. fig. 7 (detail); Mary Woodall, 'Gainsborough Landscapes at Nottingham University', *Burlington Magazine*, December 1962, p. 562; Woodall, *Letters*, pp. 18, 35, repr. facing p. 57; John Hayes, 'Gainsborough', *Journal of the Royal Society of Arts*, April 1965, pp. 325, 327; R. B. Beckett, ed., 'John Constable's Correspondence IV', *The Suffolk Records Society*, vol. x, Ipswich, 1966, p. 16; Gatt, pp. 10, 18, repr. pls 4–5 (col.); William Gaunt, *The Great Century of British Painting: Hogarth to Turner*, London, 1971, p. 219, repr. pls 33, 32 (col. detail); Jean-Jacques Mayoux, *La Peinture Anglaise De Hogarth aux Préraphaélites*, Geneva, 1972, pp. 66, 79; Herrmann, pp. 93–4, repr. pl. 85; Basil Taylor, *Constable*, London, 1973, repr. pl. 177; Geoffrey Grigson, *Britain Observed*, London, 1975, pp. 64, 185, repr. pls 28, 29 (col. detail); Hayes, p. 204, repr. pls 16, 17 (detail); Paulson, p. 247; Joseph Burke, *English Art 1714–1800*, London, 1976, pp. 211–12; Homan Potterton, 'Reynolds and Gainsborough', *Themes and Painters in the National Gallery*, Series 2, Number 3, 1976, p. 8, repr. pl. 3; British Museum, 1978, pp. 10, 12; David Coombs, *Sport and the Countryside*, Oxford, 1978, p. 49 repr. and col. detail p. 48; Simon Wilson, *British Art from Holbein to the present day*, London, 1979, pp. 46, 48, repr. p. 47; Tate Gallery, 1980–81, p. 76; Grand Palais, 1981, p. 81; Lindsay, pp. 25–6, 27, 178, 194, repr. pl. 6; Michael Rosenthal, *English Landscape Painting*, Oxford, 1982, pp. 42, 58, repr. pl. 35.

Forty years after he had painted this celebrated work Gainsborough described his feelings about it in a letter to Bate-Dudley dated 11 March 1788, only known, however, from the columns of the *Morning Herald*:

It is in some respects a little in the *Schoolboy* stile—but I do not reflect on this without a secret gratification; for—as an early instance how strong my inclination stood for LANDSKIP, this picture was actually painted at SUDBURY in the year 1748; it was begun *before I left school*;—and was the means of my Father's sending me to London.

It may be worth remark, that though there is very little idea of composition in the picture, the touch and closeness to nature in the study of the parts and *minutiae*, are equal to any of my latter productions.—In this explanation, I wish not to seem vain or ridiculous, but do not look on the Landskip as one of my riper performances. *Morning Herald*, 1789 (date of issue unknown)

The complexity of the design, and the number of unrelated figures and incidents, are so far removed from the breadth, and unified mood and subject, characteristic of Gainsborough's late style that his comments are much what one would expect. As in the smaller picture in the Tate Gallery (cat. no. 19), the distant village and church tower provide a psychologically essential glimpse of countryside beyond the confines of the wood. A favourite motif, that of two donkeys grouped together, makes its first appearance. This landscape seems to have become known as 'Cornard Wood' at the time it was owned by David Pike Watts; it was so described, for the first time, in the catalogue of the Ilam Hall pictures published by his daughter in 1828 (see above). Such emphasis on place and consequent exactness of title are not unexpected in the age of Constable, the more especially as Pike Watts was Constable's uncle. The village in the background, possibly an actual view, is not identifiable (the spire is squat, not tall, thus hardly more than reminiscent of that of St Andrew's, Great Cornard). A slightly reduced copy was in an anon. sale, Sotheby's, 22 July 1959, lot 64; and a small variant copy is in the possession of Mr Geoffrey Hughes, Utah. Also mentioned on pp. 40–41, 43, 46, 48, 51, 64, 65–7, 69, 72, 76; a detail is repr. pl. 75.

DATING Gainsborough's statement (see above) that this painting was begun before he left school and went up to London, which can only mean before 1740–41, has never been satisfactorily explained. Martin Davies (cited above, 1959) concluded that 'Gainsborough's reminiscences concerning the present picture seem not altogether credible ... but Gainsborough's date of 1748 for the picture now visible may be accepted as likely.' As the canvas shows no sign of having been reworked (x-ray photographs of the lower half of the picture, kindly taken specially, reveal no pentimenti), and since, too, it is

p. 205; Armstrong, 1904, p. 286; Woodall, *Drawings*, p. 29, repr. pl. 15; Waterhouse, no. 875; Fitzwilliam Museum *Annual Report*, 1966, repr. pl. VI; J. W. Goodison, *Catalogue of Paintings*, Fitzwilliam Museum, Cambridge, vol. III, *British School*, Cambridge, 1977, pp. 83–4, repr. pl. 18b.

A smaller canvas in the manner of *Gainsborough's Forest* (cat. no. 17), crisp and particularized in handling, with clouds echoing the silhouette of the trees. The dark clouds at the top, which fill up the picture surface, are irrelevant to the design. The painting is exceptional among Gainsborough's finished landscapes in the absence of figures or other staffage. Also mentioned on pp. 72, 74.

DATING Identical with cat. no. 17 in the pale tonality and use of pale-blue tints in the sky, the handling of the clouds, which echo the silhouette of the trees, the treatment of the foliage, the crisp painting of the foreground grasses and detail and the flat delineation of the bank beyond the pool.

### 19 Wooded Landscape with Peasant resting, Figures and Distant Village beyond a Cornfield

Canvas. 24½ × 30½   62.2 × 77.6
Painted *c.* 1747
Tate Gallery, London (1283)

PROVENANCE David P. Sellar, 1885; anon. [Sellar] sale, Christie's, 12 May 1888, lot 51, bt Agnew; purchased by the National Gallery, 1889; transferred to the Tate Gallery, 1951.

EXHIBITIONS RA, 1885 (71); Ipswich, 1927 (39); Arts Council, 1949 (3, repr. pl. 1); Arts Council, 1953 (9); 'Dutch Painting and the East Anglian School', Arts Council, Norwich, 1954 (30); 'British Paintings 1700–1960', British Council, Hermitage, Leningrad, and Pushkin Museum, Moscow, 1960 (27); Grand Palais, 1981 (15, repr.).

BIBLIOGRAPHY William Martin Conway, *The Artistic Development of Reynolds and Gainsborough*, London, 1886, pp. 79–80; Armstrong, 1898, pp. 72, 206, 207, repr. p. 15; Armstrong, 1904, pp. 95, 284, 289; Pauli, p. 96, repr. pl. 69; Boulton, pp. 49–50, 63; Gabriel Mourey, *Gainsborough*, Paris, n.d. [1906], p. 100, repr. facing p. 116; Menpes and Greig, p. 49; Myra Reynolds, *The Treatment of Nature in English Poetry*, Chicago, 1909, p. 305; R. H. Wilenski, 'The Gainsborough Bicentenary Exhibition', *Apollo*, November 1927, p. 194; Charles Johnson, *English Painting from the Seventh Century to the Present Day*, London, 1932, p. 129; C. H. Collins Baker, *British Painting*, London, 1933, p. 150; Roger Fry, *Reflections on British Painting*, London, 1934, pp. 72–3; Charles Johnson, *A Short Account of British Painting*, London, 1934, p. 49; Woodall, *Drawings*, pp. 24, 29, 31, 39; Woodall, p. 25; Waterhouse, no. 853; John Hayes, 'Gainsborough's Early Landscapes', *Apollo*, November

1962, p. 672; William Gaunt, *The Great Century of British Painting: Hogarth to Turner*, London, 1971, p. 219; Hayes, p. 202, repr. pl. 8; Paulson, p. 247; British Museum, 1978, p. 12; Lindsay, p. 22.

In this landscape the distant view is glimpsed between trees, as in *Gainsborough's Forest* (cat. no. 17), thus taking the concept adumbrated in the landscape formerly in the Cluett collection (cat. no. 15) a stage further. The motif of the distant sunlit fields, the treatment of the foliage and the track, punctuated with figures, winding through the wood are all derived from Ruisdael, though the articulation of space by means of figures diminishing in scale is also characteristic of Wijnants and other Dutch painters, and this central feature of the composition is similar to an etching by Waterloo (Dutuit, no. 111). The *repoussoir* figure seated beneath the tree in the foreground, present in the Waterloo etching, can be paralleled in such varied seventeenth-century artists as Wijnants or Gaspard Dughet. Although the village in the background could well be an actual view (the naturalism of the vignette is emphasized by the birds flying low over the fields), the identification as Dedham first proposed in the 1888 sale catalogue (cited above) is incorrect. Also mentioned on pp. 47, 48, 65, 72.

DATING Identical with cat. no. 17 in the pale-blue tints used in the sky, the concept of the flat, backdrop clouds, the treatment of the tree-trunks and foliage, the tight handling of the foreground detail, the use of a receding track to link together the different planes, and the distant view of a church tower seen between trees. The composition is considerably more unified and mature than cat. nos 9 and 15, and there is no *repoussoir* bank, as there still is in cat. no. 17.

### 20 Wooded Landscape with Peasant sleeping beside a Winding Track and Herdsman with Cattle drinking at a Pool

Canvas. 57½ × 61   145 × 144
Painted *c.* 1747
São Paulo Museum of Art, São Paulo

PROVENANCE Descended with Drinkstone Park, Suffolk, perhaps from Joshua Grigby, to the Powell family; H. Powell, 1814; bought from the Harcourt Powell estate by Arthur Tooth, *c.* 1935; Sir Kenneth (later Lord) Clark, 1936; with Frank Partridge, from whom it was purchased by the São Paulo Museum, 1951.

EXHIBITIONS BI, 1814 (22 or 38); Sassoon 1936 (124, repr. *Souvenir*, pl. 20); Bath, 1951; Tate Gallery, 1980–81 (79, repr.).

BIBLIOGRAPHY Fulcher, p. 198; anon., 'Gainsborough and the Gainsborough Exhibition at 45, Park Lane', *Apollo*, March 1936, repr. p. 130; E. K. Waterhouse, 'Gainsborough in Park Lane: Exhibition at Sir Philip Sassoon's', *Connoisseur*, March 1936, p. 123 (repr.); Woodall, *Drawings*, pp. 12–13, 33, repr. pl. 5; Woodall, p. 26; Waterhouse, pp. 18, 23, 40, no. 826, repr. pl. 46;

21

John Hayes, 'Gainsborough's Early Landscapes', *Apollo*, November 1962, p. 671; Pietro Maria Bardi, *Museu de Arte di São Paulo*, n.d. [1968], pp. 10 (repr.), 51 (repr. p. 50 col.); Hayes, *Drawings*, p. 134; British Museum, 1978, p. 10.

This is the largest landscape Gainsborough is known to have painted until after he left Suffolk, and the handling is much freer and more mature than in any previous work. Not until the Worcester landscape (cat. no. 80), probably the picture he sent to the Society of Artists in 1763, does one encounter another landscape of comparable scale. The composition, dominated by the prominent silver birch, is based, broadly speaking, on a reversal of Ruisdael's well-known *La Forêt* in the Louvre (now on deposit at Douai), of which Gainsborough had made a large chalk drawing, now in the Whitworth Art Gallery (pl. 50): the principal differences are in the staffage and the introduction of the winding track. The motif of the sprawling figure sleeping beside the track is unique in Gainsborough. The herdsman and cattle in the middleground are well managed, contrasting with the visually unrelated staffage in earlier works. The broadly painted distance is treated in planes of brown and then grey. Also mentioned on pp. 46, 48–9, 65. A copy of roughly the same size, possibly by Francis Towne, is in the Leicester Museums and Art Gallery (see pl. 287 and p. 251).

DATING Identical with cat. no. 22 in the soft, generalized treatment of the foreground track, water, and distance,

the buttery handling of the paint in the reclining figure, the soft, broad handling of the foreground grass and foliage, the open composition of the centre of the picture and the motifs of the silver birch and sunlit recess in the wood. The picture is much freer and more mature in handling than any previous work, the backdrop clouds, with their fretted outlines, are softer and less mannered than in cat. no. 13, and the tight modelling of forms characteristic of this slightly earlier phase is no longer evident.

### 21* Study of Trees

Canvas. 12½ × 14   31.8 × 35.6
Painted *c.* 1747. Ownership unknown

PROVENANCE R. J. Marnham; with John Nicholson, New York by 1947.

EXHIBITION 'Constable-Gainsborough-Turner', John Nicholson Gallery, New York, February–April 1947(8).

Only partially finished: possibly a study from nature. The dominant forked birch-tree, though here rococo in figuration, is still reminiscent of the birch in Ruisdael's *La Forêt*. A variant copy was formerly in the possession of Francis Towne (see pl. 312 and p. 263).

DATING Appears to be closely related to cat. no. 22 in the motif of the forked birch, the treatment of the track and the handling of the foliage and tufts of grass.

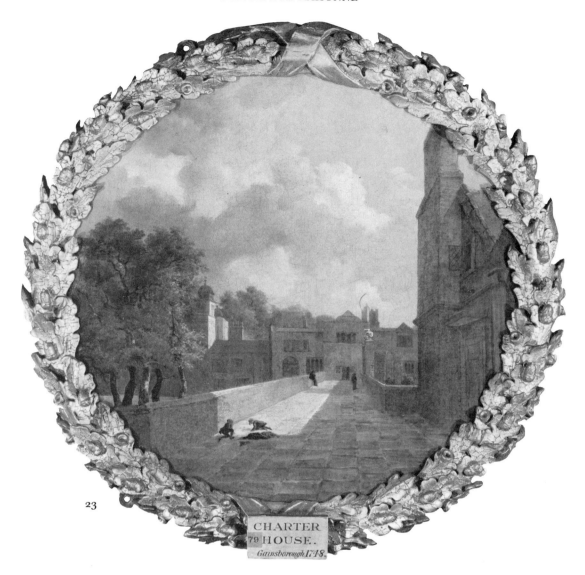

**23**

Amsterdam, July–October 1936 (37); Arts Council, 1953 (2), p. 6; 'Europäisches Rokoko', Residenz, Munich, June–October 1958 (61); 'The Origins of Landscape Painting in England', Iveagh Bequest, Kenwood, summer 1967 (9); 'Shock of Recognition: The Landscape of English Romanticism and the Dutch Seventeenth-century School', Mauritshuis, The Hague, November 1970–January 1971, and Tate Gallery, January–February 1971 (29, repr.); Nottingham, 1972 (6); 'The Painter's Eye', Gainsborough's House, Sudbury, June 1977 (2, repr.); 'British Painting 1600/1800', British Council, Art Gallery of New South Wales, Sydney, October–November 1977, and National Gallery of Victoria, Melbourne, December 1977–January 1978 (41); Grand Palais, 1981 (17, repr., and pp. 29, 30, 32).

BIBLIOGRAPHY 'Pictures in the Foundling Hospital, London', *Art-Union*, July 1840, pp. 109–10 (with wrong identifications); Fulcher, p. 237; Armstrong, 1898, p. 205; Armstrong, 1904, p. 283; Boulton, pp. 51–2, 62; William T. Whitley, *Artists and their Friends in England 1700–1799*, London, 1928, vol. I, pp. 163–4; C. H. Collins Baker, *British Painting*, London, 1933, pp. 106–7, 150; 'Vertue Note Books', III, *The Walpole Society*, vol. XXII, Oxford, 1933–4, p. 157; Charles Johnson, *A Short Account of British Painting*, London, 1934, p. 49; R. H. Nichols and F. A. Wray, *The History of the Foundling Hospital*, London, 1935, p. 262, repr. facing p. 268; Woodall, *Drawings*, p. 29, repr. pl. 14; Millar, pp. 5, 6, repr. pl. 9; Woodall, *Drawings*, pp. 24, 26–7, 30, repr. p. 21; Ellis Waterhouse, *Painting in Britain 1530–1790*, Harmondsworth, 1953, p. 183, repr. pl. 148; David Piper, 'Gainsborough at the Tate Gallery', *Burlington Magazine*, July 1953, p. 245; Waterhouse, pp. 8, 14–15, 17, 45, no. 861, repr. pl. 1 (repr. col. in the 1966 reprint); Frederick Antal, *Hogarth and his place in European Art*, London, 1962, p. 249; John Hayes, 'Gainsborough's Early Landscapes', *Apollo*, November 1962, p. 672, repr. pl. 1 (col.); Mary Woodall, 'Gainsborough Landscapes at Nottingham University', *Burlington Magazine*, December 1962, p. 562; Ellis Waterhouse, *Three Decades of British Art 1740–1770*, American Philosophical Society,

1965, pp. 21–2; John Hayes, 'Gainsborough', *Journal of the Royal Society of Arts*, April 1965, p. 326; Gatt, pp. 3, 18–20, repr. p. 15; editorial [Benedict Nicolson], 'The Thomas Coram Foundation for Children', *Burlington Magazine*, September 1966, p. 447; John Hayes, 'English Painting and the Rococo', *Apollo*, August 1969, p. 124; Denis Thomas, 'A London Hospital and the Arts', *Connoisseur*, August 1969, repr. fig. 5; Hayes, *Drawings*, p. 47; William Gaunt, *The Great Century of British Painting: Hogarth to Turner*, London, 1971, p. 36; Jean-Jacques Mayoux, *La Peinture Anglaise De Hogarth aux Préraphaélites*, Geneva, 1972, pp. 66–7; Benedict Nicolson, *The Treasures of the Foundling Hospital*, Oxford, 1972, no. 31, pp. 25, 28, 31, 65–6, repr. pl. 54; Herrmann, pp. 36, 93; Ellis Waterhouse, 'Bath and Gainsborough', *Apollo*, November 1973, p. 360; Hayes, pp. 33, 34, 35, 43, 203–4, repr. pls 19, 20 (detail); Paulson, p. 247; Joseph Burke, *English Art 1714–1800*, London, 1976, p. 212; David Coke, 'The Painter's Eye', *Connoisseur*, June 1977, p. 158; John Harris, *The Artist and the Country House*, London 1979, pp. 249, 332, 336–7, repr. pl. 379; Tate Gallery, 1980–81, p. 19; Dillian Gordon, *Second Sight: Rubens: The Watering Place/Gainsborough: The Watering Place*, National Gallery, London, 1981, pp. 16, 17, repr. fig. 15; Lindsay, pp. 23, 24, 28; Ellis Waterhouse, *The Dictionary of British 18th Century Painters*, Woodbridge, 1981, p. 135; Lindsay Stainton, 'Gainsborough and his Patrons', *Antique Collector*, January 1981, p. 34; Jeffery Daniels, 'Gainsborough the European', *Connoisseur*, February 1981, p. 111; Giles Waterfield, 'Winning Parisian Hearts', *Country Life*, 16 April 1981, p. 1051, repr. fig. 6.

One of eight circular views of London hospitals painted for the embellishment of the Court Room of the Foundling Hospital, where the Governors of that institution held their meetings; the other views were presented by Haytley, Wale and Wilson. The pictures are still *in situ* and form part of one of the most important surviving rococo decorative schemes in England. Unlike all the other artists who donated pictures to the Foundling Hospital, Gainsborough was not made a Governor: presumably he was thought too young. The Charterhouse buildings are here depicted from the north. The Terrace Walk (formerly part of the old cloister), which led to the Great Hall, is the main feature, with the Bowling Green and Chapel Tower to the left. Comparison with the bird's-eye view taken from the south, which was engraved for the reissue of Stow's *Survey of London* in 1755, confirms the broad accuracy of Gainsborough's view, which shows such specific details as the narrowing of the Terrace Walk beyond the houses on the right; the east wall of the Walk, however, should have been depicted as broken at intervals, the trees on the left have been grouped picturesquely instead of in a straight row, and those beyond the chapel never existed. With the exception of the Chapel Tower and the chimney-stack to its right, evidence for the appearance of the buildings included does not exist, since all the

other known views of the Charterhouse were either taken from the south or else depict the Bowling Green with the raised Terrace Walk seen on the right, and it is of interest to note (Gainsborough would have been flattered) that the picture was used by the architects responsible for the restoration after the Second World War, the Charterhouse having been destroyed by enemy action in May 1941. The sharply perspectival composition is likely to have been influenced by Hogarth, though it is also close, as Dillian Gordon points out (op. cit., fig. 16), to certain townscapes by Jan van der Heyden. The warm tone and thinly painted buildings are also strongly reminiscent of van der Heyden; the handling of the buildings and foliage is close in technique to Jan van Goyen. The two little boys playing marbles are characteristic of Hayman and contemporary genre; and the clouds are fundamentally rococo, in keeping with the roundel format. Also mentioned on pp. 29, 34, 43, 53–4, 57, 60, 67, 71, 120; details are repr. pls 47, 66.

DATING Presented to the Founding Hospital by the artist in 1748. The gift is recorded in the Committee's minutes for 11 May 1748.

## 24 Wooded Landscape with Figures, Donkeys, Pool and Cottage

Canvas. $26 \times 37\frac{3}{8}$   $66 \times 95$
Painted *c.* 1748

Kunsthistorisches Museum, Vienna

PROVENANCE Humphrey Roberts; Roberts sale, Christie's, 21–23 May 1908, 2nd day, lot 193 (repr.), bt Agnew; anon. [Agnew] sale, Christie's, 10 May 1912, lot 74, bt in; with Agnew, Berlin, from whom it was purchased by the Kunsthistorisches Museum, 1913.

EXHIBITIONS 'Europäisches Rokoko', Residenz, Munich, June–October 1958 (64); Grand Palais, 1981 (18, repr.).

BIBLIOGRAPHY Armstrong, 1898, p. 207, repr. p.v.; Armstrong, 1904, p. 288; Boulton, p. 51; Waterhouse, no. 859; *Katalog der Gemäldegalerie*, vol. 1, Kunsthistorisches Museum, Vienna, 1960, no. 542, p. 55; John Hayes, 'Gainsborough's Early Landscapes', *Apollo*, November 1962, pp. 667, 668, repr. fig. 4; John Hayes, 'Gainsborough and Rubens', *Apollo*, August 1963, p. 89; John Hayes, 'The Gainsborough Drawings from Barton Grange', *Connoisseur*, February 1966, p. 88; Hayes, *Drawings*, p. 134; Herrmann, pp. 92–3; *Verzeichnis der Gemälde Kunsthistorisches Museum, Wien*, Vienna, 1973, p. 73, repr. pl. 144; Hayes, p. 203, repr. pl. 7; Konstantin Bazarov, *Landscape Painting*, London, 1981, p. 85, repr. col. pp. 84–5; Lindsay, p. 27; Giles Waterfield, 'Winning Parisian Hearts', *Country Life*, 16 April 1981, p. 1051, repr. fig. 1.

The most rococo of all Gainsborough's early landscapes in the Dutch manner: the soft, swirling brushwork in the shadows of the clouds is close in technique to Fragonard, and the handling of the foliage is exceptionally feathery.

24

The usual view into distance is masked by a cottage on a bank, which links the two halves of the composition. The grey-green tonality is enlivened by touches of bright red: the skirt of the woman on the bank centre right and the cap of the boy on the right. The figures outside the cottage on the right are out of scale with their surroundings. The motif of a pool surrounded by trees is commonplace in the work of Ruisdael and Hobbema, and a precedent for a pool with a row of trees behind and a track which winds between the two halves of the design can be found in the Hobbema in the Musée Jeanne d'Aboville, la Fère, Aisne. Also mentioned on pp. 43, 53, 57, 67, 72, 167, 246. A copy by Leo Scheu (b. 1886) was with K. Schnittler, Hamburg, in 1972.

DATING Identical with cat. no. 23 in the painting of the vigorous but rather brittle, twisting tree-trunks, the loose handling of much of the foliage, with many of the leaves put in with the very tip of the brush, the fluently painted little figures and the undulating, rococo rhythms of the clouds. The broad painting of the foreground track, outlined in fluid browns, the treatment of the tree-trunks and foliage, the motif of the sunlit recess in the wood, the loose handling of the clouds and the deep green and brown tonality are also closely related to cat. no. 22.

## 25 Wooded Landscape with reclining Shepherd, Scattered Sheep and Cottage

Canvas. $17 \times 21\frac{3}{8}$  43.2 × 54.3
Painted c. 1748–50

Yale Center for British Art (Paul Mellon Collection), New Haven (B 1976.2.1)

PROVENANCE Probably James West (1704?–72), Alscot Park, Stratford, the politician, antiquary and bibliophile; thence by descent to Captain James West; with John Baskett, from whom it was purchased by Mr and Mrs Paul Mellon, December 1974; presented to the Yale Center, 1976.

EXHIBITION Tate Gallery, 1980–81 (81, repr.).

BIBLIOGRAPHY Hayes, pp. 201–2, repr. p. 4.

The use of a sunlit field as the fulcrum of the composition, the broadly massed shadows, and the sharp definition of the horizon, are derived from Gainsborough's study of Ruisdael. The composition is framed by trees on both sides and the tree with branches fanning out over the canvas is a familiar device, while the recession of the middleground is a little awkward, but in other respects this small picture is one of Gainsborough's most original and sensitive early works, fluently handled throughout. The distant panorama is superbly rendered and anticipates similar passages in Constable. The motif of the shepherd reclining against a

25

tree, and surrounded by large foreground plants, a vignette frequently used by Gainsborough (compare cat. no. 14), is characteristic of Jan Both. James West, probably the first owner of the picture, was engaged in transforming the manor farm of Alscot into 'a bijou residence' in the Gothic style in 1750–52 (Mark Girouard, 'Alscot Park, Warwickshire—I', *Country Life*, 15 May 1958, pp. 1065–6), and this landscape, then only recently painted, may have been acquired at this time. Also mentioned on pp. 47, 71, 87; a detail is repr. pl. 115.

DATING Closely related to cat. no. 22 in the richly worked, creamish impasto in the highlights of the clouds, the heavy Ruisdaelesque tonality, the breadth of chiaroscuro and sweep of brushwork throughout, and the loose, atmospheric handling of the distance. The fluid painting of the branches in the tree on the right and the motif of the sunlit field are related to cat. no. 19, but the treatment of the branches and foliage is also closely related to the background of *Mr and Mrs Andrews*, datable 1748–9.

## 26  Extensive Landscape with Reservoirs, Sluice Gate House and Seated Figure

Canvas. 20 × 26  50.8 × 66

Painted *c*. 1748–50

Private collection, London

INSCRIPTION A label on the back of the frame is inscribed in ink: *The Nine Ponds Hampstead*.

PROVENANCE With Palser Gallery, from whom it was purchased by Charles E. Russell, 1940; anon. [Russell] sale, Sotheby's, 18 October 1950, lot 54, bt Bode; with Spink, from whom it was purchased.

This view has been entitled 'The Nine Ponds, Hampstead', but, though it is almost certainly a representation of a specific place, this traditional identification is difficult to support. The three ponds on the left are, indeed, similar in formation to the Hampstead Ponds, but the five ponds on the right seem never to have existed there (though they could conceivably be an otherwise undocumented and unrecorded series of ponds related to Hampstead Spa) and the distance bears no relation to the southward view from Hampstead Heath at this or any other time; the possibility that the view represents

**26**

the Highgate Ponds, of which there are eight, is ruled out by the total dissimilarity in shape and formation, as exemplified by maps of the period (Rocque, 1746; Thompson's detailed survey, *A Plan of the Parish of Saint Pancras*, *c.* 1790–1796). The careful description of this unusual formation of ponds and the openness of the composition, uncharacteristic of Gainsborough's work, lend credence to the assumption that the scene is not imaginary, but no topographical expert has been able to suggest a credible source for the view either in the London area or in East Anglia. The treatment of the distance, punctuated by church towers and a windmill, and dominated by the threatening greys of the clouds, is strongly influenced by Ruisdael. The clouds are not treated purely as a brilliant backdrop effect, as in so many Gainsborough landscapes, but recede towards the horizon in a wholly naturalistic way. Also mentioned on pp. 71–2.

DATING Closely related to cat. no. 25 in the threatening grey clouds and creamish impasto in the lights, the handling of the foliage and the dark-green tonality of the carefully mapped out distance.

**27\* Wooded Landscape with Peasants resting and Distant Cottage**

Panel. $14\frac{1}{2} \times 11$   $36.8 \times 27.9$
Painted *c.* 1748–50

Ownership unknown

PROVENANCE Joshua Kirby (1716–74); by descent to the Rev. Henry Scott Trimmer; Trimmer sale, Christie's, 17 March 1860, lot 51, bt Rutley; G. A. F. Cavendish Bentinck; Cavendish Bentinck sale, Christie's, 8–17 July 1891, 4th day (11 July), lot 549, bt Gooden; S. D. Warren, Boston; Warren sale, American Art Association, New York, 8–9 January 1903, 2nd day, lot 66 (repr.), bt Emmerson McMillin; McMillin sale, American Art Association, New York, 20–23 January 1913, 4th day, lot 192 (repr.); with Knoedler, 1931; Thomas Frederick Cole, New York; Edwin H. Fricke, Calistoga, California; Fricke sale, Parke-Bernet's, New York, 15 March 1945, lot 14 (repr.), bt John Nicholson.

EXHIBITIONS GG, 1885 (24); RA, 1890 (4); 'Paintings from the Estate of Mrs S. D. Warren', Museum of Fine Arts, Boston, April–September 1902.

BIBLIOGRAPHY William Martin Conway, *The Artistic*

27

*Development of Reynolds and Gainsborough*, London, 1886, p. 75; Waterhouse, no. 874.

A daring, diagonal composition, emphasized by the seated peasant leaning backwards towards the spectator, in which the dark clouds and the passages of strong light on the right counterbalance the dominating mass of trees on the left. The cottage is half in light and half in shadow, a motif developed in the Mills landscape (cat. no. 35). A copy of roughly the same size as the original, in which the distance on the right has been closed by hills to accord with fashionable taste, was formerly on the London art market (see pl. 305 and pp. 258–61).

DATING Appears to be closely related to cat. no. 25 in the handling of the clouds and foliage.

## 28 View of St Mary's Church, Hadleigh, the Old Rectory and the Deanery Tower, with Figures and Donkeys in the Churchyard

Canvas. 36 × 75   91.4 × 190.5
Painted *c.* 1748–50

Private collection, Great Britain (on indefinite loan to Gainsborough's House, Sudbury)

PROVENANCE Commissioned by the Rev. Dr Thomas Tanner, Rector of Hadleigh (d. 1786); by descent to his granddaughter, Mary Elizabeth Miller, who married Lewis Monson, 1st Baron Sondes; thence through the Earls Sondes to Pamela, Lady Sondes; Sondes sale, Christie's, 5 February 1971, lot 44 (as by P. G., signed with initials and dated 1784) bt Sabin.

28

EXHIBITIONS 'The Painter's Eye', Gainsborough's House, Sudbury, June 1977 (1); Tate Gallery, 1980–81 (82, repr. and col. detail p. 92, and pp. 20 and 27).

BIBLIOGRAPHY David Coke, 'The Painter's Eye', *Connoisseur*, June 1977, p. 158 (repr.); John Harris, *The Artist and the Country House*, London, 1979, pp. 332, 336, repr. pl. 378; Michael Jacobs and Malcolm Warner, *The Phaidon Companion to Art and Artists in the British Isles*, Oxford, 1980, p. EA 13, repr. pp. EA 14–15; John Ingamells, 'Thomas Gainsborough', *Burlington Magazine*, November 1980, p. 779; Grand Palais, 1981, p. 30, repr. fig. 18 and detail fig. 19; Lindsay, p. 25.

The Rev. Thomas Tanner, son-in-law of John Potter, Archbishop of Canterbury, who became Rector of Hadleigh in 1743, shortly after his marriage, was responsible for improving and beautifying the church and for modernizing the old Rectory, installing fine new mantelpieces as well as other features. His wish to have a view of his church as an overmantel was probably inspired by the existence of an early seventeenth-century triptych (the central panel of which depicted an interior view of the church) that hung on the wall over a ground-floor chimney-piece in the Deanery Tower. This was painted by Benjamin Coleman, a local artist. It is not known to what extent Gainsborough may have acquired a reputation in Suffolk as a topographical painter—there is no evidence to indicate that he was active in this genre—but his family lived in the neighbouring town of Sudbury and his name may well have been suggested by his friend Joshua Kirby, whose firm was employed on the improvements to the church and who had painted an altarpiece for it in 1744. According to an early-nineteenth-century label formerly on the back of the canvas, Kirby participated in the execution of the picture, but the visual evidence does not support the view that more than one hand was involved, and that Gainsborough's. Certainly, if Kirby, author of a treatise on perspective, had painted the church, the foreshortening would be more accurate. (Compare his beautifully executed view of St Alban's Abbey from the south-east, a large drawing dated 1767 in the British Museum (no. 1867-12-14-768), which, incidentally, seems to be influenced in its general conception by the *Hadleigh Church*.) John Harris (cited above, p. 336) describes the work as 'a continuation in oil of the Buck tradition'. Some fifteen inches of the left side, and part of the right, of the canvas were turned back over the stretcher at some point (see below), presumably so that the picture could fit a different space, and this accounts for a certain amount of damage to the paint surface on the left. These are pentimenti in the spire and the top of the church and in the legs of the youth reclining on the tomb.

The view is taken from the south-east and depicts, from left to right: a white late seventeenth- or early eighteenth-century house; the Rectory, with its octagonal ice-house, cornfields and fretted Chinese Chippendale gateway; the Deanery Tower; St Mary's Church; the Red House in Churchgate Street; and a white lath-and-plaster house. The foreground is very broadly painted, and the churchyard, which contains hardly any graves, and is in any case exaggerated in scale, is probably wholly imaginary in conception. The plain headstone is inscribed: *P.G. 1704* (the origin of the erroneous attribution noted in the provenance). The motif of the boys playing on the slab of the large rectangular tomb seems to be derived from pl. 3 of Hogarth's *Industry and Idleness*, published in 1747. The peasant in the centre is leaning on a spade of a Suffolk type, with a tread fitted to the haft above the blade

(compare Hayes, *Drawings*, no. 813, pl. 6). The graves are bound with osiers, also characteristic of Suffolk. The familiar motif of the two donkeys appears on the left. One of the fields beyond is shown half-reaped; the other has been ploughed. The spectator is led into the composition by a winding path, as in the São Paulo and Edinburgh pictures (cat. nos 20, 29), and the design is based broadly on diagonals which meet in the centrally placed church tower and spire; the softly painted clouds form an effective background rhythm, and the threatening dark clouds on the right billow up towards the top of the canvas as they do in the Dublin, Vienna and Mellon pictures (cat. nos 13, 24, 34), an emphatic compositional stress which makes the device of a framing tree unnecessary. The topographical detail is freely but carefully and lovingly rendered, accurate in general if not in the minutiae of every particular: Gainsborough has been at pains to include such minor features as the post-and-chain fence outside the white house on the right, and he has not glossed over the state of disrepair in the string-courses of the church. Much contained in the view has now disappeared, and there are no other useful drawings or prints extant, so that, apart from showing Hadleigh as it looked in the mid-eighteenth century, the painting provides an invaluable record for the antiquarian. The house on the left, the Rectory itself and the houses on the right have been pulled down; and the fretted gate in the Rectory wall, the wicket-gate in the arch of the Deanery Tower, and the small south porch, the skylight in the aisle roof and the top of the gallery round the tower, in St Mary's, have been removed. The exterior of the church was restored in the mid-nineteenth century and the coating of plaster (seen in the Gainsborough) stripped off to lay bare the original flints; the fields on the left and the area to the east of the church have now been built up, but the rising ground in the distance, beyond the Stour (which is not visible in Gainsborough's view), still remains open country, exactly as the artist depicted it. Gainsborough evidently kept up his connection with the family, for he painted Dr Tanner's granddaughter in 1786 (Waterhouse, no. 714), incidentally the year of Tanner's death. It is of interest to note that (contrary to the usual legends, so often false and difficult to disentangle, accumulated by family tradition) both the circumstances of this commission and Gainsborough's authorship were completely lost in the course of the descent of the picture. A copy, size $18\frac{1}{2} \times 30\frac{1}{8}$ inches, which shows the picture as it was, folded back to fit a different space subsequent to its inheritance by Dr Tanner's daughter in 1786, appeared in the saleroom in 1979 and is now in the possession of Sidney Sabin. (I am much indebted to Mr Sidney Sabin's researches in the compilation of this entry.) Also mentioned on pp. 51, 62, 71; details are repr. pls 61, 83–85.

DATING The picture must date between 1743 (the date of Dr Tanner's appointment) and 1757 (when the clamps along the base of the nave parapet in St Mary's,

not shown in the painting, were inserted), and probably after October 1747 (the date of the engraving by Hogarth from which Gainsborough seems to have borrowed: see above). Closely related to cat. no. 29 in the fresh, light tonality, the broad rococo treatment of the clouds, the loose modelling of the figures and the handling of the foliage. The fresh tonality, the broad treatment of the foreground and the handling of the tufts of grass are also related to the landscape in the portrait of Mr and Mrs Andrews (pl. 78) (Waterhouse, no. 18), painted in or soon after 1748 (the couple were married in November 1748 and the picture is probably a marriage portrait).

## 29 Extensive River Landscape with Chalky Banks, Girl talking to a Seated Peasant, Figures, Animals and Distant Village

Canvas. $30 \times 59\frac{1}{2}$ $76.2 \times 151.1$
Painted *c.* 1748–50

National Gallery of Scotland, Edinburgh (2174)

PROVENANCE T. M. Whitehead; bought by William H. Fuller in London in the 1890s; Fuller sale, American Art Association, New York, 25 February 1898, lot 33 (repr.), bt James W. Ellsworth, Chicago; with Knoedler; Kenneth Wilson, 1927; bought by Knoedler from his daughter, Hilary, Countess of Munster; Alan P. Good; Good sale, Sotheby's, 15 July 1953, lot 15, bt Tooth; purchased by the National Gallery of Scotland, 1953.

EXHIBITIONS Union League Club, New York, February 1892; Ipswich, 1927 (32); 'Recent Acquisitions VIII', Arthur Tooth, November–December 1953 (3, repr.); 'The Orange and the Rose', Victoria and Albert Museum, October–December 1964 (15, repr. pl. x); Grand Palais, 1981 (19, repr., and p. 29).

BIBLIOGRAPHY Armstrong, 1898, pp. 67, 205; Armstrong, 1904, pp. 88, 286; *Catalogue of Paintings and Sculpture*, National Gallery of Scotland, Edinburgh, 1957, p. 98; Waterhouse, no. 840, repr. pl. 24; John Hayes, 'Gainsborough's Early Landscapes', *Apollo*, November 1962, p. 672, repr. fig. 3; Gatt, p. 26, repr. pls 16–17 (col.) and pl. 15 (col. detail); Herrmann, pp. 93, 94, repr. pl. 84; Hayes, pl. 202, repr. pls 13, 135 (detail); Michael Jacobs and Malcolm Warner, *The Phaidon Companion to Art and Artists in the British Isles*, Oxford, 1980, p. EA 30 (repr.); Lindsay, p. 27, repr. pl. 7.

The horizontal format suggests that the picture was painted for a particular space, probably an overmantel: seven-and-a-half inches were added to the top of the canvas at a later date, and were removed when the painting was acquired by the National Gallery of Scotland. The superbly painted open panorama on the right, with the church tower and bridge picked out by the sunlight, seems likely to represent an actual view in

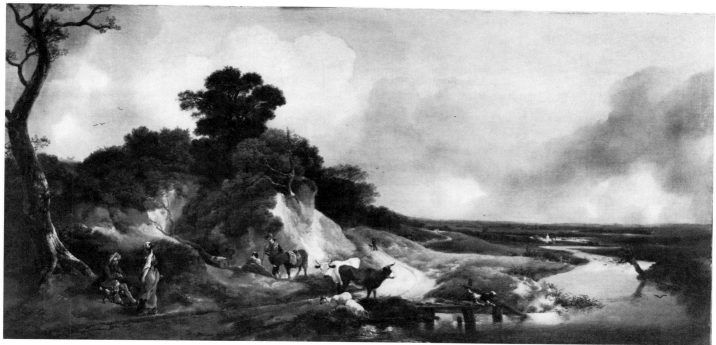

29

the Stour Valley, though the identification of the village in the middle distance as (Great) Cornard, first proposed in the Edinburgh catalogue, 1957 (cited above), cannot be supported; the treatment of the scene is derived from Ruisdael, but the horizon is more atmospheric, less sharp in silhouette, than Ruisdael, and the softness of handling is French in quality rather than Dutch. The general arrangement and balance of the composition, with the river stretching right into the foreground—the first time Gainsborough has been so daring: he avoided this possibility in the São Paulo landscape (cat. no. 20)—are remarkably close to the Ruisdael also in the National Gallery of Scotland (pl. 53). The winding track echoes the river, and the clouds on the left the silhouette of the foliage; the dark clouds on the right balance the mass of banks and trees on the left, and the framing tree is an unnecessary device. The rich, buttery modelling of the principal figures and animals, visually unrelated, is derived from Berchem. The rustic lovers theme, soon to become one of Gainsborough's favourite subjects, is adumbrated in the figures on the left; the bright-red mantle of the girl adds enlivening colour. As in earlier works, the canvas is filled with tiny scattered figures and animals. The incident of the dog barking at a passing bird is a typically naturalistic detail. Also mentioned on pp. 46, 55, 71, 72–4, 96; details are repr. pls 62, 82.

DATING Closely related to cat. no. 28 in the somewhat harsh, dramatic lighting, the broad, rococo treatment of the clouds, the fresh tonality, the handling of the foliage and the succulent, buttery modelling of the figures. The atmospheric handling of the distance is related to cat. no. 25.

## 30 Wooded Landscape with Faggot-gatherers and White Horse

Canvas. $14\frac{3}{4} \times 18\frac{3}{4}$   37.5 × 47.6
Painted *c.* 1750–53

Dr Marie-Louise Hemphill, Paris

PROVENANCE [Richard] Gainsborough Dupont sale, Wheeler and Westoby's, Sudbury, 29 May 1874, lot 120; A. P. Humphry sale, Christie's, 4 October 1946, lot 61 (with another), bt Wheeler, from whom it was purchased by Dr Robert Hemphill; anon. [Hemphill] sale, Christie's, 23 November 1951, lot 69, bt in; thence by descent.

EXHIBITION 'First Loan Exhibition', Friends of the Art Gallery, City Art Gallery, Bristol, May–June 1947 (32).

BIBLIOGRAPHY M. H. Spielmann, 'A Note on Gainsborough and Gainsborough Dupont', *The Walpole Society*, vol. v, Oxford, 1917, p. 100.

Unfinished (the middle distance on the right is only sketched in). The picture is also damaged, and therefore difficult to assess. The central clump of trees forms the fulcrum of a comparatively sophisticated vortical composition. This canvas marks the first appearance of what was subsequently to be one of Gainsborough's favourite images, the faggot-gatherer, and the right foreground is occupied by a *repoussoir* branch, soon to become a familiar feature in his landscapes.

359

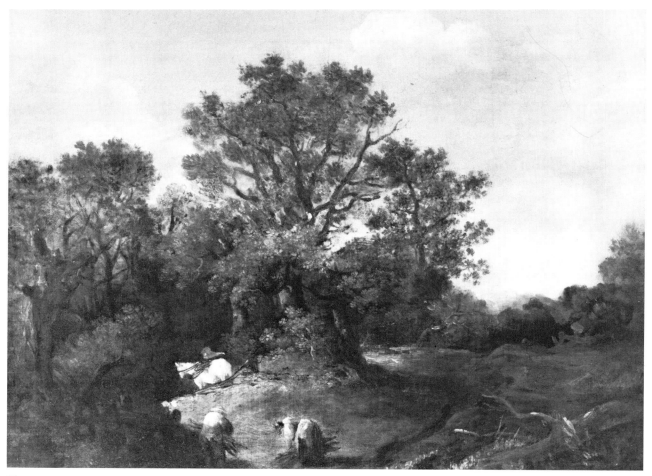

30

DATING Closely related to cat. no. 31 in the way in which the branches of the trees spread out across the canvas, and in the handling of the clouds and foliage.

## 31 Wooded Landscape with Figure on a Winding Track, Sheep, Lambs and Cottage

Canvas. $11\frac{1}{2} \times 13\frac{1}{2}$  29.2 × 34.3
Painted *c.* 1750–53

Countess of Plymouth (on indefinite loan to the National Museum of Wales, Cardiff)

PROVENANCE Probably William Beckford (1759–1844); Dukes of Hamilton; Hamilton Palace sale, Christie's, 17 June–20 July 1882, 10th day (8 July), lot 1104, bt Agnew; Robert Windsor-Clive (later 1st Earl of Plymouth), 1888; thence by descent to the Hon. Rowland Windsor-Clive; anon. [Windsor-Clive] sale, Christie's, 25 March 1966, lot 79 (repr.), bt Leggatt and Colnaghi, from whom it was purchased by the Countess of Plymouth.

EXHIBITIONS RA, 1894 (5); 'Illustrating Georgian England', Whitechapel Art Gallery, March–May 1906 (Upper Gallery, 9); 'County Art Treasures', Victoria Institute, Worcester, May–July 1937 (103); 'Treasures from Midland Homes', Museum and Art Gallery, Birmingham, November–December 1938 (131); Bath, 1951 (37); Nottingham, 1962 (7); 'Realism and Romance in English Painting', Agnew's, 1966 (26, repr.).

BIBLIOGRAPHY Armstrong, 1898, p. 208; Armstrong, 1904, p. 290; Waterhouse, no. 881; Mary Woodall, 'Gainsborough Landscapes at Nottingham University', *Burlington Magazine*, December 1962, p. 562.

The winding track articulating distance, characteristic of Dutch painting, has here been given a wholly rococo serpentine undulation, though one may still find sources for such a treatment in Dutch art (compare the Ruisdael in the J. G. Johnson collection, Philadelphia Museum of Art (no. 563), repr. Jakob Rosenberg, *Jacob van Ruisdael*, Berlin, 1928, pl. 64). The branches of the trees fan out across the surface of the picture, and the silhouette is echoed in the clouds. The use of a sheep and two lambs to occupy a dominant position in the foreground is unusual. Also mentioned on p. 72.

DATING Identical with cat. no. 19 in the pale tonality and use of pale-blue tints for the sky, the treatment of the grey backdrop clouds and the handling of the foliage. Arguably, therefore, this picture should be dated earlier than is proposed here. The composition, however, is

**32a** x-ray photograph showing the portrait of a man underneath cat. no. 32. University of California at Los Angeles, Los Angeles.

## 33 Wooded Landscape with Herdsmen and Cows and Distant Village

Canvas. 40×36⅛  101.6×91.8
Painted *c.* 1750–53

Minneapolis Institute of Arts, Minneapolis (53.1)

ENGRAVINGS Engraved in reverse and published by Benjamin Green as in the late collection of Monsieur D'Esenfans, 1 January 1796; drawn by J. Ashley and lithographed and published by C. Hullmandel, 1823.

PROVENANCE Noel Desenfans (1745–1807); R. Roe; Dr Thomas Turton, Bishop of Ely (1780–1864) by 1848; Bishop of Ely sale, Christie's, 13–15 April 1864, 3rd day, lot 228, bt Cox; William Cox sale, Foster's, 13–14 December 1865, 2nd day, lot 186, bt Nathan; Francis Cook, 1885; bt from the Cook collection by Agnew, *c.* 1946; H. F. P. Borthwick-Norton, 1950; with Agnew, from whom it was purchased by the Minneapolis Institute of Arts, 1953.

EXHIBITIONS BI, 1848 (133); GG, 1885 (190); RA, 1903 (13); 'Old Masters', Agnew's, 1947 (11); Minnesota State Fair, St Paul, August–September 1954; 'Great Traditions in Painting from Midwestern Collections', University of Illinois, Urbana, Champaign, Illinois, October–November 1955 (11, repr.); 'Twenty-fifth Anniversary Exhibition: Notable Paintings from Midwestern Collections', Joslyn Art Museum, Omaha, Nebraska, November 1956–January 1957; 'English Landscape Painters', Phoenix Art Museum, Phoenix, Arizona, December 1961–January 1962 (5, repr.).

BIBLIOGRAPHY Fulcher, p. 236 (with an out-of-date ownership: R. Roe); Armstrong, 1898, p. 205; Armstrong, 1904, p. 286; Maurice W. Brockwell, *A Catalogue of the Paintings at Doughty House Richmond & Elsewhere in the*

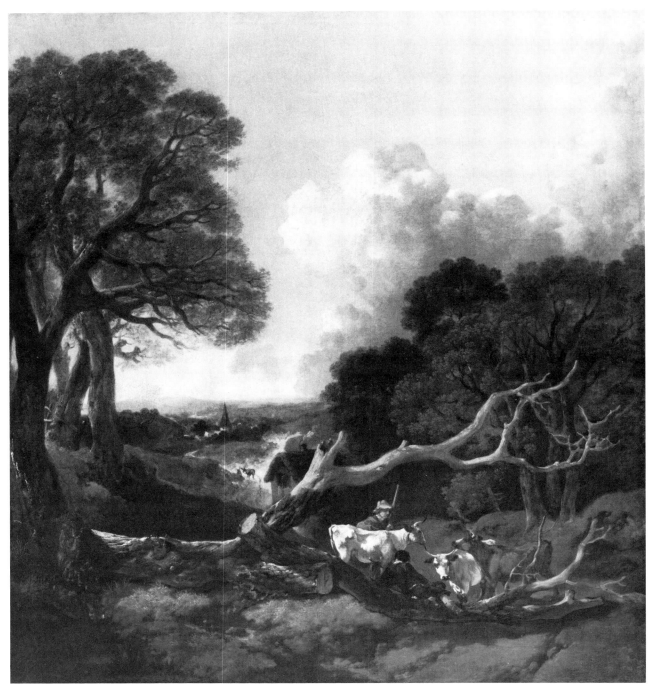

33

*Collection of Sir Frederick Cook Bt.*, London, vol. III, 1915, no. 405, p. 20, repr. facing; Maurice W. Brockwell, 'The Cook Collection: Part III', *Connoisseur*, January 1918, p. 10, repr. p. 8; R. S. D. [Davis], 'Institute acquires Landscape by Thomas Gainsborough', *Bulletin of the Minneapolis Institute of Arts*, 2 January 1954, pp. 2, 4, 5, 7, repr. pp. 1, 3, 6 (detail); 'A Landscape by Gainsborough in the Minneapolis Institute of Arts', *Art Quarterly*, spring 1954, pp. 87–8, repr. p. 86; Waterhouse, no. 830, repr. pl. 36; Gatt, p. 24, repr. pl. 9; *European Paintings from the Minneapolis Institute of Arts*, New York, 1971, no. 14, pp. 36–7, repr. facing p. 36; Herrmann, p. 95; Geoffrey Grigson, *Britain Observed*, London, 1975, pl. 26; Hayes, p. 204, repr. pl. 26; Lindsay, p. 27, repr. pl. 19.

About $1\frac{3}{4}$ inches of the original design was removed from the top of the canvas at some time prior to its acquisition by Minneapolis. The composition is broadly Claudean in character, with clouds echoing the silhouette of the trees on the right. The magnificent great branches, linking the two sides of the composition and masking the drop into the middleground, are a brilliant, though very obviously contrived, device, reminiscent of such land-

34

scapes by Pijnacker as that in the Wallace Collection (no. 115), and unique in Gainsborough's work. The distance is articulated by a country track winding between coulisses. The figures and cows are well grouped, though the white cow on the left is somewhat stiffly posed. This landscape marks the first use of warm, reddish-brown tones in the foreground, later to become characteristic of the Ipswich style. The church spire is reminiscent of St Andrew's, Great Cornard, and of St Mary's, Great Henny, both near Sudbury. Also mentioned on p. 74; a detail is repr. pl. 89.

DATING Closely related to cat. no. 31 in the use of pale-blue tints in the sky, the decorative treatment of the branches, the handling of the foliage and the flatness of the composition. The rich, succulent painting of the cows, the modelling of the figures, the soft, generalized treatment of the distance and the use of the clouds to echo the silhouette of the trees are also very similar to cat. no. 34. Although a pale, fawn priming is still being used, however, and the tonality is generally light, the foreground is painted in the warm reddish-brown tones characteristic of Gainsborough's landscapes of the mid-1750s and which do not appear in earlier work.

**34 Wooded Landscape with Stream and Weir, Country Cart, Reclining Peasant with Cow and Sheep, and Ruined Building on a Bank**

Canvas. $31\frac{1}{2} \times 37\frac{1}{4}$  $80 \times 94.6$
Painted $c$. 1750–53

Yale Center for British Art (Paul Mellon Collection), New Haven (B 1977.14.57)

ENGRAVING Engraved in reverse by William Austin,

**34a** Engraving of cat. no. 34 by William Austin, published 1764. British Museum (1872-6-11-178).

and published by John Ryall as in the possession of Panton Betew, 1764 (34a).

PROVENANCE With Panton Betew, 1764; with John Nicholson, New York, who sold it to Jeremy Maas, from whom it was purchased by Mr and Mrs Paul Mellon, December 1961; presented to the Yale Center, 1976.

EXHIBITIONS 'Painting in England 1700–1850: Collection of Mr and Mrs Paul Mellon', Virginia Museum of Fine Arts, Richmond, 1963 (31, repr. in the Plates Volume, p. 97, col.); 'Painting in England 1700–1850: From the collection of Mr and Mrs Paul Mellon', RA, 1964–5 (32).

BIBLIOGRAPHY John Baskett, 'Painting in England 1700–1850: the Collection of English Paintings formed by Mr and Mrs Paul Mellon: on exhibition at the Museum of Fine Arts, Richmond, Virginia, until August 18th', *Connoisseur*, June 1963, repr. p. 104; Luke Herrmann, 'The Paul Mellon Collection at Burlington House', *Connoisseur*, December 1964, p. 218.

This landscape marks the first use of the warm reddish priming characteristic of the Suffolk style. The strongly marked rococo silhouette and horizontal emphasis are matched by a completely generalized treatment of distance. The tall framing tree is similar to that in the Edinburgh picture (cat. no. 29). So prominent a picturesque ruined building is an unusual feature in the Suffolk style, and is somewhat reminiscent as a motif of the buildings among trees seen across a river in a Watteau print which Gainsborough would certainly have known (anon. [Jean de Jullienne], *Figures du Differents Caractères, de Paysages, & d'Etudes Dessinées d'Après Nature par Antoine Watteau*, Paris, 2 vols, n.d.

[1726–8], vol. 1, pl. 91). The motif of the figure reclining, with one leg outstretched and the other dangling, to be used for the pose of the portrait of John Plampin (pl. 37; Waterhouse, no. 546, repr. pl. 13), derives ultimately from Watteau's *Antoine de la Roque*, but was familiar in English rococo painting (see Homan Potterton's National Gallery publication, *Reynolds and Gainsborough*, 1976, pls 8–11). The engraving (34a) slightly 'improves' on the picture, as may have been customary (see cat. nos 59–61), in this case by filling out the foreground. Several copies of this composition exist (see p. 242), including Waterhouse, no. 839 and one attributed to Towne (see p. 251). Also mentioned on pp. 72, 74, 81, 88.

DATING Closely related to cat. nos 32 and 33 in the handling of the highly plastic clouds, which echo the silhouette of the landscape, the treatment of the foliage, the modelling of the figure and animals and the soft, generalized handling of the distance. The motif of the figure resting a leg on a lopped tree-trunk reappears in cat. no. 37. The whole tone of the picture, however, is completely different from that of any of Gainsborough's earlier landscapes through the use of a warm reddish priming, which becomes habitual in his work of the mid- and late-1750s.

### 35 Hilly Landscape at the Edge of a Wood with Horse drinking at a Pool, Figures, Donkeys and Cottage

Canvas. $24\frac{3}{4} \times 29\frac{3}{4}$   $62.9 \times 75.6$
Painted *c.* 1750–53
Private collection, England

perimeter of the fortifications. The scene is introduced by the couple on the right, the man pointing the way in a manner characteristic of later eighteenth-century British portraiture (compare Gainsborough's *The Byam Family* of *c.* 1764; Waterhouse, no. 108, repr. pl. 82), and the girl trying to keep her hat on in the fresh breeze which pervades the painting. The gentleman seen in the foreground, seated on a tree-trunk, in the pose inspired by Watteau and used for the peasant in the Mellon landscape (cat. no. 34), is probably intended to represent Thicknesse himself. This picturesque view in a panoramic setting, with foreground figures, is in the tradition of such topographical works as Lambert's *Dover Castle*, of which the earliest version, at Goodwood, is signed and dated 1735. Unusually for an engraved work, there are no respectable copies, perhaps because it was a topographical view rather than a pastoral. Also mentioned on pp. 62–3, 71, 76–7, 81, 88, 92, 242, 263; a detail is repr. pl. 73.

DATING The painting must have been executed during the spring or summer of 1753. Thicknesse did not take up his post as Lieutenant-Governor of Landguard Fort until February 1753, and he tells us (Thicknesse, p. 14) that he took the picture to be engraved 'in the following winter', which, from the date of the engraving, 1754, must be that of 1753–4.

## 38* View of Felixstowe Cottage with Flag flying and Sailing Boat

Canvas. Size unknown

Painted *c.* 1753–4

Ownership unknown

ENGRAVING Etched by Gainsborough *c.* 1753–4; engraved by John Swaine, and published by John Nichols, 1 August 1816 (*Gentleman's Magazine*, cited below), as 'copied from one of the earliest Productions of *GAINSBOROUGH*'.

PROVENANCE Philip Thicknesse (1719–92).

BIBLIOGRAPHY *Gentleman's Magazine*, August 1816, p. 105 and engraved facing.

Known only from Gainsborough's etching—of which an impression survives in a private collection—which refers to the subject as having been painted, and from the print engraved by Swaine which was published in the *Gentleman's Magazine* for August 1816. A study, in which the flag is shown at half-mast, was formerly contained in one of Gainsborough's sketch-books, purchased by George Hibbert in 1799 (38a; see Hayes, *Drawings*, no. 555, where the connection with the lost painting of Felixstowe Cottage was not recognized and the dating to a later period of Gainsborough's career is thus erroneous). The view is of a cottage at Felixstowe (situated on the coast, about three miles from Landguard Fort) which belonged to Philip Thicknesse; a former fisherman's hut that he converted into an exotic 'folly', it was used by him as a summer retreat from *c.* 1753 to 1766. The musical instruments in the etched frame (doubtfully the real

frame of the picture) allude to the musical talents of Thicknesse.

DATING The similarity of the etching technique to that in Gainsborough's early etching (Hayes, *Printmaker*, no. 1), published in 1754, suggests a date of *c.* 1753–4, and it is possible, therefore, that the picture was painted for Thicknesse as the result of his evident pleasure with the view of Landguard Fort (cat. no. 37).

## 39* Open Landscape with Plough Team and Dog, Windmill on a Sandy Bank, Cottage, Figures, Animals and Distant Estuary (The Suffolk Plough)

Canvas. Perhaps $17\frac{1}{2} \times 22$   44.5 × 55.9

Painted *c.* 1753–4

Ownership unknown

ENGRAVING Etched by Gainsborough, *c.* 1753–4.

PROVENANCE Perhaps Susan, Countess of Guildford, 1833; Colonel J. S. North, 1858; Baroness North, 1885; and anon. [Lord North] sale, Christie's, 13 July 1895, lot 54, bt Arthur Tooth.

EXHIBITIONS Perhaps Suffolk Street, 1833 (108); BI, 1858 (143); RA, 1871 (241); GG, 1885 (133).

BIBLIOGRAPHY Edward Edwards, *Anecdotes of Painters*, London, 1808, p. 142; Hayes, *Printmaker*, no. 21. pp. 3, 105 (with erroneous identification suggested); Grand Palais, 1981, p. 203, repr.

According to Edwards, cited above, who is the only source to have mentioned this subject, one of Gainsborough's rare early etchings 'represents a man ploughing on the side of a rising ground, upon which there is a windmill. The sea terminates the distance. This he [Gainsborough] called the Suffolk Plough.' Since the publication in 1971 of my catalogue of Gainsborough's prints an impression of this etching has come to light and is now in the possession of Mr Cavendish Morton. This impression, which is not quite finished, bears the following inscription in pencil beneath the plate mark: 'Begun to be Etched by Mr Gainsborough from a Picture of his own but spoil'd & never finished/ The Plate was never used.' The picture was clearly one Gainsborough regarded as of significance in his output to date, and the print was not greatly reduced in size: $13\frac{1}{16} \times 15\frac{1}{4}$ inches. The only other canvas he etched himself (again on a large plate) was *The Gipsies* (cat. no. 44). Several simplified versions of the composition exist, all in reverse from the print, of which only one seems to be from Gainsborough's own hand (cat. no. 36). What may have been the original work, since the proportions correspond roughly to those of the print and it is the only one in which, as in the print, the man ploughing is accompanied by a boy, was owned by the Baroness North in 1885, but has not reappeared since its sale at Christie's in 1895. The sophistication of the rococo composition (one may note the winding track which partly echoes and

**39** Cat. no. 39, from the etching in reverse by Gainsborough. Cavendish Morton, England.

partly continues the contour of the bank) and the dominance of the principal subject-matter are characteristic of Gainsborough's style as it developed at Ipswich, and the design seems to have been developed from the simpler version, which is in any case datable a few years earlier on stylistic grounds, rather than the other way about. The Suffolk-type wheel plough is accurately delineated. Also mentioned on p. 257.

DATING Related to cat. no. 37 in the breadth of composition, the mass of detail successfully assimilated into the design, and the rococo track winding into the distance.

### 40  Coastal Scene with Sailing Boats, Country Cart, Peasants and Animals on a Sandy Bank, Cottage and Church Tower

Canvas. $32 \times 42\frac{1}{2}$  $81.3 \times 108$

Painted *c*. 1753–4

Christchurch Mansion, Ipswich (1941.76)

PROVENANCE Williams; anon. [Williams] sale, Christie's, 23 (altered to 25) April 1831, lot 86, bt Pinney; Commander F. V. Stopford sale, Christie's, 18 July 1941, lot 96, bt Gooden and Fox for Ipswich Museums and Art Gallery.

EXHIBITIONS 'Principal Acquisitions made for the Nation through the National Art-Collections Fund', National Gallery, November 1945–January 1946 (39); Arts Council, 1949 (4); 'Some paintings of the British School 1730–1840', British Council, National Gallery of South Africa, Cape Town, 1952 (11); 'Dutch Painting and the East Anglian School', Arts Council, Norwich, 1954 (31); 'Engelse landschapschilders van Gainsborough tot Turner', British Council, Boymans Museum, Rotterdam, 1955 (32, repr.); 'A Hundred Years of British Landscape Painting, 1750–1850', Leicester Museums and Art Gallery, 1956 (7); 'British Painting in the Eighteenth Century', British Council, Montreal Museum of Fine Arts, National Gallery of Canada, Ottawa, Art Gallery of Toronto, Toledo Museum of Art, October 1957–March 1958 (14, repr. p. 105); 'The Story of the Orwell', Christchurch Mansion, Ipswich, September–November 1959 (204); 'Opening Exhibition', Gainsborough's House, Sudbury, April 1961; 'Primitives to Picasso', RA, 1962 (164); 'A Selection of Paintings and Drawings from Christchurch Mansion, Ipswich', Aldeburgh Festival, June 1963 (11); 'The Origins of Landscape Painting in England', Iveagh Bequest, Kenwood, Summer 1967 (10); 'Gifts to Galleries: Works of Art acquired with the Aid of the National Art-Collections Fund for Galleries outside

40

London', Walker Art Gallery, Liverpool, 1968 (31, repr. pl. 13); 'Two Centuries of British Painting: from Hogarth to Turner', British Council, National Gallery, Prague, National Gallery of Slovakia, Bratislava, May–August 1969 (58); 'Shock of Recognition: The Landscape of English Romanticism and the Dutch Seventeenth-century School', Mauritshuis, The Hague, November 1970–January 1971, and Tate Gallery, January–February 1971 (31, repr.); 'Pittura Inglese 1660–1840', British Council, Palazzo Reale, Milan, January–March 1975 (49, repr.); 'The Painter's Eye', Gainsborough's House, Sudbury, June 1977 (9).

BIBLIOGRAPHY Woodall, pp. 28–9, 30, repr. p. 29; Waterhouse, no. 838, repr. pl. 25; John Woodward, *British Painting: A Picture History*, London, 1962, p. 64 (repr.); Patricia M. Butler, *Paintings in Ipswich*, 1973, p. 6; Herrmann, p. 95, repr. pl. 87; Paulson, p. 247; British Museum, 1978, p. 10.

This landscape contains the most elaborate and carefully contrived grouping of figures and animals Gainsborough had so far produced. The rustics are seen resting from their labours: one of the peasants is playing a pipe, and the girl is mopping her brow. There are certain weaknesses in the picture. The church tower is painted too high for it to be related to the ground, and the device

of the framing tree, from which Gainsborough found it so hard to escape, tends to unbalance the composition. The motif of the drover leaning cross-legged over the cow can be paralleled in Berchem (compare the landscape in the Wallace Collection, no. 183). Also mentioned on pp. 74, 79, 82–4; a detail is repr. pl. 106.

DATING The motif of the peasant sleeping on a bank and of the cart disappearing out of sight down the hill are identical with cat. no. 37. Closely related to cat. no. 36 in the treatment of the clouds, the generalized modelling of the brownish–orange sandy bank, the handling of the foliage and the soft, broad painting of the distance.

### 41 Wooded Landscape with Peasant crossing a Footbridge, Cows, Cottage and Church

Canvas. 25 × 30   63.5 × 76.2
Painted *c.* 1753-4

Bowes Museum, Barnard Castle

PROVENANCE F. J. Nettlefold; presented by him to the Bowes Museum, 1949.

EXHIBITIONS 'Pictures from the Bowes Museum, Barnard Castle', Agnew's, October–December 1952 (52); Nottingham, 1962 (8).

41

42

BIBLIOGRAPHY C. Reginald Grundy, 'A Catalogue of the Pictures and Drawings in the Collection of Frederick John Nettlefold', London, vol. ii, 1935, pp. 91, 106, repr. p. 107 (col.); Waterhouse, no. 852; Hayes, *Printmaker*, p. 35, repr. pl. 29.

The picture has traditionally been called a view of Elmsett Church, but the church is not remotely like St Peter's, Elmsett, and is almost certainly imaginary: a picturesque image of a ruined church, sharply highlit and placed where it is purely for artistic reasons. The composition is dominated by the twisting, rococo forms of the dead tree and the undulating track which winds round it. The motif of the peasant crossing a footbridge is new; the white cow is as stiffly posed as that in the Minneapolis landscape (cat. no. 33). Much of the paint surface in the middle distance has been affected by Gainsborough's painting over a layer of pigment not sufficiently dry, a hastiness frequently apparent in his work, especially that of the 1750s.

DATING Closely related to cat. no. 40 in the handling of the clouds, the broad modelling of the sandy bank, the handling of the figure and cows, the fluid painting of the foliage and the soft, generalized distance.

## 42 Wooded Landscape with Mounted Peasant on a Country Track, Peasants round a Fire by a Fence, and Cow

Canvas. $24\frac{3}{4} \times 29\frac{3}{4}$  62.9 × 75.6
Painted c. 1753–4

Fitzwilliam Museum, Cambridge (1654)

PROVENANCE With Edward Noyes, Chester; Edmund Peel (1826–1903); by descent to his son, Major Hugh E. E. Peel; anon. [Peel] sale, Christie's, 28 July 1933, lot 49, bt for the Friends of the Fitzwilliam Museum, by whom it was presented.

EXHIBITIONS 'Gainsborough, English Music and the Fitzwilliam', Fitzwilliam Museum, Cambridge, May 1977 (5).

BIBLIOGRAPHY Friends of the Fitzwilliam Museum, *Annual Report*, 1933 (repr.); Waterhouse, no. 860; Hayes, *Drawings*, p. 137; J. W. Goodison, *Catalogue of Paintings*, Fitzwilliam Museum, Cambridge, vol. iii, *British School*, Cambridge, 1977, p. 83.

This picture has been badly damaged, and the right-hand half of the canvas is to a large extent repainted. The composition is closely related to the woodland scene in the Tate Gallery (cat. no. 19), but the more generalized treatment and the bare suggestion of the church tower at the horizon clearly exemplify the differences between Gainsborough's style of the late 1740s and that of the early 1750s. The motif of peasants grouped round a fire at the edge of a wood is new. The cow in the middle distance is a necessary accent, but unrelated to the scene. A copy, in which the horseman on

the country track is replaced by a cart, was formerly in the collection of Count Matsukata, Japan.

DATING The picture is closely related to cat. no. 40 in the use of bright-blue tints in the sky, the handling of the clouds—grey in the shadows, with richly worked impasto in the lights—and the fluid, generalized treatment of the foliage (which, however, is now to a large extent repainted).

## 43 Open Landscape with Wood-gatherer, Peasant Woman with her Baby on a Donkey, and Peasants seated round a Cooking Pot on a Fire

Canvas. $19 \times 24\frac{1}{2}$  48.3 × 62.2
Painted c. 1753–4

Tate Gallery, London (5845)

PROVENANCE Given by the artist to Joshua Kirby (1716–74); thence by descent to the Rev. Henry Scott Trimmer; Trimmer sale, Christie's, 17 March 1860, lot 35, bt Rutley; G. A. F. Cavendish Bentinck; Cavendish Bentinck sale, Christie's, 8–17 July 1891, 4th day (11 July), lot 553, bt Martin Colnaghi, probably for Arthur James; bequeathed to the National Gallery by Mrs Arthur James, 1948; transferred to the Tate Gallery, 1961.

EXHIBITIONS GG, 1885 (18); Arts Council, 1953 (4).

BIBLIOGRAPHY Walter Thornbury, *The Life of J. M. W. Turner, R.A.*, London, 1862, vol ii, pp. 59–60; William Martin Conway, *The Artistic Development of Reynolds and Gainsborough*, London, 1886, pp. 78–9; Pauli, repr. pl. 64; Martin Davies, 'Three Gainsboroughs in the National Gallery, London', *Art Quarterly*, spring 1950, p. 169, repr. p. 168; Waterhouse, no. 864; Martin Davies, *The British School*, National Gallery, London, 2nd ed., rev., 1959, p. 42; John Hayes, 'The Gainsborough Drawings from Barton Grange', *Connoisseur*, February 1966, p. 90; Hayes, *Drawings*, p. 146; Hayes, *Printmaker*, p. 41, repr. pl. 33; Hayes, pp. 24, 206; British Museum, 1978, p. 10; Kathryn Moore Heleniak, *William Mulready*, New Haven and London, 1980, p. 245n; Grand Palais, 1981, p. 26.

This canvas is unfinished and in the foreground on the left has only been mapped out in dead colour. According to the Rev. Kirby Trimmer, the client disliked the work and Gainsborough, in a temper, slashed the canvas with a knife; he subsequently gave it to Joshua Kirby, who had it repaired. Two slashes across the picture are detectable. The composition takes up the theme of peasants round a fire from the Fitzwilliam picture (cat. no. 42), but this is the first of Gainsborough's landscapes in which figures predominate. The design is dominated by the central tree, with its branches and foliage spreading across the canvas in a more decisive way than in earlier works. Also mentioned on p. 76.

43

DATING Closely related to cat. no. 42 in the tight modelling and highlighting of the tree-trunk and the handling of the foliage; the motif of peasants round a fire also appears in cat. no. 42. The priming, however, is executed in the light fawn, characteristic of the earlier landscapes, which Gainsborough continued to employ, as it suited him, throughout his career.

## 44*  Wooded Landscape with Peasants and Donkey round a Fire, Figures and Distant Church (The Gipsies)

Canvas. Size unknown
Painted *c*. 1753–4

Ownership unknown

ENGRAVINGS Etched by Gainsborough, *c*. 1753–4; engraved and 'finished', after the etching by Gainsborough, by J. Wood, and published, March 1759.

PROVENANCE Thomas William, 1st Earl of Lichfield (1795–1854); Lichfield sale, Shugborough Hall, Robins's, 1–16 August 1842, 9th day, lot 77, bt Burland, Liverpool; John Wiltshire, 1856; Wiltshire sale, Christie's, 25 May 1867, lot 131, bt Cox; William Cox sale, Foster's, 30 April–1 May 1879, 2nd day, lot 221, bt Williams; anon. [Graves & Co.] sale, Christie's, 27 May 1882, lot 165, bt in; with Henry Graves, 1885; anon. [Gooden] sale, Christie's, 23 March 1895, lot 92, bt McLean.

EXHIBITION 'Pictures by Ancient Masters and Deceased British Artists', British Gallery, winter 1868 (103).

BIBLIOGRAPHY Fulcher, p. 234; Walter Thornbury, *The Life of J. M. W. Turner, R.A.*, London, 1862, vol. ii, p. 60; Armstrong, 1898, p. 209 (twice); Armstrong, 1904, p. 291 (twice); Chauncey Brewster Tinker, *Painter and Poet*, Cambridge, Mass., 1938, p. 80, repr. p. 79; Arts Council, 1953, p. 11; Waterhouse, no. 887; Hayes, *Printmaker*, pp. 6, 41, repr. pl. 36; Hayes, pp. 205–6, repr. pl. 113; British Museum, 1978, p. 11.

This composition is known only from the engraving by Wood. It is a more elaborate restatement of the subject adumbrated in the Tate Gallery picture (cat. no. 43); none of the figures, however, is identical with those in the Tate picture, and the oak-tree, with the tentacles of its branches spreading out over the entire composition, dominates the scene in a far more pervasive way. A picture which fetched the comparatively high price of £15 4s. 6d. at the Gainsborough Dupont sale, Christie's, 10–11 April 1797, 2nd day, lot 68, was described in the catalogue as 'The original sketch for the celebrated Picture of the Gipsies, very fine effect'; this sketch has not come to light. Surprisingly, for an important engraved work, which one might have expected Thomas Barker in particular to have copied, no respectable copies are recorded; but a variant copy, size 30 × 25 inches, in reverse from the engraving, and thus presumably based on the lost original, is in the possession of Harold Day, Eastbourne.

46

**46a** Engraving, printed in reverse, of cat. no. 46 by Samuel Middiman, published 1 February 1782. British Museum (1867-1-12-104).

47

BIBLIOGRAPHY John Stacy, *A General History of the County of Norfolk*, Norwich, vol. 2, 1829, p. 803; Fulcher, p. 233; Armstrong, 1898, pp. 206, 208; Armstrong, 1904, pp. 284, 290; Menpes and Greig, p. 175; Waterhouse, no. 865.

Several of Gainsborough's favourite motifs appear together in this canvas: the plough team and windmill from *The Suffolk Plough* (cat. no. 39), a church half-hidden by trees, the two donkeys, and a lopped tree-trunk used as a *repoussoir*. The Suffolk type wheel plough, which appears in the foreground of one of Gainsborough's drawings (62a), is carefully particularized. The picture is composed of broad, undulating masses which meet in the generalized view into distance between. It is recorded as hanging in the breakfast-room at Intwood Hall, Norfolk, in 1829 (see above). Numerous copies of this engraved work exist, including a free rendering by Crome (see pp. 266–7). See also pp. 88, 242.

DATING Closely related to cat. no. 40 in the use of a warm reddish priming and of bright blue tints for the sky, the handling of the clouds, the treatment of the foliage, the generalized distance and the motif of the church tower seen behind trees. The motifs of the plough team and of the windmill on a hill appear also in cat. nos 36 and 39.

## 47 Extensive Landscape with Ruined Church among Trees, Peasants, Donkeys and Distant Village

Canvas. $24 \times 28\frac{3}{8}$  $61 \times 72$
Painted *c.* 1754–5

Count Natale Labia, Cape Town

PROVENANCE George, 6th Duke of Marlborough (1793–1857), Whiteknights, by 1819; Charles Turner, Norwich; Mrs Benjamin Gibbons; Gibbons sale, Christie's, 5 May 1883, lot 25, bt Agnew; Rev. B. Gibbons sale, Christie's, 26 May 1894, lot 26, bt A. Smith; Sir J. C. Robinson, 1897–8; Sir Joseph B. Robinson; Robinson sale, Christie's, 6 July 1923, lot 13, bt in; thence by descent.

EXHIBITIONS 'Pictures Ancient and Modern by Artists of the British and Continental Schools', New Gallery, 1897–8 (167); 'The Robinson Collection', RA, 1958 (27, repr. in the *Souvenir*, p. 51); 'The Joseph Robinson Collection', National Gallery of South Africa, Cape Town, 1959 (68, repr. pl. XLVII); 'Sammlung Sir Joseph Robinson 1840–1929', Kunsthaus, Zurich, August–September 1962 (52); 'Twenty Masterpieces from the Natale Labia Collection', Wildenstein's, London, April–May 1978 (17, repr., and p. 7).

BIBLIOGRAPHY Mrs Hofland, *A Descriptive Account of . . . Whiteknights*, London, n.d. [1819], p. 125; Armstrong, 1898, p. 207; Armstrong, 1904, p. 288; Waterhouse,

48

no. 854; *Natale Labia Collection on Loan to the South African National Gallery Cape Town*, Cape Town, n.d. [1976], unpaginated, repr. facing text.

The sentiment which was to become an increasingly dominant feature of Gainsborough's landscapes is more overt in this canvas than in most of the early works: the glowing evening sky permeates the whole scene and the two figures resting beside the twin trees are basking in the peaceful moments at the ending of the day. The ruined church in the background is so prominent a feature as to suggest that it is not only a picturesque motif but an evocation of time passing (a drawing of a churchyard and ruined church, dating from the late 1750s, is in an English private collection: 125d; Hayes, *Drawings*, no. 189, pl. 59). The foliage of the twin trees fans out to fill the canvas and balance the mass on the right; and the foreground is filled with characteristic motifs familiar from the previous picture (cat. no. 46): donkeys and a lopped tree-trunk, diagonally placed as in Berchem. One or two copies are in existence. An early-nineteenth-century canvas, omitting the baby donkey, falsely signed and dated with the improbable date 1780, is in the North Carolina Museum of Art, Raleigh (no. 81 in the 1956 catalogue; Waterhouse, no. 855; see pl. 302 and p. 258).

DATING  Closely related to cat. no. 46 in the treatment of the foliage and of the foreground detail. The backdrop clouds, and the way in which the foreground is silhouetted against the panorama and in which the winding river partly echoes this silhouette, are similar to cat. no. 37. The use of trees with widely spreading branches to tie the distance in with the foreground and thus preserve the integrity of the picture plane, and the handling of the sky, with brilliant lemon-yellows in the lights, are closely related to cat. no. 43. The use of a warm reddish priming, the generalized modelling of the sandy bank, the treatment of the figures and foliage and the soft, broad handling of the distance are also closely related to cat. no. 40.

## 48*  Wooded River Landscape with Mounted Peasant and Cattle, Figures, Ruined Building and Sailing Boats

Canvas. 25 × 42  63.5 × 106.7
Painted *c.* 1753–4

Ownership unknown

PROVENANCE  Rev. R. Longe, 1856; F. D. Longe sale, Christie's, 9 December 1905, lot 109, bt Charles Fairfax Murray; Barnet Lewis; Lewis sale, Christie's, 28 February–3 March 1930, lot 90 (repr.), bt Leggatt, from whom it was purchased by the Cairo Museum; with Agnew, 1937; with Frost and Reed, from whom it was purchased, 1947.

EXHIBITIONS  Fine Art Club, Ipswich, 1887 (143); 'English Landscape Painting 1750–1930', London Artists' Association, Cooling Galleries, June 1930 (28);

49

'Coronation Exhibition of British Pictures', Agnew's, 1937 (41).

BIBLIOGRAPHY Fulcher, p. 238; Menpes and Greig, p. 177; Waterhouse, no. 847.

A hillock had been used as the principal component in the landscape formerly owned by Colonel Bibby (cat. no. 36), but this is the first use of a similar feature as the fulcrum for the rococo development of an entire composition. The motif of the man drinking on the left is unique in Gainsborough. A picturesque ruined castle, less integrated with the landscape than the ruined building in the Mellon picture (cat. no. 34), is depicted in the distance, and the estuary scene has given Gainsborough the opportunity to paint a glowing, luminous background. The terrain is characteristic of the Orwell. A copy was formerly on the London art market.

DATING Appears to be closely related to cat. nos 35 and 40 in the modelling of the hillock on the right and in the handling of the figures, animals, foliage and distance.

## 49 Extensive Landscape with Peasants and Donkeys on a Winding Track, Cottage, Haymakers and Distant Windmill on a Hill

Canvas. 24 × 42   61 × 106.7
Painted c. 1754–6

Duke of Norfolk, Arundel Castle

PROVENANCE John Jackson, Pimlico; Jackson sale, Foster's, 21 April 1828, lot 73, bt Peacock; anon. [Daubney] sale, Christie's, 6–7 May 1836, 2nd day, lot 103, bt Powell; Henry, 14th Duke of Norfolk (1815–60) by 1856; thence by descent.

EXHIBITION Tate Gallery, 1980–81 (83, repr.).

BIBLIOGRAPHY Fulcher, p. 231; Armstrong, 1898, p. 206; Armstrong, 1904, p. 288; Waterhouse, no. 858; Clifford Musgrave, 'Arundel Park, Sussex', *Connoisseur*, June 1963, repr. fig. 18; Hayes, p. 206, repr. pl. 14; Lindsay, pp. 38–9.

The broadest, most gently rhythmical and most mature landscape Gainsborough had so far painted. The shape of the canvas (similar to that of cat. no. 48) suggests that it was intended for a particular position in a room, probably an overdoor rather than an overmantel; such a purpose would account for the breadth of massing and the slow, undulating rhythms. The reflected light on the bark of the tree-trunk is somewhat theatrical in character, but the fall of light and shadow over the rest of the landscape is both naturalistic and finely managed. With the exception of the two donkeys, the figures and animals are integrated with the landscape, and do not stand out as 'motifs' introduced for purely compositional reasons (as the tree-trunk, of course, does). The tree-trunk, with its stripped bark, is reminiscent of such Ruisdaels as the *Egmond aan Zee* in the Currier Gallery of Art, Manchester, New Hampshire, and the haymaking scenes in the background are suggestive of Lambert genre. Also mentioned on pp. 74, 82.

DATING Closely related to cat. no. 50 in the treatment of the clouds, the foliage and the foreground detail, the undulating rhythms and the motif of the stripped and highlit tree-trunk. The breadth of conception, the handling of the foliage and the crisp, firm modelling of the donkeys are also similar to the group portrait of Mr and Mrs John Browne, owned by the Marchioness of Cholmondeley (see pl. 79), datable c. 1754–5.

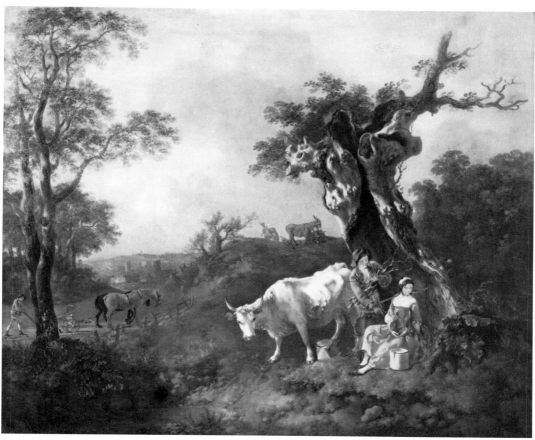

50

## 50 Wooded Landscape with Woodcutter courting a Milkmaid, White Cow, Plough Team, Figures and Donkeys on a Hillock, and Distant Village

Canvas. 42 × 50½    106.7 × 128.2
Painted in 1755

Marquess of Tavistock and the Trustees of the Bedford Settled Estates, Woburn Abbey

PROVENANCE Purchased from the artist by John, 4th Duke of Bedford (1710–71), 1755; thence by descent.

EXHIBITIONS BI, 1817 (134); BI, 1859 (141); 'Paintings from Woburn Abbey', Arts Council, National Gallery of Scotland, 1950 (33, repr. pl. VII); 'Paintings and Silver from Woburn Abbey', Arts Council, Royal Academy, 1950 (55, repr. pl. VII); Bath, 1951 (8, p. 5, detail repr. opp. p. 13); 'Le Paysage anglais de Gainsborough à Turner', British Council, Orangerie, Paris, 1953 (45, repr. pl. 9); Arts Council, 1953 (14, p. 7); 'Engelse landschapschilders van Gainsborough tot Turner', Boymans Museum, Rotterdam, 1955 (34, repr.); 'Europäisches Rokoko', Residenz, Munich, June–October 1958 (62); 'Paintings, Silver, Tapestries lent by the Duke of Bedford' (and otherwise titled), Portland Art Museum, Portland, Oregon, January–February 1961, Vancouver Art Gallery, February 1961, and M. H. de Young Memorial Museum, San Francisco,

March–April 1961 (8, repr. col.); 'Englische Malerei der grossen Zeit von Hogarth bis Turner', Wallraf-Richartz Museum, Cologne, and Palazzo Venezia, Rome, October–December 1966 (16, repr.); 'Shock of Recognition: The Landscape of English Romanticism and the Dutch Seventeenth-century School', Mauritshuis, The Hague, November 1970–January 1971, and Tate Gallery, January–February 1971 (32, repr.).

BIBLIOGRAPHY Fulcher, p. 204; Dr Waagen, *Galleries and Cabinets of Art in Great Britain*, London, 1857, p. 331; George Scharf, *A Descriptive and Historical Catalogue of the Collection of Pictures at Woburn Abbey*, London, 1889, no. 375, p. 238; Gladys Scott Thomson, 'Two Landscapes by Gainsborough', *Burlington Magazine*, July 1950, pp. 201–2, repr. fig. 19; Mary Woodall, 'The Gainsborough Exhibition at Bath', *Burlington Magazine*, August 1951, pp. 265–6; E. K. Waterhouse, 'The Exhibition "The First Hundred Years of the Royal Academy"', *Burlington Magazine*, February 1952, p. 51; Ellis Waterhouse, *Painting in Britain 1530–1790*, Harmondsworth, 1953, p. 184, repr. pl. 147B (detail); C. H. Collins Baker, 'The Kennedy Memorial Gallery', *Connoisseur*, October 1954, p. 142; Waterhouse, pp. 8, 18, 19, 24, no. 829, repr. pl. 41; Kenneth Garlick, 'Later Portraits at Woburn Abbey', *Apollo*, December 1965, p. 493, repr. fig. 3; Mark Girouard, 'English Art and the Rococo: Part II. Hogarth and his Friends', *Country Life*,

27 January 1966, repr. p. 190 (detail); Gatt, p. 26, repr. pls 22–23 (col.); John Hayes, 'Gainsborough and the Bedfords', *Connoisseur*, April 1968, pp. 219, 220; John Hayes, 'English Painting and the Rococo', *Apollo*, August 1969, pp. 117, 120, 122, 124, repr. fig. 7; Hayes, *Drawings*, pp. 4, 149; Hayes, pp. 43, 206, repr. pl. 27; John Barrell, *The Dark Side of the Landscape*, Cambridge, 1980, pp. 8, 35, 36, 41, 48–52, 53, 54, 70, 72, 75, 87, 132–3, 156, repr. p. 37, detail p. 48; Tate Gallery, 1980–81, p. 21; Grand Palais, 1981, p. 34, repr. fig. 26; Lindsay, p. 38; Ellis Waterhouse, *The Dictionary of British 18th Century Painters*, Woodbridge, 1981, p. 135; Michael Rosenthal, *English Landscape Painting*, Oxford, 1982, pp. 32, 38, repr. pl. 23.

This canvas was intended 'for a Chimney piece' (Gladys Scott Thomson, cited above), and an entry in an account book at Woburn for 8s. 2d. paid for 'carriage and porterage of a picture from Ipswich' on 31 May 1755 clearly refers to this picture. The payments for both this and the companion picture (cat. no. 51) were made in November 1755, Joshua Kirby, who appears to have acted as Gainsborough's agent in the metropolis, receiving the money in London on the artist's behalf. Both Woburn Abbey and Bedford House, London, were in the course of redecoration during the 1750s, wallpaper and damask being used to replace the tapestries that had formerly hung in most of the rooms, and it is clear that the two Gainsborough landscapes were intended as part of the refurnishing. But for which house were they done? Precise dates for the work at Bedford House are lacking, but at Woburn the work of redecorating and wallpapering the Gallery and the state rooms in the west front was in progress in 1754–6: Rysbrack's bill for a chimneypiece in the principal saloon is dated 29 May 1756, and bills for chimneypieces in the hall, the gallery and the state rooms were submitted by John Devall in 1755 and 1756 (for the redecoration at Bedford House, see Gladys Scott Thomson, *The Russells in Bloomsbury 1669–1771*, London, 1940, pp. 339–49; and for the work at Woburn the same author's *Family Background*, London, 1949, pp. 58–82). The two Gainsboroughs could well have formed part of the Woburn programme; and it was discovered by the present duke that this picture exactly fits an overmantel in one of the ground-floor rooms next to the hall, now used as a private sitting-room and office. In this composition, for the first time, Gainsborough has used the familiar dominating dead tree, succulently painted in the lights, as an integral part of his principal subject: a milkmaid coyly turning away from a woodcutter who is asking for a bowl of milk. The motifs of the plough team and donkeys reappear; the couple scurrying home were first used in his river scene, now missing (cat. no. 48). This distance on the left is closed with a townscape, instead of the more customary fields and a church tower. Michael Rosenthal (cited above, p. 32) identifies this as 'a view down to Ipswich', maintaining that Gainsborough 'has therefore located his subject'; although a very generalized image, it is indeed suggestive of mid-

eighteenth century Ipswich and the hills beyond. Also mentioned on pp. 12, 62, 77, 79, 97, 103, 257; a detail is repr. pl. 97.

DATING The receipt for payment, dated 17 November 1755, is preserved in the archives at Woburn: Gainsborough rendered his account on 24 May 1755 (Gladys Scott Thomson, cited above).

## 51 Wooded Landscape with Peasant Boy mounted and Two Horses, Pond with Ducks, Haymakers and Haycart, Woman suckling a Baby and other Figures and Church Tower among Trees

Canvas. $36\frac{1}{4} \times 40\frac{1}{4}$  92.1 × 102.2
Painted in 1755

Marquess of Tavistock and the Trustees of the Bedford Settled Estates, Woburn Abbey

PROVENANCE Purchased from the artist by John, 4th Duke of Bedford (1710–71), 1755; thence by descent.

EXHIBITIONS BI, 1817 (148); BI, 1859 (159); 'Paintings from Woburn Abbey', Arts Council, National Gallery of Scotland, 1950 (32); 'Paintings and Silver from Woburn Abbey', Arts Council, Royal Academy, 1950 (54); Bath, 1951 (7, p. 5); Arts Council, 1953 (13, p. 7, repr. pl. v); 'Engelse landschapschilders van Gainsborough tot Turner', Boymans Museum, Rotterdam, 1955 (33); 'Landscape in Britain *c.* 1750–1850', Tate Gallery, November 1973–February 1974 (54, repr., and p. 12).

BIBLIOGRAPHY Fulcher, p. 204; Dr Waagen, *Galleries and Cabinets of Art in Great Britain*, London, 1857, p. 331; George Scharf, *A Descriptive and Historical Catalogue of the Collection of Pictures at Woburn Abbey*, London, 1889, no. 374, p. 238; Gladys Scott Thomson, 'Two Landscapes by Gainsborough', *Burlington Magazine*, July 1950, pp. 201–2, repr. fig. 20; Mary Woodall, 'The Gainsborough Exhibition at Bath', *Burlington Magazine*, August 1951, pp. 265–6; E. K. Waterhouse, 'The Exhibition "The First Hundred Years of the Royal Academy"', *Burlington Magazine*, February 1952, p. 51; Ellis Waterhouse, *Painting in Britain 1530–1790*, Harmondsworth, 1953, pp. 184–5; Waterhouse, pp. 8, 18, 19, 24, no. 833, repr. pl. 39; Kenneth Garlick, 'Later Portraits at Woburn Abbey', *Apollo*, December 1965, p. 493, repr. fig. 4; Gatt, p. 26, repr. pl. 19 (col.); John Hayes, 'Gainsborough and the Bedfords', *Connoisseur*, April 1968, pp. 219–20, repr. fig. 3; Hayes, *Drawings*, p. 4; Hayes, pp. 43, 206, repr. pl. 45; British Museum, 1978, p. 12; John Barrell, *The Dark Side of the Landscape*, Cambridge, 1980, pp. 8, 35, 41, 87, repr. p. 36; Tate Gallery, 1980–81, p. 21; Lindsay, p. 38; Ellis Waterhouse, *The Dictionary of British 18th Century Painters*, Woodbridge, 1981, p. 135; Michael Rosenthal, *English Landscape Painting*, Oxford, 1982, pp. 28, 32, repr. pl. 21.

Probably intended as an overmantel as part of the redecoration in progress in the 1750s both at Bedford

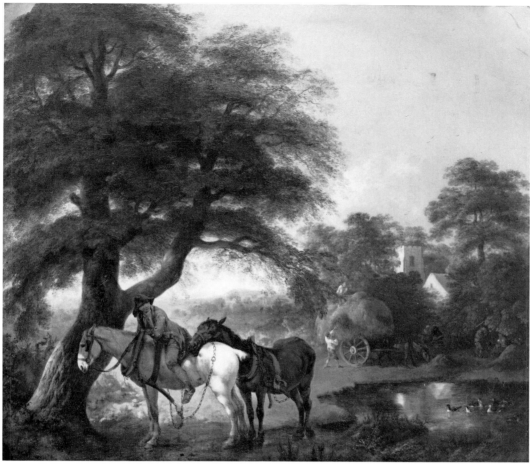

51

**51a** Study from life used for cat. no. 51. Canvas. $21\frac{3}{4} \times 25\frac{1}{2}$ / 55.2 × 64.8. Tate Gallery, London (1484).

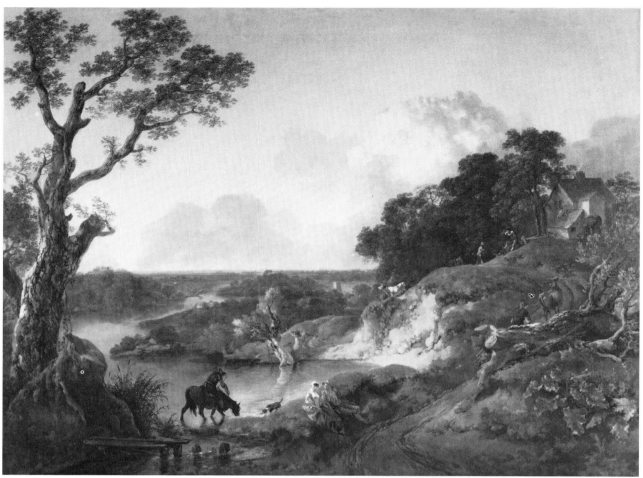

52

House, London, and at Woburn (see under the entry for the companion picture, cat. no. 50). An oil sketch from life used for the second horse—but made from a white, not a chestnut horse—is in the Tate Gallery (51a; Waterhouse, no. 824). Both in spirit and in tonality this canvas is totally different from its companion. The foliage of the foreground tree is exceptionally rhythmical and dominates the composition, though not, perhaps, linking the foreground subject quite satisfactorily with the background. A pale, soft light suffuses the distance, where a cottage and windmill on a hill are discernible. The genre element—including a cart being loaded with hay, a woman suckling her baby with a rustic looking on and another outstretched behind her, two figures leaning over the gate and ducks on the pond—is more predominant than in previous landscapes. The motif of the haymakers and haycart was used by Lambert in a landscape signed and dated 1742 (anon. sale, Christie's, 11 July 1930, lot 99, bt Ehrich). Also mentioned on pp. 12, 13, 62, 74, 76, 257; a detail is repr. pl. 12.

DATING Gainsborough's account for this picture was rendered on 24 July 1755 (Gladys Scott Thomson, cited above); the receipt for payment, dated 17 November 1755, is preserved in the archives at Woburn.

## 52 Wooded River Landscape with Horse drinking, Rustic Lovers, Figures, Cows, and Cottage on a Hill

Canvas. $37 \times 49\frac{1}{2}$  $94 \times 125.7$
Painted *c.* 1754–6

St Louis Art Museum, St Louis, Missouri (168:28)

PROVENANCE Mathew Mitchell (d. 1819); Mitchell sale, Christie's, 8–9 March 1819, 1st day, lot 97, bt Pinney; by descent to Colonel William Pinney; Pinney sale, Arber and Waghorn's, 21 July 1898, lot 22, bt Agnew; with Knoedler; John Fowler, St Louis; bequeathed by Cora Liggett Fowler, 1928.

EXHIBITIONS BI, 1857 (152); Cincinnati, 1931 (32, pp. 11–12, repr. pl. 1); 'Fifty Masterworks from the City Art Museum of St Louis', Wildenstein's, New York, November–December 1958 (28, repr. p. 46); 'From El Greco to Pollock: Early and Late Works by European and American Artists', Baltimore Museum of Art, October–December 1968 (25, repr. p. 44); Tate Gallery, 1980–81 (84, repr., col. p. 101); Grand Palais, 1981 (20, repr., detail fig. 27, col. p. 70, and p. 34).

BIBLIOGRAPHY Armstrong, 1898, p. 207; Armstrong, 1904, p. 288; J. B. M. [Musick], 'The John Fowler

**52a** Study from life for cat. no. 52. Pencil. $7\frac{3}{4} \times 5\frac{7}{8}$ / 19.7 × 14.9. British Museum (O.o.2-21).

Memorial Collection', *Bulletin of the City Art Museum of St Louis*, April 1929, pp. 20–21, repr. p. 21; Walter Heil, 'Die Gainsborough-Ausstellung in Cincinnati', *Pantheon*, September 1931, pp. 70, 381, repr. p. 380; Waterhouse, no. 834, repr. pl. 47; Gatt, p. 26, repr. pls 20–21 (col.); Hayes, *Drawings*, p. 144; John Ingamells, 'Thomas Gainsborough', *Burlington Magazine*, November 1980, p. 779; Michael Rosenthal, *English Landscape Painting*, Oxford, 1982, p. 66, repr. pl. 59.

A study from life for the peasant girl with a basket of eggs is in the British Museum (52a; Hayes, *Drawings*, no. 820): in the finished picture the youth is holding her left arm and she is shown looking bashfully downwards. The motif of rural lovers has now become a stock feature in Gainsborough's Suffolk landscapes. X-ray photographs, kindly taken specially, demonstrate that the composition was planned in detail before painting was begun, as no changes of even a minor description were made during execution. The elaborate design is the most thoroughly serpentine in all Gainsborough's landscapes of this period, with the exception of *Landguard Fort* (cat. no. 37): the branches on the right are exceptionally contrived, and the cow bellowing, above the bank, plays a similar rôle in the composition to the donkey silhouetted in the foreground of *Landguard Fort*. Even in so sophisticated a composition Gainsborough has still used the familiar device of a framing tree. The artificiality of the scene is underlined by the hot tonality. Also mentioned on pp. 74, 76, 77, 79, 82, 98

DATING Identical with cat. no. 50 in the warm reddish tonality, the handling of the clouds, the framing tree on the left, with its fluidly painted branches, the bushy trees and handling of the foliage, the crisp treatment of the foreground branches, burdocks and rushes, the firm contouring of the figures and the developed rococo rhythms of the composition. The breadth of conception, the softly painted and wonderfully atmospheric panorama and the motif of the little figures in conversation are closely related to cat. no. 49. The generalized modelling of the sandy bank in tones of bright orange can be paralleled in cat. no. 40.

### 53* Wooded Landscape with Church, Farmhouse, Barn, Figures and Donkey

Canvas. $19\frac{5}{8} \times 24\frac{3}{4}$  50 × 63
Painted *c.* 1754–6

Ownership unknown

PROVENANCE Adamovics; Lennox; Lennox sale, Wawra's, Vienna, 20 April 1931, lot 59 (repr.) (as Wijnants).

This picture appeared in a Viennese auction sale between the two World Wars with an attribution to Wijnants (see above), and can only be judged from the reproduction published at that time. It is, in fact, an amalgam of Gainsborough's Suffolk-period motifs: a pollarded tree as a *repoussoir*, felled timber, a sandy bank, a donkey, a church tower shrouded by trees. The composition is unusual in being dominated by a cluster of buildings, but this very unusualness, and the almost complete masking of the church tower by foliage (compare cat. no. 5), a daring effect for an imitator to have painted, diminish the possibility of the work being a later concoction. It has to be admitted that the composition is not entirely satisfactory, and that it is more crowded with familiar motifs, and indeed more static, than one would expect from Gainsborough of the mid-1750s; but the quality of handling discernible from the reproduction inclines one towards acceptance, and it is hoped that inclusion here will help to reveal the original, lost to view for half a century.

DATING Appears to be closely related to cat. no. 52 in the treatment of the foliage, the sandy bank and the felled timber and in the careful plotting of the distant panorama.

### 54 Open Landscape with Peasant, Calves in Country Cart, Farm Buildings, Rowing Boat and Distant Church

Canvas. 20 × 25  50.8 × 63.5
Painted *c.* 1754–6

Mr and Mrs R. Stanton Avery, San Marino, California

PROVENANCE Edward W. Lake; Lake sale, Christie's,

53

54

55

11–12 July 1845, lot 32, bt Smith; Beriah Botfield, 1848; with Martin Colnaghi; William H. Fuller, New York; Fuller sale, American Art Association, New York, 25 February 1898, lot 22 (repr.), bt George R. White; T. J. Blakeslee; Blakeslee sale, American Art Association, New York, 13–14 April 1899, 2nd day, lot 123 (repr.); Newport Private Collector sale, American Art Association, New York, 3 December 1936, lot 42 (repr.) (as attributed to Gainsborough), bt J. H. Weitzner.

EXHIBITIONS Union League Club, New York, February 1892; Tate Gallery, 1980–81 (85, repr.).

BIBLIOGRAPHY Armstrong, 1898, p. 205; Armstrong, 1904, p. 286; Waterhouse, no. 862.

An unusually enclosed composition, dominated by the farm buildings on the right, but opening out into the usual panoramic view punctuated by a distant church tower. The tonality is deep and Ruisdaelesque, enlivened by the contrast of the bright cloud. The motif of calves in a country cart is paralleled in a drawing of this date in the National Gallery of Art, Washington (Hayes, *Drawings*, no. 152, repr. pl. 41).

DATING Identical with cat. no. 52 in the richly worked handling of the clouds, the loose painting of the foliage on the right, the crisp touch in the foreground grasses and plants and the soft, generalized treatment of the distance.

## 55 Wooded Landscape with Milkmaid milking Cows, Peasants outside Farm Buildings, Pond and Distant Church

Canvas. 30 × 40    76.2 × 101.6
Painted *c.* 1754–6

Yale Center for British Art (Paul Mellon Collection), New Haven (96)

PROVENANCE John Milne, Wakefield, 1844; Lt-Colonel J. B. G. Tottie, West Yorkshire Regiment; with Leggatt, 1936; Lillian S. Whitmarsh; Whitmarsh sale, Parke-Bernet's, New York, 7–8 April 1961, 2nd day, lot 297 (repr.), bt John Nicholson, who sold it to Jeremy Maas, from whom it was purchased by Mr and Mrs Paul Mellon, October 1961; presented to the Yale Center, 1976.

EXHIBITIONS 'Painting in England 1700–1850: Collection of Mr and Mrs Paul Mellon', Virginia Museum of Fine Arts, Richmond, 1963 (34, repr.; repr. in the plates volume, p. 90); 'Painting in England 1700–1850: From the Collection of Mr and Mrs Paul Mellon', RA, 1964–5 (33).

BIBLIOGRAPHY Hayes, *Drawings*, p. 28, repr. pl. 321; Hayes, p. 206, repr. pl. 29; British Museum, 1978, p. 12; Lindsay, p. 38.

A rough sketch, probably from nature, in which the

**55a** Study, probably from nature, used for cat. no. 55. Pencil. $5\frac{13}{16} \times 7\frac{5}{8}$ / 14.8 × 19.4.
British Museum (O.0.2-52).

main elements of the composition are already de-
termined, but excluding the staffage, and with the
dominant trees on the left and the view into the distance
not yet included, is in the British Museum (55a; Hayes,
*Drawings*, no. 212). The branches of the trees and fretted
outline of the clouds form an elaborate surface pattern.
The deliberate inclusion, on the left, of several carefully
delineated farm implements is unusual, but entirely
relevant to the subject. Also mentioned on p. 75.

DATING Identical with cat. no. 52 in the use of pale-blue
tints in the sky, the modelling of the clouds with mauvish
tones in the darks, the treatment of the branches on the
left, the handling of the foliage, the crisp outlining of the
figures, the orange tones used in the lights in the
foreground (compare the sandy bank in cat. no. 52), the
quality of the reflections in the water and the soft,
generalized treatment of the distance.

### 56 Wooded River Landscape with Peasants, Cattle watering, Ferry Boat and Buildings

Canvas. 49 × 39   124.5 × 99.1
Painted *c.* 1754–6

Private collection, England

PROVENANCE Thomas Spencer, of Hart Hall, Suffolk;
Mary Spencer, who married Henry Thompson, 1769;
by descent in the Thompson family to Henry, Lord
Knaresborough (1845–1929); anon. [Knaresborough]
sale, Christie's, 20 June 1913, lot 87, bt A. Wertheimer;
with Arthur Tooth; with J. W. Anderson, Detroit, 1916;
with Arthur Tooth, 1919; with Hirschl and Adler, New
York, 1957; Mr and Mrs Nathan Oppenheimer; with

Newhouse Galleries; with Leggatt, 1976, from whom it
was purchased.

EXHIBITIONS Tate Gallery, 1980–81 (86, repr. and col.
back cover, p. 21); Grand Palais, 1981 (21, repr.).

BIBLIOGRAPHY Waterhouse, p. 18, no. 827, repr. pl. 37;
Jeffery Daniels, 'Gainsborough the European', *Con-
noisseur*, February 1981, p. 111 and repr. col.

The upright format is unusual in Gainsborough's Suffolk
landscapes, and was presumably dictated by a require-
ment to fill a particular space; the unnaturally tall
framing tree on the left and the build-up of forms on the
right, paralleled in Pijnacker, suggest that both artists
were solving the problems posed by the format in a
similar way, rather than any direct influence. The boy
lazing on the back of the donkey is an exceptionally
arresting image (see pl. 198). The motif of cows at a
watering place makes its first appearance in Gains-
borough. The ferry boat is reminiscent of Van Goyen.
The handling of the pinks and yellows at the horizon and
the glow which permeates the whole canvas seem to have
been inspired by Cuyp. Also mentioned on pp. 62, 74, 84,
265; details are repr. pls. 110, 198.

DATING Closely related to cat. no. 52 in the very free
brushwork in the clouds, the bushy trees and handling of
the foliage, the loosely painted sandy bank, the roughly
handled foreground track, painted in greys and reddish-
browns, the modelling of the cows, the firm outlines of
the figures and the feeling for light and atmosphere in
the distant landscape. Though the picture is quite
different in format, the rococo composition is also very
similar in principle to cat. no. 52, and includes the
framing tree.

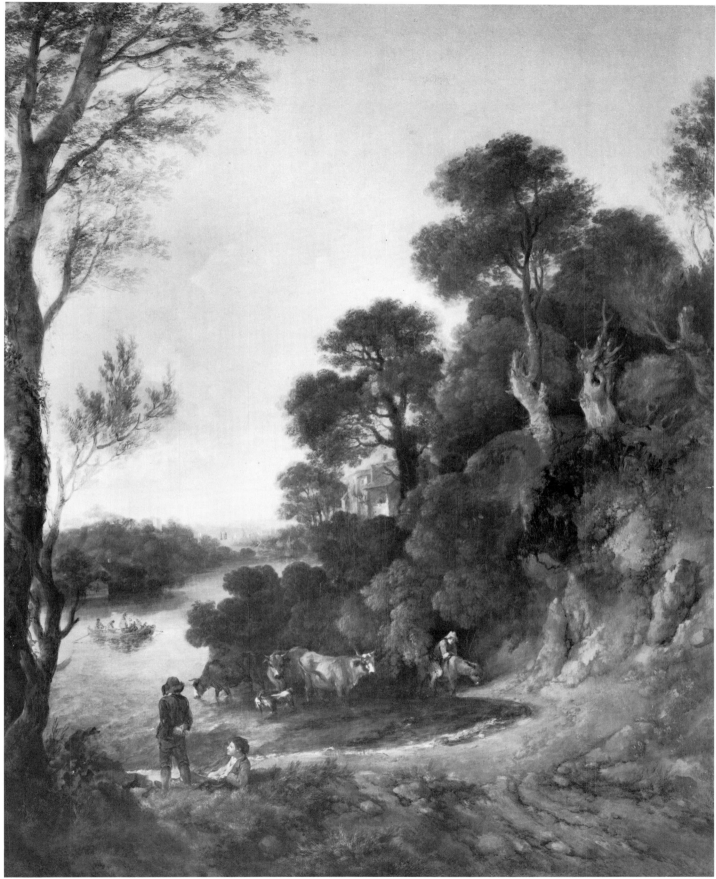

56

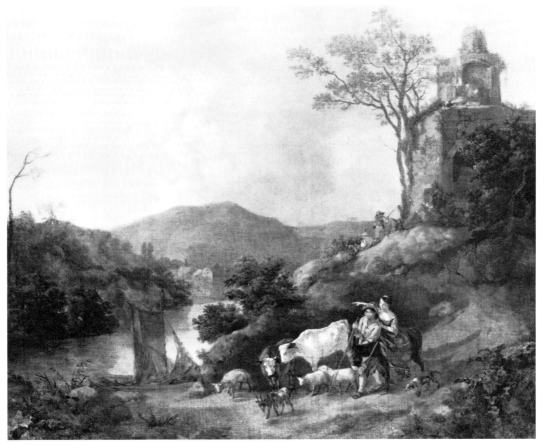

57

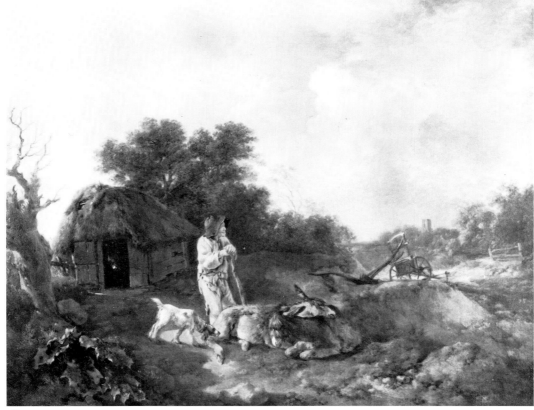

58

**57 Mountainous River Landscape with Sailing Boat, Herdsman and Animals, Woman on a Donkey, Figures, Cow and Ruined Building on a Hill, and Distant Village**

Canvas. $32\frac{1}{2} \times 38$   $82.6 \times 96.5$
Painted *c*. 1754–6

Private collection, England

PROVENANCE Samuel Woodburn; Woodburn sale, Christie's, 24–25 June 1853, 1st day, lot 26, bt Norton; Benjamin Gibbons; thence by descent; with Arthur Tooth, 1944–54; anon. [Tooth] sale, Christie's, 10 December 1954, lot 40, bt Leger, who sold it to John Mitchell, 1960, from whom it was purchased by a private collector; anon. sale, Sotheby's, 15 March 1978, lot 108 (repr. col.), bt in.

BIBLIOGRAPHY Waterhouse, no. 837.

The composition, with a prominent ruined building on the hillside and the distance closed by mountains, is unique in Gainsborough's early work, and is evidently inspired by such Berchems as that formerly in the Cook collection (pl. 105), where the gesture of the woman is also similar. Rural lovers, however, remain the subject of the picture. Also mentioned on p. 82.

DATING Closely related to cat. no. 52 in the free, richly worked painting of the clouds, the soft handling of the rocks and banks, the treatment of the foliage and the crisp, precise outlining of the figures and of the foreground rushes and burdocks.

**58 Wooded Landscape with Old Peasant and Donkeys outside a Barn, Ploughshare and Distant Church**

Canvas. $19\frac{1}{2} \times 23\frac{1}{2}$   $49.5 \times 59.7$
Painted *c*. 1755–7

Michael Clarke-Jervoise, Harrogate (on indefinite loan to Temple Newsam House, Leeds)

PROVENANCE Bought by Jervoise Clarke (1734–1808); thence by descent.

EXHIBITIONS BI, 1814 (72); BI, 1855 (149); GG, 1885 (211); Arts Council, 1953 (10); 'Pictures from Hampshire Houses', Winchester College and Southampton Art Gallery, July–August 1955 (15); Nottingham, 1962 (9); Tate Gallery, 1980–81 (87, repr.); Grand Palais, 1981 (22, repr.).

BIBLIOGRAPHY Fulcher, p. 201; Armstrong, 1898, p. 206; Armstrong, 1904, p. 283; Waterhouse, no. 871, repr. pl. 20; Alastair Smart, 'Dramatic Gesture and Expression in the Age of Hogarth and Reynolds', *Apollo*, August 1965, repr. fig. 13 (detail); British Museum, 1978, p. 11; Lindsay, p. 27; Michael Rosenthal, *English Landscape Painting*, Oxford, 1982, p. 66, repr. pl. 58.

The introduction of a toothless old peasant as a principal figure is unique in Gainsborough's early landscapes, and the sentimental intention of this image, a premonition of *The Woodman* of 1787 (Waterhouse, no. 806), is emphasized by the warm evening glow suggested by the pinkish tones in the clouds, the reddish highlights in the tree and fence on the left and the reddish tones prevalent in the foreground. Gainsborough painted a similar old peasant at this period, as it were a portrait-in-little with donkey and landscape background, which was later engraved by Woollett (pl. 102; Waterhouse, no. 816a, repr. pl. 35). The carefully delineated ploughshare is irrelevant to the theme, and seems to have been introduced because Gainsborough enjoyed painting such implements; similar 'set-pieces' appear in a drawing of this period (Hayes, *Drawings*, no. 178, repr. pl. 58). The dog and sleeping donkeys are also lovingly painted from direct observation. Also mentioned on p. 80; a detail is repr. pl. 100.

DATING Closely related to cat. no. 57 in the use of bright-blue tints in the sky, the free, richly worked handling and pinkish tones of the highlights in the clouds, the soft modelling and warm red tonality of the foreground banks and the very precise outlining of the burdocks on the left. The bushy trees, the rich, buttery paint used in modelling the clothes of the peasant and the warm glowing reds in the highlights of the tree and fence on the left are also very similar to cat. no. 50.

**59 Wooded Landscape with Peasant courting a Milkmaid, Cows, Donkeys, Bridge over a Stream, Cottages and Distant Church and Windmill**

Canvas. $29\frac{1}{2} \times 47\frac{5}{16}$   $74.9 \times 120.2$
Painted *c*. 1755–7

Montreal Museum of Fine Arts, Montreal (12/6/53)

ENGRAVING Engraved in reverse as *The Rural Lovers* by François Vivares, 1760, and published by him (as a pair with *The Hop Pickers*, after George Smith of Chichester) as in the possession of Panton Betew, 1 August 1760 (59a).

PROVENANCE With Panton Betew, 1760; Angerstein (?); anon. [Mrs Ford] sale, Christie's, 15 July 1893, lot 91, bt Dowdeswell; with the French Gallery, from whom it was purchased by David Morrice, Montreal, 1894; presented by his family to the Montreal Museum of Fine Arts in memory of their parents, 1915.

EXHIBITIONS 'Artists of the Early English School', French Gallery, 1893 (9, as ex-Angerstein); 'British Masters', French Gallery, 1894; Montreal Museum of Fine Arts, 1894; 'Masterpieces from Montreal', Sarasota, Buffalo, Rochester, Raleigh, Philadelphia, Columbus, Pittsburgh and New York, January 1966–April 1967 (34, repr.); Tate Gallery, 1980–81 (88, repr.).

BIBLIOGRAPHY Bell, p. 67; Armstrong, 1898, p. 207; Armstrong, 1904, p. 284 (wrongly in both editions as

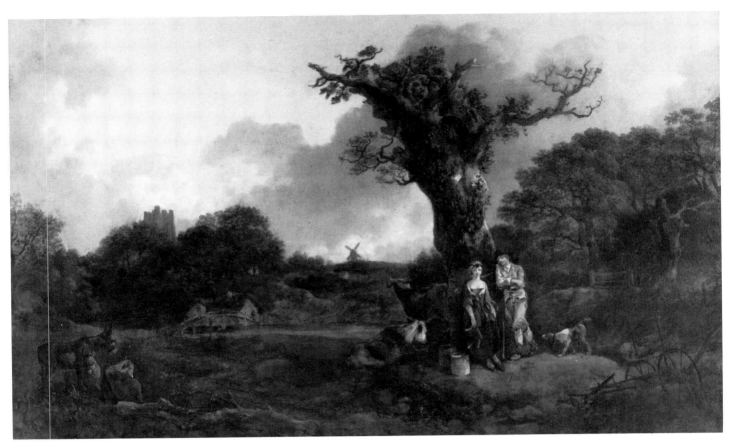

59

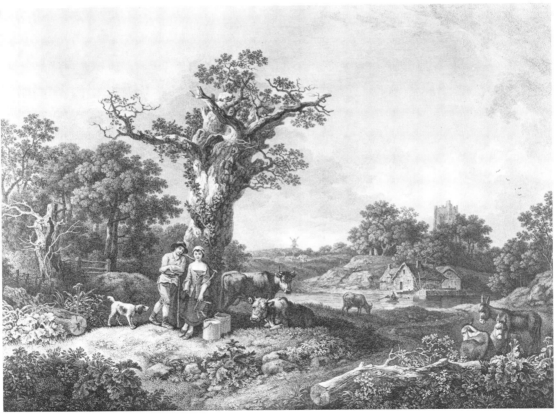

**59a** Engraving, printed in reverse, of cat. no. 59 by François Vivares, published August 1760. British Museum (1875-7-10-3382).

owned by James Ross, Montreal, and size 44 × 23 inches); Menpes and Greig, p. 179; Whitley, p. 27; Chauncey Brewster Tinker, *Painter and Poet*, Cambridge, Mass., 1938, p. 80; Woodall, *Drawings*, pp. 38–9, repr. pl. 35 (engraving repr. pl. 34); Mary Woodall, 'The Gainsborough Exhibition at Bath', *Burlington Magazine*, August 1951, p. 266; Waterhouse, no. 844, repr. pl. 40; John Steegman, *Catalogue of Paintings*, Montreal Museum of Fine Arts, Montreal, 1960, no. 57, p. 68; *Handbook*, Montreal Museum of Fine Arts, n.d. [1960], no. 57, p. 87 (repr.); John Hayes, 'Gainsborough', *Journal of the Royal Society of Arts*, April 1965, repr. fig. 6; Hayes, *Drawings*, p. 149; British Museum, 1978, p. 12; John Ingamells, 'Thomas Gainsborough', *Burlington Magazine*, November 1980, p. 779.

The subject of rural lovers beneath a dominating dead tree, the milkmaid somewhat spotlit, the swain for the first time characterized as a sentimental figure, is complemented by many of Gainsborough's familiar incidental motifs: the *repoussoir* branch and donkeys, the church half-hidden by trees, the distant windmill, and the extraneous introduction of a ploughshare as incidental detail. The engraving (59a) differs somewhat from this picture. There is no bridge or ploughshare, the cows are facing the spectator, a mass of plants and grasses have been introduced in the foreground, a cow and rowing-boat are included in the middle distance and one of the cottages has become a water-mill. It is possible, therefore, that the engraving was made from a variant of the Montreal canvas no longer extant. On the other hand, the size given in the letterpress (29¼ × 47¼ inches) corresponds, while it is clear that the engraver has taken liberties with these proportions, and the ornamental foreground plants and grasses are wholly untypical of Gainsborough's work and would also seem to be an 'improvement' for which the engraver was responsible. Numerous copies of this engraved composition exist, by James Lambert, William Hannan and William Cowper among others (see pl. 297 and p. 257). Also mentioned on pp. 79, 88, 103, 242.

DATING Identical with cat. no. 58 in the use of bright-blue tints in the sky, the richly worked pinkish impasto in the highlights of the clouds, the treatment of the foliage, the buttery handling of the paint in the costume of the figures and the crisp painting of the burdocks and foreground detail. The theme of the peasant making advances to a milkmaid in the shelter of a pollarded tree derives from cat. no. 50, but the peasant is now the rather lanky type characteristic of Gainsborough's male figures of the later 1750s; the use of touches of red in the foreground grass is also similar to cat. no. 50. The motif of donkeys used as a foreground *repoussoir* is paralleled in cat. nos 46 and 47.

**60\*  Wooded Landscape with Peasants at a Stile, Sleeping Pigs, Farm Buildings and Distant Church**

Size unknown
Painted *c*. 1755–7

Ownership unknown

ENGRAVING Engraved in reverse and published by François Vivares as in the possession of Panton Betew, March 1765.

PROVENANCE With Panton Betew, 1765.

BIBLIOGRAPHY Waterhouse, no. 888a.

The dominant tree stump is a recurrent feature at this period, but the rustic carrying a basket on his head and the group of pigs are unfamiliar motifs: the former is more characteristic of the Smiths of Chichester. Since all three copies in reverse from the engraving and therefore made from the original picture, one of which may be attributed to Ibbetson (see below), contain a faggot-gatherer in place of the rustic and seated girl, either Gainsborough painted a variant of the engraved design, which was the one familiar to the copyists, or the substitution of the two figures for the faggot-gatherer was an 'improvement' for which the engraver was responsible. Several copies of this engraved picture are extant: three, as stated above, are after the original painting and with a faggot-gatherer substituted for the two figures, one by Ibbetson (see pl. 279 and p. 243), one in an English private collection (see pl. 299 and pp. 257–8) and one a watercolour of some quality (in Gainsborough's style of the mid-1750s) formerly in the L. G. Duke collection; two others exist, made after the engraving. Also mentioned on pp. 88, 242.

DATING Appears to be related to cat. no. 58 in the bushy trees and treatment of the foliage, the precise handling of the foreground detail and the motifs of the pollarded tree stump and of animals asleep.

**61\*  Wooded Landscape with Woman and Small Boy passing a Pool with Ducks, Cows, Farmhouse and Distant Church**

Size unknown
Painted *c*. 1755–7

Ownership unknown

ENGRAVING Engraved in reverse and published by François Vivares as in the possession of Panton Betew, March 1765.

PROVENANCE With Panton Betew, 1765.

BIBLIOGRAPHY Waterhouse, no. 888.

A study from life which was used for the reclining cow is in a private collection (61a; Hayes, *Drawings*, no. 862).

**60** Cat. no. 60, from the engraving, printed in reverse, by François Vivares, March 1765. British Museum (1867-12-14-208).

The motif of a woman carrying a basket, and her little boy, walking along a country track past a pond, and the child stopping to point out something, occurs in Wijnants (compare the landscape in an anon. sale, Christie's, 2 April 1976, lot 19, repr.); this vignette of the little boy stopping to admire the ducks is also in the tradition of Hayman genre, rather than of pastoral landscape, and it is perhaps significant that, in neither of the copies known, both of which were made from the original picture (see below), was this incident included; on the other hand, as may have been the case with cat. no. 60, the engraver could have added staffage which did not exist in the original. A copy, varying very slightly and without staffage, is in an English private collection (see pl. 300 and pp. 257–8): the size of this canvas, $17\frac{1}{8} \times 19\frac{1}{8}$ inches, may reflect the size of the original. A larger canvas, size $28\frac{3}{8} \times 36\frac{3}{8}$ inches, was formerly with Buttery (see pl. 301 and p. 258): in this copy two cows are included on the bank, but the staffage is different and closer in character to Wijnants than to Gainsborough. Both are in reverse from the engraving and presumably, therefore, depend from the original painting. A water-colour copy by an amateur artist is in the collection of the Earl of Radnor at Longford Castle. Also mentioned on pp. 88, 242.

DATING Appears to be related to cat. no. 57 in the bushy trees, the treatment of the foliage, and the precise handling of the foreground detail.

## 62   Open Landscape with Peasant Boy and Cows, Milkmaid crossing a Stile, Woodcutters and Church Tower and Houses among Trees

Canvas. $28 \times 53\frac{1}{2}$   $71.1 \times 135.9$
Painted c. 1755–7

Earl Howe, London

PROVENANCE Charles Jennens (1700–73) by 1761, who bequeathed it to Admiral Lord Howe (1725/6–99); thence by descent to Edward, 6th Earl Howe; Howe sale, Christie's, 18 November 1966, lot 107 (repr.), bt in.

EXHIBITION BI, 1860 (189).

BIBLIOGRAPHY R. and J. Dodsley, *London and its Environs Described*, London, 1761, vol. v, p. 80; Waterhouse,

**61** Cat. no. 61, from the engraving, printed in reverse, by François Vivares, March 1765. British Museum (1871-8-12-5655)

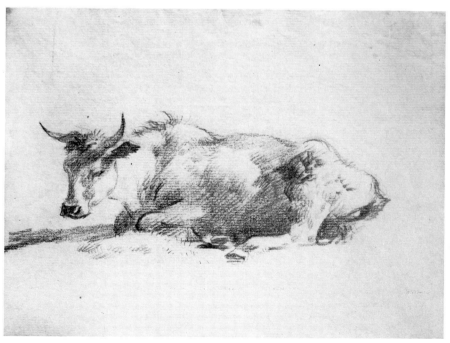

**61a** Study from life used for cat. no. 61. Pencil. $5\frac{7}{16} \times 7\frac{1}{8}$ / 13.8 × 18.1. Private collection, England.

397

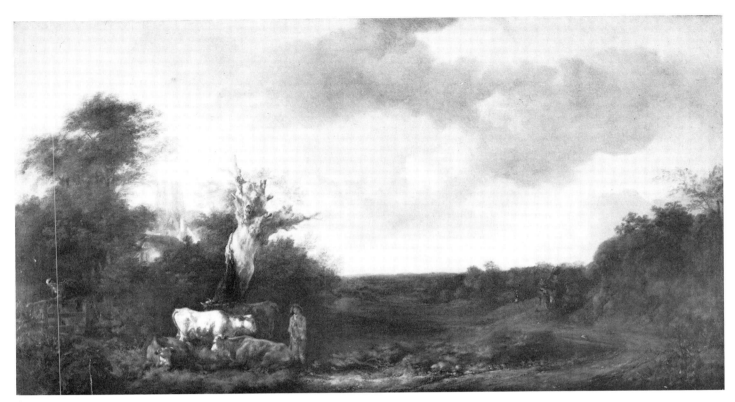

62

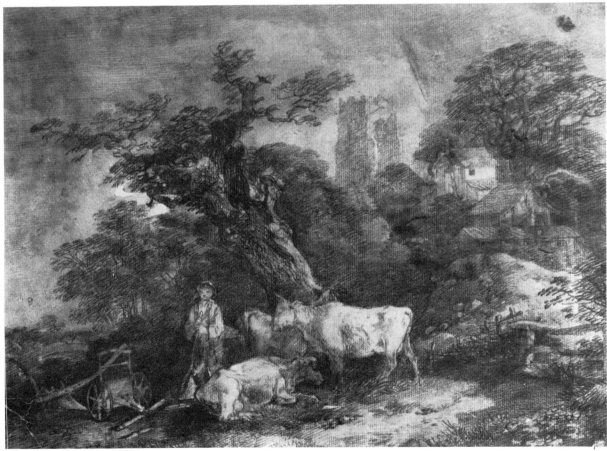

**62a** Finished drawing used in reverse for the left side of cat. no. 62. Pencil, varnished. $11\frac{1}{8} \times 14\frac{1}{2}$ / 28.3 × 36.8. Private collection, Connecticut.

64

## 64 Open Landscape with Rustic Lovers, Country Cart and Donkeys near a Cottage among Trees

Canvas. 25 × 30   63.5 × 76.2
Painted *c.* 1755–7

Private collection, London

PROVENANCE Probably Francis Chaplin, and bequeathed by him to Sir Richard Sutton (1799–1855), 1838; thence by descent.

EXHIBITIONS Nottingham, 1962 (11); 'The Origins of Landscape Painting in England', Iveagh Bequest, Kenwood, summer 1967 (11).

BIBLIOGRAPHY Waterhouse, no. 851; Mary Woodall, 'Gainsborough Landscapes at Nottingham University', *Burlington Magazine*, December 1962, p. 562.

The composition is based on crossing diagonals, with the two rustic lovers at the centre; the long log and the cart disappearing into the distance are rather obvious elements in the design. The dead tree-trunk is here used as an incidental feature, enlivening the passage with a cottage and donkeys among trees on the left.

DATING Identical with cat. no. 62 in the warm reddish tonality, the loosely painted pinkish highlights in the clouds, the bushy trees, the very particularized foreground detail and tight handling of the foreground track, the massing on the left, the soft, generalized distance and low horizon. The rhythmical handling of the foliage is similar to cat. no. 51, and the motifs of the cottage half-hidden among trees and of the log acting as a *repoussoir* leading the spectator into the composition are paralleled in cat. no. 61.

**65** Cat. no. 65, from a presumed early copy. Formerly with Marshall Spink, London.

**65 Extensive Landscape with Drover kissing a Peasant Girl who is dropping a Basket of Eggs, Country Cart with Calves, Peasant and Dog, Cottage with a Woman at the Doorway and Pigs outside, and Distant Church**

Canvas. Probably about $37\frac{1}{2} \times 49\frac{1}{2}$   95.3 × 125.7
Painted *c*. 1755–7

Ownership unknown

PROVENANCE Either the original or the copy here illustrated was Richard Westall (1765–1836) (?); Charles Meigh; Meigh sale, Christie's, 21–22 June 1850, 2nd day, lot 162, bt in; anon. [Mrs Peek] sale, Christie's, 30 June 1877, lot 73 (as from the collection of Richard Westall), bt Cox; Sir J. C. Robinson, 1897–8. The copy was Wadsworth Atheneum, Hartford, Conn.; with Julius Weitzner; with Marshall Spink, 1955.

EXHIBITION Either the original or the copy here illustrated was 'Pictures Ancient and Modern by Artists of the British and Continental Schools', New Gallery, 1897–8 (192).

BIBLIOGRAPHY Armstrong, 1898, p. 207; Armstrong, 1904, pp. 289, 292; Waterhouse, no. 832; Hayes, *Drawings*, p. 147.

The composition is known only from the accomplished full-scale copy reproduced here, formerly in the Wadsworth Atheneum, Hartford, Connecticut, which is probably derived from a lost original. The familiar theme of the rustic lovers is taken well beyond the coyness characteristic of the Woburn, St Louis and Montreal pictures (cat. nos 50, 52, 59), but the hollow, pollarded tree remains the setting. The motif of broken eggs, with its sexual overtones, can be traced back to Mieris, and was taken up by Greuze in *Les Oeufs Cassés* (see Anita Brookner, *Greuze*, London, 1972, pl. 17 and 16); but the Gainsborough is pure rustic genre, and has nothing of the mawkishness characteristic of both the Mieris and the Greuze. The motif of the country cart laden with calves reappears (compare cat. no. 54). The panoramic stretch of open country is unusual for the date, though there are parallels with the St Louis and Sutton pictures (cat. nos 52, 64), and the inclusion of so uncharacteristic a feature militates against the work being the concoction of an imitator. The motif of the thatched cottage, with a figure standing at the doorway, prefigures the 'Cottage Door' theme developed at a later period (see cat. no. 95). The two sides of the composition are linked by the peasant in the foreground. What may be assumed to be the original rather than the present

68

## 68 Wooded Landscape with Peasants in a Country Waggon, Milkmaid and Cows, and Distant Cottage, Village and Church Spire

Canvas. 25 × 30   63.5 × 76.2
Painted *c.* 1756–7

Private collection, Newcastle, Australia

PROVENANCE One of a pair said to have been painted for Francis Hayman (1708–76) (Fulcher, p. 174); John Heywood, 1814; J. Heywood Hawkins, 1844; by descent to Mrs J. E. Hawkins; Hawkins sale, Christie's, 30 October–2 November 1936, 1st day, lot 102 (repr.), bt Agnew; with Lockett Thompson; L. H. Wilson; L. H. Wilson Trust sale, Sotheby's, 31 March 1976, lot 28 (repr. col.), bt Agnew, from whom it was purchased.

EXHIBITIONS BI, 1814 (41); BI 1844 (158 or 163); BI, 1859 (147); either this or cat. no. 79 was 'National Exhibition of Works of Art', Exhibition Building, Leeds, 1868 (1031); Nottingham, 1962 (12); Grand Palais, 1981 (23, repr., p. 34) (catalogued but not exhibited).

BIBLIOGRAPHY Fulcher, pp. 174, 199, 207; Boulton, pp. 51, 62; Waterhouse, no. 857, repr. pl. 53; John Hayes, 'The Gainsborough Drawings from Barton Grange', *Connoisseur*, February 1966, p. 90; Herrmann, p. 95.

The exceptional tightness of handling characteristic of certain works of the later 1750s is most apparent in this picture, where its effect is accentuated by the brilliant lighting, in this case from two sources, naturalistic and unnaturalistic: the horizon and a studio source focussing from the upper left. The handling of paint is rich and juicy, and the reflected lights in the tree on the right are modelled in a variety of tints. Passages on the right are comparable with Fragonard. The composition is strongly serpentine, and the lyrical, evening mood is established by the bright lemon yellow of the horizon, which first attracts the eye. The distance is more carefully delineated than in the previous group of landscapes (cat. nos 62–67). According to Fulcher (p. 174), Gainsborough declared that he would 'never bestow so much time on pictures again' as on this landscape and its companion (cat. no. 79). Also mentioned on pp. 35, 63–4, 84–7, 97; a detail is repr. pl. 114.

DATING Identical with cat. no. 67 in the deep-reddish and dark-green tonality, the richly worked cream and pinkish impasto in the highlights of the clouds, the handling of the deep-green foliage in the middle-ground trees, the pale, spikily painted foliage in the tree on the left, the very particularized treatment of all the foreground detail and the tight modelling of the foreground track in grey and reddish-brown touches; the foreground trees are far more fluently painted, however, and modelled in a rich variety of colour unparalleled in any earlier landscape.

69

**69 Wooded Landscape with Shepherd Boy and Four Sheep, Cows, Figure crossing a Footbridge over a Stream, and Distant Church**

Canvas. Oval. $30\frac{1}{2} \times 25\frac{1}{4}$   $77.5 \times 64.1$
Painted *c.* 1757–9

Toledo Museum of Art, Toledo, Ohio (33.20)

ENGRAVING Mezzotinted by George Sanders, 1871, as *Bramford near Ipswich*.

PROVENANCE Painted for Robert Edgar, Ipswich (Fulcher, p. 235); by descent to Mrs Mileson Gery Edgar, from whom it was bought by Sir George Donaldson in the 1890s; H. Darell Brown; Brown sale, Christie's, 23 May 1924, lot 20 (repr.), bt Blaker; with Croal

Thomson; with Howard Young, from whom it was purchased by Arthur J. Secor, Toledo, 1926; presented by him to the Toledo Museum of Art, 1933.

EXHIBITIONS BI, 1861 (214); Fine Art Club, Ipswich, 1887 (181); 'A Century of British Art from 1737 to 1837', Grosvenor Gallery, winter 1888 (218); 'Loan Collection and Exhibits in the British Royal Pavilion', Paris Exhibition, 1900 (48); RA, 1903 (122); 'The French Taste in British Painting during the First Half of the 18th Century', Iveagh Bequest, Kenwood, summer 1968 (41).

BIBLIOGRAPHY Fulcher, p. 235; *Engravings from the Works of Thomas Gainsborough, R.A.*, published by Henry Graves & Company, London, n.d. [*c.* 1880], p. 111; Armstrong,

73

considerably more freely painted than any other of Gainsborough's Suffolk landscapes, and the loose, rhythmical handling of the foliage, and the technique used for highlighting the leaves, are more closely paralleled in the landscape depicted on the wall in the background of the portrait of Richard Savage Nassau at Brodick Castle, painted in the later 1750s (pl. 127). The looped technique used in painting the foliage, detectable in passages in the Newcastle landscape (cat. no. 68), is paralleled in a number of portrait backgrounds of the later 1750s: examples are *Lambe Barry* (Waterhouse, no. 41, pl. 33), *Katherine Edgar* (Waterhouse, no. 232) and *William Wollaston* (Waterhouse, no. 734, pl. 61).

## 74  Wooded Landscape with Mounted Peasant leading a Horse, Woodcutter and Distant Hills and Church Tower

Canvas. 40 × 50¼  101.6 × 127.6
Painted *c.* 1759–60

Private collection, Great Britain

PROVENANCE Painted for Samuel Kilderbee (1725–1813) 'at Bath, about the year 1760' (according to an old printed label on the back of the stretcher, seemingly from a sale catalogue, but signed beneath in ink: . . . *Kilderbee*, first noted by the reporter of *The Times*, 27 May 1879); Kilderbee sale, Christie's, 30 May 1829, lot 124 (not noted as painted *c.* 1760), bt Emmerson; William Wells, 1841; Wells sale, Christie's, 20 May 1852, lot 55 (not noted as painted *c.* 1760), bt Fordham; D. T. White, 1856; William Benoni White sale,

Christie's, 23–24 May 1879, 2nd day, lot 208 (as 'Painted at Bath for the late S. Kilderbee, Esq., about 1760'), bt Agnew for Sir Robert Loyd-Lindsay (later Lord Wantage); thence by descent.

EXHIBITIONS BI, 1841 (118); GG, 1885 (193); 'Pictures and Drawings in the National Loan Exhibition', Grafton Galleries, 1909–10 (93); 'Pictures and Furnishings from Scotland's Famous Houses', National Trust for Scotland, Edinburgh, August–September 1950 (84); Bath, 1951 (22); Nottingham, 1962 (13, repr. cover (detail)).

BIBLIOGRAPHY Fulcher, p. 238; William Martin Conway, *The Artistic Development of Reynolds and Gainsborough*, London, 1886, pp. 85–6; Armstrong, 1898, p. 208 (listed twice); *Catalogue of Pictures forming the Collection of Lord and Lady Wantage*, London, 1902, no. 83, p. 60; Armstrong, 1904, p. 290 (again listed twice); Mary Woodall, 'The Gainsborough Exhibition at Bath', *Burlington Magazine*, August 1951, p. 266; Waterhouse, no. 910, repr. pl. 80; Hayes, *Drawings*, p. 166; Herrmann, p. 96, repr. pl. 88; Hayes, p. 210, repr. pl. 48; Tate Gallery, 1980–81, p. 105; Grand Palais, 1981, pp. 41, 106; Lindsay, pp. 55–6.

This picture is in exceptionally good condition, and the trees preserve Gainsborough's original brown glazes, which give them additional vitality and shimmer. It is also the earliest of Gainsborough's landscapes in the grand manner. The brushwork is considerably looser than in the Berners coastal scene (cat. no. 73), and the treatment of the distance, with greenish-blue hills and higher mauvish hills beyond, is freer than in the Muller

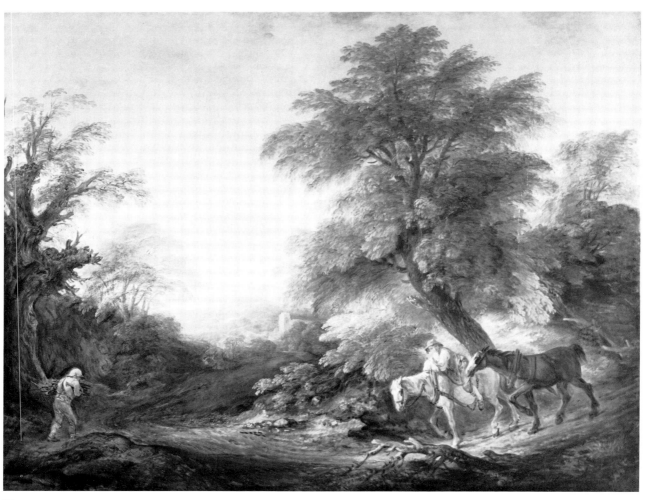

**74**

landscape (cat. no. 71). Although this fluency of handling and the complete assurance in composing a landscape in the classical idiom seem to favour a later dating, there is an early tradition that the landscape was painted *c.* 1760 (see above) and the touch in the foliage is so characteristic of the early 1760s and of no other period that the dating proposed here is preferable: the new maturity and freedom both of composition and handling are comparable with the full-length of Ann Ford, the first portrait Gainsborough painted at Bath. The motif of a boy on a white horse, accompanied by a brown horse, placed beneath a tree with exceptionally rhythmical foliage, derives from the Woburn landscape (cat. no. 51), but here the horses are shown in movement. This canvas marks the first appearance of one of Gainsborough's favourite later motifs: a woodcutter trudging home after the day's labours. Minor pentimenti are detectable in the placing of the right legs of the chestnut horse. Also mentioned on pp. 93, 97, 98, 99, 102, 120, 270; details are repr. pls 119, 121.

DATING Closely related to the watercolour in the Whitworth Art Gallery, Manchester, of beech trees at Foxley, dated 1760 (Hayes, *Drawings*, no. 248, pl. 80), both in composition and in the rhythmical treatment of the

bushy foliage. The pale tonality, the rhythmical treatment of the foliage, the looped technique used for painting the leaves evident throughout and the loose modelling of the banks and foreground track are also closely related to cat no. 73. The fluent and vigorous modelling of the tree-trunk on the left is identical with the background of *William Poyntz* (Waterhouse, no. 554, pl. 63), exhibited SA, 1762.

## 75 Wooded Landscape with Peasants in a Country Waggon, Drover on a Footbridge, Horses drinking at a Stream, and Distant Hills

Canvas. $56 \times 59\frac{3}{4}$  $142.2 \times 151.8$
Painted *c.* 1759–62

Tate Gallery, London (310)

ENGRAVING Engraved by J. C. Bentley and published by George Virtue for the *Art Journal*, 1 March 1849, facing p. 72.

PROVENANCE Described as being an overmantel in a house in Bedford Square for some eighty or ninety years (*Art Journal*, 1 March 1849, p. 72), but also identifiable with Gainsborough Dupont sale, Christie's, 10–11 April

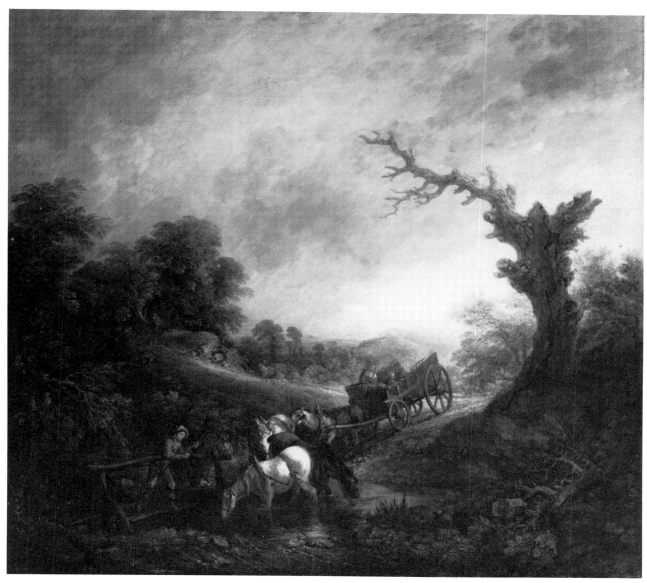

75

1797, 2nd day, lot 101, bt Steers; John Ewer, 1814; anon. [Ewer] sale, Christie's, 12 May 1832, lot 8, bt Robert Vernon (1774–1849); presented to the National Gallery by Robert Vernon, 1847; transferred to the Tate Gallery, 1919.

EXHIBITIONS BI, 1814 (51); BI, 1841 (120); Suffolk Street, 1932 (8); Arts Council, 1953 (23, p. 7).

BIBLIOGRAPHY Probably Farington Diary, 14 April 1797 (Kenneth Garlick and Angus Macintyre, ed., *The Diary of Joseph Farington*, New Haven and London, vol. III, 1979, p. 823); anon., 'The Vernon Gallery', *The Art-Union*, November 1847, p. 366; *Art Journal*, 1 March 1849, p. 72; Fulcher, pp. 197, 200, 207; George M. Brock-Arnold, *Gainsborough*, London, 1881, repr. facing p. 25; Mrs Arthur Bell, *Thomas Gainsborough, R.A.*, London, 1902, repr. facing p. 30; A. E. Fletcher, *Thomas Gainsborough, R.A.*, London, 1904, repr. facing p. 48; Pauli, p. 99, repr. pl. 77; M. H. Spielmann, 'A Note on Thomas Gainsborough and Gainsborough Dupont', *The Walpole Society*, vol. V, Oxford, 1917, pp. 98, 108; probably Farington Diary, ed. James Greig, London, vol. I, 1922, p. 206; Mary Woodall, 'The Gainsborough Exhibition at Bath', *Burlington Magazine*, August 1951, p. 266; Ellis Waterhouse, *Painting in Britain 1530–1790*, Harmondsworth, 1953, p. 188; Waterhouse, p. 18, no. 897, repr. pl. 65; Gatt, pp. 27–8, repr. pls 24–25 (col.), 26 (col. detail); Hayes, *Drawings*, p. 169; Jean-Jacques Mayoux, *La Peinture Anglaise De Hogarth aux Préraphaélites*, Geneva, 1972, p. 74, repr. p. 73 (col.); Herrmann, p. 96; Paulson, p. 247, repr. pl. 153; Simon Wilson, *British Art from Holbein to the present day*, London, 1979, p. 48, repr. p. 47 (col.); Marcia Pointon, 'Gainsborough and the Landscape of Retirement', *Art History*, vol. 2, no. 4, December 1979, pp. 449–50, repr. pl. 39.

As in the Kilderbee landscape (cat. no. 74), the sunset glow is enlivened with scattered touches of pink and

76

yellow, but the distant hills, reminiscent of Cuyp in handling, melt more atmospherically into the horizon. The track and foreground detail are modelled with touches of paint put in with the tip of the brush, a technique looser than, but rooted in, the 'tight' style of the later 1750s. The motif of a family travelling home at rest in a country waggon had first appeared in the Newcastle landscape (cat. no. 68), but here, with the halt by a stream to allow the horses to slake their thirst, the theme of repose after the labours of the day is more overt. Two or three copies of this composition, one by which Gainsborough was particularly well known in the nineteenth century, are in existence. Also mentioned on pp. 98, 99, 103.

DATING Closely related to cat. no. 74 in the rhythmical composition and treatment of the foliage, the looped technique used for painting the leaves, the modelling of the tree-trunk on the right in vigorous, short, twisting touches, the loose modelling of the foreground track, the scattered touches of pink and yellow enlivening the sunset, and the glowing mountainous distance. The modelling of the tree-trunk on the right is also identical with the background of *William Poyntz* (Waterhouse, no. 554, pl. 63), exhibited SA, 1762.

## 76 Wooded Landscape with Figures, Cottage and Pool

Canvas. $11\frac{3}{4} \times 13\frac{1}{2}$   29.8 × 34.3
Painted *c.* 1759–62

Private collection, Hampshire

PROVENANCE Ralph Allen (1694–1764), Prior Park, Bath; thence by descent.

BIBLIOGRAPHY Waterhouse, no. 895, repr. pl. 56.

Although this little picture is dominated by a strong sunset glow, executed in rich yellow impasto, there is very little feeling for light or reflections in the landscape, the trees on the right lack plasticity and the handling is dull. However, since the picture was originally owned by Ralph Allen, one of Gainsborough's first patrons at Bath, there is little reason to doubt its authenticity, and this view is supported by the existence of a copy, of the same size as the original, which was formerly on the New York art market. Also mentioned on p. 120.

DATING Closely related to cat. no. 75 in the bushy trees and treatment of the foliage, the fluent outlining of the tree-trunks on the right, which do not melt into the distant glow, the loose handling of the foreground track in short, nervous touches, and the broken impasto in the painting of the sky.

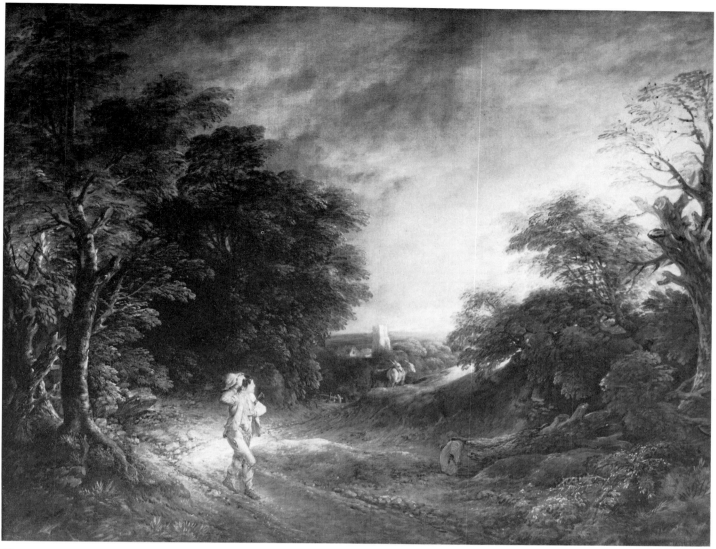

77

## 77 Wooded Landscape with Woodcutter, Donkeys and Distant Church

Canvas. $39\frac{1}{2} \times 50$   100.3 × 127
Painted *c*. 1762–3

Museum of Fine Arts, Houston (61-9)

PROVENANCE Presented by the artist to his physician at Bath, Dr Rice Charlton (1710–89); Charlton sale, Christie's, 5–6 March 1790, 2nd day, lot 91, bt Haraden; Dr Freckleton, 1823; Freckleton sale, Christie's, 1 May 1858, lot 22, bt in; anon. [Mrs Freckleton] sale, Christie's, 12 July 1873, lot 138, bt Cox, from whom it was purchased by William, 1st Earl of Dudley (1817–85); Dudley sale, Christie's, 16 June 1900, lot 39, bt Agnew; with Arthur Tooth, from whom it was purchased by Senator W. A. Clark; Clark sale, American Art Association, New York, 11–12 January 1926, 2nd day, lot 101 (repr.), bt in; Mrs Charles W. Clark, by whom it was bequeathed (in memory of Harry C. Wiess) to the Museum of Fine Arts, Houston, 1969.

EXHIBITIONS 'Paintings, the works of the Old Masters of Various Schools, and of Deceased British Artists, contributed by the Proprietors of most of the Principal Collections in Liverpool and the neighbourhood', Liverpool Royal Institution, 1823 (99); Tate Gallery, 1980–81 (108, repr., p. 106).

BIBLIOGRAPHY Fulcher, p. 235; Armstrong, 1898, p. 205; Armstrong, 1904, p. 286; Menpes and Greig, p. 180; Whitley, pp. 81–2; Waterhouse, no. 899; J. T. [John] Hayes, 'A Turning Point in Style: *Landscape with Woodcutter*', *Museum of Fine Arts, Houston Bulletin*, summer 1973, pp. 25–8, 29, repr. fig. 1, cover (col. detail) and fig. 5 (detail); Hayes, *Drawings*, p. 172; Grand Palais, 1981, p. 107.

The woodcutter, strongly spotlit by the evening light, is the principal subject, but it is characteristic of Gainsborough at this period that, far from presenting him as a noble image in so grand a landscape, he has shown him as a country yokel, in the act of scratching his head, a

78

motif which is found in one of the Sutton pictures (cat. no. 64). The distance is also lowered in emotional key, and thus differs from the distances in the Kilderbee and Tate landscapes (cat. nos 74 and 75), by the presence of the two donkeys. The motif of a single figure on a winding track can be found in Ruisdael, the sombre tonality of whose landscapes was the principal influence on Gainsborough at this time. The dramatic chiaroscuro was the product of the practice of painting by candle-light in a darkened studio which Gainsborough developed in the early 1760s. Several copies of this composition exist, two by Thomas Barker (see pl. 326 and p. 275). Also mentioned on pp. 98–9, 102, 112, 120, 271, 275.

DATING Closely related to cat. nos 74 and 75 in the rhythmical treatment of the foliage, the technique for highlighting the leaves, the fluent modelling of the tree-trunk on the right and the loose handling of the foreground track. The generally subdued tonality, the grey atmospheric sky, the dark-green trees, the handling of the foliage, the very crisp treatment of the brambles in the foreground on the right, and the bushy trees in the middle distance, are also closely related to the background of *Dr Charlton* (Waterhouse, no. 136, pl. 87), not exhibited SA until 1766 but painted *c.* 1763–4: Dr Charlton (see above) was the person for whom this landscape was executed.

## 78  Wooded Landscape with Boy leading a Donkey and Dog, and Extensive Panorama with Buildings and Distant Hills

Canvas. $11\frac{7}{8} \times 13\frac{1}{2}$  $30.2 \times 34.3$
Painted *c.* 1762–4

Private collection, England

INSCRIPTIONS Inscribed on the back of the stretcher in ink in a nineteenth-century hand: *Painted by Gainsborough Given by him to/Anne Vannam Somerville* [?] *Fownes* (the last word difficult to decipher); and on a label: *A.F. Somerville/Dinder House.*

PROVENANCE Presented by the artist to Ann-Vannam Somerville (later Mrs Fownes), of Dinder House, near Wells, Somerset; thence by descent to Commander John Somerville; J. A. F. Somerville sale, Sotheby's, 15 March 1978, lot 119 (repr. col.), bt English private collector.

A small, sketchy landscape, light in tone, in which the Claudean formula of design has been used in a very personal and rhythmical way. The drop from the foreground into the terrain which fills the centre of the composition is unusual in Gainsborough, and may have been suggested by the character of the countryside on the edge of the Cotswolds. The motif of a peasant leading a

blue mountains beyond are very solidly modelled. The motif of the rustic lovers was imitated by William Jackson (see pls 323, 324). Also mentioned on pp. 35, 120, 271

DATING Closely related to cat. no. 77 in the rhythmical treatment of the foliage, the loose modelling of the foreground track, the broken highlighting of the tree-trunk in the foreground, the bluish-green distance and the impasto breaking through the trees from the glowing, sunset sky. The rhythmical handling of the foliage, the particularized treatment of the foreground grass, with many of the tufts painted in touches of red, the deep reddish and dark-green tonality of the right half of the composition and the jewel-like quality of the whole picture are also similar to cat. no. 68, to which it was intended as a companion, though the treatment is far freer throughout.

## 80  Mountainous Wooded Landscape with Horse drinking, Flock of Sheep descending an Incline, Milkmaid crossing a Footbridge and Cows

Canvas. $57\frac{1}{2} \times 62$   146.1 × 157.5
Painted *c.* 1763

Worcester Art Museum, Worcester, Mass. (1919.1)

PROVENANCE Probably Gainsborough Dupont sale, Christie's, 10–11 April 1797, 2nd day, lot 99, bt Sir William Young; William Beckford; Fonthill Abbey sale, Phillips's, 9 September 1823 ff., 27th day (15 October), lot 299; anon. [Peacock] sale, Christie's, 19 May 1832, lot 46**, bt William Scrope; Thomas Todd, Aberdeen, 1857; Todd sale, Foster's, 30 March 1859, lot 32, bt in; Mrs Todd, Inverness; Todd sale, Foster's, 28 April 1869, lot 102, bt for Joseph Gillott; Gillott sale, Christie's, 19 April–4 May 1872, 4th day (27 April), lot 284, bt Cox; with Arthur Tooth, from whom it was purchased by Sir Horatio Davies, 1892; anon. [J. H. Eddy] sale, Christie's, 20 June 1896, lot 95, bt Arthur Tooth, from whom it was purchased by C. P. Taft, Cincinnati, 1902; bought by Knoedler jointly with Scott and Fowles, 1910, from whom it was purchased by G. L. Fischer, 1912; bought back by Knoedler and Scott and Fowles, 1913; Knoedler share sold in 1919 to Scott and Fowles, from whom it was purchased by the Worcester Art Museum, 1919.

EXHIBITIONS Probably SA, 1763 (43); BI, 1832 (115); 'Art Treasures of the United Kingdom', Manchester, 1857 (76); 'Paintings by Thomas Gainsborough, R.A., and J. M. W. Turner, R.A.', Knoedler's, New York, January 1914 (28); 'Panama-Pacific International Exposition', San Francisco, February–December 1915 (2917); 'Eighteenth Century English Painting', Fogg Art Museum, Harvard, 1930 (32); Cincinnati, 1931 (27, repr. pl. 6); 'Landscape Paintings of the Sixteenth to the Twentieth Centuries', Berkshire Museum, Pittsfield, January–July 1937 (18); 'Masterworks of Five Centuries', Golden Gate International Exposition, San Francisco, February–December 1939 (128, repr.); 'The Art of Eighteenth Century England', Smith College Museum of Art, Northampton, Mass., January 1947 (35); Tate Gallery, 1980–81 (110, repr., pp. 27, 106); Grand Palais, 1981 (41, repr., p. 107).

BIBLIOGRAPHY Fulcher, p. 206; M. H. Spielmann, 'A Note on Thomas Gainsborough and Gainsborough Dupont', *The Walpole Society*, vol. v, Oxford, 1917, pp. 98, 107; R. W. [Wyer], 'A Grand Landscape by Thomas Gainsborough', *Bulletin of the Worcester Art Museum*, April 1919, pp. 3–6, repr. p. 4; Walter Heil, 'Die Gainsborough-Ausstellung in Cincinnati', *Pantheon*, September 1931, p. 381; Wylie Sypher, 'Baroque Altarpiece: "The Picturesque"', *Gazette des Beaux Arts*, January 1945, repr. fig. 14; Waterhouse, p. 24, no. 898, repr. pl. 66; Eloise Spaeth, *American Art Museums and Galleries*, New York, 1960, p. 32; John Woodward, *British Painting: A Picture History*, London, 1962, p. 64 (repr.); John Hayes, 'Gainsborough and Rubens', *Apollo*, August 1963, pp. 89–90, repr. figs 1, 3 (detail); John Hayes, 'Gainsborough', *Journal of the Royal Society of Arts*, April 1965, p. 320, repr. fig. 8; John Hayes, 'The Gainsborough Drawings from Barton Grange', *Connoisseur*, February 1966, p. 91; *European Paintings in the Collection of the Worcester Art Museum*, Worcester, Mass., 1974 ('British School' by St John Gore), pp. 27–30, repr. p. 541; Hayes, pp. 210–11, repr. pls 70, 136 (detail); Paulson, p. 247; John Ingamells, 'Thomas Gainsborough', *Burlington Magazine*, November 1980, p. 779; Konstantin Bazarov, *Landscape Painting*, London, 1981, p. 86, repr. col.; Lindsay, pp. 62–3.

This is by far the most freely and vigorously handled landscape Gainsborough had painted so far. The dominant, dark, sombre trees reflect the renewed influence of Ruisdael, while the motif of sheep descending to a watering place may have been inspired by Rubens. Also mentioned on pp. 98–101, 107, 113, 270; details are repr. pls 77, 127, 128.

DATING Closely related to cat. no. 77 in the dark, sombre tonality, the rhythmical treatment of the foliage, the technique for highlighting the leaves, the crisp, spiky highlights in the tree-trunks on the right and elsewhere and the loose handling of the foreground track in quick, nervous touches. The fitful light in the sky, the very free handling of the distance and the treatment of the foliage are also related to the background of *The Byam Family* (pl. 129; Waterhouse, no. 108, pl. 82), painted *c.* 1763–4. Since cat. no. 80 is by far the most ambitious and important landscape Gainsborough painted at this period, there is a strong presumption that this was the 'large landskip' he exhibited at the Society of Artists in 1763 (43).

81

## 81 Hilly Wooded Landscape with Peasant and Dog crossing a Bridge over a Stream

Canvas. $17 \times 24\frac{1}{8}$   $43.2 \times 61.3$
Painted *c.* 1763–4

Mrs E. C. B. Huntington, London

PROVENANCE With Arthur Tooth; Mrs E. C. B. Huntington; Huntington sale, Christie's, 20 November 1964, lot 69, bt in.

Either an unfinished work, or a rough oil sketch for the Jacob picture (cat. no. 82). Since the design has an especially lively Rubensian thrust and counter-thrust, the likeliest explanation is that Gainsborough was trying out a new and vigorous compositional idea but ultimately found it difficult to develop, re-using the material in a more conventional way (see cat. no. 82).

DATING Related to the background of *The Byam Family* (pl. 129; Waterhouse, no. 108, pl. 82), painted *c.* 1763–4, in the freedom of brushwork and the rich lights breaking through the trees. The handling of the tree-trunks and foliage, and the suggestion of the foreground detail, are also related to cat. no. 97, an unfinished work hardly more than laid in.

## 82 Hilly Wooded Landscape with Peasant and Dog crossing a Bridge over a Stream, Milkmaid and Cows

Canvas. $25 \times 30$   $63.5 \times 76.2$
Painted *c.* 1763–4

Private collection, England

PROVENANCE John Jacob (1723–76), of 'The Rocks', near Bath; thence by descent.

EXHIBITIONS Bath, 1951 (10, p. 5); Nottingham, 1962 (14, repr.); Tate Gallery, 1980–81 (111, repr.).

BIBLIOGRAPHY Mary Woodall, 'The Gainsborough Exhibition at Bath', *Burlington Magazine*, August 1951, p. 266; Waterhouse, no. 896, repr. pl. 55; Mary Woodall, 'Gainsborough Landscapes at Nottingham University', *Burlington Magazine*, December 1962, p. 562; John Hayes, 'Gainsborough and Rubens', *Apollo*, August 1963, p. 90.

The uncompleted version of this composition owned by Mrs Huntington (cat. no. 81) is more horizontal in format, and does not contain the motif of the milkmaid and cows in the middle distance. In the present canvas Gainsborough has abandoned the powerful lateral

86

Christie's, 10–12 May 1890, 1st day, lot 18, bt Agnew; William Nicholson, 1909; anon. [Nicholson] sale, Sotheby's, 19 March 1947, lot 157, bt Bernard.

EXHIBITIONS BI, 1841 (101); BI, 1843 (133); GG, 1885 (3); Fine Art Club, Ipswich, 1887 (147).

BIBLIOGRAPHY Fulcher, p. 207; Armstrong, 1898, p. 208; Armstrong, 1904, p. 290; Waterhouse, no. 914.

Although on a small scale, this is one of the grandest— and it is also one of the simplest—compositions Gainsborough had so far painted, a truly classical work, in which the trees seem to fall naturally into a Claudean arrangement. The cows are effectively grouped and placed right in the centre of the canvas; the barn and trees behind are used to give weight to the design, and the foreground branch is appropriately sturdy, completely different in concept from the rococo branch which was entirely suitable in the context of the Mullens picture (cat. no. 83).

DATING Closely related to cat. no. 84 in the handling of the foliage and foreground detail, the broken modelling

of the cows and the rough highlights in the sky, breaking through the trees.

## 86* Wooded Rocky Landscape with Peasants in a Country Waggon and Pool

Canvas. 14 × 11¾  35.6 × 29.8
Painted c. 1765–6

Private collection, United States

PROVENANCE Charles, Viscount Eversley (1794–1888); Eversley sale, Christie's, 9 May 1896, lot 56, bt Agnew; with Howard Young by 1928; with Robert C. Vose, from whom it was purchased by Miss Helen Norton, Montreal, 1931; sold back at her death to Vose Galleries, Boston, about 1969, and purchased from them.

BIBLIOGRAPHY 'Notable Works of Art now on the Market', *Burlington Magazine (Advertisement Supplement)*, December 1969, repr. pl. LXXIV.

Another small canvas in which, as in cat. no. 85,

87

Gainsborough is experimenting with broad and simple forms in the interests of grandeur. In this case the cows have been replaced by a waggon, but the rocks on the left are as strong in emphasis as the foreground branch in the earlier work, the trees are even more dominant, and indeed massive, and the distractions of an elaborately or vividly painted background, characteristic both of the late Suffolk and the early Bath styles, are similarly eliminated. The conception is developed in a definitive form in the St Quintin picture (cat. no. 87), so that this little work is probably, therefore, to be regarded as a try-out for that major exhibited landscape.

DATING Appears to be closely related to cat. no. 85 in the painting of the foreground detail, the sketchy handling on the right, the treatment of the tree-trunks and foliage and the rough impasto in the clouds. The dark, overpowering trees anticipate the mood of cat. no. 87.

## 87 Wooded Landscape with Country Waggon, Milkmaid and Drover

Canvas. 57 × 47    144.8 × 119.4
Painted in 1766

Private collection, England

PROVENANCE Purchased by Sir William St Quintin (1700–70), 1766; thence by descent.

EXHIBITIONS SA, 1766 (53); 'Yorkshire Fine Art & Industrial Exhibition', York, May–November 1879 (507); RA, 1896 (91); 'Picture of the Month', City Art Gallery, Leeds, April 1951; Bath, 1951 (20); 'The First Hundred Years of the Royal Academy 1769–1868', RA, 1951–2 (26); Arts Council, 1953 (31, p. 7); 'Two Centuries of British Painting', British Council, Montreal Museum of Fine Arts, National Gallery of Canada,

Ottawa, Art Gallery of Toronto and Toledo Museum of Art, October 1957–March 1958 (15, repr. p. 104); Tate Gallery, 1980–81 (112, repr.).

BIBLIOGRAPHY Anon., *A Critical Review of the Pictures*, London, 1766, p. 6; Fulcher, p. 185; Armstrong, 1898, p. 207; Armstrong, 1904, p. 283; Algernon Graves, *The Society of Artists of Great Britain 1760–1791*, 1907, p. 98; Menpes and Greig, p. 70; Mary Woodall, 'The Gainsborough Exhibition at Bath', *Burlington Magazine*, August 1951, pp. 265, 266; E. K. Waterhouse, 'The Exhibition "The First Hundred Years of the Royal Academy"', *Burlington Magazine*, February 1952, p. 51, repr. fig. 20; Ellis Waterhouse, *Painting in Britain 1530–1790*, Harmondsworth, 1953, p. 188; Waterhouse, pp. 19, 24, no. 900, repr. pl. 92; John Hayes, 'Gainsborough and Rubens', *Apollo*, August 1963, pp. 90, 91; Hayes, *Drawings*, p. 173; Hayes, pp. 43, 44, 212–13, repr. pl. 71; John Ingamells, 'Thomas Gainsborough', *Burlington Magazine*, November 1980, pp. 779–80; Lindsay, pp. 70, 79.

Gainsborough's preoccupations of this period (see cat. nos 85, 86) came to fruition in this grand landscape, painted for public exhibition in London. As in the Vose landscape (cat. no. 86), the trees are massive and dominating, exceptionally close in mood to Ruisdael, but in this composition they extend across the entire canvas and the distance towards which the waggon is travelling is merely suggested by the sunlight penetrating the recesses of the lane. For this major exhibited work Gainsborough has reintroduced the theme of rustic lovers, transforming it in the process into more of a romantic idyll, and their prominence as subject-matter is emphasized by dramatic lighting. The modelling of the tree-trunks in horizontal strokes and the precise highlighting of the foliage are similar to the technique of the Worcester landscape, painted three years earlier (cat. no. 80). The picture was painted on two canvases joined together. Also mentioned on pp. 102, 104, 120, 181.

DATING The frame of the picture is dated 1766, and the following entry was made by Sir William St Quintin, ancestor of the present owner, in his account book under the year 1766: 'Gainsborough. 1 picture. £43.11.6.' (transcribed from the (now missing) account book by H. Isherwood Kay). This evidence makes it certain that this was the landscape which Gainsborough sent up to the Society of Artists in 1766, as no other picture datable to the 1760s fits the contemporary comments on no. 53. Horace Walpole noted in his catalogue, 'A milkmaid and clown', and an anonymous reviewer wrote, 'In this picture there is much to be commended, the figures are in a fine taste, the cart-horses and fore-ground are extremely fine and well painted, but the trees are too blue and hard' (anon., *A Critical Review of the Pictures*, London, 1766, p. 6).

## 88 Wooded Landscape with Peasants in a Country Waggon, Drover holding a Horse while a Woman is helped in, and Distant Hill (The Harvest Waggon).

Canvas. $47\frac{1}{2} \times 57$   120.7 × 144.8
Painted in 1767

Barber Institute of Fine Arts, Birmingham

ENGRAVINGS Engraved by Edward Finden, and published by T. G. March, 28 November 1843; mezzotinted by Richard Josey, 1876.

PROVENANCE Reputed to have been painted at Shockerwick Park, near Bath (see below); presented by the artist to Walter Wiltshire, 1774 (Wiltshire's son to J. H. Anderdon, 1841, quoted Whitley, p. 40); John Wiltshire sale, Christie's, 25 May 1867, lot 126 (as painted at Shockerwick), bt Davis for Sir Dudley Marjoribanks (later Lord Tweedmouth (1820–94)); sold privately to Sir Samuel Montagu (later Lord Swaythling (1832–1911)), 1904; Swaythling sale, Christie's, 12 July 1946, lot 20 (repr.), bt Barber Institute.

EXHIBITIONS SA, 1767 (61); BI, 1814 (37); RA, 1880 (140); GG, 1885 (33); RA, 1896 (94); 'Loan Collection and Exhibits in the British Royal Pavilion', Paris Exhibition, 1900 (63); RA, 1907 (109); 'Old English Masters', Königliche Akademie der Künste, Berlin, 1908 (64) (*Illustrated Souvenir*, 20, repr.); 'Aeldre Engelsk Künst', Ny Carlsberg Glyptotek, Copenhagen, 1908 (7); 'British Empire Exhibition', Palace of Arts, Wembley, 1924 (v. 28; repr. p. 36 in the *Illustrated Souvenir*); Ipswich, 1927 (55); 'Meisterwerke Englische Malerei aus Drei Jahrhunderten', Secession, Vienna, September–November 1927 (24); 'Exposition Rétrospective de Peinture Anglaise (XVIII$^e$ et XIX$^e$ Siècles)', Musée Moderne, Brussels, October–December 1929 (64); 'British Art', RA, 1934 (332); 'Cinque Siècles d'Art', Exposition Universelle et Internationale de Bruxelles, May–October 1935 (1109; repr. pl. CCXL in the *Illustrated Souvenir*); Sassoon, 1936 (100; repr. *Souvenir*, pl. 21); 'Old Masters from Hampshire Houses', Winchester College, June–July 1938 (21); 'La Peinture Anglaise XVIII$^e$ & XIX$^e$ Siècles', Louvre, Paris, 1938 (49; repr. *Souvenir*); Arts Council, 1953 (32, p. 7, repr. pl. IX); 'Europäisches Rokoko', Residenz, Munich, June–October 1958 (65); 'Royal Academy of Arts Bicentenary Exhibition 1768–1968', RA, 1968 (142); 'Landscape in Britain c. 1750–1850', Tate Gallery, November 1973–February 1974 (57, repr.); Grand Palais, 1981 (42, repr. pp. 38, 39, 41).

BIBLIOGRAPHY Anon., *A Critical Examination of the Pictures*, London, 1767, p. 9; Allan Cunningham, *The Lives of the most eminent British Painters, Sculptors, and Architects*, London, vol. 1, 1829, pp. 330–31; Edward and William Finden, *Royal Gallery of British Art*, n.d., unpaginated, engr. facing text; Fulcher, pp. 70–71, 199; John Timbs, *Anecdote Biography*, London 1860, p. 162; J.

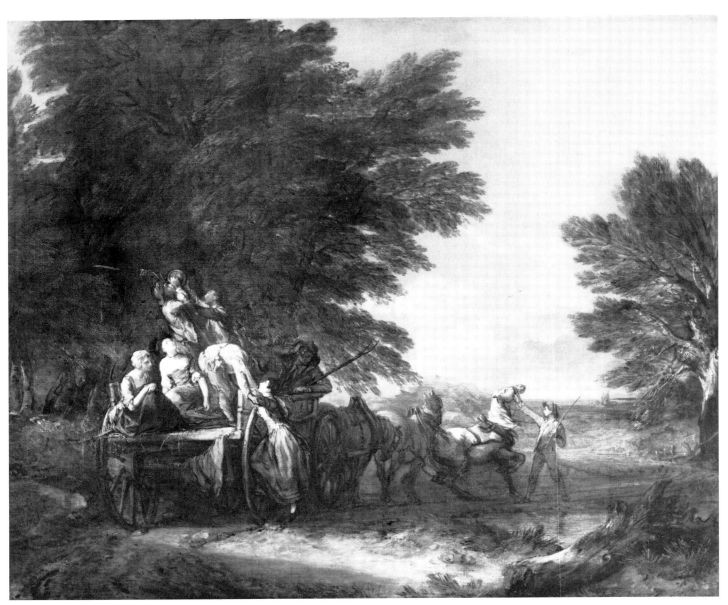

88

Beavington-Atkinson, 'Thomas Gainsborough' (article in Robert Dohme, *Kunst und Künstler des Mittelalters und der Neuzeit*, Leipzig, vol. 6, 1880), p. 42; *Engravings from the Works of Thomas Gainsborough, R.A.*, Henry Graves & Company, London, n.d. [*c.* 1880], no. 117; George M. Brock-Arnold, *Gainsborough*, London, 1881, p. 34; William Martin Conway, *The Artistic Development of Reynolds and Gainsborough*, London, 1886, pp. 54, 82–3; Armstrong, 1894, pp. 32, 60, 82; Bell, pp. 66–7, 122, repr. facing p. 64; Armstrong, 1898, pp. 114, 118, 208; Georges Lafenestre, 'La Peinture Ancienne à l'Exposition Universelle', *Gazette des Beaux-Arts*, December 1900, p. 560; Mrs Arthur Bell, *Thomas Gainsborough, R.A.*, London, 1902, pp. 9, 55; Gower, pp. 52, 113, 127, repr. facing p. 58; Chamberlain, pp. 78, 158; Armstrong, 1904, pp. 151, 156, 157, 283; A. E. Fletcher, *Thomas Gainsborough , R.A.*, London, 1904, pp. 82, 88, 93, 98; Boulton, pp. 95, 141–2, 153;

Armstrong, 1906, pp. 82, 204; Algernon Graves, *The Society of Artists of Great Britain 1760–1791*, 1907, p. 98; Menpes and Greig, pp. 80, 90, 95, 174; Myra Reynolds, *The Treatment of Nature in English Poetry*, Chicago, 1909, p. 306; *Art Journal*, March 1911, repr. p. 96; Whitley, pp. 40, 50–51; E. Rimbault Dibdin, *Thomas Gainsborough*, London, 1923, p. 85; R. H. Wilenski, 'The Gainsborough Bicentenary Exhibition', *Apollo*, November 1927, p. 195; William T. Whitley, *Artists and their Friends in England 1700–1799*, London, 1928, vol. II, p. 65; Charles Johnson, *English Painting from the Seventh Century to the Present Day*, London, 1932, pp. 130, 133, 134, repr. facing p. 134; C. H. Collins Baker, *British Painting*, London, 1933, p. 151; R. H. Wilenski, *English Painting*, London, 1933, pp. 115–6; Herbert Read, 'English Art', *Burlington Magazine*, December 1933, repr. pl. VIIIB; Charles Johnson, *A Short Account of British Painting*, London, 1934, p. 55; *Royal Academy of Arts*

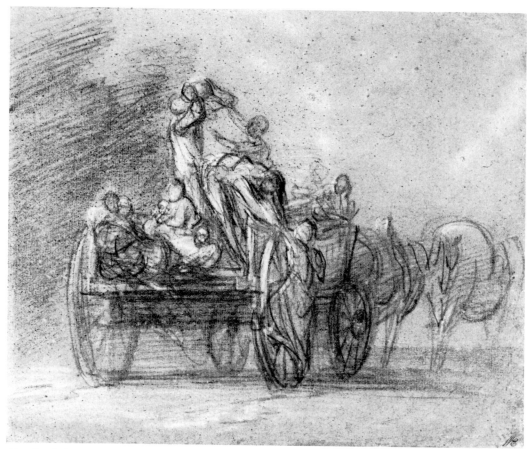

**88a** Study for cat. no. 88. Black and white chalks on grey-blue paper. $9\frac{13}{16} \times 11\frac{1}{4}$ / 24.9 × 28.6. Private collection, London.

*Commemorative Catalogue of the Exhibition of British Art, 1934*, Oxford, 1935, no. 192, repr. pl. LXIII (bottom); E. K. Waterhouse, 'Gainsborough in Park Lane: Exhibition at Sir Philip Sassoon's', *Connoisseur*, March 1936, p. 124; Woodall, *Drawings*, pp. 17, 20, 44–8, 49, 54–5, 56, 57, 61, 72, 110, repr. pl. 40; Millar, pp. 9–10, repr. pl. 25; Woodall, pp. 68, 91–3, 95, repr. facing p. 80 (col.); Mary Woodall, 'The Gainsborough Exhibition at Bath', *Burlington Magazine*, August 1951, p. 266; E. K. Waterhouse, 'The Exhibition "The First Hundred Years of the Royal Academy"', *Burlington Magazine*, February 1952, p. 51; *Catalogue of the Paintings, Drawings and Miniatures in the Barber Institute of Fine Arts*, Cambridge, 1952, pp. 38–9, repr. p. 41; Ernest Short, *A history of British painting*, London, 1953, p. 172; Ellis Waterhouse, *Painting in Britain 1530–1790*, Harmondsworth, 1953, pp. 188–9, 231, repr. pl. 154; David Piper, 'Gainsborough at the Tate Gallery', *Burlington Magazine*, July 1953, p. 246; C. H. Collins Baker, 'The Kennedy Memorial Gallery', *Connoisseur*, October 1954, p. 140; Waterhouse, pp. 24, 34, 40, no. 907, repr. pl. 99; Mary Woodall, 'Gainsborough Landscapes at Nottingham University', *Burlington Magazine*, December 1962, p. 562; Woodall, *Letters*, repr. facing p. 112 (detail); John Hayes, 'Gainsborough and Rubens', *Apollo*, August 1963, pp. 92, 94, repr. fig. 5 (detail); Hayes, *Drawings*, pp. 38, 175, 205, 297, 300, repr. pl. 330; Mary Webster,

*Francis Wheatley*, London, 1970, pp. 14, 118, repr. fig. 11; William Gaunt, *The Great Century of British Painting: Hogarth to Turner*, London, 1971, repr. pl. 56; Jean-Jacques Mayoux, *La Peinture Anglaise de Hogarth aux Préraphaélites*, Geneva, 1972, pp. 71–2, repr. p. 72 (col.); Herrmann, pp. 96–7, 103, 104, 117, repr. pl. XII (col.); Hayes, pp. 43, 213, repr. pls 77, 80 (detail); Paulson, p. 247; David Coombs, *Sport and the Countryside*, Oxford, 1978, p. 49, repr.; Marcia Pointon, 'Gainsborough and the Landscape of Retirement', *Art History*, vol. 2, no. 4, December 1979, p. 453; John Barrell, *The Dark Side of the Landscape*, Cambridge, 1980, pp. 59–62, 64, 69, 70, 109, repr. pp. 59, 60 (detail); Tate Gallery, 1980–81, p. 27; Dillian Gordon, *Second Sight: Rubens: The Watering Place/ Gainsborough: The Watering Place*, National Gallery, London, p. 18, repr. fig. 21; Lindsay, pp. 79, 86, 120, 187; Ellis Waterhouse, *The Dictionary of British 18th Century Painters*, Woodbridge, 1981, p. 138; Michael Rosenthal, *English Landscape Painting*, Oxford, 1982, pp. 58, 68, 82–6, repr. pl. 62.

A study from nature of a waggon related closely both in type and in the viewpoint chosen is in the possession of Lord Knutsford (Hayes, *Drawings*, no. 824). A sketch for the figure composition is owned by an English private collector (88a; Hayes, *Drawings*, no. 825). In the finished picture the figure group is more closely

integrated and the pyramidal structure more clearly emphasized: the group on the left is replaced by two women only, of whom the girl on the right is looking upwards towards the two men—one of whom is holding a rake—who are fighting for the cider jar. The figure in the front of the waggon, who is looking over his shoulder away from the principal group, is holding a hay fork, an implement which links compositionally with the tree-trunks that fan out behind. X-ray photographs kindly taken by Mlle Hours at the Laboratoire de Recherche at the Louvre show that no alterations were made in the figure group in the course of execution (there are some slight pentimenti in the trees left and upper right). A small drawing, in which the figure grouping is closely related to *The Harvest Waggon*, but probably executed some ten years later, is in the British Museum (Hayes, *Drawings*, no.417). The motif of the harvest waggon occurs in Rubens's *The Return from the Fields* in the Pitti Palace, but in this the waggon is empty and the peasants are on foot. There is no reason to believe, as John Barrell suggests (*op.cit.*), that the subject represents a group of peasants *en route* for the annual harvest celebration rather than the return from the fields: it has been noted above that the two men are carrying farm implements. The figure composition is the most elaborate Gainsborough had ever attempted, and is clearly derived from his study of Rubens's *The Descent from the Cross* (pl.136). The exceptionally brilliant and vigorous treatment of the foremost horse, held in check by the bridle, is also a passage worthy of Rubens. There is a tradition that Gainsborough used his daughters as models (Finden, cited above), and this is supported by the visual evidence (pl.137): the girl being helped into the waggon is clearly identifiable as Margaret (compare Waterhouse, no.280, repr. pl.153), while the girl looking upwards is probably (though less certainly) Mary (compare Waterhouse, no.289, repr. pl.175, and, for a more relevant pose, no.286, repr. pl.51). Other figures in the group also give the impression of being portraits, and this is what one might expect in such a composition. The motif of the peasant scratching his head had appeared in the Sutton and Houston pictures (cat. nos 64, 77). The docile grey horse is traditionally the horse that Gainsborough rode at Shockerwick, and which was given to him by Walter Wiltshire (Whitley, cited above). As in the picture exhibited at the Society of Artists in the previous year (cat. no.87), the trees form a massive foil to the subject-matter, and the figures are spotlit; but the lighter treatment of the foliage on the right of the main group of trees and the inclusion of the trees on the right introduce a Claudean element into the design and the palette is wholly different, high instead of low in key. The distance and hills are very freely painted. The familiar branch fills up the right foreground. A reduced grisaille copy is in the Metropolitan Museum (46.13.1). Also mentioned on pp. 24, 102–4, 107, 110, 112, 120, 123, 145, 151, 158, 237, 238, 280, 291; details are repr. pls 133, 137, 217.

DATING No other landscape painted before 1774, the date of its presentation to Walter Wiltshire, fits Horace Walpole's note on SA, 1767 (61): 'This landscape is very rich, the group of figures delightfully managed, and the horses well drawn, the distant hill is one tint too dark' (Algernon Graves, *The Society of Artists of Great Britain*, London, 1907, p. 98). An anonymous reviewer commented, 'The trees are hard, and the sky too blue' (anon., *A Critical Examination of the Pictures*, London, 1767, p. 9). Supporting evidence that *The Harvest Waggon* was a publicly exhibited picture comes from the fact that Francis Wheatley used the composition for a picture of his own dated 1774, now in the Nottingham City Art Gallery (pl. 27). With regard to dating, however, the evidence of a copy in chalks sold at Sotheby's, 27 July 1960, lot 56, should be taken into account; this drawing is inscribed: *Tho Gainsborough 1771*, and thus suggests the possibility that, unless it is a much later work, which is probable, it was done from a picture exhibited that year. Neither of Gainsborough's landscape exhibits of 1771 has been identified; we know that they were much admired and that, at the time of their execution, the artist thought them 'the best I ever did'. A tradition has long existed that *The Harvest Waggon* was exhibited in 1771 (see under Henry J. Pfungst sale, Christie's, 15 June 1917, lot 61). If *The Harvest Waggon* could be established as RA, 1771, it is likely that its companion, the Camrose picture (cat. no. 113), was the other work exhibited that year.

## 89 Wooded Landscape with Mounted Peasants and Pack-horse returning from Market and Cows at a Pool

Canvas. $47\frac{3}{4} \times 67$    121.3 × 170.2
Painted *c.* 1767–8

Toledo Museum of Art, Toledo, Ohio (55.22)

ENGRAVING Engraved by Francesco Bartolozzi as *Peasants going to Market*, and published by Colnaghi, 1 August 1802.

PROVENANCE Commissioned in the 1760s by William, Lord Shelburne (later 1st Marquess of Lansdowne (1737–1805)), for the drawing-room at Bowood (see Britton and Warner, cited below); Lansdowne sale, Coxe's, 25 February 1806, lot 105; Edward Jeffries Esdaile (1785–1867), Cothelestone House, Somerset; by descent to Colonel William Esdaile; with Edward Speelman, from whom it was purchased by the Toledo Museum of Art, 1955.

EXHIBITIONS RA, 1887 (147); 'Royal Academy of Arts Bicentenary Exhibition 1768–1968', RA, 1968 (146); Tate Gallery, 1980–81 (113, repr. and col. detail p. 113, p. 27); Grand Palais, 1981 (43, repr., pp. 41–2, 50).

BIBLIOGRAPHY Anon. [John Britton], *The Beauties of Wiltshire*, vol. 2, London, 1801, p. 218; Rev. Richard Warner, *Excursions from Bath*, Bath, 1801, p. 216; Armstrong, 1898, p.205; Armstrong, 1904, p.286; *Connoisseur*, November 1955, repr. p. 209; Waterhouse, p. 24, no.906, repr. pl.98; anon., 'How carefully do you

89

look?' *Museum News*, Toledo Museum of Art, winter 1961, p. 21 (repr.), detail repr. p. 5; John Woodward, 'Wilkie's Portrait of Esdaile', *Burlington Magazine*, March 1962, p. 117; John Hayes, 'Gainsborough and Rubens', *Apollo*, August 1963, pp. 91, 96, repr. fig. 4 and cover (detail); John Hayes, 'Gainsborough', *Journal of the Royal Society of Arts*, April 1965, pp. 320–21, 324, repr. figs 9, 10 (detail); John Hayes, 'British Patrons and Landscape Painting 5. The Encouragement of British Art', *Apollo*, November 1967, p. 358, repr. fig. 1; Hayes, *Drawings*, p. 175; Herrmann, p. 97; J. T. [John] Hayes, 'A Turning Point in Style: *Landscape with Woodcutter*', *Museum of Fine Arts, Houston Bulletin*, summer 1973, pp. 26, 28, repr. fig. 3; Hayes, pp. 36, 213, repr. pls 73, 72 (col. detail); *European Paintings*, Toledo Museum of Art, Toledo, Ohio, 1976, p. 61, repr. pl. 316; Marcia Pointon, 'Gainsborough and the Landscape of Retirement', *Art History*, vol. 2, no. 4, December 1979, p. 451, repr. pl. 41; John Barrell, *The Dark Side of the Landscape*, Cambridge, 1980, pp. 53–4; John Ingamells, 'Thomas Gainsborough', *Burlington Magazine*, November 1980, p. 780; Michael Kitson, 'Gainsborough Observed', *Apollo*, November 1980, p. 352; Lindsay, pp. 84, 94; Ellis Waterhouse, *The Dictionary of British 18th Century Painters*, Woodbridge, 1981, p. 138; Lindsay Stainton, 'Gainsborough and his Patrons', *Antique Collector*, January 1981, p. 35 (repr.); Michael Rosenthal, *English Landscape Painting*, Oxford, 1982, pp. 58, 68, repr. pl. 61.

This picture was among five works by contemporary British artists which were noted in 1801 as hanging in the drawing-room at Bowood, a room decorated by Cipriani. According to John Britton (cited above), 'Three of these pieces were painted at the request of the Marquis [Lord Shelburne], with a particular injunction that each artist would exert himself to produce his *chef d'oeuvre*, as they were intended to lay the *foundation of a school of British landscapes*'. As the Gainsborough was one of the more important of the five works (the others were by Wilson, Barret, Deane and Pocock) and described as 'a capital Performance' in the 1806 sale catalogue, it may be presumed that it was one of the three to which Britton referred. The influence of Rubens is evident throughout, both in handling and in the richness of colour: even the tree-trunks are modelled in the most varied tints (blues, lilacs, yellows, oranges and reds), contrasting sharply with those in the St Quintin picture of a year or two earlier (cat. no. 87). The

90

massive trees which give grandeur to the figure subject are even more rhythmically disposed than in *The Harvest Waggon* (cat. no. 88), forming a majestic arc. This is the first appearance in Gainsborough of the subject of peasants travelling to, or returning from, market, which was to become one of the artist's favourite themes. The girl with the basket of eggs is an attractive and sophisticated type, like the milkmaid in the St Quintin picture, and henceforward this remains the case with most of the peasant girls whose role in Gainsborough's designs is of any prominence. It is not entirely clear why the rustic has doffed his hat, but the motif introduces a note of clownish romance consonant with the tradition of John Gay's popular pastoral, *The Shepherd's Week*. Also mentioned on pp. 104, 110, 112, 115, 120, 125, 134; details are repr. pls 134, 135.

DATING Closely related to cat. no. 88 in the pale-blue tints used in the sky, the rich, broken modelling of the tree-trunk on the left, the rough modelling of the tree-trunks in the centre, the clear outlining and the high-

lighting of the horses and figures, the strongly lit foreground and the sketchily painted distance; but there is a much richer variety of tones in the modelling of the forms, and the horizon is painted in a far more broken and vigorous impasto. The rough, broken dabs of creamy impasto at the horizon, the modelling of the tree-trunk on the left, and the fresh green tonality are also closely related to the background of *Lord Vernon* in the Southampton Art Gallery (Waterhouse, no. 693, pl. 97), exhibited at the Society of Artists in 1767.

## 90 Open Landscape with Herdsman, his Sweetheart and a Herd of Cows

Canvas. $50\frac{3}{8} \times 39$    $128 \times 99$
Painted *c*. 1767–8

National Gallery of Ireland, Dublin (796)

PROVENANCE Carl Friedrich Abel (1725–87); Abel sale, Greenwood's, 13 December 1787, lot 45; John Crosdill (1751–1825), by 1814; by descent through General

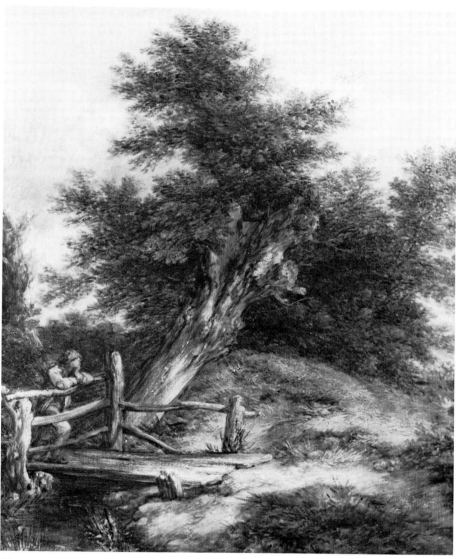

91

Thoyts to Mrs Hautenville Cope; anon. [Cope] sale, Christie's, 6 May 1910, lot 93, bt Sir Hugh Lane (1875–1915), who sold it to Arthur M. Grenfell; Grenfell sale, Christie's, 26 June 1914, lot 45 (repr.), again bt Sir Hugh Lane, by whom it was bequeathed to the National Gallery of Ireland, 1918.

EXHIBITIONS BI, 1814 (14); RA, 1876 (29); GG, 1885 (77); Fine Art Club, Ipswich, 1887 (136); 'Pictures by Old Masters given and bequeathed to the National Gallery of Ireland by the late Sir Hugh Lane', National Gallery of Ireland, Dublin, 1918 (32); 'Thomas Gainsborough Bicentenary Exhibition', National Gallery of Ireland, Dublin, 1927; Nottingham, 1962 (16); Grand Palais, 1981 (44, repr.).

BIBLIOGRAPHY Anon. [William Hazlitt], 'On Gainsborough's Pictures', Champion, 31 July 1814, p. 247; William Hazlitt, Criticisms on Art, London, 1943, p. 194 (note) (quoted from his article in the Champion, op. cit.); Fulcher, p. 197; William Martin Conway, The Artistic

Development of Reynolds and Gainsborough, London, 1886, p. 94; Armstrong, 1898, p. 208; Armstrong, 1904, p. 290; Catalogue of Pictures in the National Gallery of Ireland, Dublin, 1928, no. 796, p. 44; Waterhouse, no. 909, pl. 93; Stephen Reiss, Aelbert Cuyp, London, 1975, pp. 11, 109, repr. p. 11.

The pastoral subject-matter is closely related to the Wells picture (cat. no. 85), but in this work figures are included, there are eight cows instead of only three, the principal cow is conceived in monumental terms and the composition is much grander, the supporting trees being replaced by clouds which take up the baroque diagonal of the cattle. As has been pointed out by Stephen Reiss (cited above), the composition was evidently inspired by the Cuyp now in the Fitzwilliam Museum (pl. 142), which was in the possession of William Wells of Redleaf by 1834 (see under Master Paintings, Agnew's, May–July 1975 (15)), or by a similar picture by that artist; even the usual repoussoir log or branch is replaced by Cuyp's plants and thistles. The herdsman with his arm round the

peasant girl is not depicted as a youthful swain but as an older man. A small copy is in the National Museum of Wales, Cardiff. Also mentioned on pp. 112, 114, 135.

DATING Closely related to cat. no. 89 in the richly built up impasto in the lights of the clouds, the rough, broken modelling of the tree-trunk, employing varied tints of red, pink, lilac, yellow and grey, the soft handling of the foliage, the rough, loose highlighting of the cows, the modelling of the figures and the fresh green tonality.

## 91 Wooded Landscape with Peasant at a Stile

Oak panel. 14 × 12   35.6 × 30.5
Painted *c*. 1767–8

Private collection, Great Britain

ENGRAVING Engraved by James Stow, and published by him as in the collection of James Hamilton, 21 November 1796.

PROVENANCE Presented by the artist, after being entranced by his playing of the violin, to Colonel James Hamilton (1746–1804), whose daughter, Lucy, married General Robert Anstruther (1768–1809); thence by descent.

EXHIBITIONS Fine Art Club, Ipswich, 1887 (179); Nottingham, 1962 (17).

BIBLIOGRAPHY John Thomas Smith, *Nollekens and his Times*, London, 1828, vol. I, p. 184; Allan Cunningham, *The Lives of the most eminent British Painters, Sculptors, and Architects*, London, vol. I, 1829, p. 340; Fulcher, pp. 136, 152; John Timbs, *Anecdote Biography*, London, 1860, p. 169; William Sandby, *The History of the Royal Academy of Arts*, London, 1862, vol. I, p. 111; Richard and Samuel Redgrave, *A Century of Painters of the English School*, London, 1866, vol. I, p. 166; George M. Brock-Arnold, *Gainsborough*, London, 1881, pp. 45, 49, 52; Armstrong, 1894, pp. 36, 70, 73; Mrs Arthur Bell, *Thomas Gainsborough, R.A.*, London, 1902, p. 23; Gower, p. 87; Armstrong, 1904, pp. 181, 206–7; Armstrong, 1906, pp. 90, 175, 178; Gabriel Mourey, *Gainsborough*, Paris, n.d. [1906], p. 67; Whitley, p. 365, repr. facing; Hugh Stokes, *Thomas Gainsborough*, London, 1925, p. 126; Woodall, *Drawings*, p. 79; Waterhouse, no. 889; Hayes, *Drawings*, p. 278.

Though the picture is quite small, the composition has force and grandeur, and takes up the baroque diagonals of the Dublin picture (cat. no. 90): the vigorous, sloping tree stump is close in character to those in the sketch in the possession of Mrs Huntington (cat. no. 81), which were never developed, and demonstrates how, under the influence of Rubens, Gainsborough now felt more confident in the use of such bold motifs. It is worth recalling here Gainsborough's letter to William Jackson of 11 May 1768: 'Pray do you remember carrying me to a Picture dealers somewhere by Hanover Square, and my being struck with the leaving and touch of a little bit

of Tree' (Woodall, *Letters*, no. 54, p. 109). The peasant resting against a stile is an unusual motif, and gives the impression of having been observed from life. A copy, made from the engraving (see above), was formerly on the London art market.

DATING Identical with cat. no. 90 in the fresh handling of the foliage, the rich modelling of the tree stump in tones of pink and orange, the use of thick, dragged impasto and the motif of the sloping stump silhouetted against a clump of bushy trees.

## 92* Wooded Landscape with Sportsmen, Hounds and Cottages (The Return from Shooting) (after Teniers)

Canvas. 45 × 59   114.3 × 150
Painted *c*. 1768–71

Private collection, England

PROVENANCE Perhaps Gainsborough Dupont sale, Christie's, 10–11 April 1797, 2nd day, lot 17 (with two others), bt Hammond; William Smith, 1814; John Allnutt, 1843; Allnutt sale, Christie's, 18–20 June 1863, 3rd day (20 June), lot 485, bt in; with Rutley, from whom it was purchased by Edward Wheler Mills, before 1865; by descent to Brigadier R. J. Cooper; Cooper sale, Christie's, 12 December 1947, lot 3, bt Leggatt; with Jetley, 1957; anon. [W. Middleton] sale, Christie's, 25 November 1960, lot 70 (repr.), bt in.

EXHIBITIONS BI, 1814 (15); BI, 1843 (181); BI, 1859 (160); RA, 1886 (73); 'Spring Picture Exhibition', Whitechapel Art Gallery, March–April 1908 (47); 'Counterfeits, Imitations and Copies of Works of Art', Burlington Fine Arts Club, London, 1924 (22); 'Pictures by T. Gainsborough, R.A.', Agnew's, June–July 1928 (21); 'Annual Exhibition of English Landscapes and other Important Pictures', Leggatt's, 1948 (30, repr. col.); 'English Painters 1700–1850', Leggatt's, 1951 (21, repr. col.).

BIBLIOGRAPHY Anon. [William Hazlitt], 'On Gainsborough's Pictures', *Champion*, 31 July 1814, p. 247; William Hazlitt, *Criticisms on Art*, London, 1843, p. 194 (note) (quoted from his article in the *Champion*, op. cit.); Fulcher, pp. 197, 207; M. H. Spielmann, 'A Note on Thomas Gainsborough and Gainsborough Dupont', *The Walpole Society*, vol. V, Oxford, 1917, pp. 98, 105; Woodall, *Drawings*, p. 21; Waterhouse, no. 1029; John Hayes, 'Gainsborough and Rubens', *Apollo*, August 1963, p. 90; Tate Gallery, 1980–81, p. 26; Grand Palais, 1981, p. 39.

A faithful copy, in size, composition, handling and tone, executed, as Hazlitt says (cited above), 'with much taste and feeling', of the Teniers in the Earl of Radnor's collection at Longford Castle (92a), where Gainsborough would have seen it: the superlative quality of the original, fully revealed once more since its

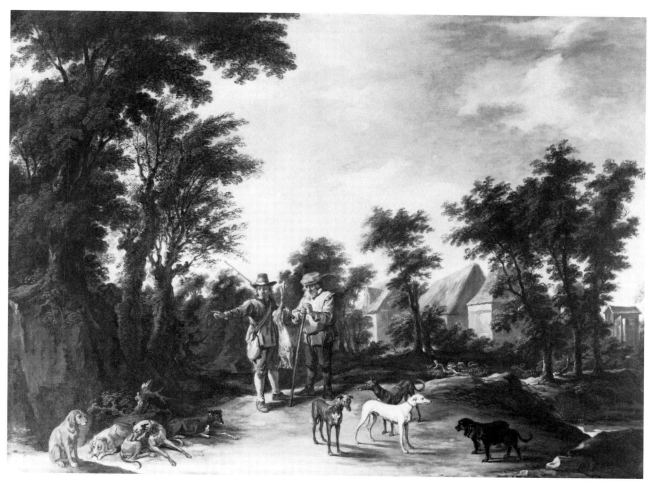

92

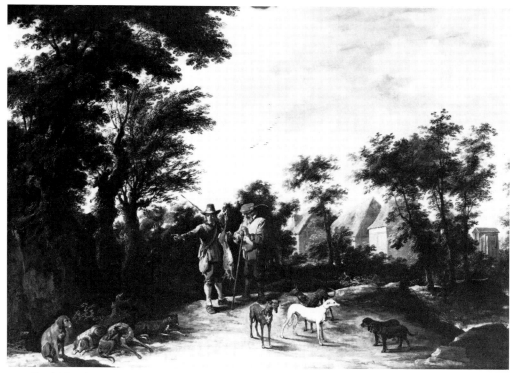

**92a** David Teniers the Younger (1610–90): *The Return from Shooting*. Canvas.
$45\frac{1}{2} \times 60\frac{1}{2}$ / 115.6 × 153.7. The Earl of Radnor, Longford Castle.

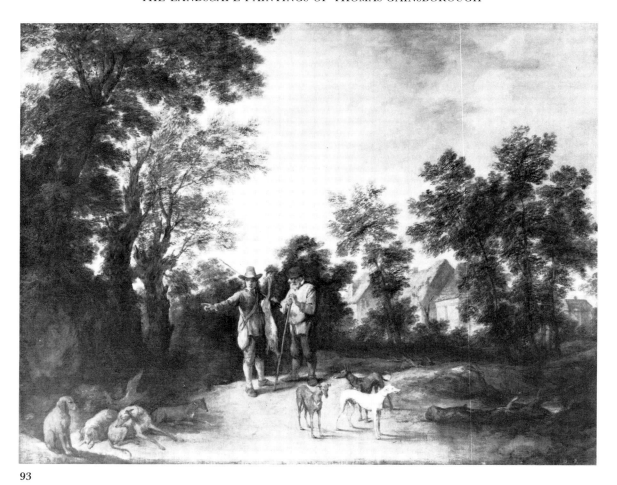

93

recent cleaning, amply explains Gainsborough's enthusiasm. Also mentioned on pp. 108, 115.

DATING Appears to be related to cat. no. 89 in the rough, broken modelling of the tree-trunks on the left, the bright, yellowish impasto breaking through the branches and the soft handling of the foliage. Gainsborough painted a half-length of William, 1st Earl of Radnor, in 1770 (Waterhouse, no. 569, pl. 121)—his first portrait of a member of the Radnor family—and it seems likely that he made the copy at this time.

## 93 Wooded Landscape with Sportsmen, Hounds and Cottages (The Return from Shooting) (after Teniers)

Canvas. $46\frac{1}{8} \times 57\frac{7}{8}$   $117 \times 147$
Painted c. 1768–71

National Gallery of Ireland, Dublin (668)

PROVENANCE Joshua Kirby (1716–74); by descent to the Rev. Henry Scott Trimmer; Trimmer sale, Christie's, 17 March 1860, lot 93*, bt Rutley; John Clark; Clark sale, Christie's, 8 June 1895, lot 95, bt Lawrie; T. G. Arthur, Glasgow, 1904; Arthur sale, Christie's, 20 March 1914, lot 146, bt Lane; presented by Sir Hugh Lane (1875–1915) to the National Gallery of Ireland, 1914.

EXHIBITIONS 'Pictures by Old Masters given and bequeathed to the National Gallery of Ireland by the late Sir Hugh Lane', National Gallery of Ireland, Dublin, 1918 (27); 'Thomas Gainsborough Bicentenary Exhibition', National Gallery of Ireland, Dublin, 1927.

BIBLIOGRAPHY Armstrong, 1898, p. 204; Armstrong, 1904, p. 285; anon., 'Recent Additions to the Dublin Gallery—11', *Burlington Magazine*, November 1918, pp. 179–80, repr. p. 183; *Catalogue of Pictures in the National Gallery of Ireland*, Dublin, 1928, no. 668, p. 44; Woodall, *Drawings*, pp. 20–21, repr. pl. 13; Waterhouse, no. 1030; John Hayes, 'Gainsborough and Rubens', *Apollo*, August 1963, p. 90; Tate Gallery, 1980–81, p. 26; Grand Palais, 1981, p. 39.

A full-scale variant of the Teniers at Longford Castle (cat. no. 92), but this time executed in Gainsborough's own style and in the fresh tonality characteristic of his work at this period. The two dogs on the right have been replaced by a log. Also mentioned on pp. 108, 115.

DATING Closely related to cat. no. 89 in the fresh green tonality, the slender branches, the soft, fluid painting of the foliage and the precise outlining but loose highlighting of the animals and figures. The spiky treatment of the foliage anticipates cat. no. 94.

94

**94 Extensive Wooded River Landscape with Fishing Party in a Boat, Peasant crossing a Footbridge, Cows watering, and Distant Shepherd with Flock of Sheep, Sailing Boats and Church Tower (View near King's Bromley-on-Trent, Staffordshire)**

Canvas. $46\frac{1}{4} \times 66\frac{1}{4}$   117.5 × 168.3
Painted *c*. 1768–71

Philadelphia Museum of Art, Philadelphia (E′24-3-6)

PROVENANCE Painted to Samuel Newton (died 1783), of King's Bromley, Staffordshire (see below); by descent in the Lane family; Mrs John Lane, 1829; John Newton Lane, 1854; William Delafield; Delafield sale, Christie's, 30 April 1870, lot 88 (as 'VIEW NEAR KING'S BROMLEY, ON TRENT . . . *A chef d'oeuvre painted for the family of John Newton Lane, Esq.*'), bt Agnew for Richard Hemming; Hemming sale, Christie's, 28 April 1894, lot 82, bt Agnew, from whom it was purchased by William L. Elkins, Philadelphia, 1894; bequeathed by George W. Elkins to the Philadelphia Museum of Art, 1924.

EXHIBITIONS BI, 1854 (146); 'Paintings in the Elkins Gallery', Philadelphia Museum of Art, 1925 (19); 'Condition: Excellent', Worcester Art Museum, Mass., March–April 1951 (14); 'British Painting in the Eighteenth Century', British Council, Montreal Museum of Fine Arts, National Gallery of Canada, Ottawa, Art Gallery of Toronto and Toledo Museum of Art, October 1957–March 1958 (16, repr. p. 107); 'Royal Academy of Arts Bicentenary Exhibition 1768–1968', RA, 1968 (144).

BIBLIOGRAPHY J. P. Neale, *Views of The Seats of Noblemen and Gentlemen*, 2nd Series, vol. IV, London, 1828 (unpaginated); Jones's *Views of the Seats, Mansions, Castles, etc. of Noblemen and Gentlemen*, London, 1829, vol. II (unpaginated); Fulcher, p. 208; Armstrong, 1898, p. 205; *Catalogue of Paintings in the Private Collection of W. L. Elkins*, pt. II, London, 1901, no. 62, repr. facing; Armstrong, 1904, p. 284; *Catalogue of Paintings in the Elkins Gallery*, Philadelphia Museum of Art, 1925 (no. 19); 'The New Museum of Art Inaugural Exhibition', *Pennsylvania Museum Bulletin*, March 1928, p. 19; Waterhouse, p. 30, no. 945, repr. pl. 122; John Hayes, 'Gainsborough and Rubens', *Apollo*, August 1963, p. 92, repr. fig. 7; Hayes, *Drawings*, p. 168; Herrmann, p. 97,

repr. pl. 90; Allen Staley, 'British Painting from Hogarth to Alma-Tadema', *Apollo*, July 1974, repr. fig. 3; Hayes, p. 213, repr. pl. 74 (col.); Paulson, p. 247; Lindsay, p. 94; Ellis Waterhouse, *The Dictionary of British 18th Century Painters*, Woodbridge, 1981, repr. p. 138; Richard Dorment, *Catalogue of the English Paintings in the Philadelphia Museum of Art* (forthcoming).

This canvas is an unusual, and most revealing, example of Gainsborough combining his predilection for Rubens with the depiction of an actual view (see also cat. no. 146, where he painted a scene in the Lake District in terms of Rubensian rhythm). Since its sale at Christie's in 1870 the picture had been known as a view near King's Bromley-on-Trent, in Staffordshire, and the original owner's house and property were indeed at King's Bromley. These facts have been discounted because of Gainsborough's strongly expressed letter to Lord Hardwicke of *c.* 1764 concerning his disinclination ever to paint views, and erroneous descriptions of such landscapes as that now at Yale (cat. no. 108) as 'A VIEW IN SHROPSHIRE.' But Richard Dorment (cited above) has now established beyond question that the canvas does represent King's Bromley. The view is taken from about half a mile upstream, on the south side of the Trent, the position of the north terrace of Samuel Newton's property; the tower of All Saints church is roughly accurate (the pinnacles were added in 1870) and seen from the right angle, though the nave should be visible and the church is too near the river. Gainsborough has, however, exaggerated the width of the Trent, and inserted sailing vessels which it would not have been possible to use on the river. The trees, of course, are now quite different, and the footbridge was doubtless an addition. It is not known how Gainsborough knew Samuel Newton (wrongly cited as 'Lane' on pp. 96, 120), whose ancestor had bought King's Bromley in 1670; and the portraits he painted of Mr and Mrs Newton (listed in Neale, cited above) are untraced. The most attractive hypothesis is that he first visited his patron in the company of a mutual friend—possibly in the course of a visit to the Unwins, in Derbyshire, we know from his letters he was planning to make at this time—and was excited by the possibility of the scene from the terrace as the basis for a painting. The topography would have been distorted to accord with his conception in the course of working up his sketches in the studio. X-ray photographs, kindly taken specially, show that the cow behind the principal tree, which plays an important part in the composition, was added as an afterthought; otherwise nothing in the design was altered during the course of execution. The marked lateral emphases and Rubensian movement and counter-movement which dominate the canvas develop to the full the ideas first adumbrated in the sketch owned by Mrs Huntington (cat. no. 81). The depth of ground-plan, characteristic of Ruben's landscapes, is unusual for Gainsborough, and was inspired by the topography of the scene. Though the feeling for light and distant haze

are also Rubensian qualities, the treatment of the foliage and the palish tone leave the spectator with a strong impression of Teniers's influence. The inclusion of rustic lovers in a group in a fishing-boat is a motif Gainsborough did not repeat; the carefree theme of the picnic party gives added poignancy to the beautiful effects of light. The peasant crossing the footbridge is visually unrelated to the main group and seems an unnecessary addition; in fact, however, a footbridge in precisely this position occurs in a drawing of the early 1760s (Hayes, *Drawings*, no. 257, pl. 384) which may have been at the back of Gainsborough's mind when he composed this picture for, down to the group of cows in the middle-ground, it anticipates the design to an extraordinary degree. Also mentioned on pp. 96, 110, 112, 120, 238.

DATING Closely related to the drawings presented to Lord Bateman in September 1770 (Hayes, *Drawings*, nos 299, 312, 316, 325, pls 103, 108, 112) in the predominating slender, sturdy trees and soft, bushy foliage. Identical with cat. no. 89 in the fresh, light tonality, the pale tints used in the sky, the very rough, broken impasto in the handling of the clouds, the modelling of the sturdy tree-trunks, the fresh, soft handling of the bushy foliage, the loose highlighting of the cows, the spiky painting of the foreground rushes, the sketchy handling of the distance and the motifs of the cow drinking and of the church tower seen between trees. There is, however, little trace of the rich variety of colour used in the modelling of many of the forms in cat. no. 89.

## 95  Wooded Landscape with Peasant Children, Mounted Peasants and Pack-horses going to Market, Figures by the Wayside, and Distant Cottage with Family outside the Door and nearby Flock of Sheep

Canvas. $47 \times 57\frac{1}{2}$   $119.4 \times 146.1$
Painted *c.* 1768–71

Iveagh Bequest, Kenwood, London

PROVENANCE Painted for John, 2nd Viscount Bateman (d. 1802); thence by descent through William Hanbury, of Kelmarsh Hall (later 1st Baron Bateman, 1780–1845); sold by William, 2nd Lord Bateman (1826–1901); with Agnew, from whom it was purchased in 1888 by Sir Edward Guinness (later 1st Earl of Iveagh, 1847–1927), by whom it was bequeathed, 1928.

EXHIBITIONS BI, 1814 (116*); RA, 1881 (42); GG, 1885 (68); RA, 1903 (6); 'Pictures from the Iveagh Bequest', City Art Gallery, Manchester, April–June 1928 (55); 'Works by Late Members of the Royal Academy and of the Iveagh Bequest of Works by Old Masters (Kenwood Collection)', RA, winter 1928 (199); 'Engelse land-schapschilders van Gainsborough tot Turner', Boymans Museum, Rotterdam, 1955 (36, repr.); 'Englische Malerei der grossen Zeit von Hogarth bis Turner', Wallraf-Richartz Museum, Cologne, and Palazzo Venezia, Rome, October–December 1966, (18, repr.);

95

'English Landscape Painting of the 18th and 19th Centuries', National Museum of Western Art, Tokyo, and Kyoto National Museum of Modern Art, Kyoto, October 1970–January 1971 (20, repr.).

BIBLIOGRAPHY J. P. Neale, *Views of The Seats of Noblemen and Gentlemen*, vol. III, London, 1820 (unpaginated); William Martin Conway, *The Artistic Development of Reynolds and Gainsborough*, London, 1886, p. 85; Bell, p. 80; Armstrong, 1898, pp. 114, 206; Armstrong, 1904, pp. 151, 283; Boulton, p. 180; Sir Charles Holmes, *Pictures from the Iveagh Bequest and Collections*, London, 1928, no. 3, p. 4, repr. pl. 11; Woodall, *Drawings*, p. 55; Woodall, p. 93, repr. p. 95; Waterhouse, no. 912, repr. pl. 114; Mary Woodall, 'Gainsborough Landscapes at Nottingham University', *Burlington Magazine*, December 1962, p. 562; Gatt, p. 30, repr. pls 30–31 (col.); *Catalogue of the Paintings*, Iveagh Bequest, Kenwood, Greater London Council, rev. ed., 1972, no. 3, p. 13, repr. pl. VI; Herrmann, p. 97, repr. pl. 89; British Museum, 1978, p. 20; John Barrell, *The Dark Side of the Landscape*, Cambridge, 1980, pp. 53–4; Grand Palais, 1981, p. 46, detail repr. fig. 43.

Gainsborough presented a group of drawings to Lord Bateman in September 1770, and this landscape may have been painted at that time. The theme is closely related to the Toledo landscape (cat. no. 89), but the grouping of the figures and horses is subtler, the composition more gently rhythmical and the whole concept infinitely more poetic. The transitions in the sky are among passages of exceptional delicacy and beauty. The motif of a family grouped outside a cottage door, which subsequently became one of Gainsborough's principal themes, makes its first appearance in this picture, albeit in the background. The foliage, painted in short, spiky touches, is strongly influenced by Teniers, and not since the Kilderbee landscape (cat. no. 74) has a

96

single tree so dominated a composition. In 1821 the picture hung in the saloon at Kelmarsh Hall, and the drawings were in the billiard room (Neale, cited above). Also mentioned on pp. 110, 115–16, 120, 132, 150–51, 285; details are repr. pls 147, 185.

DATING Closely related to cat. no. 94 in the pale-blue tints used in the sky, the sensitive effects of light at the horizon, the firm modelling of the figures, the handling of the foliage in short, spiky touches, the treatment of the foreground rushes and the pale, sketchy distance.

### 96 Wooded Landscape with Drover and Two Cows, Shepherd and Flock of Sheep, Pool and Mansion among Trees

Canvas. $47\frac{1}{2} \times 57\frac{1}{2}$   120.7 × 146.1
Painted $c.$ 1768–71

Estate of the late A. C. J. Wall

PROVENANCE E. Pleydell Bouverie; Bouverie sale, Christie's, 22 February 1890, lot 127, bt Agnew; anon. [A. Fraser & Co.] sale, Christie's, 20 May 1920, lot 71, bt Leger; with Leggatt, from whom it was purchased by Victor Rienaecker, $c.$ 1920; with Colnaghi, 1937; with

Partridge, from whom it was purchased by A. C. J. Wall, 1938; Trustees of the late A. C. J. Wall sale, Christie's, 20 November 1970, lot 212 (repr.), bt in; Trustees of the late A. C. J. Wall sale, Christie's, 21 June 1974, lot 98 (repr.), bt in.

EXHIBITIONS Ashmolean Museum, Oxford, 1924; 'English Masters', New York, 1925; 'Centenary Exhibition', Castle Museum, Norwich, 1925; Ipswich, 1927 (47); 'Pictures and other Objects of Art', Burlington Fine Arts Club, winter 1932–3 (77); Sassoon, 1936 (130, repr. *Souvenir*, pl. 63b); Norwich, 1952.

BIBLIOGRAPHY R. H. Wilenski, 'The Gainsborough Bicentenary Exhibition', *Apollo*, November 1927, p. 195; Charles Johnson, *English Painting from the Seventh Century to the Present Day*, London, 1932, p. 131; Woodall, *Drawings*, pp. 52–3, repr. pl. 57; Waterhouse, no. 989.

A large landscape which Gainsborough left unfinished; the trees on the left, for example, are only very broadly modelled in fluid brushstrokes over a thinly painted dead-colour laid in on top of the red priming. The drover and cows were outlined after the completion of the landscape design. This canvas marks the first appearance of the country mansion as a motif; Gains-

97

borough took up the theme again in the Perret picture (cat. no. 116) and in a number of drawings executed in the early 1780s. The architecture of the house is extremely improbable, and it is clear that Gainsborough was only interested in its elements from the point of view of pictorial design. The foreground branch echoes the rhythms of the composition.

DATING Related to cat. no. 95 in the strongly rhythmical design, the compositional use of the motif of the log in the foreground and the fresh tonality. The broken impasto in the sky, the loose handling of the foliage, the banks, and the animals, and the motif of the country mansion set among trees are also related to the landscape depicted on the wall in the background of *The Cruttenden Sisters* (pl. 148; Waterhouse, no. 174), painted in the late 1760s.

## 97 Wooded Landscape with Herdsman, Cattle watering and Tall Building

Canvas. $16\frac{3}{4} \times 21\frac{3}{8}$  42.5 × 54.3
Painted *c*. 1768–71

Tate Gallery, London (1825)

PROVENANCE Henry Vaughan, by whom it was bequeathed to the National Gallery, 1900; transferred to the Tate Gallery, 1962.

EXHIBITION Ipswich, 1927 (48).

BIBLIOGRAPHY Pauli, repr. pl. 76; Millar, p. 10, repr. pl. 6 (col.); Basil Taylor, *Gainsborough*, London, 1951, p. 8, repr. pl. 3 (col.); Waterhouse, no. 990; Martin Davies, *The British School*, National Gallery, London, 2nd ed., rev., 1959, p. 39.

A small unfinished canvas in which the curious structure masking the distance is more closely related to the Gaspardesque characteristic of so many of Gainsborough's drawings of the mid-1780s than to the type of country mansion represented in the Wall picture (cat. no. 96). Also mentioned on p. 132.

DATING Identical with the landscape in the background of *The Cruttenden Sisters* (pl. 148; Waterhouse, no. 174), painted in the late 1760s, in the broken impasto in the sky, the handling of the foliage, the banks, and the cows, and the motif of the country mansion.

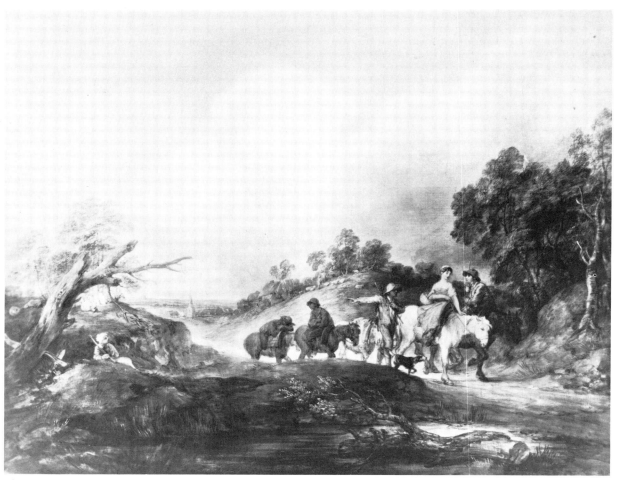

98

## 98 Wooded Landscape with Drover, Mounted Peasants and Pack-horse returning from Market, Shepherds and Flocks of Sheep on Banks, Cottages and Distant Church

Canvas. 40 × 50   101.6 × 127
Painted *c*. 1771–2

Cincinnati Art Museum, Cincinnati (1946.110)

PROVENANCE  The Rev. John Lucy (1790–1874), Charle-cote Park, Warwick; Lucy sale, Christie's, 1 May 1875, lot 42, bt Rose for William, 1st Earl of Dudley (1817–85); anon. [Dudley] sale, Christie's, 13 July 1923, lot 128, bt Sulley; with Scott and Fowles, New York, 1926; purchased by Miss Mary Hanna by 1931; presented by her to the Cincinnati Art Museum, 1946.

EXHIBITIONS Cincinnati, 1931 (31, pp. 12–13, repr. pl. 32 and p. 5, detail); 'British Painting', Birmingham Museum of Art, Alabama, January–February 1957; 'Masterpieces: A Memorial Exhibition for Adele R. Levy', Wildenstein's, New York, April–May 1961 (23, repr.).

BIBLIOGRAPHY Armstrong, 1898, p. 207; Armstrong, 1904, p. 289; W. H. S. [Siple], 'The Reopening of the Museum', *Bulletin of the Cincinnati Art Museum*, January 1930, p. 10, repr. p. 8; Walter H. Siple, 'The Gainsborough Exhibition held in May', *Bulletin of the Cincinnati Art Museum*, July 1931, p. 76, repr. p. 92; 'The Gainsborough Exhibition in Cincinnati', *Burlington Magazine*, August 1931, p. 86; Walter Heil, 'Die Gainsborough-Ausstellung in Cincinnati', *Pantheon*, September 1931, pp. 70, 384, repr. p. 381; Waterhouse, no. 947, pl. 178; Hayes, *Drawings*, p. 278; John Hayes, 'A Galaxy of Gainsboroughs', *Apollo*, April 1971, pp. 293–4, 296, repr. figs 3, 11 (detail).

The composition is based on a strong diagonal, emphasized by the lighting; the clouds are more broadly conceived and less broken in handling than in earlier landscapes. The Claudean idea of a figure pointing out some feature of beauty in the distance makes its first appearance in Gainsborough in this picture, though, as in Berchem, the motif is used here quite prosaically and without the poetic intentions of Claude. There is a pentimento in the head of the peasant girl, which was originally painted a little higher and to the left and in a frontal pose.

DATING Closely related to the background of *Lady Margaret Fordyce* (Waterhouse, no. 265, pl. 136), exhibited at the Royal Academy in 1772, in the wiry, sturdy

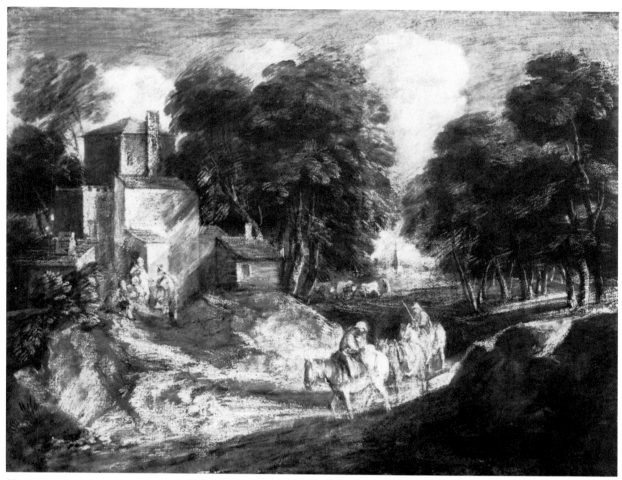

**99**

trees, the modelling of the tree-trunks, the spiky handling of the foliage and the strong lighting. The loose handling of the banks and foreground detail, the motif of the log in the foreground and the rhythmical composition are also closely related to cat. nos 96 and 97, though the tonality is generally a warm brownish-red.

### 99 Wooded Landscape with Mounted Peasants and Pack-horse, Drover and Cattle, Farmhouse with Figures outside, and Distant Church Spire

Paper mounted on canvas. $39\frac{1}{2} \times 50\frac{3}{8}$   $100.3 \times 128$
Painted *c.* 1771–2

Indianapolis Museum of Art, Indianapolis (54.99)

PROVENANCE A. Sanderson; Baron Cassell van Doorn; Albert K. Schneider; N. J. Estate [Schneider] sale, Parke-Bernet's, New York, 14 October 1953 (72, repr.); with Agnew; with Julius Weitzner, New York; Mrs Nicholas H. Noyes, by whom it was presented to the Indianapolis Museum of Art, 1954.

EXHIBITION Perhaps RA, 1772 (98 or 99).

BIBLIOGRAPHY Armstrong, 1898, p. 207; Armstrong, 1904, p. 289; W. D. Peat, 'A Gainsborough Landscape in Gouache', *Bulletin of the Art Association of Indianapolis*, October 1955, pp. 32–4 (repr.); *A Catalogue of European Paintings*, Indianapolis Museum of Art, 1970, p. 139, repr. p. 138.

This composition is executed in watercolour and oil on six sheets of paper pasted together and varnished. Gainsborough was concerned at this date with giving his drawings in mixed media the force of oil paintings, and in developing strong effects of chiaroscuro, as in the Cincinnati landscape (cat. no. 98). In this and the Faringdon picture (cat. no. 102) he joined several pieces of paper together to see how effective his use of mixed media would be on a large scale. The white hatching in the foliage is related to the spiky touch of the Kenwood landscape (cat. no. 95). The curiously shaped house on the left is reminiscent of the building in the unfinished picture in the Tate Gallery (cat. no. 97), but is more closely integrated with the subject-matter. Also mentioned on p. 114.

DATING Closely related to cat. no. 98 in the wiry, sturdy tree-trunks, the spiky highlighting of the bushy foliage, the loose treatment of the warm reddish-brown foreground, the broadly painted but rather shapeless clouds and the strong lighting.

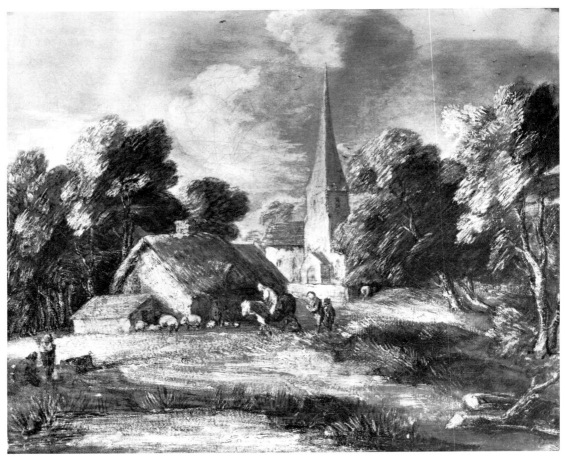

100

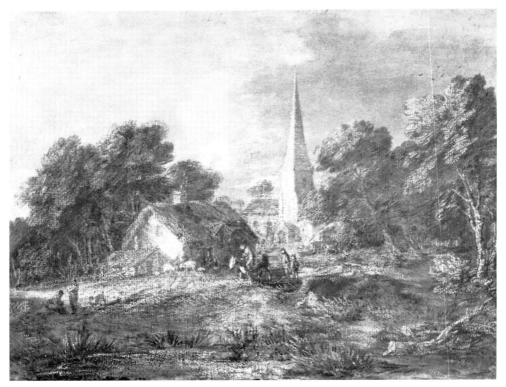

**100a** Finished drawing related to cat. no. 100. Watercolour and oil on reddish-brown toned paper, varnished and mounted on canvas. $16\frac{3}{8} \times 21\frac{1}{8}$ / $41.6 \times 53.7$. Private collection, London.

**101**

## 100  Wooded Village Scene with Mounted Peasant, Figures and Animals

Canvas. $16\frac{1}{4} \times 19\frac{7}{16}$   41.3 × 49.4
Painted *c.* 1771–2

Yale Center for British Art (Paul Mellon Collection), New Haven (965)

PROVENANCE Edward, 3rd Lord Doverdale (1904–49), Westwood Park, Droitwich; with Spink, 1952; with John Nicholson, New York, 1958; John E. Green; with Hirschl and Adler, New York; with Jeremy Maas, from whom it was purchased by Mr and Mrs Paul Mellon, 1963; presented to the Yale Center, 1976.

The composition is identical with a varnished drawing in mixed media formerly in the collection of Mrs D. A. Williamson (100a; Hayes, *Drawings*, no. 347), which is of roughly the same date, and is the same size. There are weak passages, such as in the proportions and perspective of the church, that are not present in the varnished drawing, and these give one pause. Technically, however, the picture seems to belong with the others in this group (cat. nos 99–104), notably cat. no. 103, though it is undoubtedly the most unsatisfactory. The existence of the two versions of this subject underlines Gainsborough's preoccupation at this period with experiments in a variety of techniques by means of which he could develop his effects; both versions are comparatively pale in tonality, and the thick, dragged impasto used in the present canvas should be contrasted with the drier oil employed in the Indianapolis landscape (cat. no. 99). This is the first village scene in Gainsborough's landscape paintings, but the theme, which clearly derives from Teniers, had already been developed in drawings (Hayes, *Drawings*, no 318, pl. 111); the tall spires in this and other paintings of this period are also more likely to be derived from Teniers than from actual churches in the West Country.

DATING Closely related to cat. no. 99 in the wiry, sturdy tree-trunks, the handling of the foliage, the highlighting and strong chiaroscuro and the broad treatment of the clouds. The highlighting of the foliage is also closely related to cat. no. 103.

## 101  Wooded Village Scene with Drovers and Cattle

Paper, mounted on canvas. $24\frac{1}{2} \times 29\frac{3}{8}$   62.2 × 74.6
Painted *c.* 1771–2

Yale Center for British Art (Paul Mellon Collection), New Haven (413)

PROVENANCE W. M. de Zoete, 1927; Michael Bevan; with John Nicholson, New York, 1958; with Jeremy Maas, from whom it was purchased by Mr and Mrs Paul

445

102

Mellon, May 1962; presented to the Yale Center, 1976.

EXHIBITIONS Ipswich, 1927 (43); 'English Pictures', Summer Exhibition, Leggatt's, 1956 (36); 'Painting in England 1700–1850: Collection of Mr and Mrs Paul Mellon', Virginia Museum of Fine Arts, Richmond, 1963 (35, repr.); 'Painting in England 1700–1850: From the collection of Mr and Mrs Paul Mellon', RA, 1964–5 (50).

Painted on two pieces of paper mounted on canvas. A strong, reddish-brown preparation has been used as a priming; the forms are outlined in black chalk, their shapes blocked out with washes, and the highlights executed in a dryish oil. The chiaroscuro is as bold as that in the Indianapolis landscape (cat. no. 99), and far more effective in disposition. The village scene is more developed than in the smaller canvas at Yale (cat. no. 100), and Gainsborough has incorporated the motif of a herdsman driving cattle, familiar from his drawings of this period (compare Hayes, *Drawings*, no. 312, pl. 108).

DATING Closely related to cat. no. 99 in the wiry, slender tree-trunks, the spiky highlighting of the bushy foliage and the broken modelling of the cows and banks. The rough treatment of the threatening grey clouds is related to cat. no. 100.

## 102  Rocky Wooded Landscape with Drovers and Cattle

Paper, mounted on board. $39\frac{1}{2} \times 49$  $100.3 \times 124.5$
Painted *c.* 1771–2

National Trust, Buscot Park (Faringdon Collection)

PROVENANCE S. Herman de Zoete; de Zoete sale, Christie's, 8–9 May 1885, 1st day, lot 177, bt Colnaghi; Walter de Zoete sale, Christie's, 5 April 1935, lot 76 (repr.), bt Leggatt, from whom it was purchased by Gavin, 2nd Lord Faringdon (1902–76); passed to the Trustees of the Faringdon Collection, 1962.

EXHIBITIONS Perhaps RA, 1772 (98 or 99); Sassoon, 1936 (76) (repr. *Souvenir*, pl. 63a); 'British Country Life through the Centuries', 39 Grosvenor Square, June 1937 (284) (repr. *Illustrated Souvenir*, pl. 168); Arts Council, 1949 (20); 'Gainsborough Drawings', Arts Council, November 1960–February 1961 (22).

BIBLIOGRAPHY Waterhouse, no. 926; St John Gore, 'Buscot Park: The English Pictures', *Connoisseur*, January 1966, repr. p. 3; Hayes, *Drawings*, pp. 169, 188; *The Faringdon Collection: Buscot Park*, 1975, no. 16, p. 10, repr. pl. 11a.

This composition is executed in watercolour and oil,

103

varnished, on six sheets of brown tinted paper pasted together (compare cat. no. 99). It is not an unfinished lay-in, as described in the catalogue of the Sassoon exhibition (cited above). The key is basically subdued, and the picture has a truth of tone lacking in the other more powerful works in this group; the chiaroscuro is marvellously controlled and the shepherd and girl riding side-saddle, silhouetted in the pass, are exquisitely lit. Also mentioned on p. 114.

DATING Closely related to cat. no. 99 in the roughly modelled, wiry tree-trunks, the handling of the spiky highlights in the foliage and the broken modelling of the cows and rocks.

## 103  Rocky Wooded Landscape with Rustic Lovers, Drover and Cattle

Canvas. 40 × 50   101.6 × 127
Painted c. 1771–2

Count Theo Rossi di Montilera, Cap d'Ail

PROVENANCE Reputed to have been purchased by the Rev. Thomas Case-Morewood, Thetford; by descent to R. C. A. Palmer-Morewood; Mrs Palmer-Morewood sale, Christie's, 22 November 1968, lot 99 (repr.), bt

Bernard; with Arthur Tooth, 1969; anon. sale, Sotheby's, 27 June 1973, lot 51 (repr. col.), bt Marlborough Fine Art, from whom it was purchased by Count Theo Rossi di Montilera.

EXHIBITION 'Some Masterpieces of 18th Century Painters in England', Marshall Spink's, June–July 1951; Arts Council, 1953 (38, repr. pl. XIII).

BIBLIOGRAPHY David Piper, 'Gainsborough at the Tate Gallery', *Burlington Magazine*, July 1953, p. 246; Waterhouse, p. 24, no. 925, repr. pl. 135; Hayes, *Drawings*, p. 188.

This canvas is dominated by powerful effects of light and by a rich, juicy use of paint, with loaded impasto in the strongly lit rock and in the clouds, and encrusted highlights in the foliage. The cows returning home are conceived in an unusual, loose double diagonal, into which the figures on the left are drawn. A copy, of the same size as the original, was formerly on the London art market. Also mentioned on p. 114.

DATING Closely related to cat. no. 99 in the wiry, sturdy tree-trunks, the highlighting of the foliage, the broad treatment of the rather shapeless clouds and the strong chiaroscuro. The loaded impasto in the highlights is closely related to cat. no. 100.

104

## 104  Wooded Village Scene with Mounted Peasants, Horses, Figures and Pigs

Canvas. 42 × 54   106.7 × 137.2
Painted *c.* 1771–2

Private collection, England

PROVENANCE Probably William Sharp of Fulham (1729–1820), surgeon to George III, one of whose daughters married T. J. Lloyd-Baker; thence by descent.

EXHIBITIONS 'Pictures Lent by Owners Resident in the County', Guildhall, Gloucester, May–June 1934 (24); Nottingham, 1962 (19); 'English Landscape Painting of the 18th and 19th Centuries', National Museum of Western Art, Tokyo, and Kyoto National Museum of Modern Art, Kyoto, October 1970–January 1971 (21, repr.); 'The Painter's Eye', Gainsborough's House, Sudbury, June 1977 (15, repr.).

BIBLIOGRAPHY Waterhouse, p. 24, no. 924, repr. pl. 134; Hayes, *Drawings*, pp. 188, 191; John Barrell, *The Dark Side of the Landscape*, Cambridge, 1980, pp. 64–5, repr. p. 64.

A variation of the village scene in the Mellon Collection (cat. no. 101), in which the cottages are seen closer to, the clouds echo the shapes of the tree and the herdsman

and cattle travelling down an incline towards the right are replaced by peasants and horses descending in the opposite direction; the disposition of the buildings is perhaps more natural and the detail more lively. As in all these village scenes, the composition is strongly lit from the left, and the view into the distance is masked. The canvas is executed in a fairly washy technique over the pinkish priming, with encrusted and dragged impasto in the highlights. The white horse, which is less integrated into the composition than any of the other components and thus attracts particular attention, has affinities with the horse modelled by Gainsborough from which plaster casts were subsequently made, the one surviving originally being owned by Constable (see the catalogue of the exhibition, 'Landscape in Britain *c.* 1750–1850', Tate Gallery, 1973, no. 58, repr.). Gainsborough had used a white horse as the principal subject of one of his landscapes some fifteen years earlier (see cat. no. 63). Also mentioned on pp. 115, 128.

DATING Identical with cat. no. 103 in the broad treatment of the clouds in thick, white impasto, the rough modelling of the wiry tree-trunks, the handling of the foliage in varied tones of green and brown—with thick impasted highlights applied in spiky touches—the soft painting of the pinkish and reddish rocks, the roughly painted figures and the strong, rather harsh lighting.

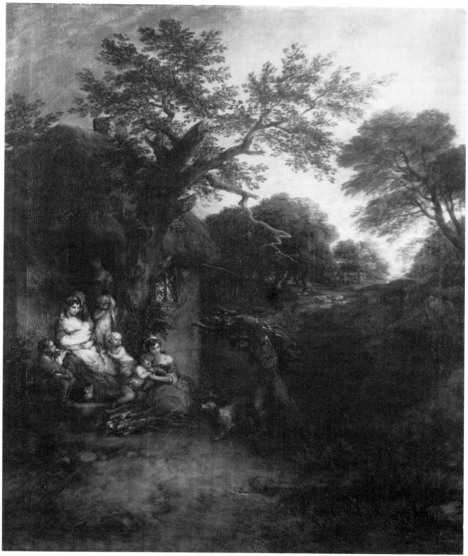

105

## 105  Wooded Landscape with Family grouped outside a Cottage, Woodcutter returning, and Flock of Sheep (The Woodcutter's Return)

Canvas. 58 × 48½  147.3 × 123.2
Painted *c.* 1772–3

Duke of Rutland, Belvoir Castle

PROVENANCE Purchased from the artist by Charles, 4th Duke of Rutland (1754–87); thence by descent.

EXHIBITIONS RA, 1889 (179); 'Loan Collection of Pictures and Drawings by J. M. W. Turner RA and of a Selection of Pictures by some of his Contemporaries', Corporation of London Art Gallery, 1899 (169, pp. 135–6); RA, 1906 (95); Sassoon, 1936 (29, repr. *Souvenir*, pl. 56); 'The First Hundred Years of the Royal Academy 1769–1868', RA, 1951–2 (90, wrongly as RA, 1782 (166)); 'A Hundred Years of British Landscape Painting, 1750–1850', Leicester Museums and Art Gallery, 1956 (9).

BIBLIOGRAPHY *Gentleman's Magazine*, December 1773, p. 614; *Morning Herald*, 25 August 1789; J. P. Neale, *Views of The Seats of Noblemen and Gentlemen*, London, vol. II, 1819 (unpaginated); Jones's *Views of the Seats, Mansions, Castles, etc. of Noblemen and Gentlemen*, London, 1829, vol. I (unpaginated); Rev. Irvin Eller, *The History of Belvoir Castle*, London, 1841, p. 209; Dr Waagen, *Treasures of Art in Great Britain*, London, 1854, vol. III, p. 399; Fulcher, p. 231; Armstrong, 1898, p. 207 (listed twice); Gower, p. 118, repr. facing p. 90; Lady Victoria Manners, 'Notes on the Pictures at Belvoir Castle', Part II, *Connoisseur*, July 1903, repr. facing p. 131, and Part III, *Connoisseur*, September 1903, p. 13; Armstrong, 1904, p. 289 (listed twice); Whitley, pp. 94, 185–6, 332; Woodall, *Drawings*, p. 64; Woodall, pp. 100–102; Mary Woodall, 'A Gainsborough Cottage Door', *Connoisseur*, October 1954, p. 110; Waterhouse, pp. 19, 31, 32, 33 (wrongly as RA, 1782), no. 960, repr. pl. 227; John Hayes, 'Gainsborough's Later Landscapes', *Apollo*, July 1964, p. 21; Jonathan Mayne, 'Thomas Gainsborough's

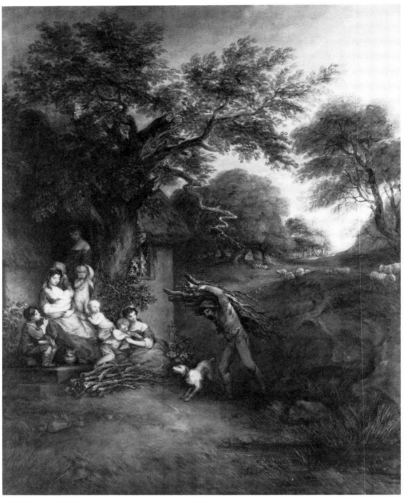

**106**

Exhibition Box', *Victoria and Albert Museum Bulletin*, vol. I, no. 3, July 1965, p. 21; Hayes, pp. 36, 44, 217, repr. pl. 114; British Museum, 1978, p. 22 (wrongly as 1782); John Barrell, *The Dark Side of the Landscape*, Cambridge, 1980, p. 70, repr. p. 72; Tate Gallery, 1980–81, p. 27, repr. fig. 8; Grand Palais, 1981, p. 46, repr. fig. 44; Lindsay, pp. 114, 150 (wrongly as 1782).

This is the first of Gainsborough's 'Cottage Door' compositions; the theme continued to haunt his imagination for the rest of his life. The figures are linked in a well-contrived compositional flow and are carefully and solidly modelled, the woman with a baby in her arms is emphasized by spotlighting, and the smaller children look like putti who have escaped from a Correggio altarpiece; the scene is essentially artificial and the sentiment is heightened by the rich sunset effect and the encrusted impasto, reminiscent of later Constable, of the reflections in the diamond window-panes. The principal tree seems to be rooted in the very doorstep of the cottage. The picture painted for Giardini (cat. no. 106) is an exact repetition executed by Gainsborough himself. Also mentioned on pp. 110, 120, 151, 153, 155, 181.

DATING Almost certainly the landscape with a cottage, a 'scene of beauty, and domestic love', purchased by a noble lord, mentioned in an anonymous poem of December 1773: the picture fits this date on stylistic grounds, none of Gainsborough's other 'Cottage Door' scenes were painted as early, and there is no reason to assume that the Duke of Rutland, who, it was reported, 'laid about him, like a dragon to buy pictures', should only have begun purchasing works of art after his succession to the title in 1779. Related to the background of *Master John Heathcote* (Waterhouse, no. 358, pl. 148), painted in 1772–3, in the rich, broken yellow-brown impasto in the sky, the handling of the foliage and the spiky treatment of the foreground grass. The encrusted impasto in the lights of the sky at the horizon, the handling of the foliage on the right in soft, spiky touches, the soft treatment of the foreground, the bushy trees in the middle ground, the firmly modelled heads of the figures and the pretty, sophisticated type used for the girl on the right of the group are also related to cat. no. 107.

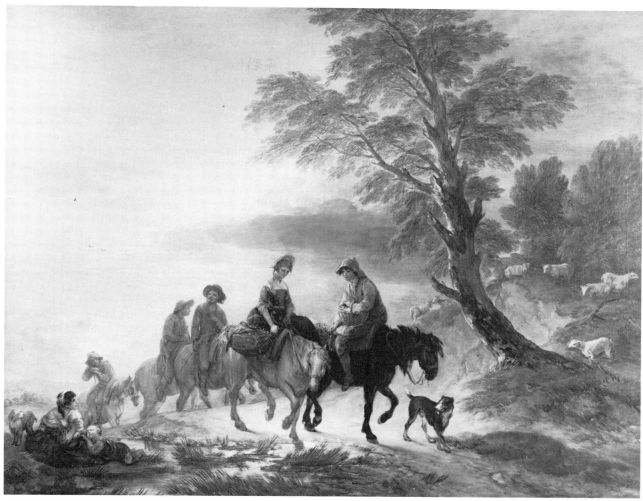

107

## 106 Wooded Landscape with Family grouped outside a Cottage, Woodcutter returning and Flock of Sheep

Canvas. 58½ × 47½   148.4 × 120.7

Painted *c.* 1773

Private collection, Geneva

PROVENANCE Painted for Felice de Giardini (1716–96); Richard Rigby (1722–88), Mistley Hall, Essex, by 1786; Rigby sale, Christie's, 9 January 1789, lot 9, bt Peters; Chandos, 1st Lord Leigh (1791–1850), by 1839; by descent to Francis, 3rd Lord Leigh (1855–1938), from whom it was purchased by Duveen before 1930; Harry (later Sir Harry) Oakes (1874–1943); thence by descent; anon. sale, Christie's, 23 November 1973, lot 133 (repr.), bt in; anon. sale, Christie's, New York, 19 January 1982, lot 58 (repr.) (as attributed to Gainsborough), bt by a Swiss private collector.

EXHIBITIONS '18th Century English Painting', Fogg Art Museum, Harvard, 1930 (24); Cincinnati, 1931 (33, citing references which apply to the Rutland picture, cat. no. 105) and repr. pl. 36; 'English Painting of the Late 18th and Early 19th Centuries', California Palace of the Legion of Honor, San Francisco, 1933 (20, wrongly cited as the Rutland picture, cat. no. 105) and repr. p. 48; 'Pintura Britanica en Mexico Siglos XVI al XIX', Museo Nacional de Arte Moderno, Mexico City, November–December 1963 (25).

BIBLIOGRAPHY *Morning Herald*, 3 April 1786; anon., *Authentic Memoirs, and a Sketch of the Real Character of the late Right Honorable Richard Rigby*, London, 1788, p. 22; Whitley, p. 235; Waterhouse, no. 961; Woodall, *Letters*, p. 47.

An exact replica of the Rutland 'Cottage Door' painting (cat. no. 105) which Gainsborough executed for his friend Giardini (see below). It is one of the rare instances in which Gainsborough repeated one of his own designs (see also cat. nos 145 and 147, both reductions); but the sunset glow does not really permeate the picture as it does in the Rutland canvas and, as might be expected in a repetition, the figures are weaker and the handling more summary. The foliage of the principal tree is rather more rhythmical and less broken in outline. Without the documentation, one might well doubt the authenticity of this work. The participation of Dupont is unlikely as he was only apprenticed to Gainsborough in 1772. Also mentioned on pp. 120, 151, 188.

DATING Gainsborough referred to this painting in a letter to Cipriani dated 14 February 1774 (Woodall, *Letters*, no. 13, p. 47): he had apparently told Giardini '(meerly [sic] to try his temper, and a damn'd trick it was) that the Picture he has of mine of the Cottage & ragged Family, was only a *Copy*'. Closely related to cat. no. 105 in the use of pale tints in the sky, the richly encrusted, broken impasto in the lights of the sky at the horizon, the bushy trees in the middle ground, the reddish bank on the right, the soft spotlighting of the figure group and the warm russet tonality.

## 107  Open Landscape with Mounted Peasants going to Market, a Woman with Two Children resting beside a Sedgy Pool, and Sheep on a Bank

Canvas. 48 × 58   121.9 × 147.3
Painted *c.* 1773

Royal Holloway College, Egham

PROVENANCE Purchased from the artist in 1773 by Henry Hoare (d. 1785); Stourhead Heirlooms sale, Christie's, 2 June 1883, lot 16, bt Martin for Royal Holloway College.

EXHIBITIONS BI, 1814 (36); RA, 1870 (124); Arts Council, 1949 (12); Nottingham, 1962 (18, repr.); 'Royal Academy of Arts Bicentenary Exhibition 1768–1968', RA, 1968 (143); 'La Peinture Romantique Anglaise et les Préraphaélites', Petit Palais, Paris, January–April 1972 (124, repr.); 'Pittura Inglese 1660/1840', British Council, Palazzo Reale, Milan, January–March 1975 (51, repr.); 'Zwei Jahrhunderte Englische Malerei: Britische Kunst und Europa 1680 bis 1880', Haus der Kunst, Munich, November 1979–January 1980 (35, repr. col. p. 29); Grand Palais, 1981 (45, repr. col. p. 74, and pp. 42, 45).

BIBLIOGRAPHY William Gilpin, *Observations on the Western Parts of England*, London, 1798, p. 119; Prince Hoare, *Epochs of the Arts*, London, 1813, pp. 76–7, note; J. P. Neale, *Views of The Seats of Noblemen and Gentlemen*, London, vol. v, 1822 (unpaginated); *Catalogue of the Hoare Library at Stourhead*, London, 1840, p. 742; Dr Waagen, *Treasures of Art in Great Britain*, London, 1854, vol. III, p. 173; Fulcher, p. 199; Armstrong, 1898, p. 206; Emily J. Climenson, ed., *Passages from the Diaries of Mrs Philip Lybbe Powys*, London, 1899, p. 173; Armstrong, 1904, p. 287; Whitley, p. 358; Woodall, *Drawings*, pp. 49, 50, 55, 110, repr. pl. 50; Woodall, pp. 93–4; Ellis Waterhouse, *Painting in Britain 1530–1790*, Harmondsworth, 1953, p. 188; Waterhouse, p. 25, no. 911, repr. pl. 115; Mary Woodall, 'Gainsborough Landscapes at Nottingham University', *Burlington Magazine*, December 1962, p. 562; John Hayes, 'Gainsborough and Rubens', *Apollo*, August 1963, pp. 92–3, repr. fig. 8; John Hayes, 'Gainsborough', *Journal of the Royal Society of Arts*, April 1965, pp. 321, 324; Hayes, *Drawings*, pp. 17, 68, 225, 300, repr. pls 301

(detail), 369; Hayes, *Printmaker*, p. 43; Herrmann, p. 97; editorial [Denys Sutton], 'Realms of Enjoyment', *Apollo*, November 1973, p. 337, repr. fig. 10; Hayes, p. 217, repr. pl. 115; British Museum, 1978, p. 20; John Barrell, *The Dark Side of the Landscape*, Cambridge, 1980, pp. 53–4, repr. p. 53; Dillian Gordon, *Second Sight: Rubens: The Watering Place/Gainsborough: The Watering Place*, National Gallery, London, 1981, p. 17, repr. fig. 17; Lindsay, p. 114; Giles Waterfield, 'Winning Parisian Hearts', *Country Life*, 16 April 1981, p. 1051, repr. fig. 4.

The theme of peasants going to market appearing over the brow of a hill, with a brilliant dawn behind, is found in a Cuyp now in the Mauritshuis, as has been pointed out by Dillian Gordon (op. cit., p. 17, repr. fig. 18). The two principal figures in the Gainsborough are solidly modelled, as in the Rutland picture (cat. no. 105), and may be contrasted with the similar pair of rustic lovers in the Toledo landscape painted five or six years earlier (cat. no. 89). It was such figures as the beautiful redhead that Hazlitt had in mind when he wrote that Gainsborough gave 'the air of an Adonis to the driver of a hay-cart, and models the features of a milk-maid on the principles of the antique'. The woman resting by the side of the track with her two small children is gazing up at the two lovers; Gainsborough has thus linked the theme of romance (which he had so often used in his landscapes) with that of motherly love. The effect of early morning light, perhaps inspired by some such Rubens as the *Birdcatcher* in the Louvre (pl. 144), is beautifully rendered, and the picture has a haunting, silvery quality. According to Prince Hoare (cited above), the landscape painter C. W. Bampfylde, 'being on a visit at Stourhead, offered to *mend Gainsborough's sheep*, by repainting them, and was allowed to do so', but they were restored 'to their original *deficiencies*' at the instance of Sir Richard Colt Hoare. The landscape is recorded in 1840 as hanging as an overmantel in the cabinet room at Stourhead (catalogue cited above). Also mentioned on pp. 110, 112–13, 115, 116, 120, 148, 167.

DATING Presumably identifiable with 'Gainsborough's picture' for which Henry Hoare paid eighty guineas on 6 July 1773 (entry in the Stourhead archives, kindly communicated by Mr F. St John Gore).

## 108  Extensive Wooded Landscape with Peasants, Cows, Shepherd and Sheep, Ruined Building on a Hillock, Cattle crossing a Bridge and Distant Village and Mountain

Canvas. $47\frac{1}{4} \times 57\frac{1}{4}$   120 × 145.4
Painted *c.* 1772–4

Yale Center for British Art (Paul Mellon Collection), New Haven (2282)

PROVENANCE J. Longe, 1856, for whose family it is reputed to have been painted; anon. [Longe] sale,

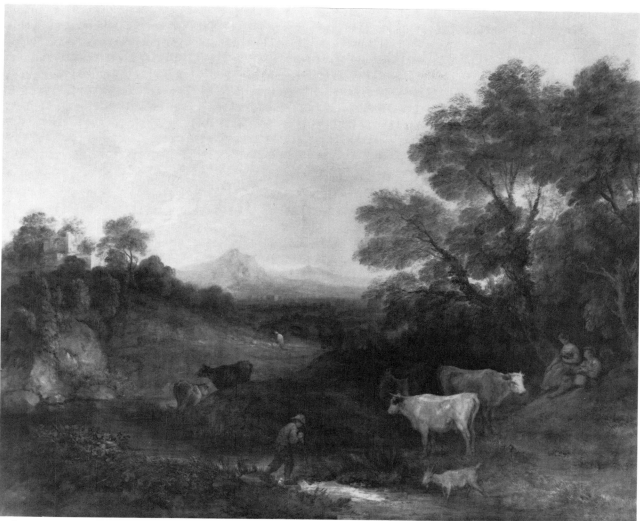

108

**108a** Study for cat. no. 108. Black chalk and stump and white chalk on grey-green paper. $10\frac{1}{2} \times 12\frac{3}{4}$ / 26.7 × 32.4. Ownership unknown.

109

**109a** Study for cat. no. 109. Black chalk and stump on buff paper prepared with grey, heightened with white. $13\frac{5}{16} \times 15\frac{3}{4}$ / 33.8 × 40. Ashmolean Museum, Oxford.

454

Christie's, 19 May 1866, lot 38 (as painted for a relative of the owner), bt Agnew for John Heugh; Heugh sale, Christie's, 10 May 1878, lot 239 (as signed *TG* and 'A VIEW IN SHROPSHIRE'), bt Agnew; J. S. Morgan, 1885; by descent to G. Morgan, from whom it was purchased by Knoedler, *c.* 1916; Colonel Robert L. Montgomery, Villa Nova, Pennsylvania; thence by descent to Alexander Montgomery; with Wildenstein; with Agnew, from whom it was purchased by Mr and Mrs Paul Mellon, January 1966; presented to the Yale Center, 1976.

EXHIBITIONS GG, 1885 (129); 'English Masters', Knoedler's, London, October–November 1911 (4); Tate Gallery, 1980–81 (114, repr.); Grand Palais, 1981 (46, repr., p. 41).

BIBLIOGRAPHY Fulcher, p. 238; William Martin Conway, *The Artistic Development of Reynolds and Gainsborough*, London, 1886, p. 84; Armstrong, 1898, p. 206; Armstrong, 1904, p. 284; Waterhouse, no. 890, repr. pl. 81; Hayes, *Drawings*, p. 194; Hayes, p. 217, repr. pl. 109; Paulson, p. 247; Malcolm Cormack, 'A Selective Promenade', *Apollo*, April 1977, repr. fig. 5; Lindsay, p. 108.

A sketch which was used almost without a change for the finished picture was formerly in the Heseltine collection (108a; Hayes, *Drawings*, no. 368): the slight alterations are in the disposition of the cows and the figures on the right. The composition is one of the most consciously Claudean Gainsborough ever painted: the distance is carefully mapped out (compare the Fairhaven Claude, which also contains the motif of the bridge (pl. 152)), and the Claudean device of the lighter tree linking the trees on the right with the distance can be found in the Yale landscape (pl. 150). The glow at the horizon is very broadly painted, and the tonality is not russet, as in the Rutland picture (cat. no. 105), but a rich brownish-green. There are no signs of the signature noted in the 1878 sale catalogue (see above), and the title, 'A View in Shropshire', given to the picture at this date is puzzling as well as erroneous. Two copies of this composition, both roughly the same size as the original, are in existence. One, signed in monogram: *TG*, and traditionally acquired in Gainsborough's lifetime by a family friend, George Coyte (d. 1781)—thus possibly a studio repetition by Dupont—is in the Proby collection at Elton Hall (Waterhouse, no. 891; this was already described as a copy by Fulcher). The other is in an American private collection (see under Waterhouse, no. 891). Also mentioned on pp. 118, 120, 131.

DATING Closely related to the background of *Master John Heathcote* (Waterhouse, no. 358, pl. 148) in the rich brownish-green tonality (with no reddish tints anywhere in evidence), the soft, spiky handling of the foliage and the bushy trees in the middle distance. The treatment of the foliage and the generalized handling of the yellowish sky at the horizon are also related to cat. no. 95.

## 109 Wooded Landscape with Rustic Lovers, Figures, Three Cows and Dog

Canvas. $47\frac{1}{2} \times 58$  120.7 × 147.3
Painted *c.* 1772–4

Earl of Jersey, Jersey, Channel Islands

PROVENANCE Schomberg House sale, March–May 1789, no. 95, bt Mrs Robert Child, grandmother of Sarah, Countess of Jersey (d. 1867); thence by descent.

EXHIBITIONS Schomberg House, 1789 (95); RA, 1895 (128); 'Franco-British Exhibition', Fine Art Palace, Shepherd's Bush, 1908 (8; repr. *Souvenir Catalogue*); Sassoon, 1936 (78; repr. *Souvenir*, pl. 53).

BIBLIOGRAPHY Fulcher, p. 195; Walter Thornbury, *The Life of J. M. W. Turner, R.A.*, London, 1862, vol. II, p. 62; Armstrong, 1898, p. 206; Armstrong, 1904, p. 287; Woodall, *Drawings*, pp. 48, 50, 55, 71, 121, repr. pl. 46; anon. [Tancred Borenius], 'Gainsborough's Collection of Pictures', *Burlington Magazine*, May 1944, p. 110; Ellis Waterhouse, 'The Sale at Schomberg House, 1789', *Burlington Magazine*, March 1945, p. 77; Woodall, p. 91; Waterhouse, no. 931, repr. pl. 124; Hayes, *Drawings*, pp. 68, 185, repr. pl. 367; Paulson, p. 247.

A study followed down to the details of highlighting and cloud arrangement in the finished picture is in the Ashmolean Museum (109a; Hayes, *Drawings*, no. 328). An overt statement of the rustic lovers theme, with the milkmaid looking coyly away, as in the Woburn picture (cat. no. 50). According to the Rev. Kirby Trimmer, the milkmaid represents 'one of the Miss Gainsboroughs' (see Thornbury, cited above), but the portraits of Gainsborough's daughters do not substantiate this, and, indeed, one does not expect to find portrait representations (or the use of living models) in landscape figures on this small scale. On the other hand she is refined and ladylike, and, in common with one or two of Gainsborough's peasant girls, wears a necklace. Rustic lovers with a group of three cows nearby is the subject of one of Berchem's etchings (Dutuit, no. 3). The composition is a simple one and the distance generalized, in contrast with the elaboration of the Mellon landscape (cat. no. 108). The motif of the diagonal tree filling out the right-hand half of the design had been used in the picture at Royal Holloway College (cat. no. 107). A small variant copy was in the Skofield sale, Parke-Bernet's, New York, 1 February 1940, lot 78 (repr.). Also mentioned on pp. 116, 120, 237.

DATING Identical with cat. no. 107 in the bushy trees, the handling of the foliage in soft, spiky touches, the sedgy pool and clearly defined foreground tufts, the generalized treatment of the distance, the silvery tonal quality and cool highlights in the principal tree. The bushy trees, the handling of the foliage, the detailed treatment of the foreground, the firm modelling of the cows and the motif of the three cows grouped together, are also closely related to cat. no. 108.

110

**110a** Drawing related to cat. no. 110. Pencil and watercolour on brown-toned paper. $7\frac{11}{16} \times 9\frac{11}{16}$ / 19.5 × 24.6. Mrs J. Peyton-Jones, London.

**110 Wooded Landscape with Drover and Cattle, Rustic Lovers and Distant Mountain**

Canvas. $38\frac{1}{2} \times 49\frac{1}{2}$ 97.8 × 125.7
Painted *c.* 1772–4

Earl of Shelburne, Bowood

PROVENANCE Carl Friedrich Abel (1725–87); Abel sale, Greenwood's, 13 December 1787, lot 47; Mrs Hester Thrale (1741–1821), by whom it was given to her niece, Mrs H. M. Hoare, *c.* 1807; anon. [Sir George Bowyer and an anon. banker] sale, Phillips's, 2–3 June 1815, 1st day, lot 18 (as painted for Abel) (?); Henry, 3rd Marquess of Lansdowne (1780–1863), by 1844 (or 1814 (?)); thence by descent.

EXHIBITIONS BI, 1814 (25 (?)); 'International Exhibition', South Kensington, 1862 (118); BI, 1867 (192); Sassoon, 1936 (128; repr. *Souvenir*, pl. 52); 'Engelse landscapschilders van Gainsborough tot Turner', Boymans Museum, Rotterdam, 1955 (38); 'The Lansdowne Collection', Agnew's, December 1954–January 1955 (34); 'Two Centuries of British Painting', Montreal Museum of Fine Arts, National Gallery of Canada, Ottawa, Art Gallery of Toronto and Toledo Museum of Art, October 1957–March 1958 (18, repr. p. 106); Tate Gallery, 1980–81 (115, repr.).

BIBLIOGRAPHY Anon. [William Hazlitt], 'On Gainsborough's Pictures', *Champion*, 31 July 1814, p. 247 (?); William Hazlitt, *Criticisms on Art*, London, 1843, p. 194 (note) (quoted from his article in the *Champion*, op. cit.) (?); Mrs Jameson, *Companion to the Most Celebrated Private Galleries of Art in London*, London, 1844, pp. 323–4; Dr Waagen, *Treasures of Art in Great Britain*, London, 1854, vol. III, p. 158; Fulcher, p. 198; Richard and Samuel Redgrave, *A Century of Painters of the English School*, London, 1866, vol. I, p. 170; George E. Ambrose, *Catalogue of the Collection of Pictures belonging to The Marquess of Lansdowne, K.G. at Lansdowne House, London and Bowood, Wilts.*, London, 1897, no. 103, p. 33; Armstrong, 1898, p. 206; Armstrong, 1904, p. 287; Whitley, pp. 361–2; Millar, p. 10, repr. pl. 27; K. C. Balderstone, ed., *Thraliana*, Oxford, 2nd ed., 1951, p. 1082, note 2; Ellis Waterhouse, *Painting in Britain 1530–1790*, Harmondsworth, 1953, p. 189; C. H. Collins Baker, 'The Kennedy Memorial Gallery', *Connoisseur*, October 1954, p. 140; Waterhouse, p. 30, no. 953, repr. pl. 125; Hayes, *Drawings*, p. 181.

A drawing showing a herdsman driving cows downhill, but in the reverse direction, and including the motifs of the single tree and a hill behind, is owned by Mrs J. Peyton-Jones (110a; Hayes, *Drawings*, no. 312); the drawing is of the same date, and may represent a first idea for the Bowood picture. As Sir Ellis Waterhouse remarked (see above), the composition suggests that the picture was one of a pair, and it was, indeed, one of two owned by Gainsborough's intimate friend, C. F. Abel, and, presumably, therefore, one of the 'two valuable landscapes' which, with 'several beautiful drawings', the artist is reported to have exchanged for a viola da gamba he particularly admired (Whitley, see above). The companion has not so far been identified. This canvas takes up the theme of the landscape in the Montilera collection (cat. no. 103), but it is conceived in a more compact and infinitely more poetical way; the mountain is treated as a more positive and dominant motif than hitherto, and the Claudean motif of the figure pointing out the beauties of the distance is used, as it was not in the Cincinnati picture (cat. no. 98), in the way in which Claude intended it (compare the Claude in the Yale University Art Gallery, which was in England before 1756 (pl. 150)). There is some confusion in the early provenance which it is difficult to resolve. If, as seems almost certain, this picture was the 'Group of cattle, in a warm Landscape' which Lord Lansdowne lent to the British Institution in 1814, it cannot have been the landscape painted for Abel that was sold at Phillips's in 1815 (it may be noted here that, in a comprehensive press account of this sale (*Morning Herald*, 3 June 1815), lot 18 was not mentioned, neither did Lord Lansdowne figure as one of the principal purchasers). Two copies of this composition exist. Also mentioned on pp. 118, 120, 125.

DATING Closely related to cat. no. 108 in the soft, spiky handling of the foliage, the firm modelling of the cows and the glowing horizon.

**111\* Open Landscape with Peasant, Milkmaid, Four Cows and Cottage**

Canvas. $21\frac{3}{4} \times 43$ 55.2 × 109.2
Painted *c.* 1772–4

Private collection, Monte Carlo

PROVENANCE With Lawrie, 1898; R. W. Hudson, 1902, from whom it was purchased; thence by descent.

EXHIBITION 'Selection of Works by French and English Painters of the Eighteenth Century', Corporation of London Art Gallery, 1902 (52).

BIBLIOGRAPHY Armstrong, 1898, p. 206, repr. p. vii; Chamberlain, pp. 144–5, 149, repr. p. 51; Armstrong, 1904, p. 287, repr. facing p. 16; Boulton, pp. 48, 62; Waterhouse, no. 905.

The motifs of the sloping tree and the loosely grouped cows link with the Jersey picture (cat. no. 109), but the figures are unrelated, and more correctly classified as staffage; the milkmaid is shown, unusually, in the process of milking. The cows silhouetted against the evening sky are suggestive of Cuyp. One of the trees on the right is cut at the top. The format suggests that the canvas was commissioned as an overmantel.

DATING Appears to be closely related to cat. no. 109 in the handling of the tree-trunk, the foliage and the cows.

111

112

A broadly Claudean composition, but with a craggy, though atmospherically painted, mountain closing the distance and equally craggy rocks on the right. The background is related to the slightly earlier Mellon landscape (cat. no. 108), but is more generalized in character. The Claudean motif of the girl pointing to the beauties of the distant landscape, first used convincingly in the Bowood picture (cat. no. 110), is repeated. The motif of a shepherd and flock of sheep in a dark dell makes its first appearance in Gainsborough. Two or three copies of this composition exist, including one at Burton Agnes. Also mentioned on p. 131.

DATING Closely related to cat. no. 110 in the treatment of the foliage in short, spiky touches, the fluid handling of the tree on the right, the warm reddish tonality of the foreground, the firmly modelled blue-grey mountains dissolving into the distance, and the glowing horizon. The treatment of the rocks, the highlighting of the foliage of the tree on the right in rapidly applied dashes of red and yellow (continued in this case in the highlighting of the rocky incline beneath the tree), the loose modelling of the figures and the Claudean composition are also closely related to cat. no. 113.

## 115 Rocky Wooded Landscape with Rustic Lovers by a Pool, Cows and Distant Buildings and Mountains

Canvas. 48 × 57   121.9 × 144.8
Painted *c*. 1774–7

National Trust, Petworth House (Egremont Collection: 106)

PROVENANCE Probably purchased by George O'Brien, 3rd Earl of Egremont (1751–1837); thence by descent.

EXHIBITION 'English Pictures 1730–1830 from National Trust Houses', Agnew's, November–December 1965 (18, repr.).

BIBLIOGRAPHY Dr Waagen, *Treasures of Art in Great Britain*, London, 1854, vol. III, p. 39; Fulcher, p. 200; *Autobiographical Recollections by the late Charles Robert Leslie, R.A.*, London, 1860, vol. 2, p. 220; Menpes and Greig, p. 49; C. H. Collins Baker, *Catalogue of the Petworth Collection of Pictures in the Possession of Lord Leconfield*, London, 1920, no. 106, p. 47; Waterhouse, no. 952, repr. pl. 179; R. B. Beckett, ed., 'John Constable's Correspondence III', *The Suffolk Records Society*, vol. VIII, Ipswich, 1965, p. 116; Hayes, *Drawings*, pp. 19, 197; St John Gore, 'Three Centuries of Discrimination', *Apollo*, May 1977, p. 356, repr. fig. 24.

A sketch which, with the exception of the staffage, was followed closely in the finished picture, is in the collection of Mrs Cecil Keith (115a; Hayes, *Drawings*, no. 378): in the final design the sheep were omitted, the figures altered in pose, and three cows instead of one disposed on the bank. The composition is, very broadly, a variant on the Mellon picture (cat. no. 114), the most significant alteration being the substitution of the drover for the mother and child, thus emphasizing the Claudean pastoral intentions. The three cows fit snugly into the mass of trees and rocks on the right. This was the landscape which so moved Constable (cited above). Waagen (cited above) described it as 'of very poetical invention, and exhibiting the artist in a light previously unknown to me'. A large copy, including the flock of sheep which appears in the drawing, is in the collection of the Marquess of Exeter at Burghley House; a small copy, by a little-known painter named Butterfield, is also at Petworth. Also mentioned on pp. 131, 140, 298 (see note 184).

DATING Closely related to cat. no. 114 in the fluidly painted, bushy trees, the highlighting of the foliage in the tall tree on the right with rich touches of yellowish paint, the loosely modelled figures, the exaggerated proportions of the girl's thighs, the motif of pointing towards the beauty of the glowing horizon, and the Claudean composition closed by mountains; but the distance is now more summarily painted, the plasticity of the mountains is suggested in a few loose, sketchy brushstrokes, and the lights in the clouds are very broadly handled. The deep tonality, the handling of the bushy foliage, the modelling of the rocks (with some use of dragged paint), the thick, dragged brushstrokes in the strongly lit pool and the treatment of the distance in a careful gradation of tones are also related to cat. no. 117. The dark-green bushy foliage, silhouetted against the evening sky, is similar to the background of *The Hon. Mrs Graham* (Waterhouse, no. 323, pl. 173), exhibited at the Royal Academy in 1777.

## 116 Hilly Wooded Landscape with Mansion, Children descending Steps, White Horse and Woman driving Cows

Canvas. 60 × 72   152.4 × 182.9
Painted *c*. 1774–7

Robert Perret, Kinderhook, N.Y.

ENGRAVING Lithographed by Louis Marvy (as in the collection of Thomas Baring) and published in *Sketches after English Landscape Painters*, London, n.d. [*c*. 1850] (unpaginated) (in one edition lithographed in colour).

PROVENANCE Probably Schomberg House sale, March–May 1789, no. 68; Mrs Gainsborough sale, Christie's, 2 June 1792, lot 82, bt in by Bate-Dudley; Margaret Gainsborough, 1799; later purchased by George, Prince of Wales (later George IV, 1762–1830); anon. [Prince Regent] sale, Christie's, 29 June 1814, lot 21, bt Rutley; Sir George Warrender (1782–1849) by 1817; Warrender sale, Christie's, 3 June 1837, lot 21 (as 'painted by Gainsborough for the Prince of Wales'), bt Stewart; Sir Thomas Baring (1772–1848); Baring sale, Christie's, 2 June 1848, lot 61 (as 'A LODGE IN WINDSOR PARK, with

116

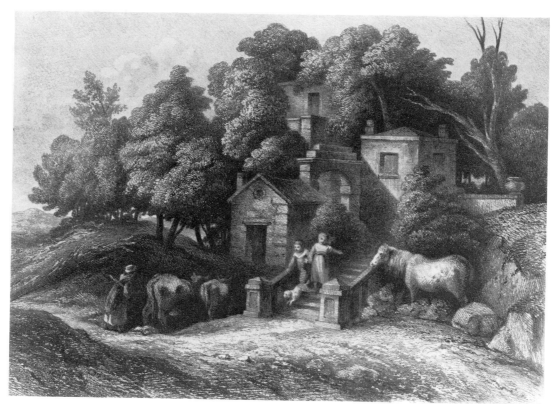

**116a** Lithograph of cat. no. 116 by Louis Marvy, *c.* 1850. British Museum (1855-12-8-18).

royal children descending some stone steps'), bt in; Thomas Baring (1799–1873), 1854; anon. sale, Robinson and Fisher's, 27–28 May 1897, 2nd day, lot 190, bt Colnaghi; anon. sale, Robinson and Fisher's, 21 June 1900, lot 109 (with drawing), bt S. T. Smith; purchased by J. Pierpont Morgan in Washington, c. 1900; by descent to his daughter, Mrs George Nichols; with Coleman Galleries, New York, from whence it was purchased by Robert Perret, 1951.

EXHIBITIONS Probably Schomberg House, 1789 (68); BI, 1817 (25); BI, 1840 (84), as including portraits of George IV and the Princess Royal when children.

BIBLIOGRAPHY Farington Diary, 8 February 1799 (Kenneth Garlick and Angus Macintyre, *The Diary of Joseph Farington*, New Haven and London, vol. IV, 1979, p. 1153); *Athenaeum*, 10 June 1848, p. 585; L. Marvy and W. M. Thackeray, *Sketches after English Landscape Painters*, London, n.d. [c. 1850] (unpaginated) (repr.); Dr Waagen, *Treasures of Art in Great Britain*, London, 1854, vol. II, p. 189; Fulcher, pp. 194, 204; Whitley, p. 342; William T. Whitley, 'An Eighteenth-Century Art Chronicler: Sir Henry Bate Dudley, Bart.', *The Walpole Society*, vol. XIII, Oxford, 1925, p. 61; anon. [Tancred Borenius], 'Gainsborough's Collection of Pictures', *Burlington Magazine*, May 1944, p. 109; 'American Colonial Mansion' and 'Thackeray on a Gainsborough', *Antique Collector*, October 1955, p. 244, repr. p. 223; Waterhouse, no. 991.

The paint surface is now in poor condition, owing to extensive blistering, and the composition can be studied most easily from the lithograph by Marvy (116a). The subject of a country house among trees is developed from the Wall landscape (cat. no. 96), but the mansion has been brought into the foreground, producing a greater effect of grandeur, and children are seen descending the steps. It was presumably the provenance from the collection of George IV that led to the picture being described by Christie's in 1848 as 'A LODGE in WINDSOR PARK, with royal children descending some stone steps' (see above). The horse anticipates the majestic white horse in the Kansas City picture (cat. no. 119). A 'drawing for the landscape background', which has since disappeared, was sold with the picture in 1900 (see above). A copy was formerly on the London art market. Also mentioned on pp. 132, 135, 237–8.

DATING Closely related to cat. no. 115 in the treatment of the soft, bushy foliage and the loose modelling of the cows.

## 117 Wooded Landscape with Peasants beside a Pool, Mounted Herdsman with Cattle and Goats watering and Distant Hills (The Watering Place)

Canvas. 58 × 71    147.3 × 180.3
Painted in 1777

National Gallery, London

ENGRAVINGS Related soft-ground etching and aquatint by Gainsborough, c. 1776–7 (117b; see below); engraved by William Miller and published by John Pye, July 1836.

PROVENANCE Probably Schomberg House sale, March–May 1789, no. 76; Mrs Gainsborough sale, Christie's, 2 June 1792, lot 80, bt in; Mrs Gainsborough sale, Christie's, 10–11 April 1797, 2nd day, lot 102, bt Sir Charles Long (later Lord Farnborough, 1751–1838); bequeathed to the National Gallery, 1827; transferred to the Tate Gallery, 1919; transferred back, 1953.

EXHIBITIONS RA, 1777 (136); probably Schomberg House, 1789 (76); BI, 1814 (20); BI, 1824 (156); Ipswich, 1927 (49); Arts Council, 1953 (39); 'British Paintings 1700–1960', Hermitage, Leningrad, and Pushkin Museum, Moscow, 1960 (33, repr.); 'Second Sight', National Gallery, London, February–April 1981.

BIBLIOGRAPHY *Morning Post*, 25 April 1777; *Morning Chronicle*, 25 April 1777; George Cumberland, *Bromley-Hill The Seat of the Right Hon. Charles Long*, London, 1811, p. 17; *Morning Post*, 6 August 1814; M. Passavant, *A Tour of a German Artist in England*, London, 1836, vol. I, pp. 56–7; Mrs Jameson, *Handbook to the Public Galleries of Art in and near London*, London, 1842, p. 118; Dr Waagen, *Treasures of Art in Great Britain*, London, 1854, vol. I, p. 368; Fulcher, pp. 28 (note), 110, 187, 198; John Timbs, *Anecdote Biography*, London, 1860, p. 177; Richard and Samuel Redgrave, *A Century of Painters of the English School*, London, 1866, vol. I, p. 170; J. Beavington-Atkinson, 'Thomas Gainsborough' (article in Robert Dohme, *Kunst und Künstler des Mittelalters und der Neuzeit*, Leipzig, vol. 6, 1880), pp. 40, 54, repr. p. 53; George M. Brock-Arnold, *Gainsborough*, London, 1881, pp. 73–4; William Martin Conway, *The Artistic Development of Reynolds and Gainsborough*, London, 1886, repr. facing p. 88; Armstrong, 1894, pp. 50–53, 60, repr. p. 59; Bell, pp. 66, 120–21, 124; Armstrong, 1898, pp. 72, 126, 157, 158, 184, 206, repr. p. 137; Mrs Arthur Bell, *Thomas Gainsborough, R.A.*, London, 1902, p. 55; Gower, pp. v, 7, 43, 85; Chamberlain, pp. 92–4, repr. p. 55; Armstrong, 1904, pp. 95, 168, 211, 213, 250, 284, repr. facing p. 188; A. E. Fletcher, *Thomas Gainsborough, R.A.*, London, 1904, p. 88, repr. facing p. 72; Pauli, p. 99, repr. pl. 71; Boulton, pp. 95, 181–82, 217, 245, 308, repr. facing p. 308; Algernon Graves, *The Royal Academy of Arts*, vol. III, London, 1905, p. 191; Armstrong, 1906, pp. 139, 157, repr. facing p. 150; Gabriel Mourey, *Gainsborough*, Paris, n.d. [1906], pp. 51, 100, repr. facing p. 28; Menpes and Greig, pp. 49, 90, 122, 160, 161; Myra Reynolds, *The Treatment of Nature in English Poetry*, Chicago, 1909, pp. 306–7; Whitley, p. 143; M. H. Spielmann, 'A Note on Thomas Gainsborough and Gainsborough Dupont', *The Walpole Society*, vol. V, Oxford, 1917, pp. 98, 108; E. Rimbault Dibdin, *Thomas Gainsborough*, London, 1923, p. 138, repr. p. 43 (col.); William T. Whitley, 'An Eighteenth-Century Art Chronicler: Sir Henry Bate Dudley, Bart.', *The Walpole*

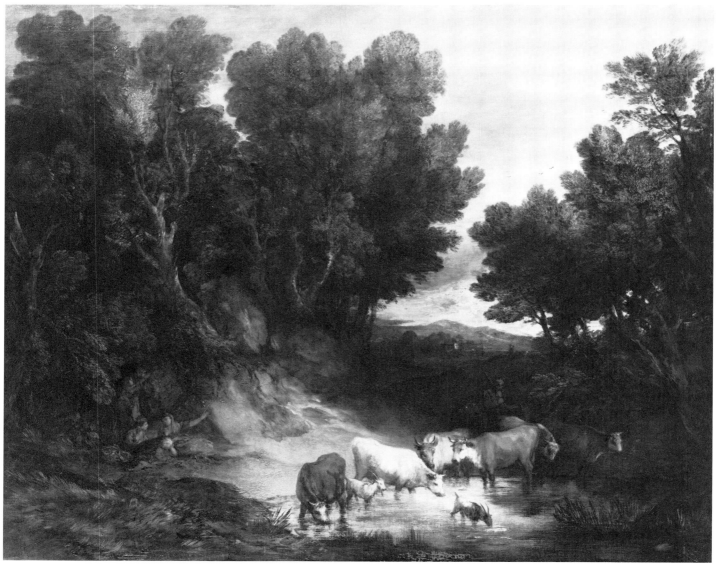

**117**

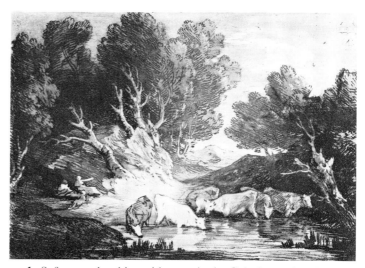

**117a** Drawing related to cat. no. 117. Black, white and coloured chalks on grey-blue paper. $9\frac{7}{16} \times 11\frac{7}{8}$ / 24 × 30.2. Private collection, England.

**117b** Soft-ground etching with aquatint by Gainsborough, related to cat. no. 117. Tate Gallery, London (2210).

*Society*, vol. XIII, Oxford, 1925, p. 32; R. H. Wilenski, 'The Gainsborough Bicentenary Exhibition', *Apollo*, November 1927, p. 195; William T. Whitley, *Artists and their Friends in England 1700–1799*, London, 1928, vol. I, pp. 322–3; William T. Whitley, *Art in England 1821–1837*, Cambridge, 1930, pp. 116, 207, 311, 347; Charles Johnson, *English Painting from the Seventh Century to the Present Day*, London, 1932, pp. 131–2, 133; C. H. Collins Baker, *British Painting*, London, 1933, pp. 107–8; Charles Johnson, *A Short Account of British Painting*, London, 1934, p. 54; Woodall, *Drawings*, pp. 20, 60–64, 96, repr. pl. 69; anon. [Tancred Borenius], 'Gainsborough's Collection of Pictures', *Burlington Magazine*, May 1944, p. 109; Millar, pp. 10, 13, repr. pl. 5 (col.); Woodall, pp. 73, 94, 95–6, repr. p. 97; Basil Taylor, *Gainsborough*, London, 1951, p. 16, repr. pl. 7 (col.); Waterhouse, pp. 25, 29, 30, no. 937, repr. pl. 181; Martin Davies, *The British School*, National Gallery, London, 2nd ed., rev., 1959, pp. 34–5; John Hayes, 'Gainsborough and Rubens', *Apollo*, August 1963, pp. 93, 94, 95, repr. fig. 10; R. B. Beckett, ed., 'John Constable's Correspondence II', *The Suffolk Records Society*, vol. VI, Ipswich, 1964, pp. 321–2; John Hayes, 'Gainsborough's Later Landscapes', *Apollo*, July 1964, p. 20; John Hayes, 'Gainsborough', *Journal of the Royal Society of Arts*, April 1965, pp. 320, 325; Emilie Buchwald, 'Gainsborough's "Prospect, Animated Prospect"', Howard Anderson and John S. Shea, ed., *Studies in Criticism and Aesthetics 1660–1800*, University of Minnesota, 1967, pp. 368, 379; Gatt, p. 34, repr. pls 38, 39 (col.); Sidney C. Hutchison, *The History of the Royal Academy 1768–1968*, London, 1968, fig. 11; Hayes, *Drawings*, p. 6; Hayes, *Printmaker*, p. 57, repr. pl. 50; Jean-Jacques Mayoux, *La Peinture Anglaise De Hogarth aux Préraphaélites*, Geneva, 1972, p. 73; Herrmann, p. 99, repr. pls 91, XIII (col.); Hayes, pp. 43, 218, repr. pl. 111; Paulson, p. 247, repr. pl. 152; Homan Potterton, 'Reynolds and Gainsborough', *Themes and Painters in the National Gallery*, Series 2, Number 3, 1976, p. 27, repr. pl. 25; British Museum, 1978, p. 18; Tate Gallery, 1980–81, pp. 26, 33, 127, repr. fig. 34; Dillian Gordon, *Second Sight: Rubens: The Watering Place/Gainsborough: The Watering Place*, National Gallery, London, 1981, pp. 2, 3, 16, 21, 22, 23, repr. p. 15; Grand Palais, 1981, pp. 23, 42, 141, repr. fig. 9; Lindsay, p. 133.

The soft-ground etching with aquatint of this subject (117b; Hayes, *Printmaker*, no. 7), one of Gainsborough's grandest and most influential designs, still broadly Claudean in concept, lacks the mounted herdsman and the two goats: since the composition was considerably enriched by this addition to the group of cows, it seems likely that the print preceded the completion of the painting. As Dillian Gordon points out (op. cit., p. 22, fig. 24) (see 117a; Hayes, *Drawings*, no. 405), several of Gainsborough's landscape drawings of this period are related in composition to *The Watering Place*. The extraordinarily powerful, dark, dominating trees mark the culmination of Gainsborough's experiments with massive trees as backgrounds of ten years earlier (see cat. nos 85, 89): both the trees and the dark, generalized background suggest the influence of Titian as well as of Rubens, whose *The Watering Place* (then in the collection of the Duke of Montagu, and now in the National Gallery) Gainsborough had advised Garrick to see in 1768 (Woodall, *Letters*, no. 27, p. 68), and with which there are a number of elements in common, notably the highlit trees growing out of a steep bank and the silhouetting of the foliage against the evening sky. The girl in the foreground is pointing towards the sunset, an effect which is very roughly handled, with much use of the palette knife. Innumerable copies of this celebrated composition are in existence, of which by far the most distinguished is the smaller version in an English private collection, probably by an artist of the Norwich school (pl. 335; see also p. 281). A watercolour by Jules Dupré, done from the original on his visit to England in 1831, is in the Whitworth Art Gallery, University of Manchester. Also mentioned on pp. 125–8, 135, 167, 182, 238, 246, 280, 281.

DATING Identifiable as RA, 1777 (136) from several contemporary descriptions. Horace Walpole noted in his catalogue, 'In the Style of Rubens, & by far the finest Landscape ever painted in England, & equal to the great Masters' (Lord Rosebery collection). The critic of the *Morning Chronicle* (25 April 1777) commented that the picture was 'one of the best of its kind that has been exhibited for many years. The red cow and the perspective light, with the broken bank and the lucid water, are all fine parts of the picture'. A visiting Italian artist wrote about it even more enthusiastically: 'His large landscape, No.136, is inimitable. It revives the colouring of Rubens in that line. The scene is grand, the effect of light is striking, the cattle very natural. But what shall I say of the pencilling? I really do not know; it is so new, so original, that I cannot find words to convey any idea of it. I do not know that any artists, living or dead, have managed their pencils in that manner and I am afraid that any attempt to imitate it will be attended with ill success' (William T. Whitley, *Artists and their Friends in England 1700–1799*, London, 1928, vol. I, p. 323). Bate-Dudley, whose review of that year's Academy in the *Morning Post* was his first notice of Gainsborough, wrote simply, 'A rural scene from nature, which discovers Mr. Gainsborough's superior taste and execution in the landscape way,' adding, 'it is confessedly a masterpiece of its kind, but is viewed to every possible disadvantage from the situation in which the directors have thought proper to place it' (*Morning Post*, 25 April 1777). The connection between these descriptions and *The Watering Place* is confirmed by the note which Joseph Farington later made against no. 136 in his catalogue: 'Mr Charles Long's' (Whitley, *loc. cit.*).

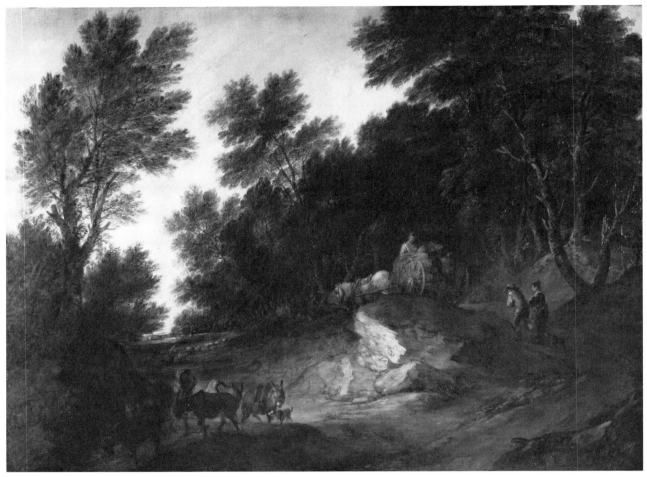

118

**118 Wooded Landscape with Figures in a Country Cart followed by two Peasants passing over a Rocky Mound, Peasant with Donkeys, and Shepherd and Sheep**

Canvas. $56 \times 74\frac{3}{4}$   $142.2 \times 189.9$
Painted *c.* 1777–8

Lady Janet Douglas-Pennant, Penrhyn Castle (on indefinite loan to the National Museum of Wales)

PROVENANCE Caulfield (?); with Farrer, from whom it was purchased by Colonel the Hon. Edward Douglas-Pennant (later 1st Lord Penrhyn, 1800–1886), *c.* 1855–60; thence by descent.

EXHIBITIONS BI, 1865 (142); Wrexham, 1876 (368); RA, 1882 (265); GG, 1885 (134).

BIBLIOGRAPHY Armstrong, 1898, p. 207; Alice Douglas Pennant, *Catalogue of the Pictures at Penrhyn Castle and Mortimer House in 1901*, Bangor, 1902 (no. 38); Armstrong, 1904, p. 288; Waterhouse, no. 934.

This picture is much the same size as *The Watering Place* (cat. no. 117) and equally monumental. But where *The Watering Place* is essentially tranquil, this is full of movement, all the forms contributing to the sweeping, rhythmical composition, a broader, more sophisticated

restatement of the design used for the St Louis landscape (cat. no. 52) painted some twenty years earlier: Gainsborough has even reintroduced the old formula of the *repoussoir* branch. An antecedent for the design may be found in the small panel by Wijnants formerly in the Sutherland collection at Stafford House (Countess of Sutherland sale, Christie's, 21 May 1976, lot 141, repr. pl. 37), but the connection is probably coincidental. The handling is exceptionally rich and broken, and the brilliant suggestion of light in the distance by means of dragged brushstrokes anticipates Constable. There is a pentimento in the second donkey, whose head was originally facing left. A copy of roughly the same size as the original was in the possession of E. Bolton, London, in 1934, and another is in a private collection in New York; a smaller copy, with a group of cows in the left foreground, is at Sudley (administered by the Walker Art Gallery, Liverpool). Also mentioned on pp. 128, 164, 167; details are repr. pls 158, 159, 216.

DATING Closely related to cat. no. 117 in the deep tonality and almost complete absence of warm colour, the softly painted, bushy, deep-green foliage, the sturdy and boldly modelled tree-trunks, the strongly lit, rocky mound, the richly encrusted impasto in the lights at the horizon and the grand, flowing composition.

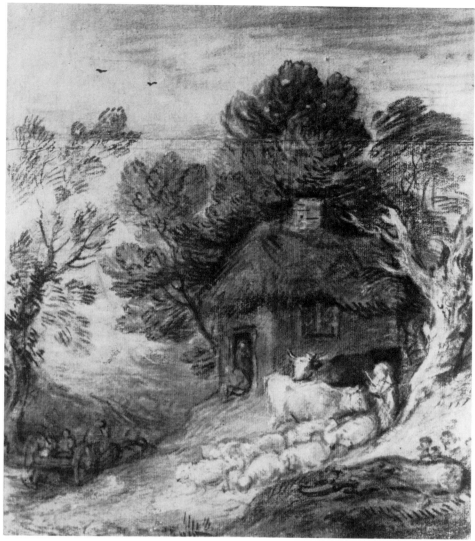

**120a** Probably study for cat. no. 120. Black chalk and stump and white chalk on grey paper. 14$\frac{15}{16}$ × 12$\frac{7}{16}$ / 37.9 × 31.6. Mrs Nicholas Argenti, London.

Rutland picture. In the final composition Gainsborough removed the cottage and country cart and introduced a milkmaid in converse with the herdsman as a 'subject'; otherwise, the painting follows the sketch closely. The strongly spotlit cows and sheep form a bold diagonal, emphasized by the familiar foreground branch and carried on in the trees, which are richly intertwined, giving a lively, romantic effect to the foliage, anticipating the *Peasant smoking at a Cottage Door* of ten years later (cat. no. 185). Though there are some touches of red in the foliage on the right, the scene is essentially twilit and drained of colour, as in the other monumental works of this period (cat. nos 117 and 118). Also mentioned on pp. 128, 153, 167, 181, 182.

DATING Closely related to cat. no. 117 in the deep green tonality (with the whole picture drained of warm colour), the softly painted, deep-green, bushy foliage, the use of enlivening dashes of red in the foliage, the rough modelling of the figures, the richly impasted highlights in the animals, the strong spotlighting, the loosely handled foreground, the generalized bluish-green distance and the rough handling of the impasto in the broken lights at the horizon, with free use of the palette knife.

**121 Hilly Landscape with Peasant Family at a Cottage Door, Children playing and Woodcutter returning**

Canvas. 48$\frac{1}{4}$ × 58$\frac{3}{4}$  122.5 × 149.2
Painted *c.* 1778

Cincinnati Art Museum, Cincinnati (1948.173)

PROVENANCE By descent to Margaret Gainsborough (1752–1820); Henry, 1st Earl of Mulgrave (1755–1831) by 1814; by descent to George, 2nd Marquess of Normanby (1819–90), who sold it to Welbore Ellis, 2nd Earl of Normanton (1778–1868), *c.* 1865; by descent to Edward, 5th Earl of Normanton (1910–67), who sold it to Duveen, 1934, from whom it was purchased by Mr

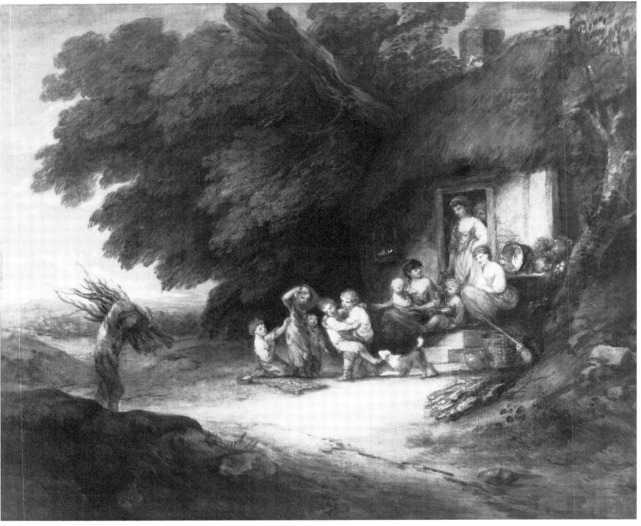

121

and Mrs Charles Finn Williams, Cincinnati, 1935; presented to the Cincinnati Art Museum, 1948.

EXHIBITIONS Probably RA, 1778 (120); Schomberg House sale, 1789, no. 69; BI, 1814 (59); RA, 1882 (177); 'Paintings from the Collection of Mr. and Mrs. Charles Finn Williams', Art Museum, Cincinnati, January–March 1937 (9, repr.); 'Pictures from the Collection of Mr. and Mrs. Charles F. Williams', Art Museum, Cincinnati, October 1939–January 1940; 'European & American Paintings 1500–1900: Masterpieces of Art', New York World's Fair, May–October 1940 (153, repr.); 'Great Paintings in Aid of the Canadian Red Cross', Art Gallery of Toronto, 1940 (41, repr. pl. 14); 'Pictures of Everyday Life', Carnegie Institute, Pittsburgh, October–December 1954 (63, repr.); Tate Gallery, 1980–81 (142, repr., col. p. 135, and p. 38).

BIBLIOGRAPHY Probably *Morning Post*, 27 April 1778; probably *General Advertiser*, 30 April 1778; *Diary*, 8 April 1789; Farington Diary, 8 February 1799 (Kenneth Garlick and Angus Macintyre, *The Diary of Joseph Farington*, New Haven and London, vol. IV, 1979,

p. 1153); Fulcher, p. 200; Armstrong, 1898, p. 206 (wrongly as a replica of cat. no. 123); Max Roldit, 'The Collection of Pictures of the Earl of Normanton, at Somerley, Hampshire', *Burlington Magazine*, December 1903, p. 231, repr. p. 218; Armstrong, 1904, p. 283 (wrongly as a replica of cat. no. 123); probably Algernon Graves, *The Royal Academy of Arts*, vol. III, London, 1905, p. 192; probably Whitley, p. 157; Woodall, *Drawings*, pp. 64, 76, 107, repr. pl. 75; 'Art at the Fair', *Art News Annual Supplement*, 1940, p. 43, repr. p. 30; anon. [Tancred Borenius], 'Gainsborough's Collection of Pictures', *Burlington Magazine*, May 1944, p. 109; Ellis Waterhouse, *Painting in Britain 1530–1790*, Harmondsworth, 1953, p. 189; Mary Woodall, 'A Gainsborough "Cottage Door"', *Connoisseur*, October 1954, p. 110; *Guide to the Collections of the Cincinnati Art Museum*, n.d. [1956], repr. p. 57; Waterhouse, no. 940, repr. pl. 192; Eloise Spaeth, *American Art Museums and Galleries*, New York, 1960, p. 122; John Hayes, 'Gainsborough's Later Landscapes', *Apollo*, July 1964, p. 21; John Hayes, 'English Painting and the Rococo', *Apollo*, August 1969, p. 124; Hayes, *Drawings*, pp. 219,

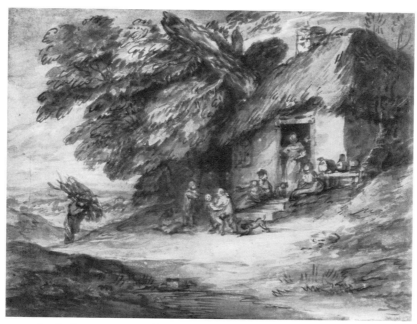

**121a** Study for cat. no. 121. Grey and grey-black washes, and white chalk. $10\frac{11}{16} \times 13\frac{5}{8}$ / 27.1 × 34.6. H.R.H. The Duchess of Kent, London.

292; John Hayes, 'A Galaxy of Gainsboroughs', *Apollo*, April 1971, pp. 294, 296, repr. pl. IX (col.), figs 9, 10 (details); Josephine Gear, *Masters or Servants?*, New York and London, 1977, p. 6; John Barrell, *The Dark Side of the Landscape*, Cambridge, 1980, pp. 70–72, 75, 76, 86, repr. p. 71; John Ingamells, 'Thomas Gainsborough', *Burlington Magazine*, November 1980, p. 780.

A study which was followed in broad essentials in the finished painting is in the collection of H.R.H. The Duchess of Kent (121a; Hayes, *Drawings*, no. 478). In the final composition a basket, broom, cooking pot and bunch of faggots have been introduced by the steps, but it is more instructive to notice in detail how Gainsborough has improved the rhythmic flow of the figure grouping. The theme is very similar to that of the Rutland *The Woodcutter's Return* (cat. no. 105), but the trees have now been placed beside the cottage, the figure composition is diagonal rather than pyramidal, the children are boisterous instead of in repose, and the husband returning with his load of faggots is more satisfactorily placed, as he is physically more detached from the group outside the cottage. The distance is hardly more than sketched, and the thick yellow impasto in the lights at the horizon is applied with an unprecedented looseness of touch; the figures, too, are loose and impressionistic. There are no grounds for supposing that Gainsborough had Shenstone's poem in mind when he painted this picture (see below); the scene is a domestic one, not a school-house. A small copy which may confidently be attributed to Dupont, identifiable with lot 140, 'A COTTAGE DOOR WITH CHILDREN AT PLAY' size $18\frac{1}{2} \times 24$ inches (after Gainsborough), by Dupont, in the [Richard] Gainsborough Dupont sale, Wheeler and Westoby's, Sudbury, 29 May 1874, was

formerly at Mansfield College (see pl. 263 and pp. 226–7). Also mentioned on pp. 112, 153–5, 190.

DATING The probable identification with RA, 1778 (120) derives from the critic of the *General Advertiser* (30 April 1778):

The design of this piece is beautiful to excess. The story is taken from the following elegant stanza of Shenstone's School-mistress:

> But now Dan Phoebus gains the middle sky,
> And liberty unbars her prison door;
> And like a rushing torrent out they fly,
> And now the grassy cirque have cover'd o'er.
> With boisterous revel-rout and wild uproar,
> A thousand ways in wanton rings they run:
> Heaven shield their short-liv'd pastimes I implore,
> For well may Freedom, erst so dearly won,
> Appear to British elf more gladsome than the fun.

The descriptive part of this stanza has formed a most exuberant subject, and he has wrought it into a most advantageous effect. The disposition is beautiful, and the keeping correct and masterly. It is in such performances as these, that the genius of Gainsborough is apparent. He gives his landscapes a warmth and beauty of colouring superior to most of his competitors; and we confess, we would forego the portion of pleasure we experience in viewing his portraits, for the ineffable delight we receive from his landscapes; and wish that he also would leave the one for the other.

Closely related to cat. no. 120 in the tonal quality, the softly painted, bushy trees, the skilfully designed figure composition (compare the arrangement of the animals), the loose modelling of the figures, the strong spotlighting

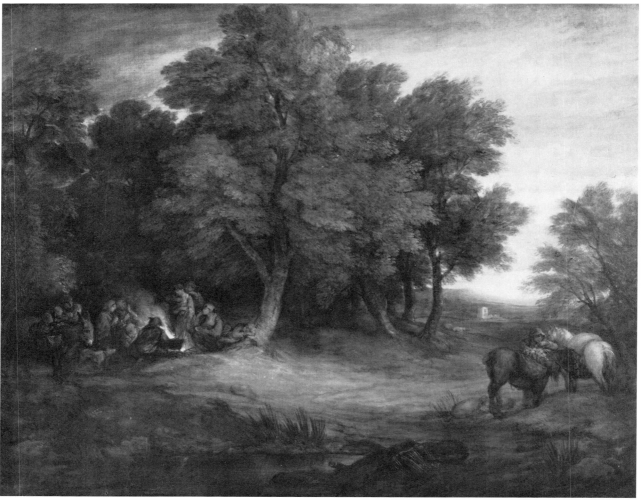

122

**122a** Study for cat. no. 122. Black chalk and stump and white chalk on blue paper.
$10\frac{1}{2} \times 12\frac{7}{8}$ / 26.7 × 32.7. Yale Center for British Art (Paul Mellon Collection),
New Haven (B1975.4.1522).

*und der Neuzeit*, Leipzig, vol. 6, 1880), p. 52; George M. Brock-Arnold, *Gainsborough*, London, 1881, p. 74 and repr. facing; William Martin Conway, *The Artistic Development of Reynolds and Gainsborough*, London, 1886, pp. 88–9; Armstrong, 1894, pp. 49, 58, 60; Armstrong, 1898, pp. 72, 126, 157, 184, 208, repr. facing p. 48; Chamberlain, pp. 158–60, repr. pl. 63; Gower, pp. 7, 89, 127; Armstrong, 1904, pp. 95, 168, 169, 211, 250, 283, repr. facing p. 56; A. E. Fletcher, *Thomas Gainsborough, R.A.*, London, 1904, p. 80; Boulton, pp. 95, 153, 181–82; Algernon Graves, *The Royal Academy of Arts*, vol. III, London, 1905, p. 192; Armstrong, 1906, pp. 128, 150, 157; Constance Hill, *The House in St. Martin's Street*, London, 1907, p. 233; Menpes and Greig, p. 90; Myra Reynolds, *The Treatment of Nature in English Poetry*, Chicago, 1909, p. 306; Whitley, pp. 94, 170; James Greig, ed., *Farington Diary*, London, vol. 5, 1925, p. 204; C. C. Abbott, *The Life and Letters of George Darley*, Oxford, 1928, p. 76; William T. Whitley, *Artists and their Friends in England 1700–1799*, London, 1928, vol. II, p. 201; William T. Whitley, *Art in England 1800–1820*, Cambridge, 1928, pp. 183, 297; Esther Singleton, *Old World Masters in New World Collections*, New York, 1929, p. 357, repr. p. 359; William T. Whitley, *Art in England 1821–1837*, Cambridge, 1930, pp. 134–5, 137, 138, 286; C. H. Collins Baker, *British Painting*, London, 1933, p. 151; R. H. Wilenski, *English Painting*, London, 1933, pl. 24; C. H. Collins Baker, *Catalogue of British Paintings in the Henry E. Huntington Library and Art Gallery*, San Marino, California, 1936, pp. 43–4, repr. pl. VIII; Chauncey Brewster Tinker, *Painter and Poet*, Cambridge, Mass., 1938, pp. 80–83, repr. p. 81; Woodall, *Drawings*, pp. 64, 88; Woodall, pp. 100–102, repr. p. 103; S. N. Behrman, *Duveen*, London, 1952, p. 141; Ellis Waterhouse, *Painting in Britain 1530–1790*, Harmondsworth, 1953, p. 189; Mary Woodall, 'A Gainsborough "Cottage Door"', *Connoisseur*, October 1954, p. 110; C. H. Collins Baker, 'The Kennedy Memorial Gallery', *Connoisseur*, October 1954, pp. 135–6; Waterhouse, pp. 29–30, no. 941, repr. pl. 203; Francis W. Hawcroft, 'Crome and his Patron: Thomas Harvey of Catton', *Connoisseur*, December 1959, p. 234–5, repr. fig. 6; Eloise Spaeth, *American Art Museums and Galleries*, New York, 1960, p. 209; Douglas Hall, 'The Tabley House Papers', *The Walpole Society*, vol. XXXVIII, Glasgow, 1962, p. 70; Woodall, *Letters*, repr. facing p. 129; Jerrold Ziff, '"Backgrounds, Introduction of Architecture and Landscape": a Lecture by J. M. W. Turner', *Journal of the Warburg and Courtauld Institutes*, vol. XXVI, 1963, p. 146 (from the transcript of Turner's lecture delivered at the RA on 12 February 1811); John Hayes, 'Gainsborough's Later Landscapes', *Apollo*, July 1964, p. 21, repr. fig. 2; Derek and Timothy Clifford, *John Crome*, London, 1968, pp. 33, 51–2, 125, 197; Gatt, p. 36, repr. pl. 44 (col.); Felicity Owen, 'Sir George Beaumont and the Contemporary Artist', *Apollo*, February 1969, p. 108, repr. fig. 5; Robert R. Wark, *The Huntington Art Collection*, San Marino, California, 1970, no. 12, p. 19, repr.; Mary Webster, *Francis Wheatley*, London, 1970, p. 70, repr. fig. 86; Herrmann, pp. 100, 103, repr. pl. 94; J. T. [John] Hayes, 'A Turning Point in Style: *Landscape with Woodcutter*', *The Museum of Fine Arts, Houston Bulletin*, summer 1973, p. 28; Hayes, pp. 36, 43, 47, 220, repr. pl. 116; Paulson, p. 247; Leslie Parris, Conal Shields and Ian Fleming-Williams, ed., *John Constable: Further Documents and Correspondence*, Suffolk Records Society, vol. XVIII, London and Ipswich, 1975, p. 165; Joseph Burke, *English Art 1714–1800*, Oxford, 1976, p. 219, repr. pl. 61; John Dixon Hunt, *The Figure in the Landscape*, Baltimore and London, 1976, p. 213; Josephine Gear, *Masters or Servants?*, New York and London, 1977, pp. 6–7, 8, 10, repr. fig. 1; Marcia Pointon, 'Gainsborough and the Landscape of Retirement,' *Art History*, vol. 2, no. 4, December 1979, p. 453; John Barrell, *The Dark Side of the Landscape*, Cambridge, 1980, p. 70; Tate Gallery, 1980–81, pp. 42, 127–8, repr. fig. 18; Grand Palais, 1981, pp. 46, 50, 141, repr. fig. 45 (wrong illustration repr.); Lindsay, pp. 143, 195.

The most majestic of Gainsborough's 'Cottage Door' compositions, based on a pyramid (of figures) within a pyramid, the background being evolved from the Rutland landscape painted two or three years earlier (cat. no. 120). The mother holding a baby in the strongly spotlit figure group stands out even more prominently than in the Rutland *The Woodcutter's Return* (cat. no. 105) and is a sentimental image in her own right, comparable with the figures in Gainsborough's 'fancy pictures' of the 1780s. Some early commentaries on this image are worth quoting in full, since they provide a valuable indication of how writers in the romantic period responded to Gainsborough's artifice. The critic of the *Literary Gazette*, 1818 (presumably W. H. Pyne) (cited above), wrote, 'The beauty of the female figure is too delightful to be questioned, though perhaps the artist has gone as far in giving it grace and elegance as his subject would permit. It does not injure that powerful impression of nature which is exhibited in the entire scene, nor that simplicity which even in his ordinary beggar children is so captivating to every eye. . . . It is said that the Duchess of Devonshire sat for this lovely cottager'. (The last assertion cannot be substantiated.) The poet and critic, George Darley, wrote to Allan Cunningham in 1828 (Abbott, 1928, cited above), 'The Matron herself is, perhaps, the most *natural* beau-ideal of a youthful Cottage Dame, on canvas: rustic beauty exalted by a gentility of expression which we seldom find in the peasant countenance, if ever.' The tree-trunk on the right now has a visual life of its own, and the foliage is richly romantic in character: an extraordinary leap forward within the context of the style first developed in the Rutland landscape. The tonal quality characteristic of this period heightens the mood of the picture. J. M. W. Turner (cited above) spoke of its 'pure and artless innocence' and as 'possessing truth of forms arising from his [Gainsborough's] close contact

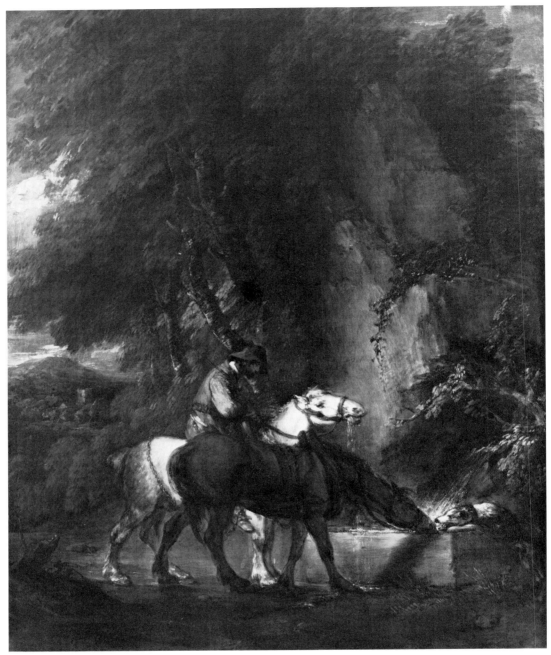

124

with nature'. John Britton (cited above) called it 'as strictly poetical as Thomson's Seasons'. As Marcia Pointon has pointed out (cited above), one critic saw the picture in terms of the poetry of retirement when it was exhibited in 1780: 'This beautiful scene where serenity and pleasure dwell in every spot, and the lovely figures [are] composed in the finest rural style, their situation worthy of them, forms a scene of happiness that may truly be called Adam's paradise' (Whitley, p. 170). The picture was displayed on its own, in the Tent Room at 40, Hill Street, London, when it was in Sir John Leicester's collection (Carey, cited above; see also p. 183). What may be a repetition by Gainsborough was formerly in the collection of Mrs Benjamin F. Jones (see Cincinnati,

1931 (24, repr. pl. 19), and Jones sale, Parke-Bernet's, New York, 4–5 December 1941, lot 24 (repr.)), but the available reproductions are inadequate for forming a judgment. Several copies of this celebrated composition exist, including a reduced copy by Mrs Coppin now in the Castle Museum, Norwich; one by Crome is no longer extant (see p. 266). Also mentioned on pp. 133, 155,167, 176, 180, 183, 267, 280, 285; a detail is repr. pl. 201.

DATING Identifiable as RA, 1780 (62) from the description given by an anonymous reviewer: 'The Artist seems to have neglected his Landscape to display the whole force of his genius in a beautiful groupe [sic] of children and their mother' (anon., *A Candid Review of the Exhibition*, London, 1780, p. 19).

**124a** Study for cat. no. 124. Brown wash, heightened with white, varnished. $9\frac{9}{16} \times 7\frac{5}{16}$ / 24.3 × 18.6. Ownership unknown.

## 124 Rocky Wooded Landscape with Mounted Drover, Horses watering at a Trough and Distant Village and Mountain

Canvas. $48\frac{1}{2} \times 39$   123.2 × 99.1
Painted in 1780

British Rail Pension Fund (on indefinite loan to the Iveagh Bequest, Kenwood)

ENGRAVINGS Mezzotinted by Henry Dawe; the lower half of the composition mezzotinted and published by D. Rymer; mezzotinted by A. N. Sanders, 1876.

PROVENANCE Possibly J. W. Steers, 1797 (see Farington, cited below); possibly Lord Robert Spencer (d. 1831) (see Farington, cited below) and Spencer sale, Christie's, 31 May 1799, lot 93, bt Foster; Sir John Leicester (later Lord de Tabley, 1762–1827); Thomas Lyster Parker (d. 1819), from whom it was purchased by William, 1st Earl of Lonsdale (1757–1844) by 1814; Lonsdale sale, Christie's, 8 March 1879, lot 7, bt in; Lonsdale sale, Christie's, 13–18 June 1887, 6th day (18 June), lot 910, bt Agnew; Sir Charles Tennant (1823–1906); by descent to Christopher, 2nd Lord Glenconner (b. 1899); with Howard Young, New York, 1930; purchased by Mr and Mrs Charles Finn Williams, Cincinnati, 1937;

by descent to Charles M. Williams, from whom it was purchased by Newhouse Galleries, New York, 1978, and sold to the present owners.

EXHIBITIONS RA, 1780 (74); BI, 1814 (68); BI, 1843 (182); BI, 1859 (169); RA, 1876 (40); 'International Exhibition', Glasgow, 1888 (195); 'Loan Collection of Pictures', Corporation of London Art Gallery, 1894 (94); 'Loan Collection of Pictures of French and British Artists of the 18th Century', Glasgow Art Gallery, 1902 (108); '18th Century English Painting', Fogg Art Museum, Harvard, 1930 (28); Cincinnati, 1931 (28, repr. pl. 41); 'English Painting of the Late 18th and Early 19th Centuries', California Palace of the Legion of Honor, San Francisco, 1933 (19); 'Opening Exhibition', Springfield Museum of Fine Arts, Springfield, 1933 (12); 'Paintings from the Collection of Mr and Mrs Charles Finn Williams', Art Museum, Cincinnati, 1937 (10, repr.); 'A Survey of British Painting', Carnegie Institute, Pittsburgh, May–June 1938 (35); 'Paintings from the Collection of Mr and Mrs Charles F. Williams', Art Museum, Cincinnati, October 1939–January 1940; 'European & American Paintings 1500–1900: Masterpieces of Art', New York World's Fair, May–October (154); 'Masterpieces of Art', Art Museum, Cincinnati,

January–February 1941 (22); Tate Gallery, 1980–81 (143, repr.).

BIBLIOGRAPHY Anon., *A Candid Review of the Exhibition*, London, 1780, p. 20; possibly Farington Diary, 12 November 1797 ('Steers has bought a picture of Gainsborough "Horses at a Fountain" for 50 guineas') and 17 November 1797 (Kenneth Garlick and Angus Macintyre, ed., *The Diary of Joseph Farington*, New Haven and London, vol. III, 1979, pp. 922, 924); possibly ibid., 2 March 1802: 'Called with Daniell at Parkes in Dean St. and saw . . . Horses drinking by Gainsborough, which was Lord Robert Spencers' (Garlick and Macintyre, op. cit., vol. v, 1979, p. 1754); Fulcher, pp. 116, 188, 201; *Engravings from the Work of Thomas Gainsborough, R.A.*, published by Henry Graves & Company, London, n.d. [c. 1880], no. 119; William Ernest Henry, *A Century of Artists: A memorial of the Glasgow International Exhibition 1888*, Glasgow, 1889, pp. 69–70; C. Morland Agnew, *Catalogue of the Pictures forming the collection of Sir Charles Tennant Bart.*, 1896, p. 31, repr. facing; Armstrong, 1898, pp. 184, 208; Max Roldit, 'The Picture Collection of Sir Charles Tennant, Bart.', *Connoisseur*, September 1901, p. 7, repr. p. 3; Armstrong, 1904, pp. 250, 283; Algernon Graves, *The Royal Academy of Arts*, vol. III, London, 1905, p. 1921; James Greig, ed., *Farington Diary*, London, vol. I, 1922, p. 340; Walter Heil, 'Die Gainsborough-Ausstellung in Cincinnati', *Pantheon*, September 1931, pp. 70, 384, repr. p. 382; Woodall, *Drawings*, p. 142; 'Art at the Fair', *Art News Annual Supplement*, 1940, p. 43; Waterhouse, p. 40, no. 944; Hayes, *Drawings*, pp. 38, 79, 219.

A rough sketch for the central motif of the composition was formerly in the Schniewind collection (124a; Hayes, *Drawings*, no. 480): in the finished picture the pose of the white horse has been altered, there is a vista on the left with distant village and mountain and, on the right, a dog is also drinking at the trough. The subject is unique in Gainsborough's *oeuvre*, and may derive from such Dutch pictures as the small panel by Jan Both in the National Gallery of Ireland (no. 706), in which the motif of a white horse drinking at a trough is the central feature. Large, picturesque rocks are here used for the first time in Gainsborough's landscapes, and they make a natural complement to the richly romantic foliage which envelops the canvas. The picture is tonal in character, and the only warm tints are the rough pinks and yellows at the horizon and the red of the drover's jacket (the use of red in the garments of Gainsborough's figures is, as we have seen, characteristic). The tilt of the drover's head recalls the similarly poetic motif in the Bowood picture (cat. no. 110). A copy, of the same size as the original, in the Whitbread Collection at Southill (Waterhouse, no. 943), is presumably identifiable with 'A Copy by [S.W.] Reynolds of Gainsborough's Horses drinking' recorded in the Southill inventory of 1816 (pl. 338 and p. 281). At least two other copies exist, including one in the Lady Lever Art Gallery, Port Sunlight; an exact copy of the lower half of the composition, early nineteenth century in date, is in the Victoria and Albert Museum (see pl. 339 and p. 281). An adaptation of the composition, with a shepherd and flock of sheep on the left and a cow instead of a horse drinking, probably by a Scottish artist of the early to mid-nineteenth century, is in an English private collection.

DATING Identifiable as RA, 1780 (74) from the description given by an anonymous reviewer: 'A rocky, Woody scene, from whence a fall of water issues. Two horses and a dog are drinking at the fall, and with the Countryman who is upon one of the horses, form a groupe [sic] which is inimitably fine. We esteem this to be his best Landscape, this year' (*A Candid Review of the Exhibition*, London, 1780, p. 20).

## 125 Wooded River Landscape with Rustic Lovers examining a Tombstone in a Graveyard, Ruined Church, Goats, Shepherd and Sheep (The Country Churchyard)

Canvas. Size unknown
Painted in 1780

Dismembered.

ENGRAVINGS Related soft-ground etching by Gainsborough, c. 1779–80 (125c; see below); aquatinted in reverse by M. C. Prestal as the *Country Churchyard*, inscribed, by permission, to Sir Joshua Reynolds, and published by Robert Pollard, 12 May 1790.

PROVENANCE Kirkman; anon. [Kirkman] sale, Christie's, 1 May 1790, bt in; anon. [Tapᵗ] sale, Christie's, 4–5 March 1803, 2nd day, lot 54, bt in; Jaubert; anon. [Jaubert] sale, Christie's, 20 May 1803, lot 64, bt in; perhaps George, 1st Duke of Sutherland (1758–1833); the picture was cut up at some point in the nineteenth century and only two pieces survive: (1) the fragment showing the two peasants studying the tombstone, which was owned by Lord Ronald Sutherland Gower (1845–1916); Gower sale, Christie's, 28 January 1911, lot 41, bt Parsons; (2) a larger fragment, showing part of the landscape background, which was in the collection of the Dukes of Sutherland, and has descended in the family.

EXHIBITIONS RA, 1780 (319); RA, 1907 (145, fragment).

BIBLIOGRAPHY *St James's Chronicle*, 29 April–2 May 1780; anon., *A Candid Review of the Exhibition*, London, 1780, p. 30; *Morning Chronicle*, 8 August 1788; *London Chronicle*, 7–9 August 1788; Fulcher, pp. 116, 188; Gower, pp. 123, 127, repr. between pp. 118 and 119, the fragment with peasants studying the tombstone repr. facing p. 118; Algernon Graves, *The Royal Academy of Arts*, vol. III, London, 1905, p. 192; Menpes and Greig, pp. 175, 178 (listed twice); Whitley, p. 170; Chauncey Brewster Tinker, *Painter and Poet*, Cambridge, Mass., 1938, p. 74, repr. frontispiece; Waterhouse, p. 30, nos 942, 1000a; John Hayes, 'Gainsborough's Later Land-

the lights are painted in thick, encrusted impasto, the sea is grey, and the effects of the gale are heightened by the powerful diagonals of the composition. The waves breaking on the shore are superbly rendered. A companion to this coastal scene was commissioned from de Loutherbourg by its purchaser, Earl Grosvenor. A small copy was in the C. H. C. P. Burney sale, Christie's, 20 June 1930, lot 129, bt Waters. Also mentioned on pp. 138–9, 164, 182, 291.

DATING Identifiable as RA, 1781 (94) from the description given by the critic of the *Morning Chronicle* (5 May 1781): 'The clouds seem in motion, the waves to be retiring from the beach, and the fishing-boats really float on the waves. We admire the comeliness and native grace of the female peasants; and we long to sit by the Shepherd on the cliff.'

## 128 River Landscape with Rustic Lovers, Mounted Herdsman driving Cattle and Sheep over a Bridge and Ruined Castle

Canvas. Oval: $48\frac{1}{4} \times 64\frac{1}{4}$  122.6 × 163.2
Painted in 1781

C. M. Michaelis, Rycote Park

ENGRAVING Related soft-ground etching by Gainsborough, *c.* 1779–80 (128b; see below).

PROVENANCE Reputed to have been selected from among the artist's works, in exchange for a violin, by Oldfield Bowles (1739–1810), of North Aston, Oxfordshire; anon [Colonel Bowles] sale, Christie's, 25 May 1850, lot 11 (as 'taken from Gainsbros studio'), bt in; H. M. Skrine, Warleigh Manor, near Bath, 1904; Sir Max Michaelis (d. 1932), Cape Town; thence by descent.

EXHIBITIONS RA, 1781 (426); Nottingham, 1962 (21); 'Englische Malerei der grossen Zeit von Hogarth bis Turner', Wallraf-Richartz Museum, Cologne, and Palazzo Venezia, Rome, October–December 1966 (21, repr.); 'English Landscape Painting of the 18th and 19th Centuries', National Museum of Western Art, Tokyo, and Kyoto National Museum of Modern Art, Kyoto, October 1970–January 1971 (23, repr.); 'Zwei Jahrhunderte Englische Malerei: Britische Kunst und Europa 1680 bis 1880', Haus der Kunst, Munich, November 1979–January 1980 (37, repr.); 'Life and Landscape in Britain 1670–1870', Agnew's, June–July 1981 (14, repr. col. frontispiece).

BIBLIOGRAPHY *Morning Herald*, 1 May 1781; *London Courant*, 8 May 1781; *Gazetteer*, 12 May 1781; *Morning Herald*, 7 June 1781; *The Ear-Wig*, London, 1781; Fulcher, pp. 189, 234; Armstrong, 1898, p. 207; Armstrong, 1904, p. 289; Algernon Graves, *The Royal Academy of Arts*, vol. III, London, 1905, p. 192; Whitley, p. 176; William T. Whitley, 'An Eighteenth-Century Art Chronicler: Sir Henry Bate Dudley, Bart.', *The Walpole Society*, vol. XIII, Oxford, 1925, p. 41; Waterhouse, pp. 31, 44, no. 959, repr. pl. 220; John Hayes,

'Gainsborough's Later Landscapes', *Apollo*, July 1964, p. 25, repr. fig. 7; Gatt, p. 35, repr. pls 46, 47 (col.); Hayes, *Drawings*, pp. 38, 223–4; Hayes, *Printmaker*, p. 75, repr. pl. 67; Herrmann, pp. 100–101; Paulson, p. 247; British Museum, 1978, p. 18.

A drawing dating from the mid- to late-1770s, in which the cows are moving in the opposite direction and there is a rowing boat beside the bridge, seems to be a first idea for this painting (128a; Hayes, *Drawings*, no. 425). The soft-ground etching of this subject (128b; Hayes, *Printmaker*, no. 11) bears the date 1 February 1780, about fifteen months before the exhibition of the picture. A drawing in the Witt Collection (128c; Hayes, *Drawings*, no. 498) is considerably more developed than the print, and is evidently related to the painting. Two cows in single file ahead of the mounted herdsman have replaced the three cows and less positive forward movement, a flock of sheep has been introduced in front of the cows and a dog included behind the horseman to enhance the rhythm of the design, and a roughly highlit tree-trunk has been added to enliven the foreground. The changes subsequent to the sketch are few but significant. In the finished painting the second cow is shown bellowing, and the introduction of a less humped-back, single-arch bridge, the placid stretch of water on the left and the addition of the arched gateway to the ruined castle, all contribute towards a more monumental effect. There are slight pentimenti in the figures on the left (the man seems to have had a pack on his back) and in the position of the legs of the foremost sheep. The canvas is not painted under the spandrels of the oval frame. The ruined castle, which, in conjunction with the emphatic cloud arrangement, stabilizes the whole composition, is a motif developed from the Fairhaven coastal scene (cat. no. 126). The broad glow from the horizon suffuses the whole picture, and the poetic mood is enhanced by the reflections in the water. The general effect may have influenced Gilpin in the oval plates which illustrate his *Tours*. The motif of cows being driven across a bridge is found in Hubert Robert (compare *The Bridge* in the Musée Fabre, Montpellier, no. 837-1-76). Walpole commented on the picture when it was exhibited, 'Some parts very fine' (Graves, cited above). Also mentioned on pp. 137–8, 182.

DATING Identifiable as RA, 1781 (426) from contemporary descriptions. Bate-Dudley described it as a 'landscape of cattle passing a bridge' (*Morning Herald*, 1 May 1781). The critic of the *London Courant* (8 May 1781) commented, 'In viewing this picture from the other side of the room, nothing can equal it. It is in a broad masterly style; and the principal light being in the centre, upon the white cow, is extremely well contrived; the other lights are kept down, and made subservient to it; the figures well grouped, and the lines happily contrasted.' The critic of the *Gazetteer* (12 May 1781) wrote, 'The sky is light and aerial, the distance harmonious, the chiaro scuro well preserved, the figures well grouped, and inimitably painted, and the *tout ensemble* makes a most capital picture.'

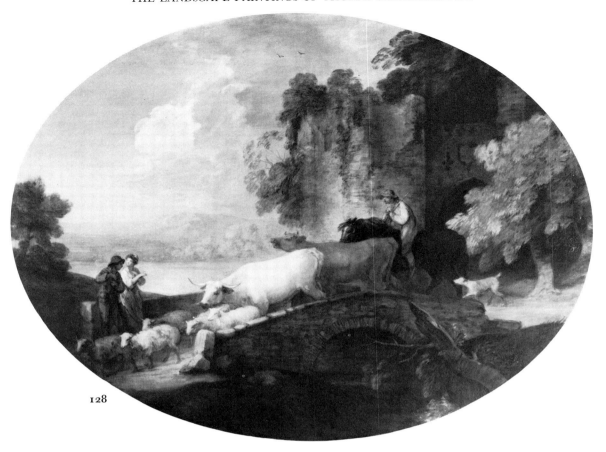

128

**128a** Drawing related to cat. no. 128. Black chalk and stump and white chalk on grey paper. $10 \times 12\frac{1}{2}$ / 25.4 × 31.7. Ownership unknown.

**129  Coastal Scene with Rocky Cliffs, Sailing Boats, Fishermen netting and Rowing Boat setting out**

Canvas. 40⅛ × 50¼    101.9 × 127.6
Painted *c.* 1781–2

National Gallery of Art, Washington, D.C.

PROVENANCE Possibly by descent to Margaret Gainsborough (see Farington Diary, cited below); probably Augustine Greenland sale, Christie's, 25–28 January 1804, 4th day, lot 43, bt Birch; probably with William Derman, from whom it was purchased 1805 by Sir John Leicester (later Lord de Tabley, 1762–1827) (see Hall, cited below); de Tabley sale, Christie's, 7 July 1827, lot 27, bt Smith for Sir George Richard Philips (b. 1789); thence by descent to Robert, 3rd Earl of Camperdown (1841–1918); anon. [Camperdown] sale, Christie's, 21 February 1919, lot 134 (repr.), bt Knoedler, from whom it was purchased by the Hon. Andrew W. Mellon, 1920; by descent to Mrs Robert Mellon Bruce, who bequeathed it to the National Gallery of Art, Washington.

EXHIBITIONS BI, 1814 (30); BI, 1832 (66); BI, 1863 (185); Tate Gallery, 1980–81 (144, repr.); Grand Palais, 1981 (67, repr.).

BIBLIOGRAPHY Possibly Farington Diary, 8 February 1799 (Kenneth Garlick and Angus Macintyre, *The Diary of Joseph Farington*, New Haven and London, vol. IV, 1979, p. 1153); *Morning Post*, 6 August 1814; anon. [William Carey], *A Catalogue of Pictures, by British Artists, in the Collection of Sir John Leicester, Bart.*, London, 1819, no. 3, p. 4 (descriptive ed., pp. 10–13); John Young, *A Catalogue of Pictures by British Artists, in the Possession of Sir John Fleming Leicester, Bart.*, London, 1821, no. 40, p. 18, etched facing; Fulcher, pp. 143–5, 198; George M. Brock-Arnold, *Gainsborough*, London, 1881, p. 68; Armstrong, 1898, p. 160; Armstrong, 1904, p. 214; Waterhouse, p. 31, no. 954, repr. pl. 224; Douglas Hall, 'The Tabley House Papers', *The Walpole Society*, vol. XXXVIII, Glasgow, 1962, p. 70; Hayes, *Drawings*, pp. 32, 221; Paulson, p. 247; John Walker, *National Gallery of Art Washington*, New York, n.d. [1975], p. 357, repr. col.; Andrew Wilton, *The Life and Work of J. M. W. Turner*, London, 1979, p. 62.

A study, of which another version is owned by Eva Andresen (Hayes, *Drawings*, no. 487, pl. 151), was with Sidney Sabin in 1972 (129a). In the finished picture the composition is reversed, an extra figure is helping to push out the boat, the two fishermen with the net are differently arranged and another figure is added; the two figures and anchor on the left were at first included but replaced by a large rock in the course of painting (the pentimento was first noticed by William Carey, cited above, p. 13). The design is based on diagonals which meet in the foam in the centre of the picture. The whole conception is close to the Grosvenor sea-piece (cat. no. 127), but in reverse: there is a similar *repoussoir* foreground, and the sea is similarly greyish, with waves and foam brilliantly rendered, the air full of moisture, and a superb sense of recession. Gainsborough has taken up the rock forms he had first used in the Williams and Fairhaven pictures (cat. nos. 124, 126) and employed them here to monumental effect. A small copy was in the C. H. C. P. Burney sale, Christie's, 20 June 1930, lot 129, bt Waters (see cat. no. 127). Also mentioned on pp. 139, 164.

DATING Closely related to cat. no. 127 in the generally pale greyish-brown tonality, the use of pale tints in the sky, the treatment of the clouds (with no gradations of tone), the modelling of the rocks in thick impasto over tones of greyish-brown, the rapidly handled foreground *repoussoir* and the sweep of the composition.

**130  Coastal Scene with Figures in Sailing Boats and Rowing Boat and on the Shore, and Milkmaid and Cows on a Bank**

Canvas. 30 × 25    76.2 × 63.5
Painted *c.* 1781–2

Hon. Colin Tennant, London

PROVENANCE Peter Delmé and Delmé sale, Christie's, 13 February 1790, lot 16 (though there described as 'A sea port with cattle and figures'), bt Sir Charles Long (later Lord Farnborough, 1751–1838); by descent to Samuel Long; Long sale, Christie's, 11 March 1882, lot 155, bt Agnew; James Price; sold in 1889 to Agnew, from whom it was purchased in 1890 by Sir Charles Tennant (1823–1906); thence by descent.

EXHIBITIONS BI, 1814 (54); BI, 1843 (156); RA, 1895 (18); 'Illustrating Georgian England', Whitechapel Art Gallery, spring 1906 (53); Arts Council, 1953 (44); 'The 18th Century and after', Leggatt's, autumn 1958 (49); Nottingham, 1962 (22, repr.); 'Shock of Recognition: The Landscape of English Romanticism and the Dutch Seventeenth-century School', Mauritshuis, The Hague, November 1970–January 1971 and Tate Gallery, January–February 1971 (33, repr.); 'Master Paintings 1470–1820', Agnew's, May–July 1982 (4, repr.).

BIBLIOGRAPHY *Morning Herald*, 4 March 1790; Fulcher, p. 200; C. Morland Agnew, *Catalogue of the Pictures forming the collection of Sir Charles Tennant Bart.*, 1896, p. 25, repr. facing; Armstrong, 1898, p. 208; Armstrong, 1904, p. 289; Woodall, *Drawings*, pp. 108, 142; Waterhouse, no. 958, repr. pl. 200.

The composition has a fine baroque sweep, but the idea of including a milkmaid milking cows in such a position seems artificial. The motif of cows on a promontory overlooking the sea is, however, common in Dutch art. The thin handling and pale tone are reminiscent of the Fairhaven coastal scene (cat. no. 126). At least three copies are extant; one of these may be the picture described by Bate-Dudley as 'the *copy* now for sale, in Mr

130

Christie's rooms, of *Cattle on a Bank*, *Water*, and a *Vessel* or Two.—The original lately was sold in Mr DELME's Collection' (see p. 285). Also mentioned on p. 164.

DATING Closely related to cat. no. 127 in the pale muted tonality, the pale tints in the sky, the grey clouds (with no gradations in tone to the rich impasto in the lights), the rapidly painted brown foreground, the thin handling of the shadows throughout and the sweep of the composition. The modelling of the broadly painted cows is very similar to cat. no. 128.

**131  Wooded Landscape with Shepherd and Flock of Sheep at a Pool, Peasant sleeping by a Cart and Two Carthorses**

Canvas. $38\frac{1}{2} \times 49$   $97.8 \times 124.5$
Painted *c.* 1781–2

Duke of Rutland, Belvoir Castle

PROVENANCE  Purchased from the artist by Charles, 4th Duke of Rutland (1754–87); thence by descent.

EXHIBITIONS  'Pictures by Old Masters', Agnew's, 1924

(26); 'Works of Art from Midland Houses', City of Birmingham Museum and Art Gallery, July–September 1953 (28).

BIBLIOGRAPHY  *Morning Herald*, 25 August 1789; J. P. Neale, *Views of The Seats of Noblemen and Gentlemen*, London, 1829, vol. 1 (unpaginated); Rev. Irvin Eller, *The History of Belvoir Castle*, London, 1841, p. 210; Dr Waagen, *Treasures of Art in Great Britain*, London, 1854, vol. III, p. 398; Fulcher, p. 231; Armstrong, 1898, p. 207; Gower, 1903, repr. opposite p. 30; Lady Victoria Manners, 'Notes on Pictures at Belvoir Castle: Part I', *Connoisseur*, September 1903, p. 13; ibid., 'The Art Treasures at Belvoir Castle: Part I', *Connoisseur*, December 1908, pp. 211–12, repr. p. 214; Armstrong, 1904, p. 289 (listed twice); Whitley, pp. 186, 332; R. R. Tatlock, 'Old Masters at Messrs. Agnew', *Burlington Magazine*, July 1924, p. 35, repr. pl. IIB; Woodall, *Drawings*, pp. 60–64, 133; Waterhouse, p. 19, no. 963; Hayes, *Drawings*, p. 218.

A study is in the possession of Sir Guy Millard (131a; Hayes, *Drawings*, no. 473). The only changes made in the finished picture were incidental: the ommission of the

494

shed on the left, and the inclusion of a basket of fodder for the chestnut horse and of a boy sleeping on the shafts of the cart. Pentimenti are visible in the legs of the white horse. The composition is lateral in arrangement, and the mood serene and peaceful. The motif of horses loosed from their cart, and of the drover asleep, is new in Gainsborough's work. The subdued tonality is relieved by a touch of scarlet in the harness on the left, and by touches of red in the chestnut horse. Also mentioned on pp. 141, 182.

DATING Closely related to cat. no. 128 in the dull grey-green tonality, the fluid handling of the foliage, the outlining of the tree-trunk on the right and the modelling of the sheep in thick impasto. The tonal quality, with the whole picture drained of warm colour, the loose impasto in the lights in the sky, the suggestion of light breaking through the trees, the fluid, generalized handling of the bushy foliage, the broad and rapidly painted foreground and the motif of the animals in silhouette are also related to cat. no. 135.

## 132  Wooded Landscape with Herdsman driving Cattle past a Pool

Transparency on glass. $11 \times 13\frac{1}{4}$   $27.9 \times 33.7$
Painted $c$. 1781–2

Victoria and Albert Museum, London (P.32–1955)

PROVENANCE Purchased from Margaret Gainsborough (1752–1820) by Dr Thomas Monro (1759–1833); Monro sale, Christie's, 26 June 1833 ff., 3rd day (28 June), lot 168, bt W. White, who bequeathed it to G. W. Reid; anon. [Buck Reid] sale, Christie's, 29 March 1890, lot 132, bt in; Leopold Hirsch; Hirsch sale, Christie's, 11 May 1934, lot 104, bt Gooden and Fox for Ernest E. Cook; bequeathed to the Victoria and Albert Museum, through the National Art-Collections Fund, 1955.

EXHIBITION GG, 1885 (394).

BIBLIOGRAPHY Waterhouse, no. 979; Jonathan Mayne, 'Thomas Gainsborough's Exhibition Box', *Victoria and Albert Museum Bulletin*, vol. 1, no. 3, July 1965, repr. fig. 4.

Gainsborough was familiar with transparency painting, and had himself painted transparencies for the decoration of Bach and Abel's concert rooms in Hanover Square, London, opened in February 1775; but it seems to have been de Loutherbourg's *Eidophusikon*, first shown in February 1781, which inspired his own 'peep-show' for displaying his ideas for landscapes (see pp. 140–42). Gainsborough's rather amateurish box (pls 171, 172) consisted of a large storage space, containing twelve slats, to house his transparencies; a system of cords and pulleys to hoist the desired transparency into position; four slats behind this position, into any one of which could be inserted a semi-transparent silk screen; and, at the back,

five candle-holders. The spectator viewed the transparencies through a large round peep-hole, fitted with a magnifying lens, in the front of the box. The lens could be adjusted to between $25\frac{1}{2}$ and $34\frac{1}{2}$ inches of the projected transparency, thus producing an image with a magnification of between two-and-a-half and five times the size of the original, according to the length of adjustment. The light transmitted from the candles behind, albeit diffused through the silk screen, produced a luminosity close to that in nature impossible to achieve in oil painting on an opaque support. It is not known whether the transparencies were intended to be viewed with the painted surface facing the candle or the spectator; there is optical evidence to favour the former method, but this matter, and others connected with the box, require further investigation (the reproductions in the present catalogue are all of the painted surface). (I am grateful to Mr Lionel Lambourne and Mr John Murdoch, of the Victoria and Albert Museum, for their help, and for allowing me to examine the official file.) Gainsborough must have painted numerous transparencies for showing in his box, but only ten survive (this one and cat. nos 133, 134, 139, 140, 154, 155, 172, 173 and 177): all these are completely tonal in quality, executed in a range of blues, greens and browns, and Gainsborough's aim was clearly to heighten and dramatize his effects of light. In this case the effect is the reflected light in the pool at which the cows have just been watering. Also mentioned on pp. 140–41.

DATING Closely related to cat. no. 131 in the dull, subdued tonality, the handling of the soft, bushy foliage, and the composition, with its strongly lit foreground pool, lateral conception and absence of distance.

## 133  Wooded Landscape with Herdsman driving Two Cows towards a Pool

Transparency on glass. $11 \times 13\frac{1}{4}$   $27.9 \times 33.7$
Painted $c$. 1781–2

Victoria and Albert Museum, London (P.35–1955)

ENGRAVING Mezzotinted by S. W. Reynolds and published by W. B. Cooke, 1 April 1824 (published in *Gems of Art*, London, 1848, pl. 18).

PROVENANCE Purchased from Margaret Gainsborough (1752–1820) by Dr Thomas Monro (1759–1833); Monro sale, Christie's, 26 June 1833 ff., 3rd day (28 June), lot 168, bt W. White, who bequeathed it to G. W. Reid; anon [Buck Reid] sale, Christie's, 29 March 1890, lot 132, bt in; Leopold Hirsch; Hirsch sale, Christie's, 11 May 1934, lot 104, bt Gooden and Fox for Ernest E. Cook; bequeathed to the Victoria and Albert Museum, through the National Art-Collections Fund, 1955.

EXHIBITIONS W. B. Cooke's 'Exhibition of Drawings', 9 Soho Square, London, 1824, p. 14; GG, 1885 (394).

BIBLIOGRAPHY Waterhouse, no. 970, repr. pl. 261; Jonathan Mayne, 'Thomas Gainsborough's Exhibition

134

Box', *Victoria and Albert Museum Bulletin*, vol. 1, no. 3, July 1965, repr. fig. 10; Gatt, pp. 10, 37–8, repr. pl. 54 (col.).

See under cat. no. 132. The effect of light in the pool and the drooping heads of the cows emphasize the poetic, pastoral character of the scene. The dead tree-trunk is used as a compositional stress somewhat similar to the tree Gainsborough had painted in during the course of developing the design for *Repose* (cat. no. 119). Also mentioned on p. 141.

DATING Identical with cat. no. 132 in the rapid handling of the soft, bushy foliage, the outlining of the tree-trunks, the fluid treatment of the foreground, and the generalized distance. The motif of the cow silhouetted against the pool is similar to cat. no. 135.

## 134  Wooded Moonlight Landscape with Pool and Figure at the Door of a Cottage

Transparency on glass. $11 \times 13\frac{1}{4}$   27.9 × 33.7
Painted *c.* 1781–2

Victoria and Albert Museum, London (P.33–1955)

ENGRAVING Mezzotinted by S. W. Reynolds and published by W. B. Cooke, 2 April 1824 (published in *Gems of Art*, London, 1848, pl. 17).

PROVENANCE Purchased from Margaret Gainsborough (1752–1820) by Dr Thomas Monro (1759–1833); Monro sale, Christie's, 26 June 1833 ff., 3rd day (28 June), lot 168, bt W. White, who bequeathed it to G. W. Reid; anon. [Buck Reid] sale, Christie's, 29 March 1890, lot 132, bt in; Leopold Hirsch; Hirsch sale, Christie's, 11 May 1934, lot 104, bt Gooden and Fox for Ernest E. Cook; bequeathed to the Victoria and Albert Museum, through the National Art-Collections Fund, 1955.

EXHIBITIONS W. B. Cooke's 'Exhibition of Drawings', 9 Soho Square, London, 1824, p. 14; GG, 1885 (394); 'The Romantic Movement', Arts Council, Tate Gallery, 1959 (165); 'Landscape in Britain *c.* 1750–1850', Tate Gallery, November 1973–February 1974 (63, repr.); 'Thomas Gainsborough's Exhibition Box and Transparencies,' Gainsborough's House, Sudbury, June–July 1979 (2); Tate Gallery, 1980–81 (146, repr.).

BIBLIOGRAPHY *Somerset House Gazette*, 10 April 1824, ed. Ephraim Hardcastle [W. H. Pyne], London, 1824,

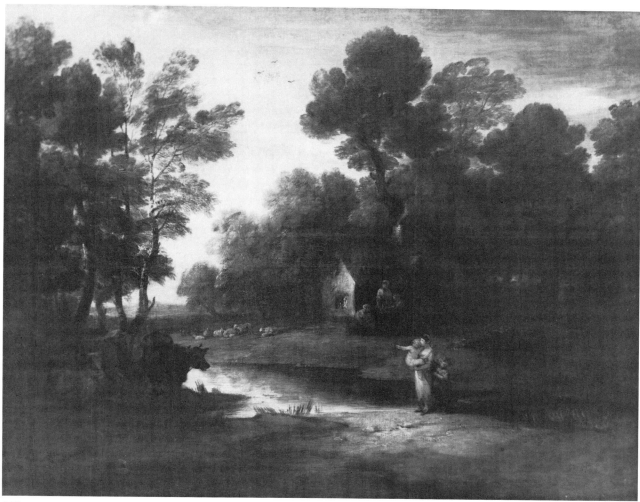

**135**

vol. 2, p. 8; Fulcher, pp. 124–5 (note); George M. Brock-Arnold, *Gainsborough*, London, 1881, p. 60; Boulton, p. 285; Waterhouse, p. 33, no. 971, repr. pl. 262; John Hayes, 'Gainsborough', *Journal of the Royal Society of Arts*, April 1965, repr. fig. 11; Jonathan Mayne, 'Thomas Gainsborough's Exhibition Box', *Victoria and Albert Museum Bulletin*, vol. 1, no. 3, July 1965, p. 21, repr. fig. 6; Gatt, pp. 10, 37–8, repr. pl. 55 (col.); Hayes, p. 222, repr. pl. 124; Grand Palais, 1981, p. 27, repr. fig. 16; Lindsay, p. 150.

See under cat. no. 132. This is the first occasion on which Gainsborough painted a moonlight scene and the first in which he tried out an indoor lighting effect: the window, and the doorway against which the figure is silhouetted, are brilliantly illumined by fire-light (the similar effect in the cottage window in the Rutland *The Woodcutter's Return* (cat. no. 105) is caused by the rays of the setting sun). Edward Edwards described the effects produced by Gainsborough's transparencies as 'truly captivating, especially in the moon-light pieces, which exhibit the most perfect resemblance of nature'. Also mentioned on pp. 141, 142.

DATING Identical with cat. no. 133 in the spindly tree-trunks, the rapid handling and highlighting of the soft, washy foliage, and the fluid treatment of the foreground. The motif of the cottage beside a pool is related to cat. no. 135.

### 135 Wooded Landscape with Figures outside a Cottage, Woodcutter returning, a Mother with Two Children watching Cows beyond a Pool, and Sheep

Canvas. 47 × 57   119.4 × 144.8
Painted in 1782

Private collection, London

PROVENANCE Joseph Gillott (1799–1873); Gillott sale, Christie's, 19 April–4 May 1872, 4th day (27 April), lot 287, bt Agnew for Kirkman D. Hodgson; purchased from R. K. Hodgson by Sir Edward Guinness (later 1st Earl of Iveagh, 1847–1927); inherited by Walter, 1st Lord Moyne, 1927; thence by descent.

EXHIBITIONS RA, 1782 (166); RA, 1903 (32); Bath, 1951 (24); 'Le Paysage Anglais de Gainsborough à Turner', British Council, Orangerie, Paris, 1953 (48, repr. pl. 10); Nottingham, 1962 (23, repr.); Grand Palais, 1981 (68, repr., p. 42).

BIBLIOGRAPHY *Morning Herald*, 1 May 1782; *London Courant*, 8 May 1782; Fulcher, p. 189; Armstrong, 1898, p. 206; Armstrong 1904, p. 287; Algernon Graves, *The Royal Academy of Arts*, vol. III, London, 1905, p. 192; Whitley, p. 185; Hugh Stokes, *Thomas Gainsborough*, London, 1925, p. 109; Mary Woodall, 'A Gainsborough "Cottage Door"', *Connoisseur*, October 1954, p. 110 (wrongly as cat. no. 105); Waterhouse, pp. 31, 32, 33 (wrongly as cat. no. 105), no 939, repr. pl. 180; John Hayes, 'Gainsborough and Rubens', *Apollo*, August 1963, p. 95, repr. fig. 11; John Hayes, 'Gainsborough', *Journal of the Royal Society of Arts*, April 1965, p. 321; Hayes, p. 222, repr. pl. 122; Dillian Gordon, *Second Sight: Rubens: The Watering Place/Gainsborough: The Watering Place*, National Gallery, London, 1981, p. 19; Lindsay, p. 152.

The brilliance of effect in this landscape is linked with those that Gainsborough was attempting to achieve in his transparencies (cat. nos 132–134), and the motif of the cow silhouetted against the pool was indeed used in one of these works (cat. no. 133). However, the group of trees on the left and the idea of silhouetting an animal against a stretch of water seem likely to be derived direct from Rubens: the moonlight scene in the Courtauld Institute Galleries (pl. 168), in which these features occur, had come into the possession of Sir Joshua Reynolds by 1778 and was used by him as an object-lesson in his Discourse to the Royal Academy that December. The broken effect of light in the window of the cottage is caused by the setting sun. The rich yellow impasto in the lights of the sky helps to unify the two halves of the composition. The figures outside the cottage are very sketchily painted; one of them is pointing out the woodcutter returning with his dog to a man seated smoking a pipe. Also mentioned on pp. 138, 141, 159; a detail is repr. pl. 181.

DATING Identifiable as RA, 1782 (166) from Bate-Dudley's review in the *Morning Herald* (1 May 1782): 'Mr. Gainsborough has exhibited but one Landscape— but that his *chef d'oeuvre* in this line. It is an evening, at Sun-set, representing a wood land scene, a sequestered cottage, cattle, peasants and their children before the cottage, and a woodman and his dog in the gloomy part of the scene, returning from labor; the whole heightened by a water and sky, that would have done honor to the most brilliant *Claude Lorain*!' Hitherto it has been assumed, wrongly, that this description refers to *The Woodcutter's Return* in the Rutland Collection at Belvoir (Whitley, pp. 185–6, followed by Waterhouse, no. 860); however, in the Rutland picture there are no cattle, the water adds nothing to the effect, and, although the woodman is certainly in shadow, he is right in the centre of the composition and by no means 'in the gloomy part of the scene'. Moreover, the Rutland painting must be a good deal earlier on stylistic grounds, and almost certainly dates from before February 1774 (see cat. nos 105, 106).

## 136 Rocky Wooded Landscape with Dell and Weir, Shepherd and Dog, Shepherd and Sheep on a High Bank, Mounted Peasant and another Figure, and Distant Village and Mountains

Canvas. $27\frac{1}{4} \times 36\frac{1}{2}$  69.2 × 92.7
Painted *c*. 1782–3

The Trustees of the late O. S. Ashcroft (on indefinite loan to the City Museum and Art Gallery, Birmingham)

PROVENANCE Possibly William Coningham and Coningham sale, Christie's, 9 June 1849, lot 22, bt Smith (this is the only picture known which the description could fit); F. C. K. Fleischmann, 1904; thence by descent.

EXHIBITIONS 'A well-known private collection of pictures of the Dutch and early English schools formed during the last 30 years', Agnew's, 1915 (2); 'Pictures Illustrative of the Evolution of Painting from the XVIIth Century to the Present Day', Castle Museum, Norwich, October–November 1925 (17); Ipswich, 1927 (60); Sassoon, 1936 (77, repr. *Souvenir*, pl. 70); 'La Peinture Anglaise XVIII$^e$ & XIX$^e$ Siècles', Louvre, Paris, 1938 (57, repr. *Souvenir*); Arts Council, 1949 (22); 'A Century of British Painting 1730–1830', British Council, Madrid and Lisbon, 1949 (19); 'Le Paysage Anglais de Gainsborough à Turner', British Council, Orangerie, Paris, 1953 (53, repr. pl. 7); 'Two Centuries of British Painting from Hogarth to Turner', British Council, National Gallery, Prague, and National Gallery of Slovakia, Bratislava, May–August 1969 (56, repr. pl. 13); 'Zwei Jahrhunderte Britischer Malerei: Das grosse Zeitalter von Hogarth bis Turner', British Council, Museum für Völkerkunde, Vienna, September–October 1969 (24, repr. pl. 9).

BIBLIOGRAPHY Armstrong, 1898, pp. 157–8, 205, repr. p. 157; Armstrong, 1904, pp. 211, 286; Alexander Watt, 'The Attitude of the French Public to the Paris Exhibition of British Art', *Apollo*, June 1938, repr. p. 297; Woodall, p. 98; Waterhouse, no. 967.

A rapidly sketched picture which is probably a preliminary essay for the Edinburgh mountain landscape (cat. no. 137): the composition is identical, except for the inclusion of a shepherd and his dog in the left foreground. The flowing rhythms characteristic of the sketch were preserved in the final canvas. If this was the picture owned by William Coningham (see above), a collector of Italian old masters, it is interesting that so sketchy a work should have been catalogued in the mid-nineteenth century as one of 'FOUR CAPITAL ENGLISH PICTURES'.

DATING Closely related to cat. no. 137 in the tonal quality and absence of warm colour, the smoothly painted, glowing horizon, the soft, fluid handling of the bushy foliage, the modelling of the rocks, with thick, dragged paint in the lights, the treatment of the woody dell, and the softly modelled mountains.

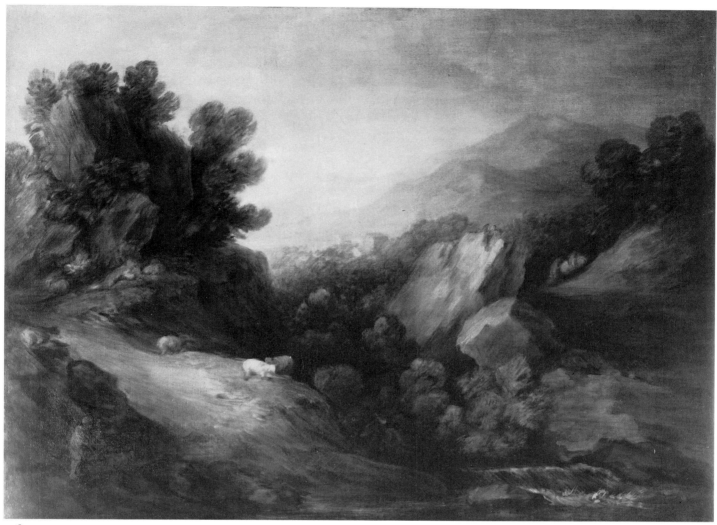

136

## 137 Rocky Wooded Landscape with Dell and Weir, Shepherd and Sheep on a High Bank, Mounted Peasant and another Figure, and Distant Village and Mountains

Canvas. $45\frac{3}{4} \times 56\frac{1}{2}$   116.2 × 143.5
Painted in 1783

National Gallery of Scotland, Edinburgh (2253)

PROVENANCE Schomberg House sale, March–May 1789, no. 72, bt Lord Gower (later 1st Duke of Sutherland, 1758–1833); by descent to George, 5th Duke of Sutherland, from whom it was purchased by the National Gallery of Scotland, through Agnew, 1962.

EXHIBITIONS RA, 1783 (34); Schomberg House, 1789 (72); 'National Exhibition of Works of Art', Exhibition Building, Leeds, 1868 (1005); 'The First Hundred Years of the Royal Academy 1769–1868', RA, 1951–2 (95); Arts Council, 1953 (45); 'British Painting in the Eighteenth Century', British Council, Montreal Museum of Fine Arts, National Gallery of Canada, Ottawa, Art Gallery of Toronto and Toledo Museum of Art, October 1957–March 1958 (19, repr. p. 110); 'The Romantic Movement', Arts Council, Tate Gallery, 1959 (164); 'Royal Academy of Arts Bicentenary Exhibition 1768–1968', RA, 1968 (147); 'Landscape in Britain c. 1750–1850', Tate Gallery, November 1973–February 1974 (59, repr. col.).

BIBLIOGRAPHY *Morning Herald*, 30 April 1783; *Morning Chronicle*, 30 April 1783; ibid., 10 May 1783; *Diary*, 8 April 1789; Fulcher, pp. 190, 194; Gower, p. 113, repr. facing p. 56; Armstrong, 1904, pp. 211, 286; Algernon Graves, *The Royal Academy of Arts*, vol. III, London, 1905, p. 193; Whitley, pp. 204, 325; William T. Whitley, *Artists and their Friends in England 1700–1799*, London, 1928, vol. 2, p. 382; E. K. Waterhouse, 'Gainsborough in Park Lane: Exhibition at Sir Philip Sassoon's', *Connoisseur*, March 1936, p. 124 (repr.); Woodall, *Drawings*, pp. 66–8, 69, 105, 130, repr. pl. 80; anon. [Tancred Borenius], 'Gainsborough's Collection of Pictures', *Burlington Magazine*, May 1944, p. 109; Ellis Waterhouse, 'The Sale at Schomberg House, 1789', *Burlington Magazine*, March 1945, p. 77; Woodall, p. 98; E. K. Waterhouse, 'The Exhibition "The First Hund-

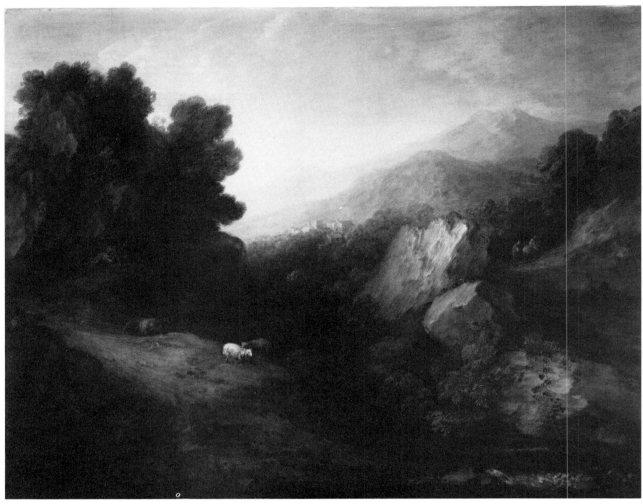

137

**137a** Study for cat. no. 137. Black chalk and stump and white chalk on brown paper. $10\frac{1}{8} \times 13\frac{7}{8}$ / 25.7 × 35.2 Cecil Higgins Art Gallery, Bedford (P.71).

red Years of the Royal Academy"', *Burlington Magazine*, February 1952, p. 51; Ellis Waterhouse, *Painting in Britain 1530–1790*, Harmondsworth, 1953, p. 190, repr. pl. 155; David Piper, 'Gainsborough at the Tate Gallery', *Burlington Magazine*, July 1953, p. 246; *Thirty Pictures in the Collection of His Grace The Duke of Sutherland*, London, 1957, p. 5, repr. p. 4; Waterhouse, pp. 31, 32, no. 966, repr. pl. 257; Woodall, *Letters*, p. 29; Hayes, *Drawings*, pp. 39, 239; Herrmann, pp. 102, 104, repr. pl. 100; Hugh Honour, *Romanticism*, London, 1979, pp. 59, 378, repr. pl. 23.

A study is in the Cecil Higgins Art Gallery (137a; Hayes, *Drawings*, no. 564). No changes were made in the finished picture, except for the inclusion of a village in the middle distance, the shepherd being shown reclining instead of standing, and some slight alterations in the disposition of the sheep. An oil which is probably a further sketch (cat. no. 136) introduces a shepherd and his dog in the left foreground, omitted in the completed composition. This is the first of Gainsborough's 'sublime' mountain scenes: in spite of the rhythmical flow of the distant mountains, an exceptional grandeur of effect is created by the dark mass of trees and rocks on the promontory, the breadth and smoothness of the glow at the horizon (contrasting with the broken Rubensian sunset effect of the Moyne landscape: cat. no. 135) and the massiveness of the thickly impasted rocks on the right. This picture marks the first appearance in Gainsborough of the sombre dell, a 'picturesque' element from now on to be a characteristic feature of his mountain landscapes. The handling is brilliant, sketchy and in places impressionistic; loose touches of green shimmer over the browns in the grassy bank on the left. The original brown glazes survive, enriching the modelling of the trees on the right. Walpole commented on the picture when it was exhibited, 'Gainsborough less excellent than he used to be' (Graves, cited above). Bate-Dudley (cited below) characterized it as 'a romantic view' (see also under cat. no. 138). A copy, entitled 'Burrington Combe', of roughly the same size as the original, was in an anon. sale, Christie's, 23 March 1956, lot 11. Also mentioned on pp. 131, 140, 163, 169, 175, 182, 237; a detail is repr. pl. 170.

DATING Identifiable as RA 1783 (34) from Bate-Dudley's review in the *Morning Herald* (30 April 1783): '*The landscape* by the same artist [Gainsborough] exhibits a romantic view; a precipice is the principal object in the foreground, with several figures, sheep, &c. descending to a rivulet that gushes through a cranny of the earth. The distances are well kept, and the sky beautifully coloured after nature.'

## 138 Rocky Wooded Landscape with Shepherd, Figure and Dog, Goat and Sheep at a Fountain, and Distant Village and Mountains

Canvas. $60\frac{1}{2} \times 73\frac{1}{2}$   $153.7 \times 186.7$
Painted *c*. 1783

Royal Academy of Arts, London

PROVENANCE Schomberg House sale, March–May 1789, no. 87; Margaret Gainsborough (1752–1820), who presented it, 'in compliance with the intention of her late father', as his diploma picture, 1799.

EXHIBITIONS Schomberg House, 1789 (87); BI, 1814 (55); BI, 1852 (148); BI, 1859 (75); 'The First Hundred Years of the Royal Academy 1769–1868', RA, 1951–2 (100); 'Diploma Works from the Royal Academy', Russell-Cotes Art Gallery, Bournemouth, June–September 1957 (805); 'Diploma and other Paintings by the Early Members of the Royal Academy', University Art Gallery, Nottingham, December 1959 (25); 'Treasures of the Royal Academy', RA, 1963 (32); 'Royal Academy of Arts Bicentenary Exhibition 1768–1968', RA, 1968 (896); 'Gaspard Dughet', Iveagh Bequest, Kenwood, July–September 1980 (81, repr.); Grand Palais, 1981 (69, repr., p. 42).

BIBLIOGRAPHY Farington Diary, 7 February 1797 (Kenneth Garlick and Angus Macintyre, ed., *The Diary of Joseph Farington*, New Haven and London, vol. III, 1979, p. 764); ibid., 10 February 1799 (ibid., vol. IV, 1979, pp. 1154–5); anon. [William Hazlitt], 'On Gainsborough's Pictures', *Champion*, 31 July 1814, p. 247; William Hazlitt, *Criticisms on Art*, London, 1843, p. 193 (note) (quoted from his article in the *Champion*, op. cit.); A Graduate of Oxford [John Ruskin], *Modern Painters*, vol. I, London 1846, pp. 91–2; Fulcher, pp. 78–9, 200; George M. Brock-Arnold, *Gainsborough*, London, 1881, pp. 66–7; Gower, p. 33; Whitley, pp. 66, 295; James Greig, ed., *Farington Diary*, London, vol. I, 1922, pp. 189 (7 February 1797), 189 (note); Hugh Stokes, *Thomas Gainsborough*, London, 1925, pp. 102–3; William T. Whitley, *Art in England 1800–1820*, Cambridge, 1928, pp. 204, 227, 229; Woodall, *Drawings*, p. 109; anon. [Tancred Borenius], 'Gainsborough's Collection of Pictures', *Burlington Magazine*, May 1944, p. 109; Waterhouse, no. 1007; Graham Reynolds, 'British Paintings from the Foundation [of the Royal Academy] to 1837', *Apollo*, January 1969, p. 32, repr. fig. 1; Hayes, *Drawings*, pp. 248, 275; Raymond Lister, *British Romantic Art*, London, 1973, repr. pl. 35; Michael Clarke, 'Gainsborough and Loutherbourg at York', *City of York Art Gallery Quarterly*, October 1973, p. 934.

A study was formerly in the possession of Arnold Haskell (138a; Hayes, *Drawings*, no. 602). A number of alterations were made in the finished picture, notably the introduction of the goat and flock of sheep beside the fountain on the left. This is by far the largest of Gainsborough's landscapes to date and, no doubt on account of its 'sublime' subject-matter, was entitled 'Romantic Landscape' at the 1814 retrospective, the only picture in the exhibition so described. The breadth of the glow at the horizon and the sombre dell in the middle distance are similar to the Edinburgh picture (cat. no. 137), but the composition is simpler and the

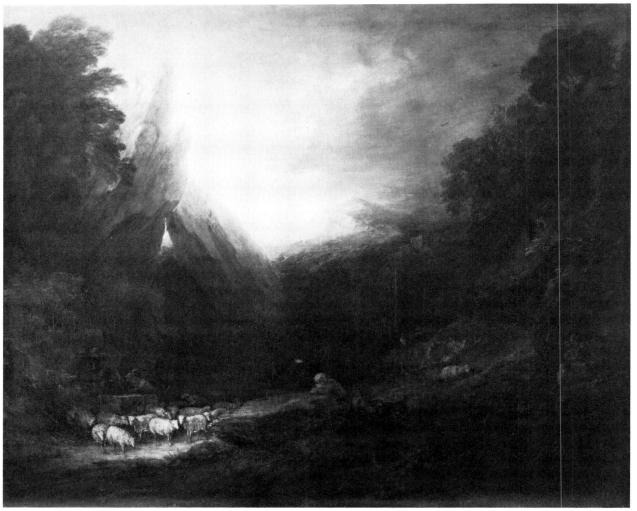

138

**138a** Study for cat. no. 138. Black chalk and stump, and brown and white chalks, on blue paper. $6\frac{15}{16} \times 8\frac{7}{16}$ / 17.6 × 21.4. Formerly Arnold Haskell, Bath.

**139**

handling less brilliant, and the large rocks on the left are more artificial in character, palpably derived from the lumps of coal which Gainsborough used for his model landscapes. The flock of sheep is strongly spotlit. Although this picture was presented to the Academy by Margaret Gainsborough in 1799 as Gainsborough's diploma painting, 'in compliance with the intention of her late father', there is no corroborative evidence to suggest that this was the work by which Gainsborough wished to be represented on the Academy's walls in perpetuity; however, it should be noted that he never painted the work he offered to execute for the Council Room in 1787 (see Chapter Six, note 32) and may conceivably, at the end of his life, have proposed this picture, which would fit the space intended admirably. There is evidence that what is probably this picture was restored at an early date, by John Rising in 1812 (Royal Academy minutes, quoted in William T. Whitley, *Art in England 1800–1820*, Cambridge, 1928, p. 204). This was one of the canvases singled out for criticism by Hazlitt (cited above): 'We cannot conceive anything carried to a greater excess of slender execution and paltry glazing.' Possibly his remarks were oc-

casioned by Rising's restoration. Two or three copies of this composition, two at least of roughly the same size as the original, are in existence. Also mentioned on p. 131.

DATING Closely related to cat. no. 137 in the tonal quality, the strong lighting effects, the broad area of unbroken yellow impasto at the horizon, the treatment of the dell and the soft handling of the bushy foliage.

## 139 Coastal Scene with Sailing and Rowing Boats and Figures on the Shore

Transparency on glass. 11 × 13¼  27.9 × 33.7
Painted *c.* 1783

Victoria and Albert Museum, London (P.43-1955)

PROVENANCE Purchased from Margaret Gainsborough (1752–1820) by Dr Thomas Monro (1759–1833); Monro sale, Christie's, 26 June 1833 ff., 3rd day (28 June), lot 168, bt W. White, who bequeathed it to G. W. Reid; anon. [Buck Reid] sale, Christie's, 29 March 1890, lot 132, bt in; Leopold Hirsch; Hirsch sale, Christie's, 11 May 1934, lot 104, bt Gooden and Fox for

140

Ernest E. Cook; bequeathed to the Victoria and Albert Museum, through the National Art-Collections Fund, 1955.

EXHIBITION GG, 1885 (394).

BIBLIOGRAPHY Waterhouse, no. 974, repr. pl. 265; Jonathan Mayne, 'Thomas Gainsborough's Exhibition Box', *Victoria and Albert Museum Bulletin*, vol. 1, no. 3, July 1965, pp. 21, 23, repr. fig.8; Gatt, pp. 10, 37–8, repr. pls 58, 59 (col.); Joseph Burke, *English Art 1714–1800*, Oxford, 1976, p. 220; British Museum, 1978, p. 17.

See under cat. no. 132. A preliminary idea for the Melbourne picture (cat. no. 141), with the design in reverse and with fewer ships. This and the succeeding design (cat. no. 140) demonstrate that, as with his drawings, one of the purposes for which Gainsborough used his transparencies was as a trial work-out for a major composition. Also mentioned on p. 140.

DATING Identical with cat. nos 140 and 141 in the very pale tonality and rapid, sketchy handling throughout.

### 140 Coastal Scene with Sailing and Rowing Boats, Figures on the Shore, and Distant Village

Transparency on glass. $11 \times 13\frac{1}{4}$   $27.9 \times 33.7$
Painted *c.* 1783

Victoria and Albert Museum, London (P.41-1955)

PROVENANCE Purchased from Margaret Gainsborough (1752–1820) by Dr Thomas Monro (1759–1833); Monro sale, Christie's, 26 June 1833 ff., 3rd day (28 June), lot 168, bt W. White, who bequeathed it to G. W. Reid; anon. [Buck Reid] sale, Christie's, 29 March 1890, lot 132, bt in; ; Leopold Hirsch; Hirsch sale, Christie's, 11 May 1934, lot 104, bt Gooden and Fox for Ernest E. Cook; bequeathed to the Victoria and Albert Museum, through the National Art-Collections Fund, 1955.

EXHIBITION GG, 1885 (394).

BIBLIOGRAPHY Waterhouse, no. 976, repr. pl. 266; Jonathan Mayne, 'Thomas Gainsborough's Exhibition

Graves, *The Royal Academy of Arts*, vol. III, London, 1905, p. 193; Whitley, p. 204; *Catalogue of the National Gallery of Victoria*, Melbourne, 1948, p. 55; *Quarterly Bulletin of the National Gallery of Victoria*, no. 3, 1949, repr. p. 82; Woodall, p. 99, repr. p. 101; Ellis Waterhouse, *Painting in Britain 1530–1790*, Harmondsworth, 1953, p. 189; Waterhouse, p. 31, no. 964, repr. pl. 244; Woodall, *Letters*, p. 29, repr. facing p. 41; Jonathan Mayne, 'Thomas Gainsborough's Exhibition Box', *Victoria and Albert Museum Bulletin*, vol. I, no. 3, July 1965, p. 23, repr. fig. 9; Hayes, *Drawings*, p. 243; Ursula Hoff, *The National Gallery of Victoria*, London, 1973, repr. p. 172; Joseph Burke, *English Art 1714–1800*, Oxford, 1976, p. 220, repr. pl. 62B; British Museum, 1978, p. 17; Ellis Waterhouse, *The Dictionary of British 18th Century Painters*, Woodbridge, 1981, p. 138, repr. p. 139.

Gainsborough painted two transparencies of this subject (cat. nos 139, 140), which are clearly preliminary ideas for the composition; both have fewer ships, and the first is in reverse. The finished picture is even larger in scale than the Royal Academy mountain scene (cat. no. 138), and must be regarded as one of Gainsborough's most important works to date. In the light of this, his instructions to the Secretary of the Royal Academy at the time of its exhibition are difficult to interpret: 'hang my Dogs & my Landskip [cat. no. 137] in the great Room. The sea Piece you may fill the small Room with' (Gainsborough to F. M. Newton, n.d.; Woodall, *Letters*, no. 2, p. 29)). Does this mean that he was dissatisfied with the picture? Certainly Bate-Dudley was unenthusiastic (see below). Did he regard it simply as a large sketch? This was how it was described by Neale (see below). To our own eyes it is a masterpiece of delicate beauty. The tonality has an exquisite silvery quality, the recession in the sea is beautifully rendered (assisted by the distant vessel on the left, which does not appear in the second transparency: cat. no. 140), and the distant landscape is painted in an appropriately sketchy manner. The intermediate sailing vessel in the centre of the picture does not seem to be an improvement on the previous design. X-ray photographs, kindly taken specially by the Australian Radiation Unit, show that Gainsborough reworked this canvas in different areas. The figure on the left was originally more upright and did not carry a stick; the boat in the right foreground was superimposed on the painting of the sea; the two ships in the middle distance were superimposed on the painting of the distant landscape, and their sails altered in the course of execution; and a distant ship included on the extreme left was painted out. This picture was presumably the 'Large Landscape, sketch' which was hanging in the Music Room at Langley Park, Norfolk in 1820 (Neale, cited above). It was first described as a 'View at the Mouth of the Thames' in the catalogue of the RA exhibition, 1878. A work with an apparently similar subject which was in Mrs Gainsborough's sale at Christie's, 10–11 May 1799, 1st day, lot 115 ('A view in a harbour with vessels, a picture of great merit', bought by

Walton for thirty-one guineas) has not come to light. Also mentioned on pp. 139, 140, 171, 182; an x-ray photograph and detail are repr. pls 205, 206.

DATING Identifiable as RA 1783 (240) from Bate-Dudley's review in the *Morning Herald* (30 April 1783): '*The sea piece, a calm*, is not equal to many of Mr. Gainsborough's subjects of that nature; it nevertheless evinces the hand of the master, particularly in the figures.' Apart from the Fairhaven coastal scene (RA, 1781; cat. no. 126), the Melbourne picture is the only calm that Gainsborough painted.

## 142 Coastal Scene with Figures in Sailing and Rowing Boats, Peasants on the Shore and Peasant, Milkmaid and Cows on a Bank

Canvas. 25 × 30   63.5 × 76.2
Painted *c.* 1782–4

Private collection, England

PROVENANCE Samuel Rogers (1763–1855) by 1814; Rogers sale, Christie's, 28 April 1856 ff., 6th day (3 May), lot 713, bt Holloway; John Dillon, 1857; Dillon sale, Christie's, 17 April 1869, lot 92, bt Agnew; John Heugh, 1873; Heugh sale, Christie's, 24–25 April 1874, 2nd day, lot 173, bt Agnew for Kirkman D. Hodgson; R. K. Hodgson, 1885; with Agnew; Pandelli Ralli; Paula de Koenigsberg, 1945; with Agnew, from whom it was purchased, 1952.

EXHIBITIONS BI, 1814 (71); BI, 1850 (56); 'Art Treasures of the United Kingdom', Manchester, 1857 (150); 'Art Treasures and Industrial Exhibition', Mechanics' Institute, Bradford, 1873 (339); RA, 1873 (51); GG, 1885 (180); 'Obras Maestras Colección Paula de Koenigsberg', Museo Nacional de Bellas Artes, Buenos Aires, October 1945 (78, repr. pl. llx); 'Fine English Pictures', Agnew's, June–July 1952 (6); Grand Palais, 1981 (70, repr.).

BIBLIOGRAPHY Anon. [William Hazlitt], 'On Gainsborough's Pictures', *Champion*, 31 July 1814, p. 247; William Hazlitt, *Criticisms on Art*, London, 1843, p. 194 (note) (quoted from his article in the *Champion*, op. cit.); Fulcher, p. 201; William Martin Conway, *The Artistic Development of Reynolds and Gainsborough*, London, 1886, pp. 92–3; Arts Council, 1953, p. 23; Waterhouse, no. 957; Clifford Musgrave, 'The Holt, Upham', *Connoisseur*, June 1962, repr. p. 75; Hayes, *Drawings*, p. 282.

A study was formerly in the Heseltine collection (142a; Hayes, *Drawings*, no. 758). Only slight changes were made in the finished picture: an extra rowing boat, with two figures rowing, was included between the figures on the shore and the principal sailing boat, and one or two minor changes were made in the arrangement of the figures. This work is a more rhythmical and spacious horizontal variant of the Tennant coastal scene (cat.

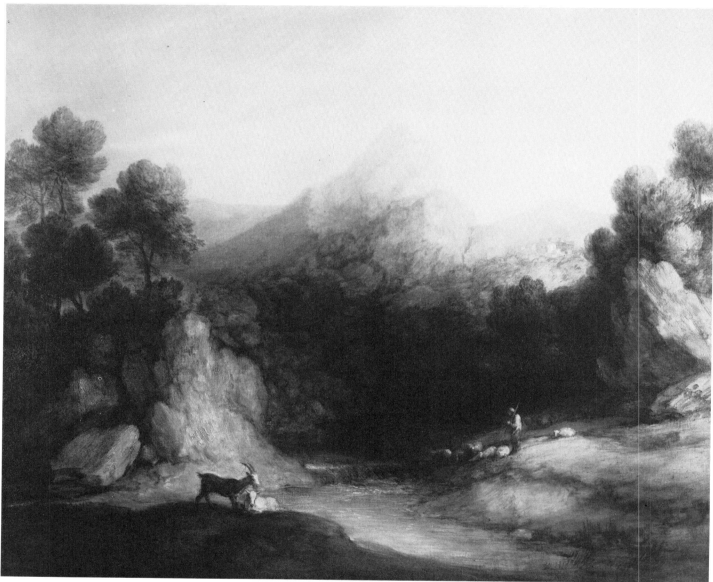

**143**

no. 130). Both the subject-matter and the tonality are reminiscent of Salomon van Ruysdael. The clouds are more softly painted and lack the abrupt transitions from lights to darks characteristic not only of the Tennant picture, but also of slightly earlier works, such as the Grosvenor sea-piece (cat. no. 127). Hazlitt (cited above) described it as 'remarkable for the elegance of the forms

and the real delicacy of the execution'. A free pencil sketch by Cotman is in an English private collection (see pl. 340 and p. 281). Also mentioned on pp. 164, 238.

DATING Closely related to cat. no. 141 in the silvery tonality and the broad, soft modelling of the clouds, figures and pale foreground.

**143 Rocky Wooded Landscape with Stream and Weir, Shepherd and Sheep, Goats and Distant Village and Mountains**

Canvas. $40\frac{1}{4} \times 50\frac{1}{2}$   102.2 × 128.3
Painted *c.* 1782–4

Philadelphia Museum of Art, Philadelphia (M′28-1-9)

PROVENANCE Charles Frederick Huth; Huth sale, Christie's, 19 March 1904, lot 53, bt Agnew; John H. McFadden, Philadelphia; bequeathed to the Philadelphia Museum of Art, 1928.

EXHIBITIONS Agnew's, 1904 (10); Portraits & Landscapes of the British School Lent by John H. McFadden', Metropolitan Museum, New York, June–October 1907 (8, repr.).

BIBLIOGRAPHY W. Roberts, *Catalogue of the Collection of Pictures formed by John H. McFadden*, London, 1917, p. 19, repr. p. 123; 'The New Museum of Art Inaugural Exhibition', *Pennsylvania Museum Bulletin*, vol. XXIII, no. 119, March 1928, p. 20; Waterhouse, p. 31, no. 968, repr. pl. 258; Gatt, p. 38, repr. pls 62, 63 (col.); Paulson, pl. 154; Richard Dorment, *Catalogue of the English Paintings in the Philadelphia Museum of Art* (forthcoming).

This canvas has all the same ingredients as the Edinburgh mountain scene (cat. no. 137): a broadly painted glow at the horizon, a distant village and mountains, a sombre dell, with water trickling over a weir, prominent picturesque rocks, and a shepherd with his flock of sheep. The composition is, however, more contrived (even the trees to left and right balance each other in height more or less exactly, and the mountain in the distance left is an awkward piece of infilling) and less developed spatially, and the impression is ultimately one of artifice rather than of the sublime. Also mentioned on p. 140.

DATING Closely related to cat. no. 137 in the tonal quality and absence of bright colour, the glowing, smoothly painted horizon, the soft, fluid handling of the bushy foliage, the rough impasto in the highlights of the animals, the modelling of the rocks with thick, dragged paint in the lights and the rapid handling of the foreground. The use of enlivening touches in the very generalized foreground is similar to cat. no. 130, and the suggestion of the shepherd's pinkish smock in a single sweeping brushstroke is paralleled in cat. no. 127.

**144 Wooded Landscape with Peasants in a Country Cart crossing a Ford, Figures and Dogs**

Canvas. $38\frac{1}{2} \times 48\frac{1}{2}$   97.8 × 123.2
Painted *c.* 1782–4

Mrs Henrietta Scudamore, London (on indefinite loan to the Victoria and Albert Museum)

PROVENANCE Purchased from the artist by Wilbraham Tollemache (later 6th Earl of Dysart, 1739–1821); by descent to Bentley, 3rd Lord Tollemache (1883–1955); Trustees of the Tollemache Estates sale, Christie's, 15 May 1953, lot 110 (repr.), bt Agnew for Sir James Caird (1864–1954); thence by descent.

EXHIBITIONS BI, 1814 (35); Suffolk Street, 1833 (72); BI, 1845 (71 or 88); BI, 1849 (143); 'Art Treasures of the United Kingdom', Manchester, 1857 (153); 'Pictures by T. Gainsborough, R.A.', Agnew's, June–July 1928 (26); 'British Art', RA, 1934 (314); Sassoon, 1936 (113, repr. *Souvenir*, pl. 76); Bath, 1951 (31); Arts Council, 1953 (ex-catalogue); 'Two Centuries of British Painting', British Council, Montreal Museum of Fine Arts, National Gallery of Canada, Ottawa, Art Gallery of Toronto and Toledo Museum of Art, October 1957–March 1958 (21, repr. p. 108); 'Europäisches Rokoko', Residenz, Munich, June–October 1958 (67); Nottingham, 1962 (24); 'English Landscape Painting of the 18th and 19th Centuries', National Museum of Western Art, Tokyo, and Kyoto National Museum of Modern Art, Kyoto, October 1970–January 1971 (24, repr.).

BIBLIOGRAPHY Edward Dayes, *Works*, London, 1805, p. 328; Fulcher, p. 199; *Royal Academy of Arts Commemorative Catalogue of the Exhibition of British Art, 1934*, Oxford, 1935, no. 210; Woodall, *Drawings*, p. 105; Mary Woodall, 'The Gainsborough Exhibition at Bath', *Burlington Magazine*, August 1951, p. 266; Waterhouse, no. 948, repr. pl. 190; John Hayes, 'Gainsborough and Rubens', *Apollo*, August 1963, p. 96; R. B. Beckett, ed., 'John Constable's Correspondence II', *The Suffolk Records Society*, vol. VI, Ipswich, 1964, pp. 73–4; ibid., IV, vol. X, Ipswich, 1966, pp. 48, 54; Hayes, *Drawings*, pp. 32, 262, repr. pl. 336; Herrmann, p. 104; British Museum, 1978, p. 20.

An oil sketch was formerly in the Blaiberg collection (144a; Hayes, *Drawings*, no. 666). No changes were made in the finished picture, except for a slight extension of the foreground and the inclusion of a dog with the couple on the left. The subject of the country cart splashing through a stream is new in Gainsborough, giving him an opportunity to demonstrate his skill at painting foam; the motion of the cart is taken up in the trees and clouds. The composition is basically diamond-shaped, with the sloping tree-trunk on the right giving weight to the design. The silvery tonality is characteristic of the period. A repetition on a smaller scale is now at Lehigh University, Pennsylvania (cat. no. 145). A small copy by the original owner of the picture, Wilbraham Tollemache, is at Helmingham Hall (see p. 287). Also mentioned on pp. 137, 138, 182, 246, 291.

DATING Closely related to cat. no. 143 in the subdued grey-green tonality and absence of warm colour, the pale greys of the sky, the soft, fluidly painted, bushy foliage, the rapidly handled brown foreground and the rough highlights in the water. The flowing modelling of the tree-trunk on the right and the rhythmical treatment of the bushy trees are similar to the background of cat. no. 148, which was being painted in November 1783.

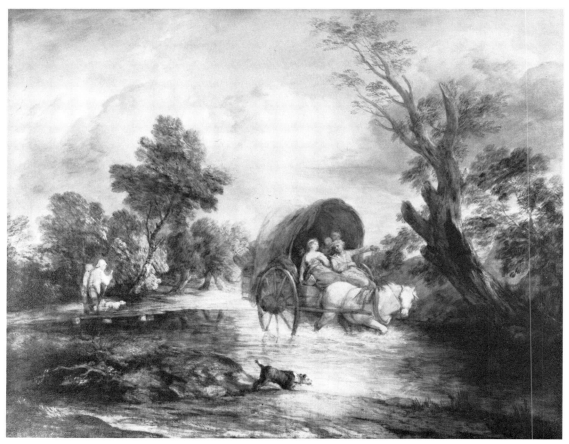

144

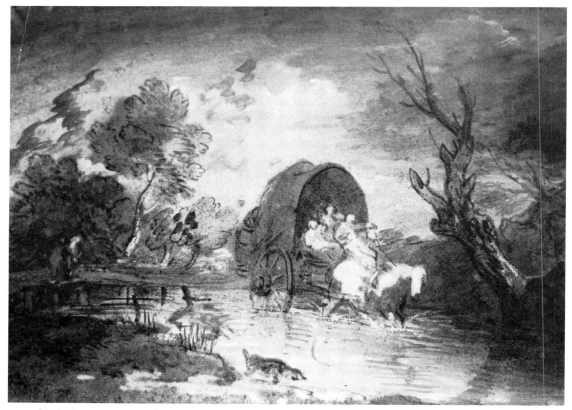

**144a** Study for cat. no. 144. Oil on brown prepared paper, varnished. $8\frac{7}{8} \times 12\frac{5}{16}$ / $22.5 \times 31.3$. Formerly Edgar Blaiberg, London.

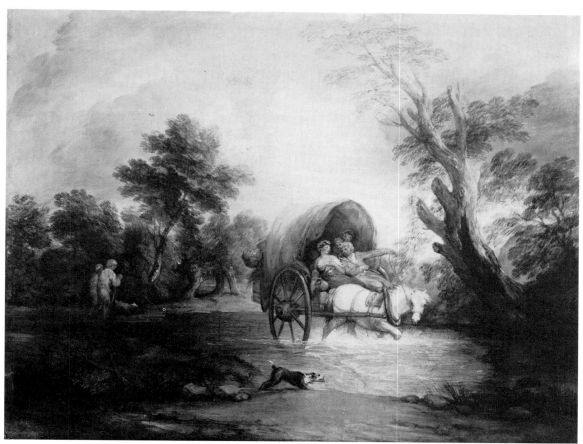

**145**

## 145 Wooded Landscape with Peasants in a Country Cart crossing a Ford, Figures and Dogs

Canvas. $27\frac{1}{2} \times 35\frac{1}{2}$   69.9 × 90.2
Painted *c*. 1782–4

Lehigh University, Bethlehem, Pennsylvania (Eugene G. Grace Collection)

PROVENANCE George Gostling, 1814; by descent to Mrs Gostling Murray; anon. [Colonel Gostling Murray] sale, Christie's, 23 June 1883, lot 767, bt Agnew; David Jardine, 1898; Jardine sale, Christie's, 16 March 1917, lot 96 (repr. frontispiece), bt Sulley; with Knoedler; Eugene G. Grace, 1927, by whom it was bequeathed to Lehigh University.

EXHIBITIONS BI, 1814 (61); either this or cat. no. 168 was BI, 1817 (68); Ipswich, 1927 (68); Cincinnati, 1931 (25, repr. pl. 31); 'A Survey of British Painting', Carnegie Institute, Pittsburgh, May–June 1938 (42).

BIBLIOGRAPHY Fulcher, pp. 200, 204; Armstrong, 1898, p. 206; Armstrong, 1904, p. 284; R. H. Wilenski, 'The Gainsborough Bicentenary Exhibition', *Apollo*, November 1927, pp. 198, 200; anon., 'The Gainsborough Exhibition in Cincinnati', *Burlington Magazine*, August 1931, p. 86; Walter Heil, 'Die Gainsborough-Ausstellung in Cincinnati', *Pantheon*, September 1931, pp. 70, 384; R. H. Wilenski, *English Painting*, London, 1933, p. 131, repr. pl. 46; Waterhouse, no. 949.

A smaller version of the Scudamore picture (cat. no. 144)—with an excellent early pedigree—which examination shows to be autograph, though less high in quality. Among well-executed passages which one would not expect even from a skilled studio assitant are the foam in the water and the vivacious little dog in the foreground. Also mentioned on p. 182.

DATING Closely related to cat. no. 144 in the very subdued tonality, the softly painted, pale-green foliage, the pale-brown foreground and the use of thick creamish impasto and grey half-tones in the modelling of the horse.

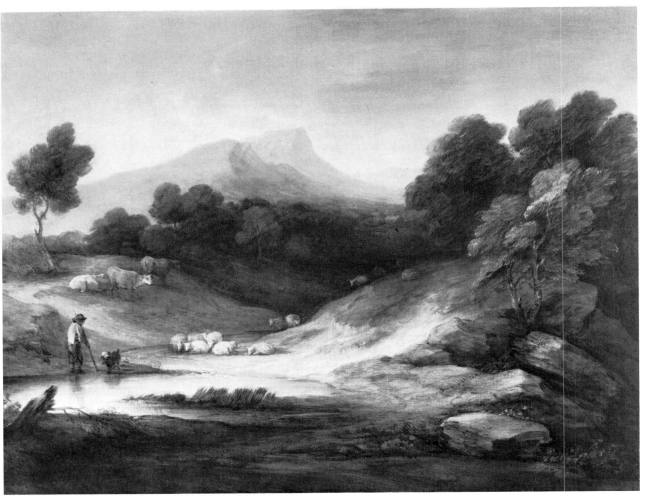

146

## 146 Rocky Wooded Upland Landscape with Shepherd and Scattered Sheep, Cows on a Bank and Distant Village and Mountains

Canvas. $47\frac{1}{4} \times 58\frac{1}{2}$  120 × 148.6
Painted in the autumn of 1783. Signed with initials bottom right: *T.G.*

Bayerische Landesbank, Munich (on indefinite loan to the Neue Pinakothek, Munich)

PROVENANCE Painted for George, Prince of Wales (later George IV, 1762–1830), who presented it to Mrs Maria Fitzherbert (1758–1837), 1810; bequeathed by her to the Hon. Mrs Dawson Damer, 1837; anon. [Colonel Damer] sale, Christie's, 27 March 1841, lot 142 (as 'PAINTED EXPRESSLY FOR THE PRINCE OF WALES'), bt in; later with Pennell, from whom it was purchased by Joseph Gillott (1799–1873), 1845; anon. [Joseph Hogarth] sale, Christie's, 13–14 June 1851, 1st day, lot 50, bt in; Elhanan Bicknell (1788–1861); Bicknell sale, Christie's, 25 April 1863, lot 81, bt Wallis; with Graves, from whom it was purchased by Thomas Curtis, 1863; by descent to Major T. L. C. Curtis; Curtis sale, Christie's, 9 July 1937, lot 37 (repr.), bt in; anon. sale, Sotheby's, 26 June 1968, lot 34 (repr. col.), bt Agnew;

Mr and Mrs Eugene Ferkauf, New York; Ferkauf sale, Christie's, 24 November 1972, lot 83 (repr.), bt Richard Green; with Agnew, from whom it was purchased by Midland Bank Ltd; with Agnew, 1978, from whom it was purchased.

EXHIBITIONS Schomberg House, July 1784; Schomberg House, 1789 (75); BI, 1814 (27); BI, 1841 (116); 'Art Treasures of the United Kingdom', Manchester, 1857 (188); Arts Council, 1949 (21); 'Works of Art from Midland Houses', City of Birmingham Museum and Art Gallery, July–September 1953 (26); 'A Hundred Years of British Landscape Painting, 1750–1850', Leicester Museums and Art Gallery, 1956 (8); Tate Gallery, 1980–81 (147, repr.)

BIBLIOGRAPHY *Morning Herald*, 26 July 1784; *Morning Post*, 30 March 1789; ibid., 6 April 1789; *Diary*, 13 April 1789; *Morning Herald*, 11 May 1789; ibid., 11 June 1789; Fulcher, p. 193; 'The Collection of Elkanah [sic] Bicknell, Esq. at Herne Hill', *Art Journal*, January 1857, p. 10; J.S., in *Notes and Queries*, 25 November 1871, p. 434; Armstrong, 1894, p. 50; Bell, pp. 122–23; Armstrong, 1906, p. 131; Whitley, pp. 229, 258–9, 325; William T. Whitley, 'An Eighteenth-Century Art Chronicler: Sir

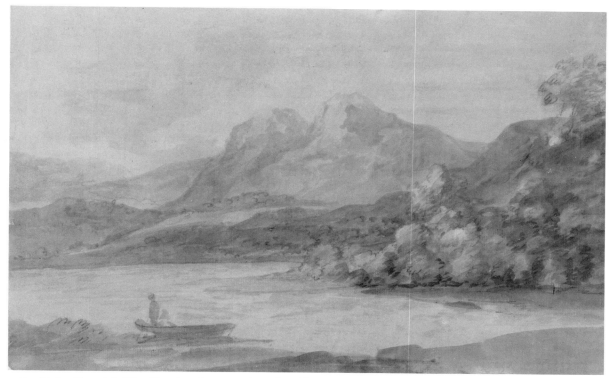

**146a** *Study of Langdale Pikes.* Pencil and grey wash. $10\frac{3}{8} \times 16\frac{1}{4}$ / 26.4 × 41.3. 1783. Dr C. B. M. Warren, Felsted.

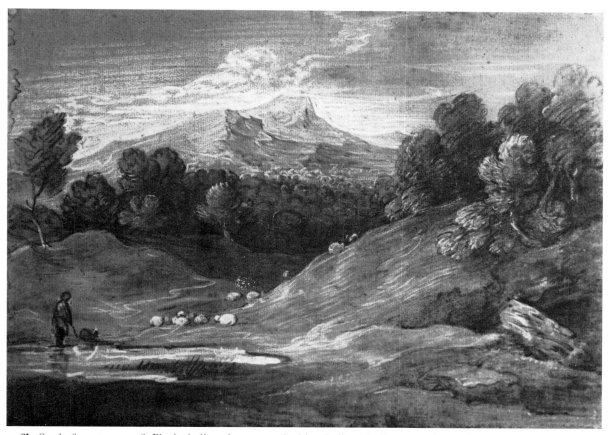

**146b** Study for cat. no. 146. Black chalk and stump and white chalk on buff paper. $9\frac{3}{16} \times 14\frac{5}{16}$ / 23.3 × 36.3 Museum of Art (Luis A. Ferré Foundation), Ponce, Puerto Rico.

Henry Bate Dudley, Bart.', *The Walpole Society*, vol. XIII, Oxford, 1925, p. 54; Woodall, *Drawings*, pp. 65–7, 69, repr. pl. 79; anon. [Tancred Borenius], 'Gainsborough's Collection of Pictures', *Burlington Magazine*, May 1944, p. 109; Woodall, pp. 97–8, repr. p. 99; Waterhouse, p. 33, no. 992, repr. pl. 259; Marlene Park, 'A Preparatory Sketch for Gainsborough's "Upland Valley with Shepherd, Sheep and Cattle"', *Art Quarterly*, summer 1962, p. 144, repr. p. 145; John Hayes, 'Gainsborough's Later Landscapes', *Apollo*, July 1964, p. 23, repr. fig. 8; Oliver Millar, *The Later Georgian Pictures in the Collection of Her Majesty The Queen*, London, 1969, vol. I, p. xxvi, repr. pl. xviii; Hayes, *Drawings*, pp. 33, 39; Hayes, *Printmaker*, p. 91, repr. pl. 82; Herrmann, p. 102; Christoph Heilmann, 'Thomas Gainsborough', *Kunstchronik*, Munich, March 1981, pp. 112, 116; Lindsay, p. 160; Michael Rosenthal, *English Landscape Painting*, Oxford, 1982, p. 70, repr. pl. 63.

A study is in the Ponce Museum of Art, Puerto Rico (146b; Hayes, *Drawings*, no. 590). No changes were made in the finished picture, except for the addition of some cows on the bank on the left and some buildings in the distance right. The mountains are evidently based on Langdale Pikes (146a; Hayes, *Drawings*, no. 577), which would have been fresh in Gainsborough's mind after his recent trip to the Lake District, but they are very softened in outline. Although similar in many respects to the Philadelphia mountain scene (cat. no. 143)— compare the breadth of glow at the horizon, the subdued tonality, and the motifs of the dell in the middle distance, the rippling stream and the shepherd with his flock of sheep—the design is based on sweeping lateral rhythms, the handling is looser and the distance more generalized. The rock forms are an integral part of the rhythmic pattern, instead of bold shapes in their own right. Although painted for the Prince of Wales, the picture was not paid for and remained in Gainsborough's studio at Schomberg House until the settlement of his debts to the artist five years after the latter's death, in 1793. A small copy was in the Penfield Sale, American Art Association, New York, 17–18 May 1934, 1st day, lot 15. A repetition on a smaller scale is owned by the Pennington-Mellor Charity Trust (cat. no. 147). Also mentioned on pp. 142, 145, 169–71, 175, 181, 182.

DATING Identifiable as the landscape exhibited at Schomberg House in July 1784 (which was bought by the Prince of Wales) from Bate-Dudley's review in the *Morning Herald* (26 July 1784): 'This Picture is, we understand, painted for the *Prince of Wales*; the scene is an *upland* and *valley*. *Sheep*, *water*, *trees*, *broken ground*, and other objects, are seen; and a solitary gloom diversifies a part of it, so as to awaken corresponding ideas in the mind'. According to another description of the picture published by the *Morning Post* at the time of the Gainsborough sale in March 1789, it was actually painted in the autumn of 1783, after a visit Gainsborough made to the Lake District in the company of

Samuel Kilderbee: 'One of the PRINCE of WALES's landscapes in the lower room, Mr. GAINSBOROUGH painted on his return from the *Lakes*; and though not a portrait of any particular spot, the picture is highly characteristic of that country' (*Morning Post*, 6 April 1789).

## 147 Rocky Wooded Upland Landscape with Shepherd and Scattered Sheep, Cows on a Bank and Distant Mountains

Canvas. $27\frac{1}{2} \times 35\frac{1}{2}$   69.9 × 90.2
Painted *c.* 1783–4

Pennington-Mellor Charity Trust, London

PROVENANCE John Pennington Mellor; thence by descent.

A smaller, autograph, repetition of the mountain scene bought by George, Prince of Wales (cat. no. 146), in which the distant village has been omitted and many of the features are less firmly modelled or defined: the rocks on the right, for example, no longer read as solid shapes. It is highly unlikely that anyone but the artist himself would have executed a looser, rather than an exact, version of the original and, as observed below, the handling is close in character to the mountain scene in the Metropolitan Museum (cat. no. 150).

DATING Closely related to cat. no. 146 in the subdued tonality, the thick yellowish impasto at the horizon, the treatment of the foliage and rocks, and the dark-brown foreground. Many of the features, notably the rocks in the right foreground, are more softly and loosely defined than in the original, and the treatment of the foliage, the hillock on the right and the distant mountains is closer to cat. no. 150.

## 148 Wooded Landscape with Groups of Fashionable People promenading or seated on a Bench, and Cows (The Mall)

Canvas. $47\frac{1}{2} \times 57\frac{7}{8}$   120.7 × 147
Painted in the winter of 1783

Frick Collection, New York (A578)

PROVENANCE Schomberg House sale, March–May 1789, no. 77; Mrs Gainsborough sale, Christie's, 2 June 1792, lot 78, bt in by Mr Skirrow; Mrs Gainsborough sale, Christie's, 10–11 April 1797, 2nd day, lot 97, bt Williamson; anon. [Elwin] sale, Phillip's, 12–13 April 1799, 1st day, lot 68, bt Howe; with Mr Sparrow, Ipswich, 1807; George Frost (1745–1821), by 1809; Samuel Kilderbee (1725–1813); Kilderbee sale, Christie's, 30 May 1829, lot 126, bt Bone for Joseph Neeld (1789–1856); thence by descent through Sir Audley Neeld to the Hon. Mrs C. Hanbury, who sold it to Agnew on behalf of Duveen, from whom it was purchased by Henry Clay Frick, 1916.

EXHIBITIONS Schomberg House, July 1784; Schomberg

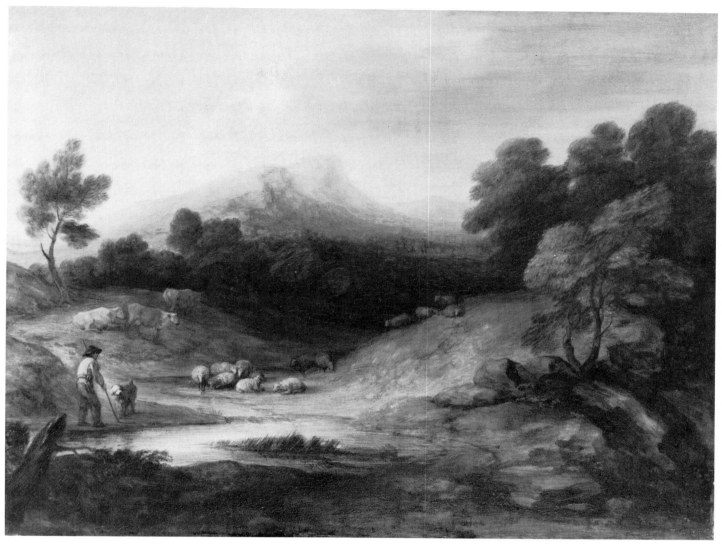

**147**

House, 1789 (77); RA, 1876 (278); RA, 1889 (4); RA, 1895 (132); 'Loan Collection of Pictures and Drawings by J. M. W. Turner RA and of a Selection of Pictures by some of his Contemporaries', Corporation of London Art Gallery, 1899 (168, pp. 133–4).

BIBLIOGRAPHY *Morning Herald*, 5 November 1783; *Morning Chronicle*, 17 December 1783; *Morning Herald*, 22 April 1784; *Morning Herald*, 26 July 1784; *Morning Chronicle*, 8 August 1788; *London Chronicle*, 7–9 August 1788; *Diary*, 13 April 1789; *Gentleman's Magazine*, July 1821, p. 90; William Hazlitt, *Conversations of James Northcote, Esq., R.A.*, London, 1830, p. 259; anon. [Thomas Green], 'Diary of a Lover of Literature', 16 October 1820, *Gentleman's Magazine*, November 1841, p. 469; Fulcher, pp. 139–40, 194; John Timbs, *Anecdote Biography*, London, 1860, p. 176; George M. Brock-Arnold, *Gainsborough*, London, 1881, p. 44 (wrongly as 1786); Armstrong, 1894, pp. 20, 58, 60, 82; Bell, pp. 26, 125–26; Armstrong, 1898, pp. 42, 126, 135, 158, 168, 171, 182, 183, 185, 206, repr. facing p. 140; Mrs Arthur

Bell, *Thomas Gainsborough, R.A.*, London, 1902, p. 41; Chamberlain, pp. 21, 44, 120–22, 144, 202, repr. p. 47; Gower, pp. 4, 28–9, 115; Armstrong, 1904, pp. 54 and note, 169, 182, 211–12, 226, 246–8, 250, 284, repr. facing p. 194; A. E. Fletcher, *Thomas Gainsborough, R.A.*, London, 1904, p. 140; Pauli, p. 101; Boulton, pp. 272–4, repr. facing p. 278; Armstrong, 1906, pp. 53, 150, 154, 157, 203, 204–5; Gabriel Mourey, *Gainsborough*, Paris, n.d. [1906], p. 99; Menpes and Greig, pp. 35, 142, 162, 163, 164; Whitley, pp. 26, 211, 212, 226, 229, 231, 250, 322, 329, 342, 348–9, 394–5, repr. facing p. 229; W. G. Blaikie-Murdoch, 'Gainsborough's The Mall', *Art in America*, vol. IV, 1916, pp. 201–3; M. H. Spielmann, 'A Note on Thomas Gainsborough and Gainsborough Dupont', *The Walpole Society*, vol. V, Oxford, 1917, pp. 97, 107; E. Rimbault Dibdin, *Thomas Gainsborough*, London, 1923, pp. 18, 39–40, 157, 159; Hugh Stokes, *Thomas Gainsborough*, London, 1925, pp. 113, 114–15, 117, 153; William T. Whitley, 'An Eighteenth-Century Art Chronicler: Sir Henry Bate Dudley, Bart.', *The Walpole Society*, vol. XIII, Oxford,

148

1925, pp. 52, 54; William T. Whitley, *Artists and their Friends in England 1700–1799*, London, 1928, vol. I, p. 108; Esther Singleton, *Old World Masters in New World Collections*, New York, 1929, pp. 331, 364–6, repr. p. 365; Charles Johnson, *English Painting from the Seventh Century to the Present Day*, London, 1932, p. 87; C. H. Collins Baker, *British Painting*, London, 1933, pp. 108, 112; R. H. Wilenski, *English Painting*, London, 1933, pp. 131–2, repr. pl. 47 and pls 48, 49 (details); Charles Johnson, *A Short Account of British Painting*, London, 1934, p. 57; George Harvey, *Henry Clay Frick The Man*, New York, 1936, p. 341; Chauncey Brewster Tinker, *Painter and Poet*, Cambridge, Mass., 1938, p. 74, repr. p. 72; James W. Lane, 'The Frick Collection Part I', *Apollo*, September 1938, repr. p. 115; Woodall, *Drawings*, pp. 80, 89; *Duveen Pictures in Public Collections of America*, New York, 1941, no. 287; anon. [Tancred Borenius], 'Gainsborough's Collection of Pictures', *Burlington Magazine*, May 1944, p. 109; Woodall, p. 102, repr.

p. 111; S. N. Behrman, *Duveen*, London, 1952, pp. 32–3; Ernest Short, *A history of British painting*, London, 1953, p. 132; Ellis Waterhouse, *Painting in Britain 1530–1790*, Harmondsworth, 1953, p. 189; Waterhouse, pp. 28, 29, 33, 39, no. 987, repr. pl. 243; John Hayes, 'Gainsborough's Later Landscapes', *Apollo*, July 1964, p. 26, repr. fig. 9; R. B. Beckett, ed., 'John Constable's Correspondence II', *The Suffolk Records Society*, vol. VI, Ipswich, 1964, pp. 12, 37; Emilie Buchwald, 'Gainsborough's "Prospect, Animated Prospect"', Howard Anderson and John S. Shea, ed., *Studies in Criticism and Aesthetics 1660–1800*, University of Minnesota, 1967, pp. 373, 375; Derek and Timothy Clifford, *John Crome*, London, 1968, p. 87; Gatt, pp. 14, 37, repr. pls 52, 53 (col.), 51 (col. detail); *The Frick Collection: An Illustrated Catalogue, Vol. I: Paintings American, British, Dutch, Flemish and German*, New York, 1968, pp. 58–64, repr. pp. 59, 61 (col. detail); John Hayes, 'English Painting and the Rococo', *Apollo*, August 1969, p. 124; Hayes,

**148a** *A View of Kensington Gardens* 'taken on the Spot'. Engraving by Thomas Cook, published 10 October 1786. British Museum (Anderdon, vol. 3, f.75).

*Drawings*, pp. 19, 56, 126, 127, 128, 295; Jean-Jacques Mayoux, *La Peinture Anglaise De Hogarth aux Préraphaélites*, Geneva, 1972, p. 77; Herrmann, pp. 103–4, 122; Hayes, pp. 26, 43, 223, repr. pl. 148; Paulson, p. 249; David Piper, ed., *The Genius of British Painting*, London, 1975, repr. p. 188; Joseph Burke, *English Art 1714–1800*, Oxford, 1976, pp. 220–21; John Dixon Hunt, *The Figure in the Landscape*, Baltimore and London, 1976, p. 57; British Museum, 1978, p. 13; Marcia Pointon, 'Gainsborough and the Landscape of Retirement', *Art History*, vol. 2, no. 4, December 1979, p. 448; Michael Jacobs and Malcolm Warner, *The Phaidon Companion to Art and Artists in the British Isles*, Oxford, 1980, repr. p. LN26; Tate Gallery, 1980–81, pp. 36, 39, 128, repr. fig. 15; Dillian Gordon, *Second Sight: Rubens: The Watering Place/Gainsborough: The Watering Place*, National Gallery, London, 1981, p. 18; Grand Palais, 1981, pp. 37, 50, 142, repr. fig. 30; Lindsay, pp. 162, 201, repr. pl. 20; Ellis Waterhouse, *The Dictionary of British 18th Century Painters*, Woodbridge, 1981, p. 138; Jeffery Daniels, 'Gainsborough the European', *Connoisseur*, February 1981, pp. 110, 113–14, repr. col. detail p. 114; Christoph Heilmann, 'Thomas Gainsborough', *Kunstchronik*, Munich, March 1981, p. 114.

Gainsborough normally made careful studies for his more elaborate compositions—several figure drawings exist for his abortive *The Richmond Water-walk* (Hayes, *Drawings*, nos 59–63) and three composition sketches for

the *Diana and Actaeon* (cat. no. 160)—and it is presumably the lottery of survival that is responsible for the fact that no drawings for this important canvas remain. The subject is unique in Gainsborough's *oeuvre*, and its derivation from the park scenes of Watteau or Fragonard is emphasized by the soft, feathery foliage which billows over the scene. In a celebrated description usually ascribed to Horace Walpole, Northcote (Hazlitt and Frick Collection catalogue, cited above), said, 'You would suppose it would be stiff and formal with the straight rows of trees and people sitting on benches—it is all in motion, and in a flutter like a lady's fan. Watteau is not half so airy.' Bate-Dudley, who referred to the picture as 'Watteau far outdone' in a report in the *Morning Herald* in November 1783 (see above), retracted this view when he described it in detail in his review of Gainsborough's first exhibition at Schomberg House:

Some have attributed this piece to be after the manner of a distinguished master of the *Flemish School*; but the imitation being strictly from nature, and the style of colouring possessing every originality, such a definition is without propriety. The *view*, altho' not taken from *St James's Park*, will perfectly well apply to that resort of gaiety, and strikes a spectator as tho' the objects were surveyed from *Buckingham-house*; and a view of the *Green Park* was included.—The *mall* appears full of Company, broken in parties of *five*, *three*, and *two*, to give diversity to the scene. Among these, are all descriptions of charac-

ters: women of *fashion*, women of *frolic*, *military beaus*, and *petit maîtres*; with a grave *keeper* or two, and a few accidental *stragglers* to illustrate the representation. Looks of *characteristic* signification, appear to be mutually exchanged by some of the groupe [sic], in passing: and others on the benches, appear making their comments. Some *deer* in the *distance*, and other objects, fill up the scene. The foliage of the trees is well executed, and the sky is as clear and unclouded as possible, to give the *verdure* of the boughs, proper *relief*.

<div align="right">

*Morning Herald*, 26 July 1784
</div>

The sky is, indeed, exceedingly pale, and Bate-Dudley's description is an accurate one (except for a slip of the pen in mentioning deer), the scene clearly being suggestive of a fashionable promenade rather than an exact view of one of the London parks (though it is interesting to compare the Gainsborough with a view of Kensington Gardens 'taken on the Spot Sunday Aug! 6th 1786' (148a). It is doubtful whether Bate-Dudley believed the scene to contain portraits, or he would probably have been specific on this point; but, according to the catalogue of Mrs Gainsborough's sale held at Christie's in 1797 (cited above), 'the figures are probably known portraits of the times.' On the analogy of Rowlandson's *Vauxhall Gardens*, exhibited in 1784, Gainsborough might have been expected to have included portraits, but none has been identified (see the Frick Collection catalogue, cited above). The figures were apparently executed from one of Gainsborough's dressed-up dolls (for these, see Hayes, *Drawings*, pp. 35, 55–6, and pls 78, 79), since the 1792 sale catalogue (cited above) refers to them as 'drest' figures, and Jackson said that 'all the female figures in the Park-scene he drew from a doll of his own creation.' These figures are the fashionably dressed equivalents of those in his 'Cottage Door' scenes (compare the Huntington picture: cat. no. 123). The near-dead tree-trunk on the right, otherwise an intrusive feature, contributes to the gentle arc of the composition. The picture has been somewhat damaged and restored on the left, and a pentimento in the head of one of the cows, revealed during the restoration in 1946, was left visible. There is another pentimento in the right shoulder of the figure on the extreme left. A copy painted by George Frost in 1820 is in the possession of the Misses N. and E Brown, Ipswich (see p. 268). Also mentioned on pp. 134, 140, 173–4, 182.

DATING Identifiable with a landscape being painted in November 1783 from Bate-Dudley's description: '*Gainsborough* is at work on a magnificent picture, in stile new to his hand . . . a park with a number of figures walking in it. To the connoisseur, the most compendious information is to say, that it comes nearest to the manner of Watteau . . . but to say no more, it is Watteau far outdone!' (*Morning Herald*, 5 November 1783). The picture was described as completed, and intended for the royal collection, in a reference made to it in another newspaper in December: 'Gainsborough's very fine

picture, that he has just painted in a manner new to him, the manner of Watteau, is, we understand, for the collection of His Majesty' (*Morning Chronicle*, 17 December 1783).

## 149 Coastal Scene with Sailing and Rowing Boats, Shepherd and Sheep

Canvas. 25 × 30   63.5 × 76.2
Painted *c.* 1783–4

Yale Center for British Art (Paul Mellon Collection), New Haven (B1977.14.54)

PROVENANCE Probably purchased from the artist by William Hamilton Nisbet, of Dirleton and Belhaven, East Lothian; by descent to R. C. Nisbet Hamilton (1804–77) by 1856; Mrs Nisbet Hamilton Ogilvy sale, Dowell's, Biel, 16 April 1921, lot 1; Sir Gervase Beckett (1866–1937) by 1936; by descent to Sir Martyn Beckett; with Agnew, from whom it was purchased by Mr and Mrs Paul Mellon, July 1962; presented to the Yale Center, 1976.

EXHIBITIONS BI, 1856 (162); 'A Century of British Painting 1730–1830', British Council, Madrid and Lisbon, 1949 (21); 'Engelse landschapschilders van Gainsborough tot Turner', Boymans Museum, Rotterdam, 1955 (39); 'Painting in England 1700–1850: Collection of Mr and Mrs Paul Mellon', Virginia Museum of Fine Arts, Richmond, 1963 (36, repr.; repr. plates volume, p. 93); 'Painting in England 1700–1850: From the collection of Mr and Mrs Paul Mellon', RA, 1964–5 (34, repr. *Souvenir*, p. 22).

BIBLIOGRAPHY Jones's *Views of the Seats, Mansions, Castles, etc. of Noblemen and Gentlemen*, vol. IV (Scotland), n.d. [1830], unpaginated; Fulcher, p. 208; Waterhouse, no. 965, pl. 223; Hayes, *Drawings*, p. 271; Luke Herrmann, 'The Paul Mellon Collection at Burlington House', *Connoisseur*, December 1964, p. 218; *Selected Paintings, Drawings & Books*, Yale Center for British Art, New Haven, April 1977, p. 30 (repr.).

This picture combines, somewhat incongruously, the pastoral subject of a shepherd and sheep with the sailing boat, rowing boat and distant shore derived from the Melbourne seascape (cat. no. 141). The dead tree-trunk on the right plays a similar compositional rôle to that in *The Mall* (cat. no. 148). The painting hung among 'an excellent collection of Pictures' at Kilgraston Castle, Perthshire, in 1830 (Jones, cited above), when it was owned by Lady Lucy Grant, granddaughter of William Hamilton Nisbet. Also mentioned on p. 182.

DATING Closely related to cat. no. 146 in the subdued tonality, the soft, fluid painting of the bushy foliage, the summary modelling of the figure, the impasted highlights in the sheep and the sweep of the composition. The silvery tonality, the pale-blue tints in the sky, the handling of the grey clouds (with rich, fresh impasto in the lights), the treatment of the sailing vessel and sketchy distance are also very similar to cat. no. 141.

<div align="center">

520
</div>

149

## 150 Wooded Upland Landscape with Two Peasants and a Dog, Figures in a Country Cart, Shepherd and Sheep, Cows, Village and Distant Mountains

Canvas. $47\frac{3}{8} \times 58\frac{1}{8}$   120.3 × 147.6
Painted *c*. 1783–4

Metropolitan Museum of Art, New York (06.1279)

PROVENANCE Smith; with Arthur Tooth by 1898, from whom it was purchased by George A. Hearn, 1904; presented to the Metropolitan Museum, 1906.

EXHIBITIONS 'Landscape Paintings', Metropolitan Museum, New York, May–September 1934 (59); University Club, New York, October–November 1948.

BIBLIOGRAPHY Armstrong, 1898, p. 207; Armstrong, 1904, p. 289; P. M. Turner, 'Pictures of the English School in New York', *Burlington Magazine*, February 1913, p. 269, repr. p. 274; 'In Memoriam George Arnold Hearn', *Bulletin of the Metropolitan Museum of Art*, January 1914, repr. p. 5; Josephine L. Allen and Elizabeth E. Gardner, *A Concise Catalogue of the European Paintings in the Metropolitan Museum of Art*, New York, 1954, p. 40; Waterhouse, no. 969, repr. pl. 191; Hayes, *Drawings*, p. 259; Paulson, pp. 221, 247.

A rapid sketch, without staffage, is in Lord Methuen's collection (150a; Hayes, *Drawings*, no. 655). In the finished picture slight alterations were made in the disposition of the trees and mountains, and staffage has been added: figures, animals and a country cart. The silhouette of the distant mountains, the prevailing lateral rhythms and the subdued tonality relate this canvas to the style of the mountain landscape bought by George, Prince of Wales (cat. no. 146). The village scene in the middle distance introduces a more homely note normally absent from Gainsborough's mountain landscapes. Also mentioned on pp. 140, 145.

150

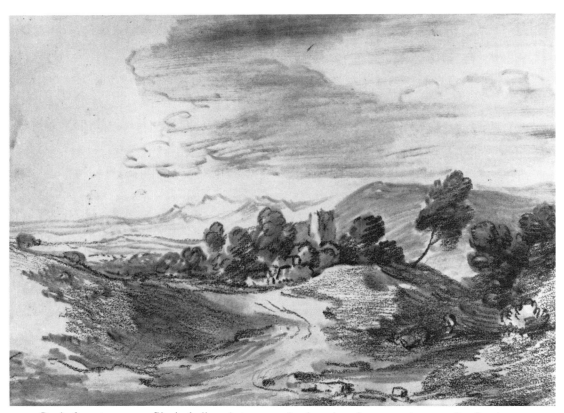

**150a** Study for cat. no. 150. Black chalk and stump, and pale-red wash. 11 × 15 / 27.9 × 38.1. Lord Methuen, Corsham Court.

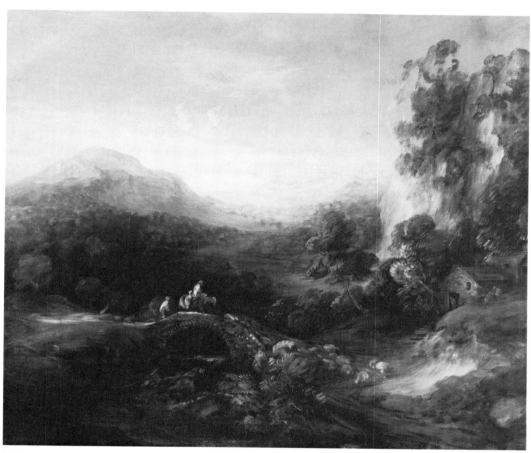

**151**

DATING Closely related to cat. nos 146 and 147 in the subdued grey-green tonality and absence of warm colour, the soft, fluid handling of the bushy foliage, the rapid handling of the foreground, the generalized treatment of the distant mountains, the motif of the dark dell, and the sweeping rhythms of the composition, which absorb all the forms.

### 151 Wooded Upland Landscape with Mounted Peasant and Figures crossing a Bridge, Sheep, Cottage and Figures under a High Cliff and Distant Mountains

Canvas. $44\frac{1}{2} \times 52\frac{1}{2}$  113 × 133.4
Painted *c.* 1783–4

National Gallery of Art, Washington, D.C.

PROVENANCE Mrs Gainsborough sale, Christie's, 10–11 April 1797, 2nd day, lot 69, bt Sir John Leicester (later Lord de Tabley (1762–1827)); Lady Lindsay, from whom it was bought by Asher Wertheimer; Sir Edgar Vincent (later Lord D'Abernon, 1857–1941), by 1912; with Duveen, 1926–31, from whom it was purchased by the Hon. Andrew W. Mellon; presented by him to the National Gallery of Art, Washington, 1937.

EXHIBITIONS 'The Second Loan Exhibition of Old Masters: British Paintings of the Late Eighteenth and Early Nineteenth Centuries', Institute of Arts, Detroit, January 1926 (9, repr.); 'Exposition Rétrospective de Peinture Anglaise (XVIIIe et XIXe Siècles)', Musée Moderne, Brussels, October–December 1929 (66); '18th Century English Painting', Fogg Art Museum, Harvard, 1930 (23); 'Landscape Painting', Wadsworth Atheneum, Hartford, Conn., January–February 1931 (61); Cincinnati, 1931 (22, repr. pl. 42); 'Century of Progress: Exhibition of Paintings and Sculpture', Chicago World's Fair, Art Institute of Chicago, June–November 1933 (192, repr.); Tate Gallery, 1980–81 (148, repr.); Grand Palais, 1981 (71, repr., p. 42).

BIBLIOGRAPHY M. H. Spielmann, 'A Note on Thomas Gainsborough and Gainsborough Dupont', *The Walpole Society*, vol. v, Oxford, 1917, pp. 97, 106; *Cicerone*, April 1926, p. 252 (repr.); Frank E. Washburn Freund, 'The English School: Mirror of its Time', *International Studio*, May 1926, p. 62, repr. p. 57; Walter Heil, 'Die Gainsborough-Ausstellung in Cincinnati', *Pantheon*, September 1931, pp. 70, 384, repr. p. 383; Charles Johnson, *English Painting from the Seventh Century to the Present Day*, London, 1932, p. 133; *Art Digest*, 15 May 1933, p. 32, repr.; Alfred M. Frankfurter, 'Art in the Century of Progress', *Fine Arts*, June 1933, p. 61, repr. p. 26; *Art Digest*, 1 June 1937, p. 8, repr.; John Piper, 'British Romantic Artists', in W. J. Turner, ed., *Aspects of British Art*, London, 1947, p. 166, repr. p. 165; Water-

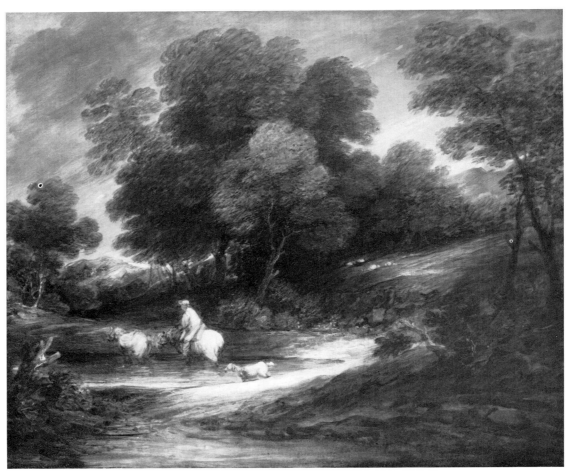

**152**

house, no. 1008, repr. pl. 287 (repr. col. in 1966 reprint); Douglas Hall, 'The Tabley House Papers', *The Walpole Society*, vol. XXXVIII, Glasgow, 1962, pp. 61, 70; John Hayes, 'Gainsborough's Later Landscapes', *Apollo*, July 1964, p. 26, repr. pl. 1 (col.); Ross Watson, 'British Paintings in the National Gallery of Art', *Connoisseur*, September 1969, p. 58, repr. fig. 6; Jean-Jacques Mayoux, *La Peinture Anglaise De Hogarth aux Pré-raphaélites*, Geneva, 1972, p. 74; Herrmann p. 103; Hayes, p. 224, repr. pls 134, 137 (detail); Paulson, pp. 247, 249; *European Paintings: an Illustrated Summary Catalogue*, National Gallery of Art, Washington, 1975, no. 99, p. 142, repr. p. 143; John Walker, *National Gallery of Art Washington*, n.d. [1975], pp. 33, 356 (repr. col.); Lindsay, p. 166.

This brilliant canvas is very sketchily handled, and is clearly unfinished: the high cliffs on the right, which were developed in the course of working out the design, are somewhat obtrusive, and may have accounted for Gainsborough's ultimate failure to carry the picture through. The strong lateral rhythms are characteristic of this period (compare cat. no. 146). The motif of figures and animals crossing a bridge was to become a familiar element in Gainsborough's late landscapes. Also mentioned on pp. 145, 147, 171, 231; details repr. pls 179, 203.

DATING Closely related to cat. no. 150 in the soft, rapid handling of the bushy trees, the softly painted mountains (with the contours outlined in long, sweeping brush-strokes) the generalized distance, the use of pinkish tones (mainly confined to the track in the centre in cat. no. 150), the motif of the dark dell and the vigorous, sweeping rhythms of the composition. The rapid handling and the highlighting of the foliage, the modelling of the sheep in loose, quick touches, the atmospheric treatment of the distance and the rough, yellowish impasto in the lights of the clouds are also closely related to the background of *Mrs Sheridan* (Waterhouse, no. 613, pl. 256), painted in 1785.

### 152 Wooded Upland Landscape with Horseman, Pack-horse and Dog crossing a Pool and Sheep on a Rising Bank

Canvas. 25 × 30  63.5 × 76.2
Painted *c.* 1783–4

Wadsworth Atheneum, Hartford, Conn.

PROVENANCE Reputed to have been owned by Sir Joshua Reynolds (1723–92); Charles Meigh; Meigh sale, Christie's, 21–22 June 1850, 2nd day, lot 133, bt Lenox; bequeathed by James Lenox to the New York

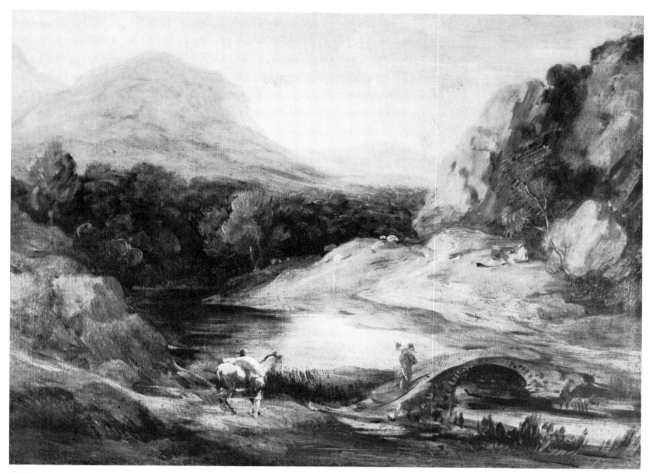

**153**

Public Library; New York Public Library sale, Parke-Bernet's, New York, 17 October 1956, lot 42 (repr.), bt John Nicholson, from whom it was purchased by the Wadsworth Atheneum, 1957.

EXHIBITION 'Masterpieces from the Wadsworth Atheneum', Knoedler's, New York, January–February 1958 (99).

BIBLIOGRAPHY *Catalogue of Paintings in the Picture Galleries*, New York Public Library, New York, 1936 (General Room, no. 48); 'Accessions of American and Canadian Museums, January–March 1957', *Art Quarterly*, summer 1957, repr. p. 213; Waterhouse, no. 1000; *Wadsworth Atheneum Handbook*, Hartford, Conn., 1958, p. 99 (repr.).

An exceptionally vigorously painted canvas, in which all the forms seem to be in movement; the placid motion of the figure and horses crossing the pool stand out against the prevailing diagonals, serpentine movement and agitation of the trees. The brilliantly handled rocky mountains on the left may be contrasted with the gently outlined mountains in *The Market Cart* (cat. no. 183), painted a dozen years later. In spite of all this, the relationship between certain of the trees is not entirely harmonious, and the handling is uncannily close to the best work of Dupont. Also mentioned on pp. 171, 232; a detail is repr. pl. 204.

DATING Closely related to cat. no. 151 in the rapid handling of the foliage and foreground and the loose modelling of the figure and animals. The rapid, washy handling of the foliage is also closely related to cat. no. 159 and more particularly to the background of *The Sloper Family* (Waterhouse, no. 622), commissioned in July 1787 but never finished.

## 153 Rocky Wooded River Landscape with Peasant and Horse, Figure Crossing a Bridge, Shepherd and Sheep and Distant Mountains

Canvas. $15\frac{1}{4} \times 21$   $38.7 \times 53.3$
Painted *c.* 1783–4

National Museum of Wales, Cardiff (775)

PROVENANCE Miss Gwendoline E. Davies (d. 1951), by whom it was bequeathed to the National Museum of Wales, 1952.

EXHIBITION 'Some Pictures from the National Museum of Wales', Agnew's, 1956 (50).

BIBLIOGRAPHY John Steegman, 'National Museum of

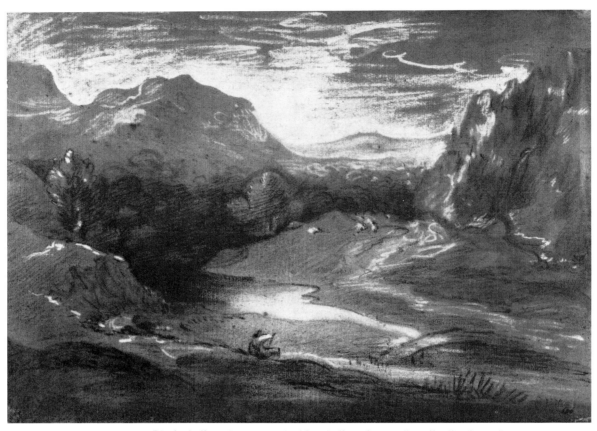

**153a**  Study for cat. no. 153. Black chalk and stump and white chalk on brown (heavily discoloured) paper.
10 × 13⅞ / 25.4 × 35.2. Victoria and Albert Museum, London (Dyce Collection 680).

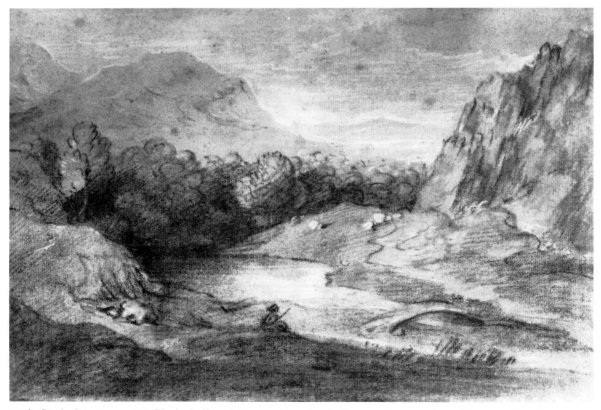

**153b**  Study for cat. no. 153. Black chalk and stump and white chalk on buff paper. 9⅝ × 14¼ / 24.4 × 36.2. John
Wright, Spondon.

Wales: The Gwendoline E. Davies Bequest', *Connoisseur*, March 1952, p. 23; *Catalogue of Oil-Paintings*, National Museum of Wales, Cardiff, 1955, p. 35; Waterhouse, no. 982; Hayes, *Drawings*, p. 284.

Two sketches exist for this picture, identical in design (except for the pose of the figure) but differing considerably in technique: one is in the Victoria and Albert Museum (153a; Hayes, *Drawings*, no. 769) and the other is owned by John Wright (153b; Hayes, *Drawings*, no. 768). In the finished picture the seated figure has been replaced by a peasant leaning over a horse, a figure is included crossing the bridge and a shepherd and tree have been introduced on the right. The subdued tonality and soft, misty effect of this sensitive but sketchy work reflect Gainsborough's absorption of the atmosphere of Lakeland scenery. The painting is exceptionally close in technique to that characteristic of the transparencies in its rapidity and softness of handling. Also mentioned on p. 141.

DATING Closely related to cat. no. 151 in the thin, sketchy handling over a pinkish priming, the loose treatment of the foreground, the soft modelling of the rocks and mountains, the highlighting of the wiry tree on the right, the suggestion of the sheep in single, curving brushstrokes, the motif of the stone bridge and the broad outlines of the composition.

### 154 Wooded Upland River Landscape with Figures crossing a Bridge, Cottage, Sheep and Distant Mountains

Transparency on glass. $11 \times 13\frac{1}{4}$   $27.9 \times 33.7$
Painted *c.* 1783–4

Victoria and Albert Museum, London (P.37–1955).

PROVENANCE Purchased from Margaret Gainsborough (1752–1820) by Dr Thomas Monro (1759–1833); Monro sale, Christie's, 26 June 1833 ff., 3rd day (28 June), lot 168, bt W. White, who bequeathed it to G. W. Reid; anon. [Buck Reid] sale, Christie's, 29 March 1890, lot 132, bt in; Leopold Hirsch; Hirsch sale, Christie's, 11 May 1934, lot 104, bt Gooden and Fox for Ernest E. Cook; bequeathed to the Victoria and Albert Museum, through the National Art-Collections Fund, 1955.

EXHIBITION GG, 1885 (394).

BIBLIOGRAPHY Waterhouse, no. 978, repr. pl. 268; Jonathan Mayne, 'Thomas Gainsborough's Exhibition Box', *Victoria and Albert Museum Bulletin*, vol. 1, no. 3, July 1965, repr. fig. 5 (reversed); Hayes, *Drawings*, p. 287.

See under cat. no. 132. A drawing owned by Christian Mustad (154a; Hayes, *Drawings*, no. 779), which differs from the transparency in a number of minor ways, and also includes two cows in the foreground, seems more likely to have been worked up later from this exceptionally rapidly handled transparency than to be, in any sense, a study for it. Gainsborough's transparencies were, in essence, studies anyway. For other cases where drawings seem to have been made *from* the transparencies, rather than the other way about, see cat. nos 172 and 173. The strongly rhythmical design is characteristic of this period, and the motif of figures crossing a bridge had been used in the Washington and Cardiff landscapes (cat. nos 151, 153). Also mentioned on pp. 140–41, 142.

DATING Closely related to cat. nos 151 and 153 in the rapid, washy handling of all the forms, the soft modelling of the mountains and bushy trees and the motif of travellers crossing a stone bridge.

### 155 Wooded River Landscape with Fisherman in a Rowing Boat, High Banks and Distant Mountains

Transparency on glass. $11 \times 13\frac{1}{4}$   $27.9 \times 33.7$
Painted *c.* 1783–4

Victoria and Albert Museum, London (P.39–1955).

PROVENANCE Purchased from Margaret Gainsborough (1752–1820) by Dr Thomas Monro (1759–1833); Monro sale, Christie's, 26 June 1833 ff., 3rd day (28 June), lot 168, bt W. White, who bequeathed it to G. W. Reid; anon. [Buck Reid] sale, Christie's, 29 March 1890, lot 132, bt in; Leopold Hirsch; Hirsch sale, Christie's, 11 May 1934, lot 104, bt Gooden and Fox for Ernest E. Cook; bequeathed to the Victoria and Albert Museum, through the National Art-Collections Fund, 1955.

EXHIBITION GG, 1885 (394).

BIBLIOGRAPHY Waterhouse, no. 977, repr. pl. 267; Jonathan Mayne, 'Thomas Gainsborough's Exhibition Box', *Victoria and Albert Museum Bulletin*, vol. 1, no. 3, July 1965, p. 21, repr. fig. 3.

The development of the design in a series of coulisses can be paralleled in a number of landscapes of this period (for instance, the Cardiff river scene: cat. no. 153), but this is the first case in which the middle distance is not filled by trees and the winding course of the river dominates the composition. The fisherman netting is a motif developed from Gainsborough's coastal scenes (cat. nos 126 and 129).

DATING Closely related to cat. no. 153 in the rapid, washy handling throughout, the modelling of the cliff on the left, the treatment of the bushy trees, the rhythmical silhouette of the mountains and the sweeping highlights in the clouds.

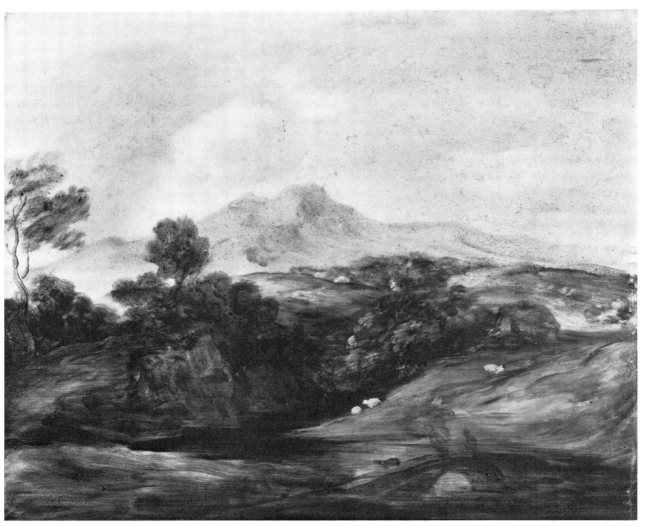

154

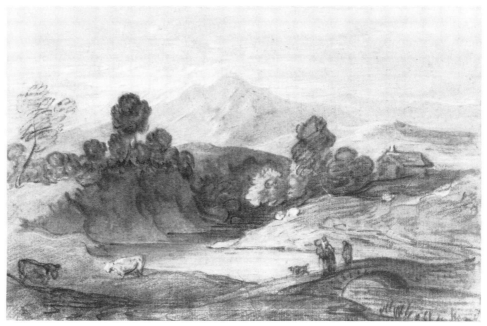

**154a** Drawing related to cat. no. 154. Black chalk and stump and white chalk on buff paper. 10 × 14¼ / 25.4 × 36.2. Christian Mustad, Oslo.

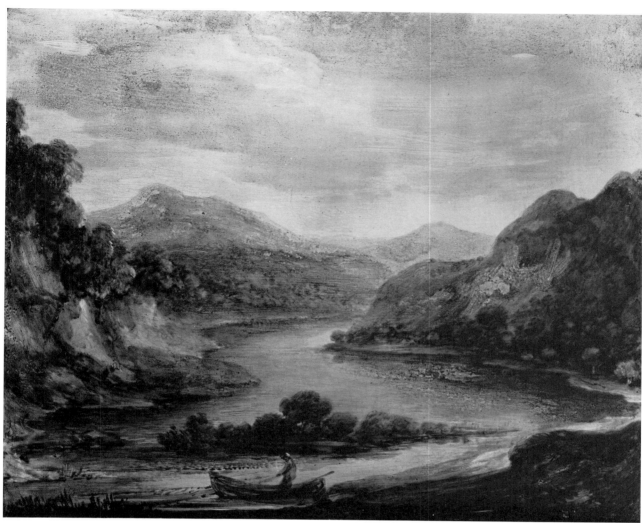

**155**

## 156 Wooded Landscape with Peasants, Country Carts, Faggot-gatherers and Barn

Canvas. $50\frac{3}{8} \times 40\frac{3}{8}$   $128 \times 102.6$
Painted *c.* 1784–5

Fine Arts Museums of San Francisco, San Francisco (75.2.8)

INSCRIPTION Inscribed in ink in a nineteenth-century hand on a label pasted on the back of the stretcher: *This Landskip, Painted by Mͬ Gainsborough/about the Year/1778, was given by him as his/CHEF D' OEUVRE/To Mͬ Kilderbee of Ipswich/in Memory of Friendship.*

PROVENANCE Presented by the artist to Samuel Kilderbee (1725–1813); Kilderbee sale, Christie's, 30 May 1829, lot 125, bt Emmerson; Brook Greville; Greville sale, Christie's, 30 April 1836, lot 79, bt Norton; Sir Charles Henry Coote (1815–95); thence by descent to Sir Ralph Coote (1874–1941), 1923; Countess de Kotzebue sale, Parke-Bernet's, New York, 27–28 January 1956, 2nd day, lot 352 (repr.), bt John Nicholson, from whom it was purchased by Mr and Mrs Roscoe Oakes; presented to the Fine Arts Museums of San Francisco, 1956.

EXHIBITIONS International Exhibition, Dublin, 1865 (56); 'Old Masters of the Early English and French Schools', Royal Hibernian Academy, Dublin, 1902–3 (28); Tate Gallery, 1980–81 (149, repr.); Grand Palais, 1981 (72, repr.).

BIBLIOGRAPHY Waterhouse, no. 941a, repr. pl. 202.

The totally enclosed nature of the landscape, especially in a large-scale work, is very unusual for Gainsborough; and the subject-matter, two country carts travelling down a wooded lane, is new. The only previous work with which this composition has some links in these respects is the St Quintin picture of 1766 (cat. no. 87). The loose, feathery foliage is close in character to such Dutch painters as Salomon van Ruysdael or Adriaen van der Velde, and the picture is, in fact, a close copy of a Pieter Molijn (Bukowski sale, Stockholm, 24 September 1931, lot 54, repr.) (pl. 196), but with the addition of a framing tree on the left. The flowing, upward movement of the trees, which are modelled in rich glazes, is echoed

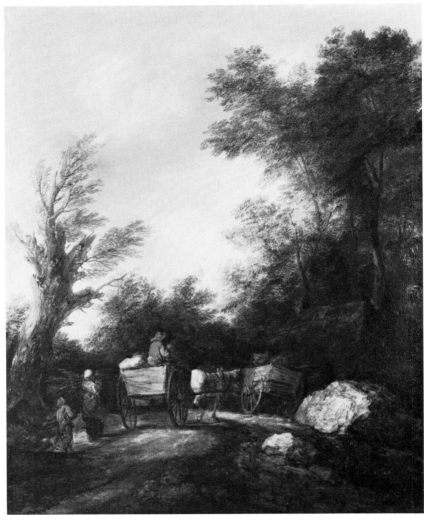

156

in the soft, spiralling clouds. One copy is in an American private collection and another, cut down and showing only the bottom half of the composition, is at Christchurch Mansion, Ipswich. Also mentioned on pp. 164, 182.

DATING The nineteenth-century source cited above gives the date of the picture as 'about the Year 1778'. However, nothing in the style or technique is comparable with pictures of the later 1770s, and the inscription cannot be accepted as reliable evidence with regard to the date of the painting. Identical with cat. no. 157 in the subdued tonality, the loose painting of the foliage, the rich modelling of the tree-trunk on the left in tints of brown, red, blue, grey and white, the soft, fluid, shapeless modelling of the foreground rocks, the free handling of the foreground track and the fluid modelling of the figures and horses. The pale-blue tints in the sky, the grey clouds (with roughly painted white impasto in the lights), the loose touch in the foliage, and the freely handled foreground track are also closely related to cat. no. 149.

### 157 Wooded Rocky Landscape with Peasants in a Country Waggon, Drover holding a Horse while a Woman is helped in, and Scattered Sheep (The Harvest Waggon)

Canvas. 48 × 59    121.9 × 149.9
Painted in the winter of 1784 and completed by January 1785
Signed with initials on the rock below the sheep: *T.G.*

Art Gallery of Ontario, Toronto (2578)

PROVENANCE Purchased by George, Prince of Wales (later George IV, 1762–1830), 1786, and presented to Mrs Maria Fitzherbert (1756–1837), 1810; bequeathed by her to the Hon. Mrs Dawson Damer, 1837; anon. [Colonel Damer] sale, Christie's, 27 March 1841, lot 141 (as 'PAINTED EXPRESSLY FOR THE PRINCE OF WALES'), bt in; John Gibbons (d. 1851); by descent to the Rev. Benjamin Gibbons; Gibbons sale, Christie's, 26 May 1894, lot 24, bt in; with Colnaghi, from whom it was purchased by Lionel (later Sir Lionel) Phillips (1855–1926), 1898; Sir Lionel Phillips sale, Christie's, 25 April 1913, lot 45, bt Agnew for Judge Elbert H. Gary, New

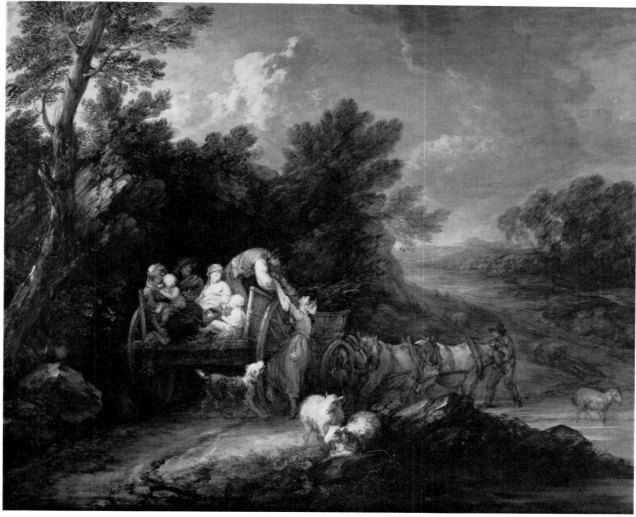

**157**

York; Gary sale, American Art Association, New York, 20 April 1928, lot 30 (repr.), bt Duveen; Mr and Mrs Frank P. Wood, Toronto, by whom it was presented to the Art Gallery of Ontario, 1941.

EXHIBITIONS Schomberg House, 1789 (74); BI, 1814 (13); BI, 1841 (127); RA, 1870 (82); RA, 1890 (163); '20 Masterpieces of the English School', Agnew's, 1895 (5); 'Pictures by Masters of the Flemish and British Schools', The New Gallery, 1899–1900 (181); 'A Loan Collection of Paintings by Old Masters', Art Gallery of Toronto, January 1929 (5, repr.); 'European Paintings and Sculpture from 1300–1800: Masterpieces of Art', New York World's Fair, May–October 1939 (131); 'Allied Art for Allied Aid', Knoedler's, New York, June 1940 (7); 'Masterpieces of Painting', Art Association of Montreal, February–March 1942 (88, repr.); 'Great Paintings', Toronto Art Gallery, February–March 1944 (21); 'Old and New England', Museum of Art, Providence, Rhode Island, January–February 1945 (7, repr. p. 59); 'A Thousand Years of Landscape East and West', Museum of Fine Arts, Boston, October–December 1945; '40 Masterpieces: A Loan Exhibition of

Paintings from American Museums', City Art Museum, St Louis, October–November 1947 (16, repr.); 'Paintings by European Masters from Public and Private Collections in Toronto, Montreal and Ottawa', Art Gallery of Toronto, Montreal Museum of Fine Arts and the National Gallery of Canada, Ottawa, 1954 (34, repr. frontispiece, col.); 'Romantic Art in Britain: Paintings and Drawings 1760–1860', Detroit Institute of Arts, January–February 1968, and Philadelphia Museum of Art, March–April 1968 (22, repr.); 'From El Greco to Pollock: Early and Late Works by European and American Artists', Baltimore Museum of Art, October–December 1968 (26, repr. p. 45); 'Rubenism', Brown University, Providence, Rhode Island, January–February 1975 (67, pp. 200, 202); Tate Gallery, 1980–81 (150, repr.); Grand Palais, 1981 (73, repr., pp. 38, 42).

BIBLIOGRAPHY *The Morning Herald*, 27 January 1785; ibid., 3 April 1786; *Morning Post*, 30 March 1789; *Morning Herald*, 11 June 1789; Fulcher, pp. 193, 233; J. S., in *Notes and Queries*, 25 November 1871, p. 434; Armstrong, 1894, p. 50; Bell, pp. 122–3; Armstrong,

1898, pp. 114, 117–18, 207, repr. facing p. 40; Gower, pp. 53, 113, repr. facing p. 52; Armstrong, 1904, pp. 151, 156–7, 283; Armstrong, 1906, pp. 131, 157; Menpes and Greig, p. 80; Whitley, pp. 235, 258–9; William T. Whitley, *Artists and their Friends in England 1700–1799*, London, 1928, vol. II, pp. 63–4, 66, repr. pl. 3; Esther Singleton, *Old World Masters in New World Collections*, New York, 1929, pp. 389–92, repr. p. 391; C. H. Collins Baker, *British Painting*, London, 1933, pp. 108, 151; Woodall, *Drawings*, pp. 81–2; anon. [Tancred Borenius], 'Gainsborough's Collection of Pictures', *Burlington Magazine*, May 1944, p. 109; Woodall, p. 92 (note); S. N. Behrman, *Duveen*, London, 1952, pp. 99–100; R. H. Hubbard, 'Art Museums in Canada: Some Developments in 1953–4', *Art Quarterly*, winter 1954, repr. p. 354; R. H. Hubbard, *European Paintings in Canadian Collections: Earlier Schools*, Toronto, 1956, p. 116, repr. pl. LV and p. xxiv (col.); Waterhouse, pp. 19, 34, no. 993, repr. pl. 270; John Hayes, 'Gainsborough and Rubens', *Apollo*, August 1963, pp. 94–5, repr. fig. 9; John Hayes, 'Gainsborough's Later Landscapes', *Apollo*, July 1964, p. 26; Oliver Millar, *The Later Georgian Pictures in the Collection of Her Majesty The Queen*, London, 1969, vol. I, p. xxvi, repr. pl. XIX; Herrmann, p. 104; *Handbook Catalogue illustré*, Art Gallery of Ontario, 1974, p. 2, repr. p. 63 (col.); Hayes, pp. 44, 47, 224, repr. pl. 78; Paulson, p. 247; British Museum, 1978, p. 22; John Barrell, *The Dark Side of the Landscape*, Cambridge, 1980, pp. 68–70, 109, repr. p. 67, 68 (detail); John Ingamells, 'Thomas Gainsborough', *Burlington Magazine*, November 1980, p. 780; Dillian Gordon, *Second Sight: Rubens: The Watering Place/Gainsborough: The Watering Place*, National Gallery, London, 1981, p. 19; Lindsay, pp. 64, 168, repr. pl. 8; Christoph Heilmann, 'Thomas Gainsborough', *Kunstchronik*, Munich, March 1981, p. 116.

The subject is related to Gainsborough's earlier *The Harvest Waggon*, in the Barber Institute (cat. no. 88), painted in 1767, and includes the motifs of the drover holding the horses still and the girl being helped into the waggon; but the spotlit figure group is no longer pyramidal, the trees and rocks behind enclose rather than heighten the design, and the winding track has become the dominant compositional rhythm. In contrast to the earlier work, it is the landscape that is in vigorous movement, not the figures and horses (the former are almost Wheatleyesque), and the concept is baroque rather than classical. The wiry, twisting tree-trunk, cut off at the top, which frames the composition, and the semicircle of intermingled trees and rocks enclosing deep shadows, seem to derive from Rubens's *Cart Overturning by Moonlight*, which Gainsborough could have seen in Lord Harcourt's collection at Nuneham (compare pl. 177); the way in which the swing of the winding track is echoed in the dark clouds is paralleled in Rubens's *Summer* at Windsor Castle (pl. 178). Both pictures are likely to have been familiar to Gainsborough (see my article in *Apollo*, August 1963, cited above: notes

8 and 26). The girl in shadow in the back of the cart is identical to Hogarth's *Shrimp Girl*. The supposition (see the letter from Lockett Agnew to Judge Gary, dated 30 April 1913, transcribed in the 1928 sale catalogue cited above) that this figure, and that of the girl climbing into the waggon, were modelled on Gainsborough's daughters, is difficult to support, though the latter is not dissimilar to the similarly posed figure in the Barber picture, who can be identified as Margaret (see cat. no. 88). The distance is very sketchily and fluidly handled. Although purchased by the Prince of Wales, the picture was not paid for and remained in Gainsborough's studio until the settlement of the Prince's debts to Mrs Gainsborough in 1793. Several smaller copies exist, including one at Nostell Priory; there is a free version by Thomas Barker in the Toledo Museum of Art (pl. 332 and p. 278). Also mentioned on pp. 145, 147, 182, 232; a detail is repr. pl. 180.

DATING Identifiable with a landscape in Gainsborough's studio in January 1785, and later bought by the Prince of Wales, from Bate-Dudley's description: 'Mr. *Gainsborough*'s celebrated landscape consists of an evening scene; the principal object of it, a farm cart returning from a country market. The figures are finished in the highest stile of pencilling' (*Morning Herald*, 27 January 1785). The identification is confirmed by Bate-Dudley's later reference to the purchaser: 'The *Prince of Wales* has purchased Mr. Gainsborough's beautiful picture of the peasants returning from market. The *Prince*'s taste for the fine arts cannot be better illustrated, than in the choice he has made of the above picture' (*Morning Herald*, 3 April 1786).

### 158 Wooded Landscape with Rustic Lovers, Herdsman, Cows and Flock of Sheep at a Pool, and Distant Mountain

Canvas. 47 × 59   119.4 × 149.9
Painted *c.* 1784–5

Private collection, England

PROVENANCE George, 5th Earl De La Warr (1791–1869) by 1844; De La Warr sale, Christie's, 2 May 1857, lot 148, bt Pennell; Captain F. H. Huth; Huth sale, Christie's, 14 June 1907, lot 101 (repr.), bt Agnew; with Sir George Donaldson (1845–1925), from whom it was bought by Knoedler, 1911; J. Horace Harding, New York; Harding sale, Parke-Bernet's, New York, 1 March 1941, lot 64 (repr.), bt M. A. Linah; with Knoedler, from whom it was purchased by the Hon. Michael Astor, 1953; Astor sale, Christie's, 25 November 1977, lot 164 (repr. col.).

EXHIBITIONS BI, 1844 (136); Agnew's, 1907 (11); 'Old Masters', Knoedler's, New York, January 1912 (p. 16, repr.; limited ed., 27, repr. p. 17); 'Paintings by Thomas Gainsborough, R.A., and J. M. W. Turner, R.A.', Knoedler's, New York, January 1914 (27); 'Pictures by Gainsborough', Knoedler's, New York, December 1923 (10); Cincinnati, 1931 (30, repr. pl. 17).

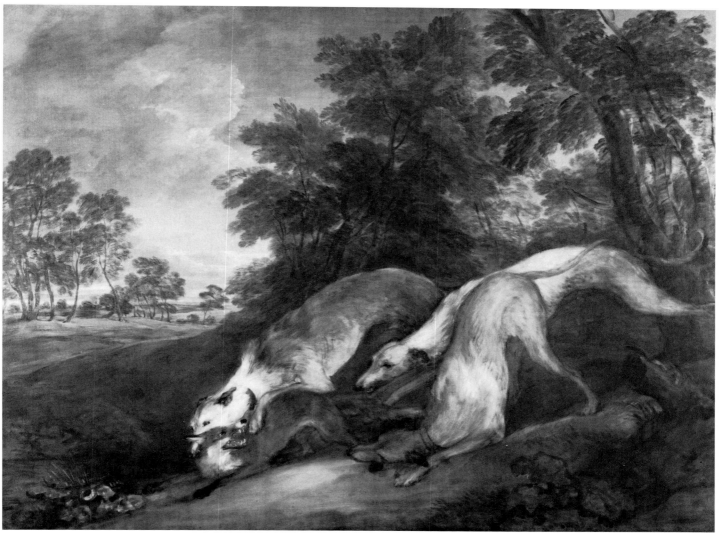

159

sale by Sir John Leicester. Probably Gainsborough felt he had taken the work as far as he could and that a higher finish would only result in destroying the effect, perhaps thereby disappointing a client, for neither picture was sold. In spite of the size and the fact that he painted a companion to it, the impression remains, however, that the Kenwood picture is a private work. Also mentioned on pp. 130, 145.

DATING Identical with cat. no. 157 in the outlining of the clouds with squiggles of rich creamish-yellow paint, the group of slender trees on the left (with the foliage rapidly painted in pale, washy tones), the soft handling of the foliage on the right, the rapid modelling of the foreground detail, the relationships of the main masses and the strongly rhythmical treatment throughout. The trees in the distance are also closely related to the background of *The Morning Walk* (Waterhouse, no. 335, pl. 274), painted in 1785.

**160 Wooded Landscape with Pool and Waterfall and Actaeon stumbling upon Diana and her Nymphs bathing (Diana and Actaeon)**

Canvas. $62\frac{1}{4} \times 74$   158.1 × 188
Painted *c.* 1785

HM The Queen, Buckingham Palace

PROVENANCE Mrs Gainsborough sale, Christie's, 10–11 April 1797, 2nd day, lot 43, bt Hammond for George, Prince of Wales (later George IV, 1762–1830); thence by descent.

EXHIBITIONS 'Pictures by T. Gainsborough, R.A.', Agnew's, June–July 1928 (4); 'British Art', RA, 1934 (160, repr. *Souvenir*, p. 28); 'Twee Eeuwen Engelsche Kunst', Stedelijk Museum, Amsterdam, July–October 1936 (44); 'The King's Pictures', RA, 1946–7 (478, repr. *Souvenir*, p. 100); Arts Council, 1953 (60, p. 8); 'Gainsborough', The Queen's Gallery, Buckingham Palace, 1970 (12, pp. 6–7, repr. pl. 6); Tate Gallery, 1980–81 (137, repr., detail fig. 11).

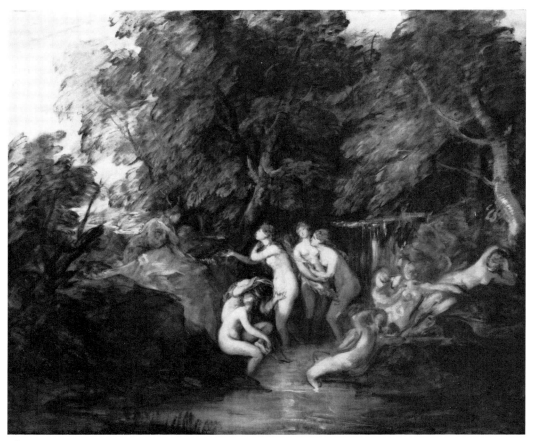

**160**

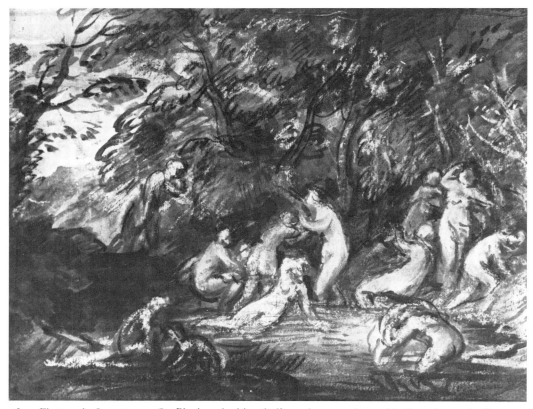

**160a** First study for cat. no. 160. Black and white chalks and grey and grey-black washes on buff paper. $10\frac{1}{16} \times 13\frac{1}{8}$ / 25.6 × 33.3. Private collection, Great Britain.

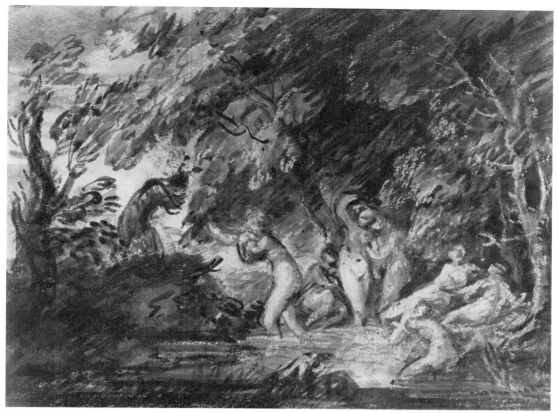

**160b** Second study for cat. no. 160. Grey and grey-black washes and white chalk on buff paper. $11 \times 14\frac{7}{16}$ / 27.9 × 36.7. Henry E. Huntington Library and Art Gallery, San Marino, California.

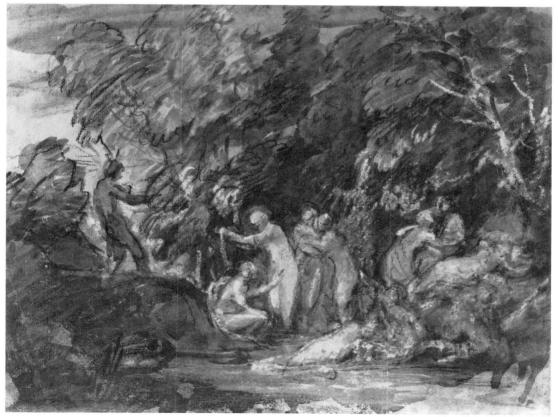

**160c** Final study for cat. no. 160. Black chalk with grey, grey-black and brown washes and bodycolour. $10\frac{13}{16} \times 14$ / 27.5 × 35.6. Cecil Higgins Art Gallery, Bedford (P.118).

BIBLIOGRAPHY Armstrong, 1898, p. 209, repr. facing p. 144; Chamberlain, p. 69; Armstrong, 1904, p. 291, repr. facing p. 200; A. E. Fletcher, *Thomas Gainsborough, R.A.*, London, 1904, p. 133; Whitley, p. 348; M. H. Spielmann, 'A Note on Thomas Gainsborough and Gainsborough Dupont', *The Walpole Society*, vol. v, Oxford, 1917, pp. 97, 98, 103; Lionel Cust, 'Notes on Pictures in the Royal Collection', *Burlington Magazine*, April 1918, p. 127, repr. pp. 126–7; *Pantheon*, August 1918, repr. p. 418; Hugh Stokes, *Thomas Gainsborough*, London, 1925, p. 117; C. H. Collins Baker, *British Painting*, London, 1933, p. 151, repr. pl. 75; R. H. Wilenski, *English Painting*, London, 1933, p. 131; Charles Johnson, *A Short Account of British Painting*, London, 1934, p. 57; *Royal Academy of Arts Commemorative Catalogue of the Exhibition of British Art, 1934*, Oxford, 1935, no. 214, repr. pl. LXIV; Chauncey Brewster Tinker, *Painter and Poet*, Cambridge, Mass., 1938, pp. 78–80, repr. p. 77; Woodall, *Drawings*, pp. 74–5, 82, 123, repr. pl. 101; Bernard Denvir, 'The King's Pictures', *Studio*, June 1947, p. 166, repr.; Woodall, p. 104, repr. p. 113; Graham Sawyer, 'A Note on Gainsborough and Adriaen de Vries', *Journal of the Warburg and Courtauld Institutes*, vol. XIV, London, 1951, p. 134, repr. pl. 29d (detail); David Piper, 'Gainsborough at the Tate Gallery', *Burlington Magazine*, July 1953, p. 246; Waterhouse, p. 37, no. 1012, repr. pl. 288; Woodall, *Letters*, repr. facing p. 40 (detail); John Hayes, 'Gainsborough's Later Landscapes', *Apollo*, July 1964, p. 22; Oliver Millar, *The Later Georgian Pictures in the Collection of Her Majesty The Queen*, London, 1969, vol. 1, no. 806, p. 43, vol. 2, repr. pl. 78; John Hayes, 'English Painting and the Rococo', *Apollo*, August 1969, p. 120; Hayes, *Drawings*, pp. 19, 40, 51, 62, 295, 296, repr. pl. 346; Oliver Millar, '"The Apollo of the Palace": Gainsborough at the Queen's Gallery', *Apollo*, September 1970, p. 185, repr. fig. 11; William Gaunt, *The Great Century of British Painting: Hogarth to Turner*, London, 1971, p. 22, repr. pl. 112; Herrmann, p. 104, repr. pl. XIV (col.); Michael Clarke, 'Gainsborough and Loutherbourg at York', *City of York Art Gallery Quarterly*, October 1973, p. 931; Hayes, pp. 18, 32, 46, 225, repr. pls 166, 169 (detail); Paulson, pp. 224, 226, 227, 248, repr. pl. 158; John Dixon Hunt, *The Figure in the Landscape*, Baltimore and London, 1976, p. 214; Oliver Millar, *The Queen's Pictures*, London, 1977, p. 131, repr. pl. 146; John Ingamells, 'Thomas Gainsborough', *Burlington Magazine*, November 1980, p. 780; Grand Palais, 1981, pp. 37, 42, 51, repr. fig. 33, detail fig. 46; Lindsay, p. 186, repr. pl. 21; Jeffery Daniels, 'Gainsborough the European', *Connoisseur*, February 1981, p. 114; Christoph Heilmann, 'Thomas Gainsborough', *Kunstchronik*, Munich, March 1981, p. 112.

The story for this mythological painting is taken from Ovid's *Metamorphoses*, and tells how Actaeon, hunting in the sacred valley of Gargaphe, stumbled unwittingly on the bathing-place of Diana and her attendants; Diana at once threw a handful of water at his face and turned him into a stag, whereupon he was torn to pieces by his own hounds. Three studies exist for this composition, and are owned, respectively, by a British private collector, the Huntington Art Gallery and the Cecil Higgins Art Gallery (160a–c; Hayes, *Drawings*, nos 810–12). The drawings are very varied in character and intention, and provide the most valuable insight into the workings of Gainsborough's pictorial imagination that has come down to us. In the first sketch (160a) the scene caused by the unexpected intrusion of Actaeon is one of confusion, heightened by the vigorously sketched tree-trunks, spiralling in different directions; some of the figures are turning away in embarrassment, one is hurriedly putting on some clothes, and another is climbing up the bank to the right; Diana is seen in the centre, about to throw a handful of water at the intruding huntsman. In the second design (160b) there are fewer figures and greater cohesion. The figures are now arranged broadly in a semicircle, and the movement to the right, created by the two reclining figures, is counterbalanced by the sturdy tree-trunk which frames the scene and by the strong diagonal emphasis of the mass of foliage. The figure putting on her clothes in the right foreground of the first drawing is still seen here, though rather altered; Diana has been moved to the left, and Actaeon is shown trying to protect himself from the handful of water with which the goddess will turn him into a stag—unsuccessfully, however, as the horns can already be seen sprouting from his head. The third design (160c) is the most restrained, and has a monumental quality not apparent hitherto. Neither the figures nor the trees suggest agitation. Actaeon is shown recoiling, instead of leaning forward, and the compositional relationship between him and Diana is less tense and dramatic than in the Huntington drawing. The two standing figures shown arm-in-arm in the Huntington drawing remain, but rather altered, and the reclining figure to their left has been replaced in the position originally adopted in the first sketch. The figure in the right foreground has been removed, and the composition thereby given a more lateral emphasis.

The third design was substantially that used by Gainsborough for the painting itself. In the latter, however, Actaeon is shown reclining on the bank, in a pose suggesting entreaty, a tree-trunk has been introduced above Diana, and a waterfall painted in over the foliage to link together the two groups of bathers more satisfactorily. The figures are all slightly altered in detail, but the grouping remains unchanged. There are numerous pentimenti, especially in the centre of the composition, and the picture has been left unfinished, probably deliberately: the figures on the right are barely more than sketched, and Sir Oliver Millar has pointed out (in the catalogue of the 'Gainsborough' exhibition, 1970, cited above) that 'cleaning and restoration, completed in 1969, seems to confirm that the picture . . . is a large sketch and not an unfinished design'. This view seems to be correct, as the character of the brushwork does not suggest that the picture could have been carried

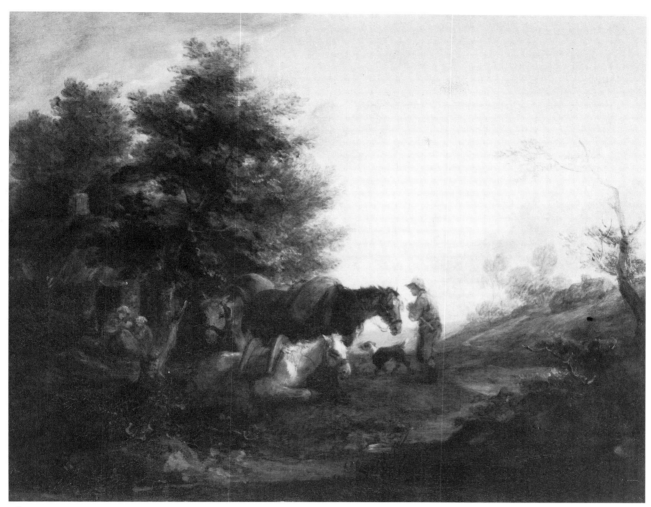

**162**

(repr.), bt Agnew, from whom it was purchased by Colonel S. J. L. Hardie; Hardie sale, Sotheby's, 19 November 1969, lot 120 (repr. col.), bt Leger, from whom it was purchased.

EXHIBITIONS Schomberg House, April 1786; Agnew's, 1902 (3); RA, 1910 (155); Nottingham, 1962 (26); 'English Paintings 1750–1900', Leger Galleries, October 1970 (13, repr.); 'Paintings from Midwestern University Collections', Wildenstein's, New York, October 1973 (20, repr.).

BIBLIOGRAPHY *Morning Herald*, 8 April 1786; Armstrong, 1904, p. 285; Whitley, p. 255; Waterhouse, p. 33, no. 998; Mary Woodall, 'Gainsborough Landscapes at Nottingham University', *Burlington Magazine*, December 1962, p. 562; John Hayes, 'Gainsborough's Later Landscapes', *Apollo*, July 1964, p. 25; Hayes, *Drawings*, p. 273; Frank Davis, 'Paintings to Gloat Over', *Country Life*, 1 January 1970, p. 12, repr. fig. 2.

This is the largest of the seven small landscapes on which Gainsborough was working in the early months of 1786 and which were exhibited at Schomberg House in April of that year. The subject of pack-horses at rest is new, and appropriately associated with the theme of a mother and her children seated outside a cottage door. Also mentioned on pp. 165–6, 229; a detail is repr. pl. 197.

DATING Identifiable as one of the landscapes exhibited at Schomberg House in April 1786 from Bate-Dudley's description in the *Morning Herald* (8 April 1786): 'The largest of these landscapes displays a romantic scene. Broken ground, water, sloping trees, and an extended upland. In the foreground, near a cottage, three horses are seen with pack-saddles on them, one is laid down to rest, and the whole seem as if weary. The driver [sic] appears near at hand, and some cottagers complete the number of figures. The sky of this piece is painted with the most exquisite touches, and the clouds marked with uncommon brightness and serenity.'

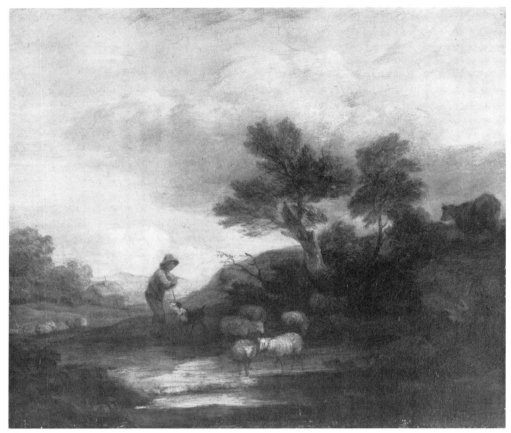

163

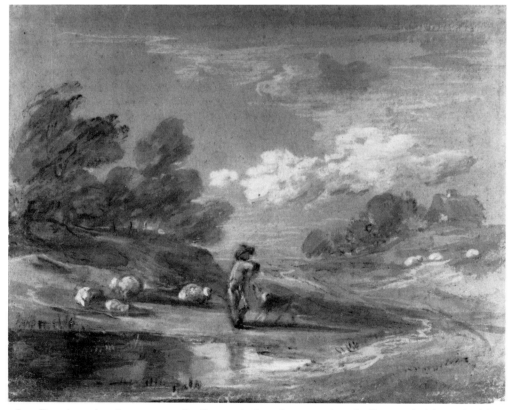

**163a** Drawing related to cat. no. 163. Brown chalk and grey wash on buff paper, heightened with white. $10\frac{7}{16} \times 12\frac{11}{16}$ / 26.5 × 32.2. Private collection, Great Britain.

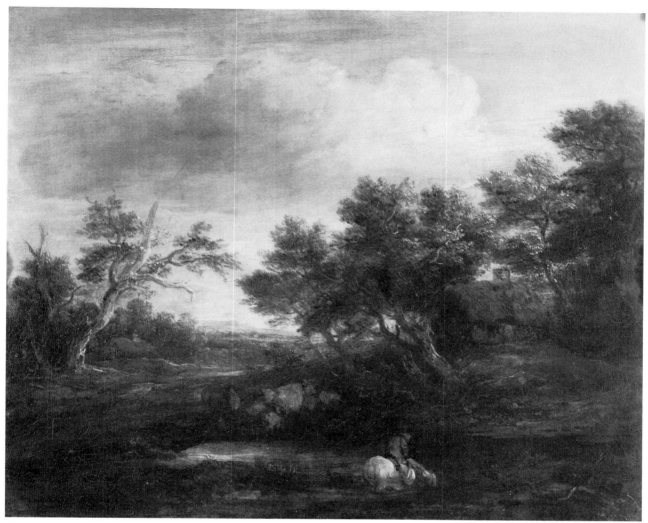

**166**

Crewkerne, 18 October 1973, lot 267, bt Richard Green jointly with Agnew, from whom it was purchased.

EXHIBITIONS Schomberg House, April 1786; Grand Palais, 1981 (ex-catalogue).

BIBLIOGRAPHY *Morning Herald*, 8 April 1786; Whitley, p. 256.

The composition is dominated by the rural lovers in the cart; the seated figure on the right is a Dutch boor in type, and the scraggy tree is identical with those in the Manchester and Spink landscapes (cat. nos 163, 164). The handling is rich and solid. The letter to which the inscriptions refer (see above) is no longer extant. A copy was formerly in the possession of Sir Ian Forbes Leith, Fyvie Castle. Also mentioned on p. 182.

DATING Identifiable as one of the landscapes exhibited at Schomberg House in April 1786 from Bate-Dudley's description in the *Morning Herald* (8 April 1786): 'The seventh view consists of a rising ground, with a country cart-team, etc. and other rural representations.'

**166  Wooded Landscape with Peasant mounted on a Horse drinking at a Pool, Cows and Sheep, and Cottage**

Canvas. $14\frac{1}{2} \times 17\frac{1}{2}$  36.8 × 44.5
Painted *c.* 1786

Ownership unknown

PROVENANCE Samuel Rogers (1763–1855) by 1814; Rogers sale, Christie's, 28 April 1856 ff., 6th day, lot 697, bt Radcliffe for Miss Angela (later Baroness) Burdett-Coutts (1814–1906); William Burdett-Coutts sale, Christie's, 4–5 May 1922, 1st day, lot 28, bt Knoedler; with Freeman, 1937; anon. [W. Hallsborough] sale, Christie's, 29 November 1957, lot 72, bt Gordon.

EXHIBITIONS BI, 1814 (6 or 10); BI, 1863 (138 or 149); 'Landscapes of the 17th and 18th Centuries', Agnew's, 1935 (11).

BIBLIOGRAPHY Mrs Jameson, *Companion to the Most Celebrated Private Galleries of Art in London*, London, 1844, p. 408; Fulcher, p. 197; Armstrong, 1898, p. 204;

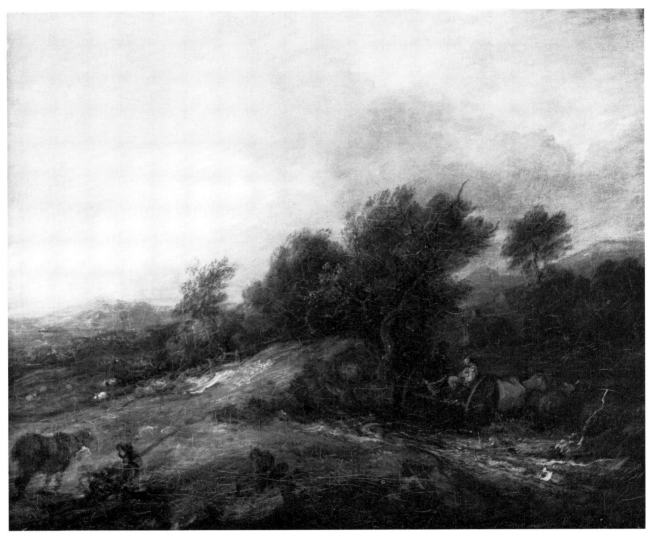

**167**

Armstrong, 1904, p. 285; Whitley, p. 256; Waterhouse, no. 927.

This little landscape combines the motifs of a sequestered cottage, a horse drinking and cows and sheep at a watering place. The scraggy trees are derived from Ruisdael, and the motif of the white horse at the pool can be paralleled in landscapes by the same artist. The highlights in the trunks and branches are somewhat finicky in touch, and lack Gainsborough's normal fluency. Also mentioned on p. 228.

DATING Identical with cat. no. 164 in the treatment of the clouds, the dark-green Ruisdaelesque tonality, the sturdy tree-trunks, the handling of the windswept foliage and the nervously applied highlights.

## 167 Wooded Upland Landscape with Peasants in a Country Cart crossing a Stream, Peasant Resting with Horse, Sheep, Cottage and Distant Hills

Canvas. 12 × 14   30.5 × 35.6
Painted *c.* 1786

Corcoran Gallery of Art, Washington, D.C. (26.92)

PROVENANCE Possibly Marquis of Thomond sale, Snell's, 11–12 August 1807, lot 16 (noted in the annotated copy in the Victoria and Albert Museum Library as withdrawn from the sale, which actually took place on 14 August); Mary, Marchioness of Thomond (d. 1820); Samuel Rogers (1763–1855) by 1814; Rogers sale, Christie's, 28 April 1856 ff., 6th day, lot 694, bt Radcliffe for Miss Angela (later Baroness)

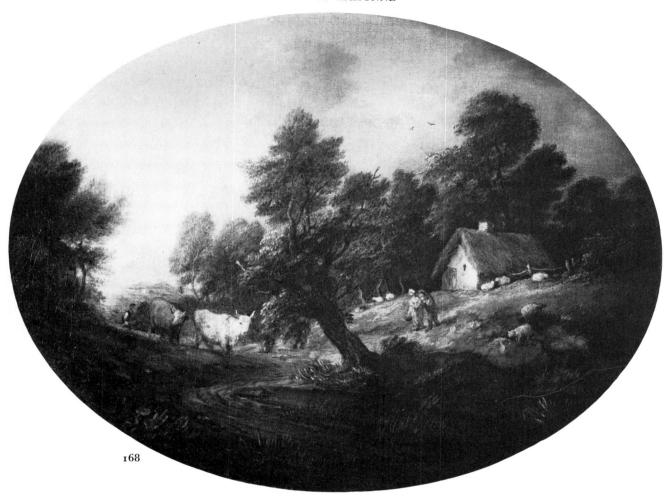

168

Burdett-Coutts (1814–1906); William Burdett-Coutts sale, Christie's, 4–5 May 1922, 1st day, lot 29, bt Knoedler, from whom it was purchased by Senator W. A. Clark; bequeathed to the Corcoran Gallery of Art, 1926.

EXHIBITIONS BI, 1814 (6 or 10); BI, 1863 (138 or 149).

BIBLIOGRAPHY Fulcher, p. 196; Armstrong, 1898, p. 204; Armstrong, 1904, p. 285; *Illustrated Handbook of The W. A. Clark Collection*, Corcoran Art Gallery, Washington, 1928, no. 2092, p. 42; Waterhouse, no. 928; John Hayes, 'Gainsborough's Later Landscapes', *Apollo*, July 1964, p. 25.

The most lively and spirited of Gainsborough's small landscapes of this date. The composition is dominated by the scraggy trees in the centre, derived from such Ruisdaels as that in the Thyssen Collection, beneath which a cart, as sketchily painted as in the Manchester picture (cat. no. 161), is splashing through a ford. Also mentioned on pp. 166,167.

DATING Closely related to cat. no. 165 in the rough treatment of the tree-trunks and foliage, and the sketchy handling of the figures. The wiry trees, the handling and highlighting of the foliage and the treatment of the clouds are also closely related to cat. no. 166.

**168  Wooded Landscape with Herdsman and Cows, Peasants on a Slope, Scattered Sheep and Cottage**

Canvas. Oval: $14 \times 18\frac{7}{8}$   $35.6 \times 47.9$
Painted *c*. 1786

Cummer Gallery of Art, Jacksonville, Florida

PROVENANCE George Gostling, 1814; anon. [Colonel Gostling Murray] sale, Christie's, 23 June 1883, lot 770, bt White; Frederick Fish, 1886; Fish sale, Christie's, 24 March 1888, lot 287, bt Agnew; William Nicholson, 1909; anon. [Nicholson] sale, Sotheby's, 19 March 1947, lot 158, bt Spink; Sir Michael Culme-Seymour; with Arthur Tooth, 1953; with Arcade Gallery, from whom it was purchased by Mrs Ninah M. H. Cummer, 1954; Cummer bequest, 1958.

EXHIBITIONS BI, 1814 (73); either this or cat. no. 145 was BI, 1817 (68); RA, 1886 (28); Fine Art Club, Ipswich, 1887 (105); 'The World of Benjamin West', Allentown Museum of Art, Allentown, Pa., May–July 1962 (46, repr.); 'The Age of Queen Charlotte', Mint Museum of Art, Charlotte, N.C., April–May 1968 (7, repr.); 'British Painting 1640–1840', Birmingham Museum of Art, Birmingham, Alabama, February–March 1970.

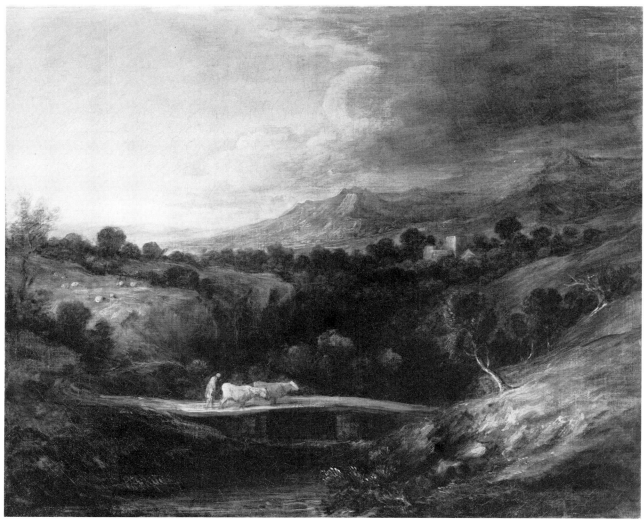

**169**

BIBLIOGRAPHY Fulcher, p. 204; Armstrong, 1898, p. 205; Armstrong, 1904, p. 286; Waterhouse, no. 916.

The oval format is rare in Gainsborough's landscapes (other examples are the Toledo and Michaelis landscapes, cat. nos 69, 128). The composition of this little pastoral is bisected by a tree which both echoes the oval and serves as a fulcrum round which the design rotates, separating the cottage and sheep, with peasants descending a slope, from the herdsman driving cows along a winding track. The deep tonality and the scraggy trees are identical with those in the landscapes once owned by Samuel Rogers (cat. nos 166, 167). The scene is an evening one, and the landscape is lit from the left by the rays of the setting sun. Also mentioned on p. 182.

DATING Closely related to cat. no. 164 in the handling and highlighting of the foliage, the rich touches of paint modelling the bank on the right and the treatment of the cows.

**169 Extensive Wooded Upland Landscape with Herdsman and Cows crossing a Bridge over a Stream, Dell, Scattered Sheep, and Distant Village and Hills**

Canvas. $15\frac{3}{4} \times 19$   $40 \times 48.3$
Painted *c.* 1786

Tate Gallery, London (2284)

PROVENANCE Edmund Higginson (1802–71), of Saltmarshe Castle, Herefordshire; Higginson sale, Christie's, 4–5 June 1846, 1st day, lot 28, bt Farrer; William Wynn Ellis (1790–1875); Wynn Ellis sale, Christie's, 6 May 1876, lot 53, bt Agnew; Mrs Martin Colnaghi, 1892; bequeathed to the National Gallery by Martin Colnaghi, 1908; transferred to the Tate Gallery, 1961.

EXHIBITIONS RA, 1892 (4); 'Selection of Works by French and English Painters of the Eighteenth Century',

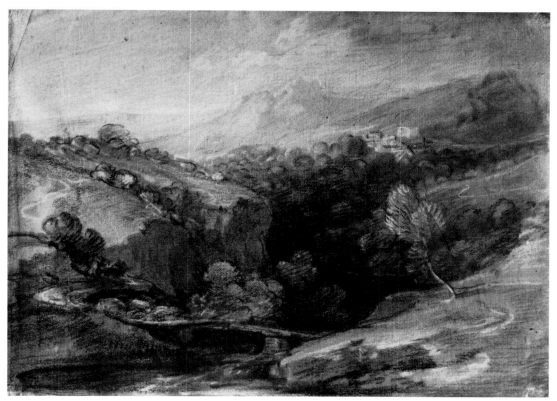

**169a** Study for cat. no. 169. Black chalk and stump and white chalk on brown paper. 10$\frac{3}{16}$ × 13$\frac{11}{16}$ / 25.9 × 34.8. Sir William Walton, Forio.

Corporation of London Art Gallery, 1902 (68); 'Twee Eeuwen Engelsche Kunst', Stedelijk Museum, Amsterdam, July–October 1936 (49); 'La Peinture Anglaise XVIIIᵉ & XIXᵉ Siècles', Louvre, Paris, 1938 (50, repr. *Souvenir*); 'British Painting from Hogarth to Turner', British Council (Hamburg, Oslo, Stockholm, Copenhagen), 1949–50 (49); Grand Palais, 1981 (74, repr.).

BIBLIOGRAPHY *A Descriptive Catalogue of the Gallery of Pictures, Collected by Edmund Higginson, Esq. of Saltmarshe*, London, 1842, no. 97, p. 40; Armstrong, 1898, p. 205; Armstrong, 1904, p. 286; Menpes and Greig, p. 176; Charles Johnson, *English Painting from the Seventh Century to the Present Day*, London, 1932, pp. 130, 132–3; Roger Fry, *Reflections on British Painting*, London, 1934, p. 78, repr. fig. 29; Charles Johnson, *A Short Account of British Painting*, London, 1934, p. 55; Woodall, p. 98; Waterhouse, p. 33, no. 984, repr. pl. 269; Martin Davies, *The British School*, National Gallery, London, 2nd ed., rev., 1959, pp. 39–40; Jonathan Mayne, 'Thomas Gainsborough's Exhibition Box', *Victoria and Albert Museum Bulletin*, vol. I, no. 3, July 1965, pp. 23–4; Hayes, *Drawings*, p. 285; Herrmann, p. 102; Paulson, p. 247.

A study, without staffage, is owned by Sir William Walton (169a; Hayes, *Drawings*, no. 771). In the finished picture a tree has been added on the left, the bridge has become a more dominant motif and staffage is included: a herdsman with two cows crossing the bridge, and a flock of sheep on the left. This is the first of Gainsborough's small landscapes of this period in which he reverts to the theme of an upland scene, with a dark dell in the centre of the picture and mountains beyond, characteristic of such major works as the Edinburgh or Philadelphia landscapes (cat. nos 137, 143). The treatment of the distant hills, with streaks of whitish pigment delineating space, can be paralleled in such Rubens landscapes as the *Cart Overturning* in Leningrad (pl. 177). The picture is characterized by breadth of chiaroscuro and very sensitive changing lights. Also mentioned on p. 229.

DATING Possibly identifiable with one of the landscapes exhibited at Schomberg House in April 1786 from Bate-Dudley's description, which fits this work in all particulars except the cottage 'seen near': 'The next Picture [to cat. no. 162], in point of dimensions, is a representation of a woody country, the face of which is covered with variety; distant thickets, jutting headlands, trees rich with foliage of the most spirited pencilling, and here and there diversified with the yellow of Autumn. On a sunny bank, kept at a proper distance, sheep are browsing; a cottage is seen near, and

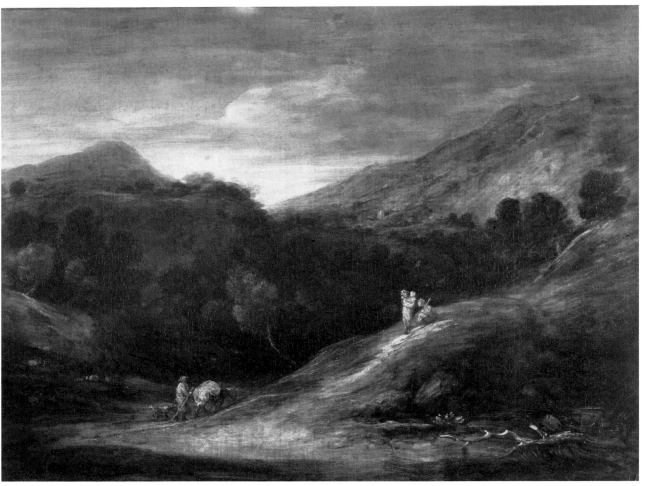

170

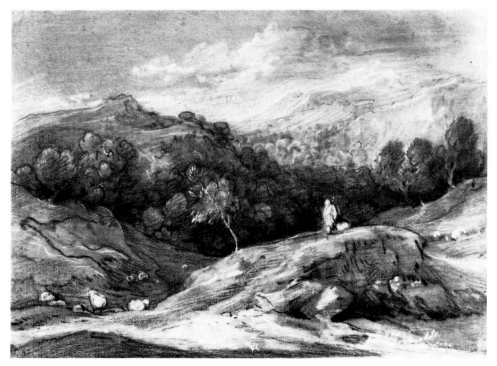

**170a** Study for cat. no. 170. Black chalk and stump and white chalk on brown paper. $9\frac{7}{8} \times 13\frac{3}{16}$ / 25.1 × 34.1. City Museum and Art Gallery, Birmingham (89'35).

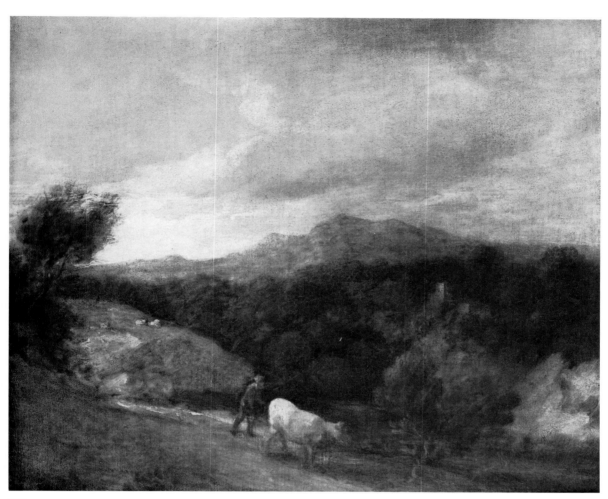

**171**

in the fore ground a herdsman is driving cattle to a sedgy watering place. The light and shade of this picture diffuse a fine effect over the scene, and a sky, rich with fervid clouds, adds to the beauty of the landscape' (*Morning Herald*, 8 April 1786). Closely related to cat. no. 164 in the handling of the clouds, the highlighting of the foliage, the loose modelling of the cows and the generalized treatment of the distance. The handling and highlighting of the foliage, the rich touches of paint modelling the bank on the right and the treatment of the foreground are also related to cat. no. 168.

## 170   Extensive Wooded Upland Landscape with Drover and Pack-horse, Mother holding a Child and Shepherd seated on a Bank, Sheep and Distant Mountains

Canvas. $15\frac{3}{4} \times 23\frac{1}{4}$   $40 \times 59.1$
Painted *c.* 1786

Private collection, England

PROVENANCE Edmund Higginson (1802–71), of Saltmarshe Castle, Herefordshire; Higginson sale, Christie's, 4–5 June 1846, 1st day, lot 54, bt Norton; Robert H. Benson, 1887; thence by descent.

EXHIBITIONS RA, 1887 (1); 'Pictures Ancient and Modern by Artists of the British and Continental Schools', The New Gallery, 1897–8 (209); Sassoon, 1936 (108, repr. *Souvenir*, pl. 71); Nottingham, 1962 (28, repr.).

BIBLIOGRAPHY *A Descriptive Catalogue of the Gallery of Pictures, Collected by Edmund Higginson, Esq. of Saltmarshe*, London, 1842, no. 141, p. 59; Armstrong, 1898, p. 204; Armstrong, 1904, p. 285; Woodall, *Drawings*, pp. 66, 67, 68, 104, repr. pl. 87; Waterhouse, no. 985; Hayes, *Drawings*, p. 285.

Traditionally regarded as 'more or less a companion' to the Tate picture (cat. no. 169) (Waterhouse, p. 120), but the only basis for this view is the shared provenance from the Higginson collection (the paintings are not the same size). A study is in the Birmingham City Art Gallery (170a; Hayes, *Drawings*, no. 772). In the finished picture a peasant with pack-horse and dog have been introduced on the left and the sheep made less prominent, the shepherd on the hillock is shown seated and a woman carrying a baby has been added, and a prominent, sharply highlit branch is included in the foreground. The flowing movement upwards towards the right is unusual, but the landscape is dominated by a soft light

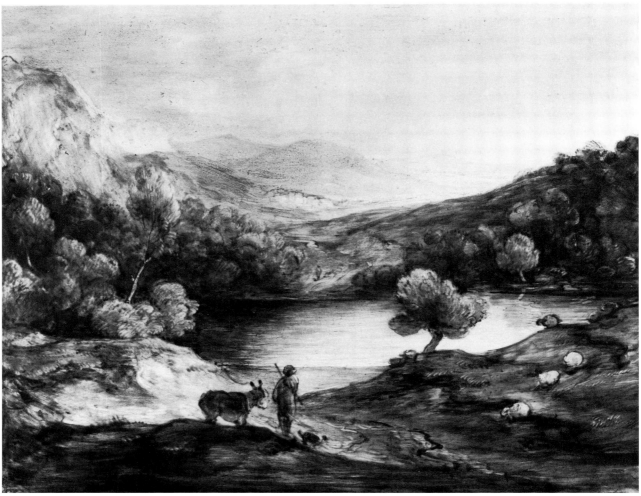

172

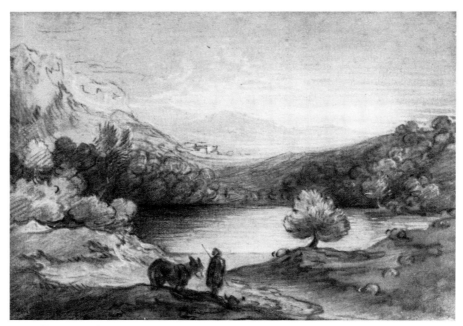

**172a** Drawing related to cat. no. 172. Black chalk and stump and white chalk on buff paper. $9\frac{5}{16} \times 14$ / 25.2 × 35.6. Wing-Commander John Higginson, Ballyward, Co. Down.

falling from the left and includes a characteristic dark dell in the middle distance. The style of this painting formed the model for much of Dupont's work (compare especially pls 228, 229, 232); none of these landscapes, though, however close in technique, possesses quite the assurance and sense of flow, subtlety of lighting and softness of contours, characteristic of the Gainsborough. A small copy, $7\frac{3}{4} \times 9\frac{3}{4}$ inches in size, was with Arthur Tooth in 1942. Also mentioned on p. 229.

DATING Closely related to cat. no. 169 in the stormy grey sky, the delicate yellows at the horizon, the sense of depth in the distant landscape, the rough modelling of the banks and slopes, the streaky highlighting and the treatment of the bushy foliage. The modelling of the pack-horse and the streaky highlighting in the banks are related to cat. no. 166. The rough, loose modelling of the figures and animals is also related to cat. no. 152, though lacking the same breadth of touch and sense of movement.

## 171 Extensive Wooded Upland Landscape with Herdsman and Cow beside a Stream, Sheep, Buildings and Distant Hills

Canvas. $12 \times 13\frac{15}{16}$   $30.5 \times 35.4$
Painted c. 1786

Dr Lewis S. Fry, Gibson Gallery, Saffron Walden (on indefinite loan to the Courtauld Institute Galleries, London)

PROVENANCE With Frost and Reed, Bristol, 1910.

This fine, small canvas is a variant of the slightly larger Tate landscape (cat. no. 169): the sheep grazing on a bank on the left, the dark dell in the middle ground, with buildings among the trees, the distant range of mountains and the broad glow at the horizon are all features to be found in both pictures.

DATING Closely related to cat. no. 165 in the treatment of the clouds and foliage, and the rich impasto in the modelling of the cow. The treatment of the foliage, the dark dell, the streaky highlights and the modelling of sheep are also closely related to cat. no. 169.

## 172 Wooded Upland Landscape with Shepherd, Donkey and Scattered Sheep, Lake and Distant Village and Hills

Transparency on glass. $11 \times 13\frac{1}{4}$   $27.9 \times 33.7$
Painted c. 1786

Victoria and Albert Museum, London (P.42–1955)

ENGRAVING Mezzotinted by S. W. Reynolds, c. 1824.

PROVENANCE Purchased from Margaret Gainsborough (1752–1820) by Dr Thomas Monro (1759–1833); Monro sale, Christie's, 26 June 1833 ff., 3rd day (28 June), lot 168, bt W. White, who bequeathed it to G. W. Reid; anon. [Buck Reid] sale, Christie's, 29 March 1890, lot 132, bt in; Leopold Hirsch; Hirsch sale, Christie's, 11 May 1934, lot 104, bt Gooden and Fox for Ernest E. Cook; bequeathed to the Victoria and Albert Museum, through the National Art-Collections Fund, 1955.

EXHIBITIONS W. B. Cooke's 'Exhibition of Drawings', 9 Soho Square, London, 1824 (p. 14); GG, 1885 (394).

BIBLIOGRAPHY *The Somerset House Gazette*, 10 April 1824, ed. Ephraim Hardcastle [W. H. Pyne], London, 1824, vol. 2, p. 8; Fulcher, p. 125 (note); George M. Brock-Arnold, *Gainsborough*, London, 1881, p. 60; Waterhouse, no. 973, repr. pl. 264; Gatt, pp. 10, 37–8, repr. pls 56, 57 (col.).

A drawing owned by Wing-Commander John Higginson (172a; Hayes, *Drawings*, no. 774) may have been a study for this transparency, but could equally well have been executed from it subsequently (see also under cat. no. 154). As in many of the transparencies still extant, the composition is dominated by a prominent sheet of water, here brilliantly lit by moonlight—an effect, suited to the medium, not found in the landscapes proper.

DATING Closely related to cat. no. 169 in the dark-green tonality, the handling of the bushy foliage, the wiry tree-trunk on the right, the sketchy modelling of the sheep, the soft treatment of the distant mountains and the sweep of the composition. The wiry tree-trunk is identical with cat. no. 170.

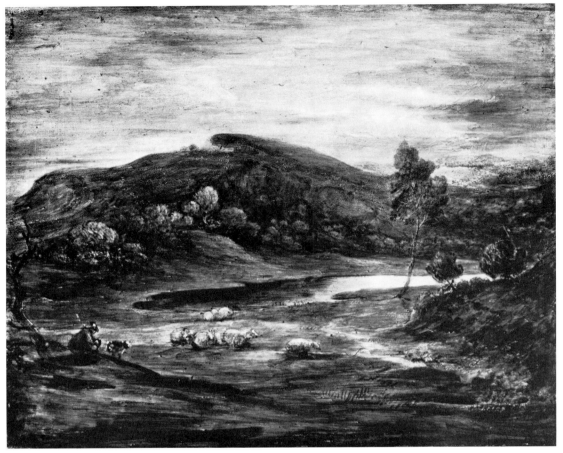

173

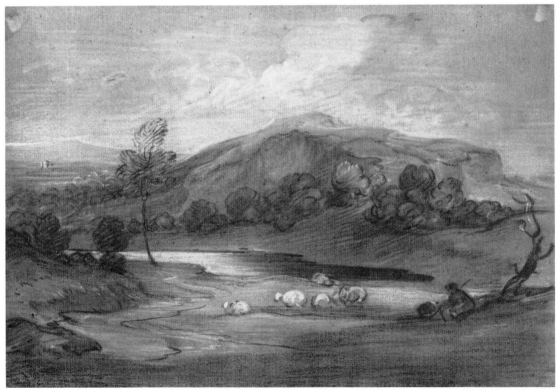

**173a** Drawing related to cat. no. 173. Black chalk and stump and white chalk on buff paper. $10\frac{3}{16} \times 14\frac{5}{16}$ / 25.9 × 36.3. Tate Gallery, London (2223).

**174a** *The Housemaid*. Canvas. 99 × 57¾ / 251.5 × 146.7. Tate Gallery, London (2928).

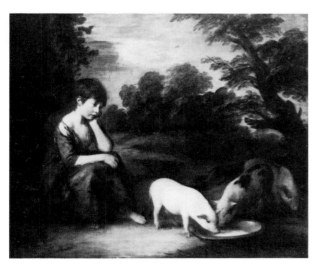

**174b** *Girl with Pigs*. Canvas. 49½ × 58½ / 125.7 × 148.6. Exhibited at the Royal Academy, 1782 (127). George Howard, Castle Howard.

most works of this period, and in contrast to the style of the previous few years. A small copy by the original owner of the picture, Wilbraham Tollemache, is now at Helmingham Hall (see p. 287). Also mentioned on pp. 156, 178, 182, 229, 246, 291.

DATING Identifiable as a landscape painted in the summer of 1786 from Bate-Dudley's description in the *Morning Herald* (24 May 1786): 'Mr. *Gainsborough* is, at this time, engaged in painting a beautiful landscape, in the foreground of which the *trio* of pigs, that are so highly celebrated by the connoisseurs, are introduced; together with the little girl, and several other rustic figures.' This identification is confirmed by his reference to the purchaser in August: 'Mr. *Gainsborough*'s last delightful landscape, in which his celebrated group of pigs was introduced, is finished, and deposited in the cabinet of that spirited encourager of merit, Mr. *Tollemache*' (ibid., 9 August 1786).

## 175  Wooded Landscape with Rustic Lovers and Two Cows

Canvas. 25 × 30 ⸱ 63.5 × 76.2
Painted *c.* 1786

Private collection, England

ENGRAVING Engraved by I. H. Wright from a drawing by W. M. Craig, and published by Longman, 2 September 1816.

PROVENANCE 'The European Museum', 1798, purchased by Francis, 3rd Duke of Bridgwater (1736–1803) (see *Morning Post*, 22 March 1798), who bequeathed it to his nephew, George Granville, Lord Gower (later 2nd Marquess of Stafford and 1st Duke of Sutherland, 1758–1833); thence by descent to John, 6th Duke of Sutherland; Trustees of the Ellesmere 1939 Settlement sale, Christie's, 18 June 1976, lot 119 (repr.), bt Richard Green, from whom it was purchased.

EXHIBITIONS 'The European Museum', 1798; BI, 1841 (103).

BIBLIOGRAPHY *Morning Post*, 22 March 1798; J. P. Neale, *Views of The Seats of Noblemen and Gentlemen*, London, vol. IV, 1821 (unpaginated); John Young, *A Catalogue of the Pictures, of the most noble the Marquess of Stafford, at Cleveland House*, London, 1825, vol. II, no. 257, p. 184, etched facing; Mrs Jameson, *Companion to the Most Celebrated Private Galleries of Art in London*, London, 1844, p. 161; Dr Waagen, *Treasures of Art in Great Britain*, London, 1854, vol. II, p. 53; Fulcher, p. 207; Armstrong, 1898, p. 205; Armstrong, 1904, p. 286; Waterhouse, no. 983.

The only canvas since *Repose* (cat. no. 119) in which Gainsborough has conceived his pastoral subject-matter on a monumental scale, possibly under the influence of Berchem (compare the landscape in the Wallace Collection, no. 640), or Cuyp, though George Robert-

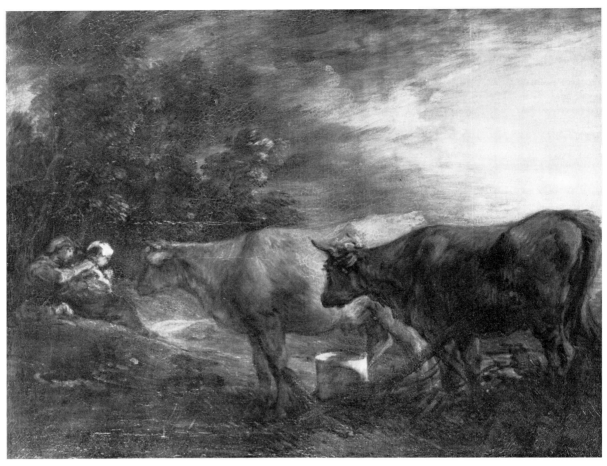

175

son's engraving of a drover and cattle, published on 12 April 1785, should also be noted. The two solidly modelled cows, which Waagen (cited above) described as influenced by Cuyp, fill the foreground and mask the view into distance, as do the trees on the left. The two lovers are highlit by the broadly painted sunset glow. In 1821 the picture hung in the New Alcove Room at Trentham (Neale, cited above).

DATING Closely related to cat. no. 174 in the pale tints used in the sky, the fluid, generalized handling of the foliage, the summary painting of the figures and the solid modelling of the cows.

## 176 Open Landscape with Herdsman driving Cows and Sheep down a Slope, and Cottage

Canvas. $21\frac{1}{2} \times 29\frac{1}{2}$ 54.6 × 74.9
Painted *c.* 1786

Dowager Marchioness of Dufferin and Ava, London

PROVENANCE Joseph Smith, of Shortgrove, Essex (1757–1822), private secretary of William Pitt, by 1814; by descent to Joseph Smith (1845–1936), from whom it was purchased by Sir Edward Guinness (later 1st Earl of Iveagh, 1847–1927), 1889; Hon. A. E. Guinness sale,

Christie's, 10 July 1953, lot 60 (repr.), bt Harvard for Maureen, Marchioness of Dufferin and Ava.

EXHIBITIONS BI, 1814 (53); 'Fine Art Exhibition', Whitechapel, March–April 1890 (144).

BIBLIOGRAPHY Fulcher, p. 200; Waterhouse, no. 946; Hayes, *Drawings*, p. 266.

A drawing which is evidently a preliminary idea for the Dufferin landscape is in the Berlin Kupferstichkabinett (176a; Hayes, *Drawings*, no. 687). In the finished picture an additional sheep has been included, the two rearmost cows have been replaced by a goat and a dog accompanying the drover, a cottage has been included on the left and trees have been introduced on the right-hand side of the composition to serve as a foil to the panoramic view opposite. The scene is a gentle, pastoral one in which the homeward theme is emphasized by the flowing diagonal composition. The panorama on the left is closed by low hills.

DATING Closely related to cat. no. 174 in the handling of the foliage, the generalized painting of the tree-trunks and branches, the fluid treatment of the trees in the middle ground, the solid modelling of the animals and the generalized bluish-green distance.

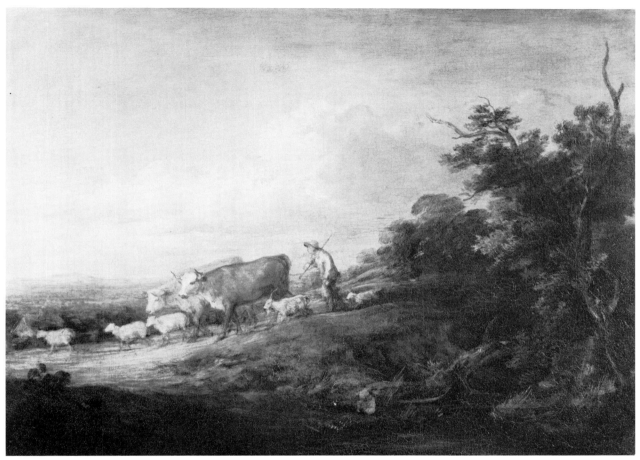

**176**

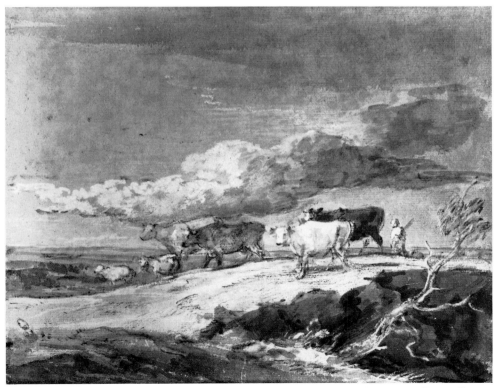

**176a** Study for cat. no. 176. Grey and grey-black washes and white chalk over an offset outline on buff paper. $10\frac{5}{16} \times 12\frac{7}{8}$ / 26.2 × 32.7. Staatliche Museen Preussischer Kulturbesitz: Kupferstichkabinett, Berlin-Dahlem (6851).

559

177

## 177   Open Landscape with Peasants, Cows, Sheep, Cottages and Pool

Transparency on glass. $11 \times 13\frac{1}{4}$   $27.9 \times 33.7$
Painted c. 1786

Victoria and Albert Museum, London (P.34–1955)

PROVENANCE Purchased from Margaret Gainsborough (1752–1820) by Dr Thomas Monro (1759–1833); Monro sale, Christie's, 26 June 1833 ff., 3rd day (28 June), lot 168, bt W. White, who bequeathed it to G. W. Reid; anon. [Buck Reid] sale, Christie's, 29 March 1890, lot 132, bt in; Leopold Hirsch; Hirsch sale, Christie's, 11 May 1934, lot 104, bt Gooden and Fox for Ernest E. Cook; bequeathed to the Victoria and Albert Museum, through the National Art-Collections Fund, 1955.

EXHIBITIONS GG, 1885 (394).

BIBLIOGRAPHY *Somerset House Gazette*, 10 April 1824, ed. Ephraim Hardcastle [W. H. Pyne], London, 1824, vol. 2, p. 8; Waterhouse, no. 975.

A scene of rustic contentment, with sheep recumbent in front of a cottage with a smoking chimney, and a peasant family looking over towards the two cows which dominate the foreground. The relationship of the two cows is identical with that of those in the picture formerly in the Astor collection (cat. no. 158).

DATING Closely related to cat. no. 176 in the pale grey-brown tonality, the softly painted clouds, the handling of the foliage and the solidly modelled cows.

## 178   Wooded Rocky Landscape with Rustic Lovers, Cows drinking at a Fountain, and Goats

Canvas. $24\frac{1}{2} \times 29\frac{1}{2}$   $62.2 \times 74.9$
Painted c. 1786

Earl of Egremont, Petworth House (28)

PROVENANCE George O'Brien, 3rd Earl of Egremont (1751–1837) by 1814; thence by descent.

EXHIBITIONS BI, 1814 (65).

BIBLIOGRAPHY Fulcher, p. 238; Armstrong, 1898, p. 206; Armstrong, 1904, p. 287; C. H. Collins Baker, *Catalogue of the Petworth Collection of Pictures in the Possession*

**178**

*of Lord Leconfield*, London, 1920, no. 28, p. 47 (repr.); Waterhouse, no. 999; R. B. Beckett, ed., 'John Constable's Correspondence III', *The Suffolk Records Society*, vol. VIII, Ipswich, 1965, pp. 58–60.

Certain weaknesses in this canvas—for example, in the modelling of the cows—may be accounted for by poor condition. The motif of peasants in conversation by the side of a centrally placed fountain at which cows are drinking is new in Gainsborough; the ornate fountain itself is slightly reminiscent of the plinth surmounted by an urn in the background of the portrait of *The Duke and Duchess of Cumberland*, painted a year or two earlier (Waterhouse, no. 178). The sunset is painted in broken impasto over the pinkish priming; the foreground is strongly spotlit from a different (studio) source of light, as so often in Gainsborough's work. The distance is extremely generalized. One copy, of roughly the same size as the original, was in an anon. sale, Knight, Frank and Rutley's, 8 December 1931, lot 272; another is in the Smithsonian Institution, Washington.

DATING Closely related to cat. no. 179 in the subdued tonality, the rich, broken impasto at the horizon, the washy treatment of the bushy foliage, the generalized modelling of the figures and cows and the rapid handling of the foreground.

### 179 Wooded Landscape with Herdsman and Three Cows at a Pool, Figure seated outside a Park Gate, and Distant Building

Canvas. $24\frac{7}{8} \times 30$  $63.2 \times 76.2$
Painted *c.* 1786

Tate Gallery, London (309)

ENGRAVING Engraved by William Miller and published by George Virtue for the *Art Journal*, August 1853, facing p. 184 (179a).

PROVENANCE Schomberg House sale, March–May 1789, no. 66, bt Woodhouse; John Woodhouse sale, Christie's, 14 February 1801, lot 32, bt William Esdaile (1758–1837); Esdaile sale, Christie's, 24 March 1838, lot 67, bt Robert Vernon (1774–1849); presented to the National Gallery by Robert Vernon, 1847; transferred to the Tate Gallery, 1919.

179

**179a** Engraving of cat. no. 179 by William Miller, published August 1853.

EXHIBITIONS Schomberg House, 1789 (66); BI, 1841 (80); BI, 1844 (8); 'A Hundred Years of British Landscape Painting, 1750–1850', Leicester Museums and Art Gallery, 1956 (10).

BIBLIOGRAPHY *Art Journal*, August 1853, p. 184; Dr Waagen, *Treasures of Art in Great Britain*, London, 1854, vol. I, p. 368; Fulcher, pp. 194, 206; Bell, p. 66 (erroneously as *c.* 1767–8), repr. facing p. 122; Armstrong, 1898, p. 206; Armstrong, 1904, p. 284; Pauli, repr. pl. 13; Gabriel Mourey, *Gainsborough*, Paris, n.d. [1906], p. 51; E. Rimbault Dibdin, *Thomas Gainsborough*, London, 1923. p. 138, repr. p. 123 (col.); Woodall, *Drawings*, pp. 60–64, repr. pl. 70; anon. [Tancred Borenius], 'Gainsborough's Collection of Pictures', *Burlington Magazine*, May 1944, p. 109; Ellis Waterhouse, 'The Sale at Schomberg House, 1789', *Burlington Magazine*, March 1945, p. 77; Waterhouse, no. 997; John Hayes, 'Gainsborough and Rubens', *Apollo*, August 1963, p. 96.

The peaceful nature of the familiar theme of cows at a watering place is emphasized by the soft, feathery trees which tower over the scene, by the broad sunset glow at the horizon and by the sensitive feeling for light in the sky and in the pool. In 1801 this landscape was catalogued by Christie's as being 'as fascinating as the most brilliant production of Rubens', and it realized a high price (230 guineas) at the Esdaile sale in 1838 (see above). Waagen (cited above), who was not normally responsive to Gainsborough's handling, described it as 'particularly clear and powerful in colouring, and careful in execution'. The motif of a park gate, with a figure seated outside, is unusual, but Gainsborough had used it, in quite a different context, in the country house drawing owned by George Howard (Hayes, *Drawings*, no. 518, repr. pl. 166). The condition of the bottom edge of the canvas is poor as, at an early stage in the picture's history, a strip of $1\frac{7}{8}$ inches had been turned back (compare the engraving by Miller, 179a). A copy in black chalk, perhaps made from a lost drawing, is in the Ashmolean Museum (Finch Bequest, 1830 (1971.52)).

DATING Related to cat. no. 174 in the pale tints in the sky and the soft, rhythmical handling of the foliage. The pale tonality, the broad modelling of the cows and the generalized treatment of the distance are also related to cat. no. 176. The motif of the cow with its head turned sharply to the right is paralleled in cat. nos 164 and 168. The rough treatment of the figure on the left, without any attempt at a precise delineation of features or form, is typical of the smaller landscapes of this period (compare cat. nos 162, 165).

## 180* Wooded Landscape with Herdsman and Cows and Scattered Sheep near a Pool, and Figures outside a Cottage

Canvas. 24 × 29   61 × 73.7
Painted *c.* 1786

Ownership unknown

PROVENANCE Purchased either by Robert Palmer (d. 1787) or his only son, Richard Palmer (d. 1806), London stewards of the Duke of Bedford; Robert Palmer, of Holme Park, Berkshire, 1845; Mrs Golding Palmer sale, Christie's, 28 July 1916, lot 26, bt Agnew; with Knoedler, 1916; with Reinhardt, New York; John N. Willys, New York, 1925; Mrs Van Wie Willys (?).

EXHIBITION BI, 1845 (79 or 86).

BIBLIOGRAPHY Fulcher, p. 207; Waterhouse, no. 996, repr. pl. 272; Jonathan Mayne, 'Thomas Gainsborough's Exhibition Box', *Victoria and Albert Museum Bulletin*, vol. I, no. 3, July 1965, p. 24.

A variant of the Tate picture (cat. no. 179), in which the trees on the left have been disposed somewhat differently, a cottage with a group of figures outside has replaced the park gate and wall and a mound with scattered sheep has been introduced in the foreground. The 'Cottage Door' scene is similarly placed to that in the Kenwood picture of fifteen years earlier (cat. no. 95), and provides an image more in harmony with the pastoral theme than the park gate in the previous work (cat. no. 179). The trees are also rather more lively, and the distance is less generalized. Richard Palmer was the son-in-law of Oldfield Bowles (see under cat. no. 128), and this picture and its companion (cat. no. 181) may conceivably have descended from Bowles. At least four copies, of roughly the same size as the original, are in existence (see p. 280). Also mentioned on pp. 182, 229.

DATING Appears to be closely related to cat. no. 179 in the richly painted sky, the soft handling of the bushy foliage and the broad lines of the composition, with the motif of the herdsman and cows passing a pool. The treatment of the foreground plants and grass appears to be closely related to cat. no. 168.

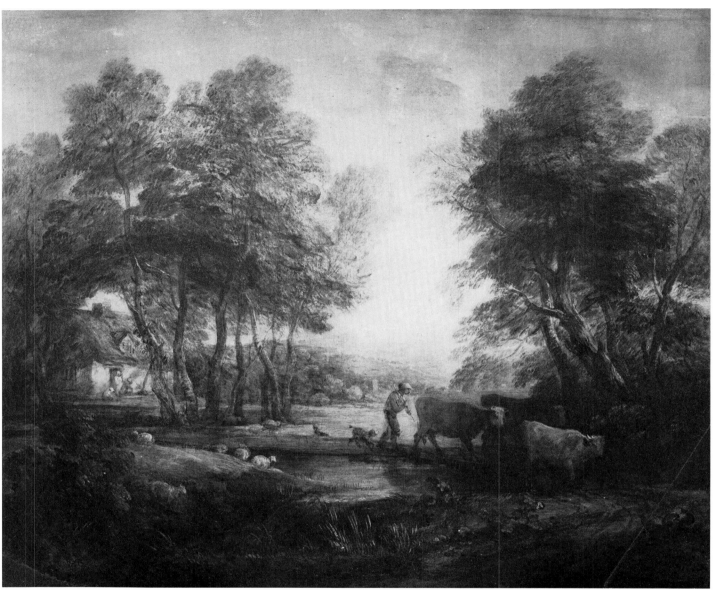

180

### 181*  Wooded Rocky Landscape with Mounted Peasant, Drover and Cattle, and Distant Building

Canvas. 24 × 29   61 × 73.7
Painted *c.* 1786

Ownership unknown

PROVENANCE Purchased either by Robert Palmer (d. 1787) or his only son, Richard Palmer (d. 1806), London stewards of the Duke of Bedford; Robert Palmer, of Holme Park, Berkshire, 1845; Mrs Golding Palmer sale, Christie's, 28 July 1916, lot 25, bt Agnew; with Knoedler, 1916; with Reinhardt, New York.

EXHIBITION BI, 1845 (79 or 86).

BIBLIOGRAPHY Fulcher, p. 207; Waterhouse, no. 995, repr. pl. 271.

Companion to the previous landscape (cat. no. 180). The scene is a pastoral one, in which the cows on their way home have been brought to a halt while the drover points out something on the left of the canvas to the peasant on horseback: the significance of his gesture is unclear. Although the picture is clearly not a sketch—the animals are solidly modelled—the trees and rocks on the left are handled with a looseness reminiscent of the study for the Edinburgh mountain landscape (cat. no. 137); the *repoussoir* branch in the foreground right is similarly loosely painted. Also mentioned on p. 182.

DATING Appears to be closely related to cat. no. 180 in the rich handling of the lights in the clouds, the wiry tree-trunks and soft treatment of the bushy foliage, and the rapid painting of the foreground detail.

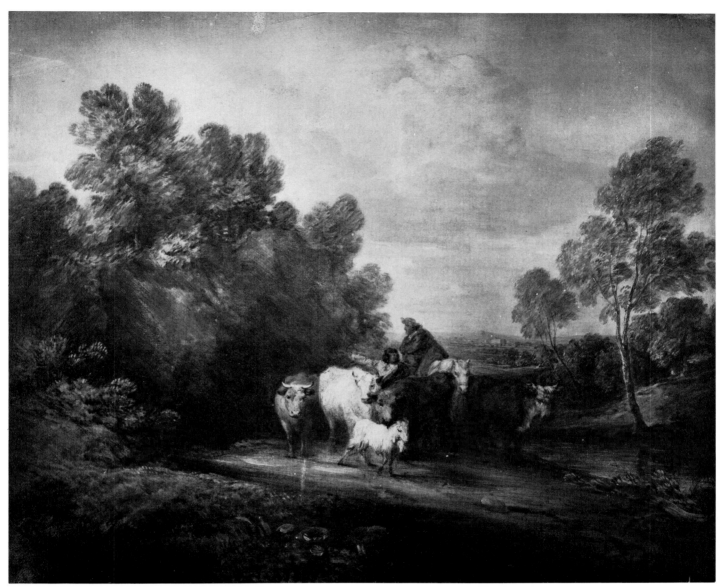

181

## 182  Wooded Landscape with Herdsman driving Cattle towards a Pool

Canvas. 30 × 25   76.2 × 63.5
Painted *c.* 1786

Sir Martyn Beckett, Bt, Nawton (on indefinite loan to the City Art Gallery, York)

PROVENANCE  Richard Johnson, Manchester; by descent to Mrs R. J. Walker; Walker sale, Christie's, 8 June 1928, lot 122, bt Buttery; with P. M. Turner; Sir Gervase Beckett (1866–1937) by 1936; thence by descent.

EXHIBITIONS  Sassoon, 1936 (111, repr. *Souvenir*, pl. 19b); 'La Peinture Anglaise XVIIIᵉ & XIXᵉ Siècles', Louvre, Paris, 1938 (58, repr. *Souvenir*); 'The Picture of the Month: Treasures from Yorkshire Houses No. 2', City Art Gallery, Leeds, January 1947; Bath, 1951 (32);

'Masterpieces from Yorkshire Houses: Ernest I. Musgrave Memorial Exhibition', Temple Newsam, Leeds, July–August 1958 (14); Tate Gallery, 1980–81 (151, repr.); Grand Palais, 1981 (75, repr.).

BIBLIOGRAPHY  Woodall, *Drawings*, pp. 74–5, repr. pl. 100; Woodall, p. 104; Emilie Buchwald, 'Gainsborough's "Prospect, Animated Prospect"', Howard Anderson and John S. Shea, ed., *Studies in Criticism and Aesthetics 1660–1800*, University of Minnesota, 1967, pp. 371–3; Hayes, *Drawings*, p. 294; Michael Clarke, 'Gainsborough and Loutherbourg at York', *City of York Art Gallery Quarterly*, October 1973, p. 931, repr. p. 933.

The broad outlines of the design are identical with *The Market Cart* in the Tate Gallery (cat. no. 183), but a herdsman driving cattle fills the place of the market cart, and neither the figures in the foreground, the faggot-

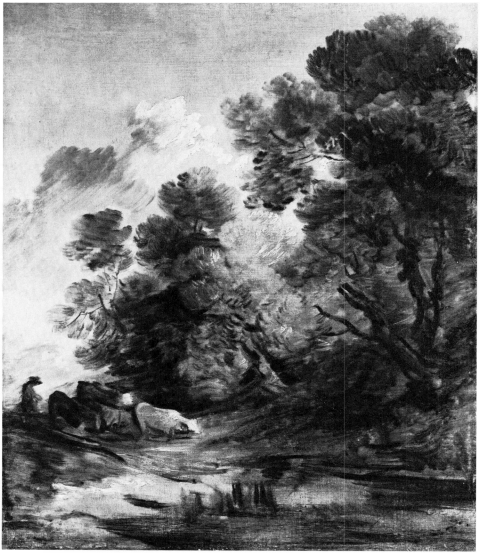

**182**

gatherer, nor the trees on the left, have been included. The canvas is brilliantly sketchy, with beautifully differentiated effects of light, and is comparable in technique with such masterly late wash drawings as the sheet in Berlin (pl. 208; Hayes, *Drawings*, no. 809, repr. pl. 236). The picture seems likely to be an oil sketch for a composition with which, for some reason, Gainsborough felt dissatisfied (the scale of the magnificent trees may have seemed out of keeping with the simple pastoral subject); afterwards he turned this sketch to good account in developing the composition of *The Market Cart*. Also mentioned on pp. 176–7.

DATING Related to cat. no. 178 in the rich, broken impasto in the lights of the clouds, the rough highlighting of the cows and the washy treatment of the foliage. Not unnaturally, the handling generally is most closely related to Gainsborough's unfinished landscapes, such as the Wall picture (cat. no. 96).

**183  Wooded Landscape with Peasants in a Country Cart accompanied by Two Children, a Wood-gatherer, Peasants resting, and Distant Mountain (The Market Cart)**

Canvas. $72\frac{1}{2} \times 60\frac{1}{4}$  184.2 × 153
Painted in the latter months of 1786 (completed by December)

Tate Gallery, London (80)

ENGRAVINGS Engraved by H. Robinson and published by John Major, 1 September 1832; engraved by E. Goodall and published by John Pye, 1 July 1836.

PROVENANCE Purchased from the artist by Sir Peter Burrell (later 1st Lord Gwydyr, 1754–1820), 1787; Gwydyr sale, Christie's, 8–9 May 1829, 2nd day, lot 87, bt Seguier for the Governors of the British Institution, who presented it to the National Gallery, 1830; transferred to the Tate Gallery, 1951.

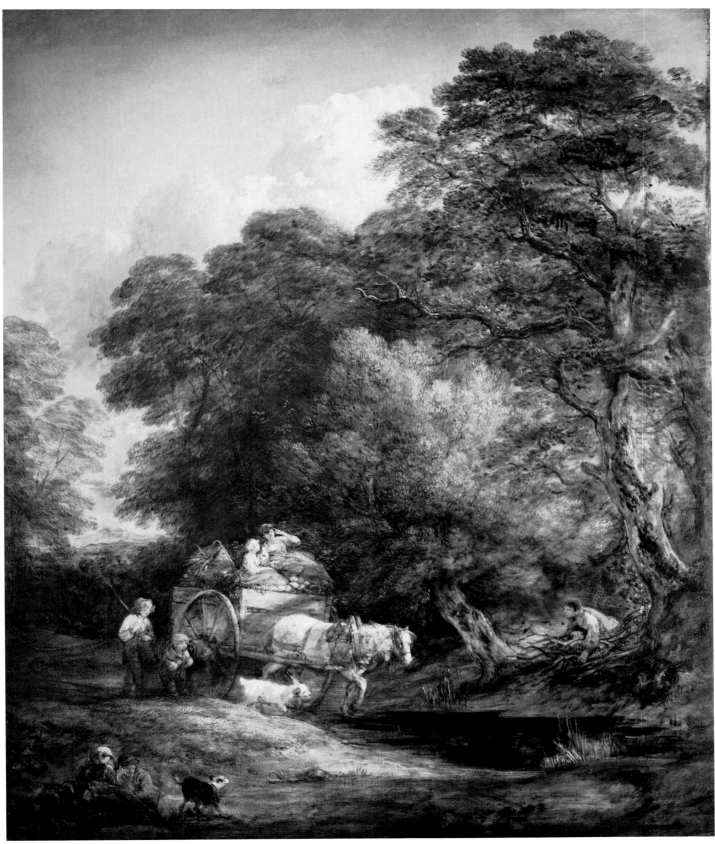

183

EXHIBITIONS Probably Schomberg House, 1789 (96); BI, 1829 (88); Arts Council, 1953 (55); 'The Romantic Movement', Arts Council, Tate Gallery, 1959 (167); 'Landscape in Britain c. 1750–1850', Tate Gallery, November 1973–February 1974 (60, repr.); Grand Palais, 1981 (76, repr., pp. 41, 42, 50, 142).

BIBLIOGRAPHY Morning Herald, 30 December 1786; ibid., 1 January 1787; World, 12 January 1787; Morning Herald, 7 May 1787; ibid., 13 June 1787; ibid., 9 July 1787; ibid., 4 August 1788; London Chronicle, 2–5 August 1788; Morning Herald, 26 August 1788; Diary, 2 April 1789; M. Passavant, A Tour of a German Artist in England, London, 1836, vol. I, p. 57; Mrs Jameson, Handbook to the Public Galleries of Art in and near London, London, 1842, pp. 100–101; Dr Waagen, Treasures of Art in Great Britain, London, 1854, vol. I, p. 368; Fulcher, p. 206; John Timbs, Anecdote Biography, London, 1860, p. 177; Richard and Samuel Redgrave, A Century of Painters of the English School, London, 1866, vol. I, p. 170; J. Beavington-Atkinson, 'Thomas Gainsborough' (article in Robert Dohme, Kunst und Künstler des Mittelalters und der Neuzeit, Leipzig, vol. 6, 1880), pp. 40, 54; Armstrong, 1894, p. 50; Bell, p. 66; Armstrong, 1898, p. 206; Mrs Arthur Bell, Thomas Gainsborough, R.A., London, 1902, p. 55; Gower, p. v.; Armstrong, 1904, p. 284; A. E. Fletcher, Thomas Gainsborough, R.A., London, 1904, pp. 88, 93, repr. facing p. 56; Pauli, pp. 97–8, repr. pl. 70; Boulton, pp. 95, 153, 306, repr. facing p. 153; Armstrong, 1906, p. 128; Gabriel Mourey, Gainsborough, Paris, n.d. [1906], p. 51, repr. facing p. 64; Menpes and Greig, p. 161, repr. facing p. 64 (col.); Myra Reynolds, The Treatment of Nature in English Poetry, Chicago, 1909, p. 306, repr. facing p. 307; Whitley, pp. 263–4, 270–71, 273–5, 304, 323, 332, 355, 356, repr. facing p. 273; E. Rimbault Dibdin, Thomas Gainsborough, London, 1923, p. 138, repr. p. 63 (col.); Hugh Stokes, Thomas Gainsborough, London, 1925, pp. 138–9, repr. facing p. 138; William T. Whitley, 'An Eighteenth-Century Art Chronicler: Sir Henry Bate Dudley, Bart.', The Walpole Society, vol. XIII, Oxford, 1925, pp. 57–8; William T. Whitley, Artists and their Friends in England 1700–1799, London, 1928, vol. II, p. 65; William T. Whitley, Art in England 1821–1837, Cambridge, 1930, pp. 56, 166, 311; Charles Johnson, English Painting from the Seventh Century to the Present Day, London, 1932, p. 132; C. H. Collins Baker, British Painting, London, 1933, p. 108; Charles Johnson, A Short Account of British Painting, London, 1934, pp. 54, 55; Woodall, Drawings, pp. 69–71, 73, 74–5, 141; anon. [Tancred Borenius], 'Gainsborough's Collection of Pictures', Burlington Magazine, May 1944, p. 110; Studio, May 1946, repr. p. 149 (col.); Woodall, p. 102, repr. p. 105; Millar, p. 13, repr. pl. 8 (col.); Basil Taylor, Gainsborough, London, 1951, p. 20, repr. pl. 9 (col.); C. H. Collins Baker, 'The Kennedy Memorial Gallery', Connoisseur, October 1954, pp. 135–6; Waterhouse, pp. 34, 40, no. 1002, and repr. pl. 286 (repr. col. in 1966 reprint); David Piper, Painting in England 1500–1870, London, 1960, pp. 37–8, repr. pp. 64 (col.), 37 (detail); John Hayes, 'Gainsborough's Later Landscapes', Apollo, July 1964, p. 26, repr. fig. 1; Emilie Buchwald, 'Gainsborough's "Prospect, Animated Prospect"', Howard Anderson and John S. Shea, ed., Studies in Criticism and Aesthetics 1660–1800, University of Minnesota, 1967, p. 379; Hayes, Drawings, p. 90; Gatt, pp. 10, 39, repr. pl. 76 (col.) and pls 74, 75 (col. detail); Jean-Jacques Mayoux, La Peinture Anglaise De Hogarth aux Préraphaélites, Geneva, 1972, p. 74; Herrmann, pp. 104–5, repr. pl. 95; Basil Taylor, Constable, London, 1973, p. 31, repr. pl. 176; Michael Clarke, 'Gainsborough and Loutherbourg at York', City of York Art Gallery Quarterly, October 1973, pp. 931–2, 935, repr. p. 932; Hayes, pp. 44, 47, 227, repr. pl. 162; Paulson, p. 247, repr. pl. 155; John Dixon Hunt, The Figure in the Landscape, Baltimore and London, 1976, p. 197; John Sunderland, Painting in Britain 1525 to 1975, London, 1976, p. 226, repr. pl. 101; Simon Wilson, British Art from Holbein to the present day, London, 1979, pp. 48–9, repr. p. 48; Tate Gallery, 1980–81, p. 129; Lindsay, pp. 185, 189, repr. pl. 14; Ellis Waterhouse, The Dictionary of British 18th Century Painters, Woodbridge, 1981, p. 138; Jeffery Daniels, 'Gainsborough the European', Connoisseur, February 1981, p. 110.

The basis for this composition, one of Gainsborough's greatest late landscapes, is the oil sketch owned by Sir Martyn Beckett (cat. no. 182), but the grandeur already fully apparent in this splendid conception has been still further enriched and developed. The trees on the right have been replaced by a single magnificent trunk, the foliage is broader, the subject is now a massive one and spotlit by a shaft of light breaking through the trees, and there are allusions to Claude in the addition of trees on the left and of the mountainous distance. The towering, luxuriant and richly variegated trees are one culmination of the backgrounds with which Gainsborough had experimented since the 1760s; the other is found in the Los Angeles picture (cat. no. 185). The girl in the heavily laden cart, whose gesture is difficult to construe, is one of the artist's familiar rustic beauties, and the subject is sentimental; but, in so grand a canvas, Gainsborough has carefully avoided the theme of rural lovers. A favourite image of this period, the woodcutter, has been included, but in a subordinate capacity. The left foreground has been filled with figures resting, instead of the customary repoussoir log (compare the cows in the Scudamore landscape: cat. no. 174). There is a clearly visible pentimento in the head of the horse, the alteration giving added thrust to the composition. Innumerable copies of this design exist (see p. 280), of which the most significant is that in the Detroit Institute of Arts (Waterhouse, no. 1003), lent to the British Institution in 1817 (72) by Sir Thomas Neave. Also mentioned on pp. 161, 176–8, 181, 229, 238.

DATING Identifiable as a landscape painted towards the end of 1786 from Bate-Dudley's description in the Morning Herald (30 December 1786):

In departing from the portraits, the eye cannot dwell too

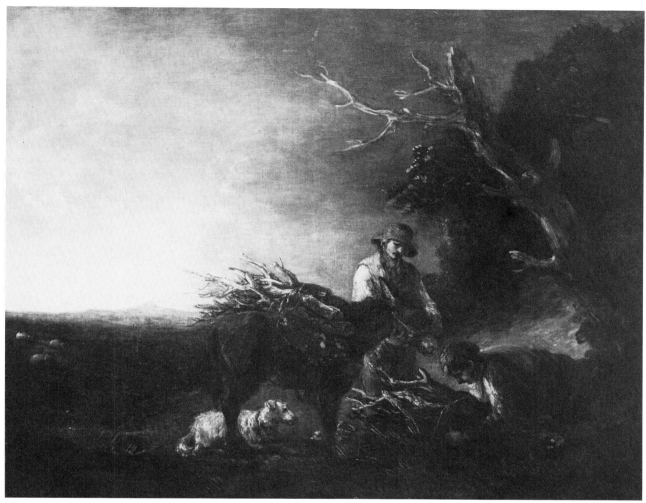

**184**

long on a beautiful landscape that Mr. *Gainsborough* has finished within these few days. It is a representation of a wood, through which a road appears. A loaded market cart, with two girls seated on top, is passing along; and beside the road, some weary travellers are resting. The foliage of the trees, is in a rich variation of hues, expressive of autumn:—here the trees are verdant—a browner aspect there prevails—and all the varied greens and yellows of the season, temper the scene, and exhibit a pleasing harmony. The interior recesses of the wood, afford charming invitations to the eye; the distances are exquisitely soft; and some broken clouds, diffused over the trees, and through the branches, give a delightful aspect to the whole.

Two days later he referred to the picture again:

In addition to what has been said of Mr. *Gainsborough*'s new landscape, we must observe, that the figures are finished in a high stile of penciling [sic]: and an object of considerable interest in the picture, is a *woodman*, tying together a heap of sear branches. Through some vistas of the wood, partial gleams of light fall; which tend to diversify still more, the autumnal variation of the foliage; and add to the richness of the scene.

*Morning Herald*, 1 January 1787

## 184 Open Landscape with Two Woodcutters loading a Donkey with Faggots, Dog and Distant Sheep

Canvas. 39½ × 49  100.3 × 124.5
Painted in the autumn of 1787

National Trust, Stourhead (Hoare Collection)

PROVENANCE Schomberg House sale, March–May 1789, no. 71, bt Maria Palmer, Lady Hoare (d. 1845); thence by descent to Sir Henry Hoare (1865–1947), who bequeathed it, with the contents of Stourhead, to the National Trust, 1947.

EXHIBITIONS Schomberg House, 1789 (71); BI, 1814 (21).

BIBLIOGRAPHY *Morning Herald*, 22 November 1787; Fulcher, pp. 194, 198; Whitley, pp. 293–4, 324; anon. [Tancred Borenius], 'Gainsborough's Collection of Pictures', *Burlington Magazine*, May 1944, p. 109; Ellis Waterhouse, 'The Sale at Schomberg House, 1789', *Burlington Magazine*, March 1945, p. 77; Waterhouse, no. 1009.

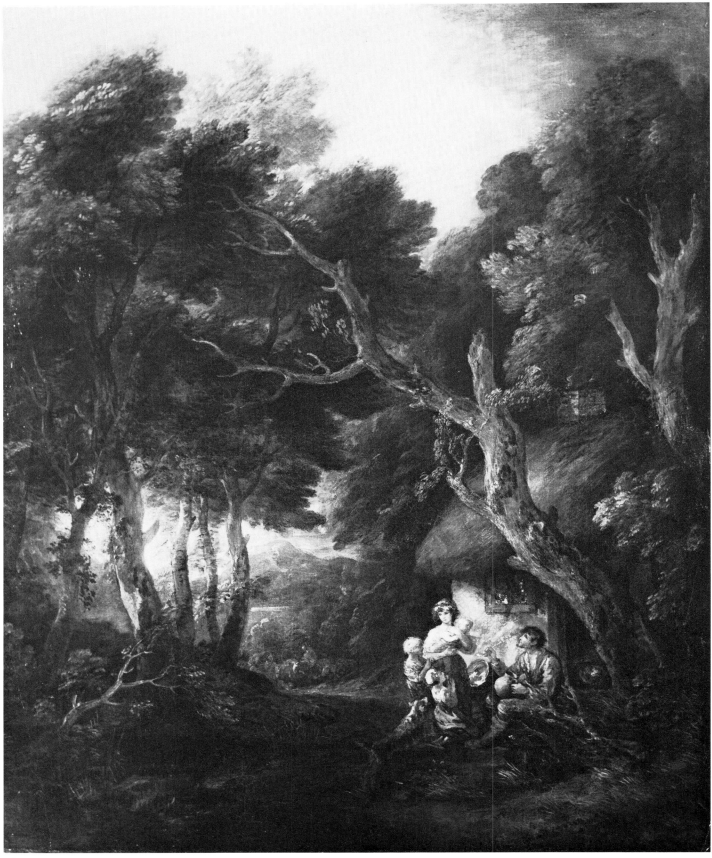

185

In this canvas, painted a few months after his celebrated picture entitled *The Woodman* (Waterhouse, no. 806), Gainsborough has ennobled the recurrent motif of the woodcutter in the context of a landscape composition. Both figures are placed in the foreground, both are monumentally conceived, and the twilight scene is richly illumined and highlit by the broadly painted sunset glow which balances the mass on the right. The standing figure, sturdy and solemn in countenance, almost anticipates Millet, and the donkey does not deserve Bate-Dudley's disparagement; the dog, an essential accent in the design, contributes a more prosaic element, and Gainsborough still has not been able to dispense with the familiar compositional prop of the dead tree-trunk arching over the scene. Bate-Dudley commented, 'The PEASANTS and DOG, with the Ass laden with firewood, is most to be admired for its finely painted background; the light is well distributed, & the effect striking.—The *Peasants* & the *Dog* merit praise,—but the *Ass* cannot be complimented for that superiority of character, which generally belongs to Mᴿ Gains-borough's animals.—It appears as if the artist,—in his adherence to Nature,—had really painted the animal as it presented itself to his notice, with more than the common portion of misery, which falls to that class of the brute creation' (*Morning Herald*, 22 November 1787). The motif of a man loading a donkey with faggots is found in Berchem (Musée Fabre, Montpellier, no. 836-4-3). Also mentioned on pp. 175–6, 182, 237.

DATING Identifiable with a picture seen in Gainsborough's studio by Bate-Dudley in November 1787 from his description of it as a landscape with peasants and dog, and an ass laden with firewood (see above).

### 185  Wooded Landscape with Family grouped outside a Cottage, Mounted Peasant and Pack-horses, and Distant Mountain (Peasant smoking at a Cottage Door)

Canvas. 77 × 62   195.6 × 157.5
Painted in the spring of 1788

University of California at Los Angeles, Los Angeles

PROVENANCE Schomberg House sale, March–May 1789, no. 60; Mrs Gainsborough sale, Christie's, 2 June 1792, lot 83, bt in by Sir Henry Bate-Dudley; Margaret Gainsborough, from whom it was purchased by Sir George Beaumont (1753–1827), 1799; thence by descent; remained at Coleorton Hall, from whence it was purchased by Spink and others, 1935; with Spink, from whom it was bought by J. Mitchell Chapman for the James Kennedy Memorial Collection, University of California at Los Angeles, 1954.

EXHIBITIONS Schomberg House, 1789 (60); GG, 1885 (212); 'British Country Life through the Centuries', 39 Grosvenor Square, London, June 1937 (303, repr.

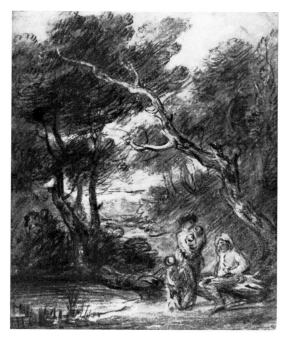

185a Study for cat. no. 185. Black chalk and stump with some red chalk, and grey and brown washes, on buff paper, touched with bodycolour. 15½ × 12½ / 39.4 × 31.7. Yale Center for British Art (Paul Mellon Collection), New Haven (B1477.14.4697).

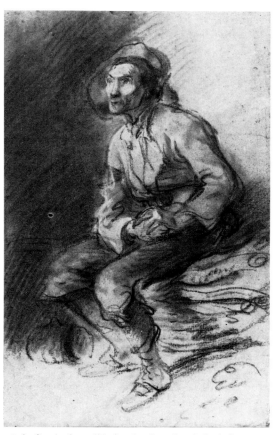

185b Study from life for the drawing (185a) for cat. no. 185. Black chalk and stump on buff paper, heightened with white. 18¹¹⁄₁₆ × 11½ / 47.5 × 29.2. Mrs Cecil Keith, Rusper.

*Illustrated Souvenir*, frontispiece); Arts Council, 1953 (56); Tate Gallery, 1980–81 (152, repr., col. p. 136, and p. 42); Grand Palais, 1981 (77, repr., and p. 47).

BIBLIOGRAPHY *Morning Herald*, 9 May 1788; ibid., 26 August 1788; ibid., 31 March 1789; *Diary*, 2 April 1789; *Morning Post*, 6 April 1789; *Morning Herald*, 9 June 1789; ibid., 8 December 1789; Farington Diary, 8 February 1799 (Kenneth Garlick and Angus Macintyre, *The Diary of Joseph Farington*, New Haven and London, vol. IV, 1979, p. 1153); ibid., 1–2 March 1799 (ibid., pp. 1166–7); ibid., 17 June 1808 (typescript, p. 4088); Jones's *Views of the Seats, Mansions, Castles, etc. of Noblemen and Gentlemen*, London, 1829, vol. I (unpaginated); Fulcher, p. 194; Armstrong, 1898, p. 204; Armstrong, 1904, p. 283; Whitley, pp. 319, 323–4, 325, 342, 355, 356, 368; William T. Whitley, 'An Eighteenth-Century Art Chronicler: Sir Henry Bate-Dudley, Bart.', *The Walpole Society*, vol. XIII, Oxford, 1925, pp. 60–61; James Greig, ed., *The Farington Diary*, London, vol. 5, 1925, p. 76 (17 June 1808); Woodall, *Drawings*, p. 64; anon. [Tancred Borenius], 'Gainsborough's Collection of Pictures', *Burlington Magazine*, May 1944, p. 109; C. H. Collins Baker, 'The Kennedy Memorial Gallery', *Connoisseur*, October 1954, pp. 135–6, 142, repr. p. 137 (col.); Waterhouse, pp. 19, 34, no. 1011, repr. pl. 285; John Hayes, 'Gainsborough and Rubens', *Apollo*, August 1963, p. 95, repr. fig. 13; John Hayes, 'Gainsborough's Later Landscapes', *Apollo*, July 1964, pp. 21, 26; John Hayes, 'Gainsborough', *Journal of the Royal Society of Arts*, April 1965, pp. 323–4, 325, repr. fig. 12; Hayes, *Drawings*, pp. 32, 39, 46, 52, 84, 102, 293, 308, repr. pl. 350; John Sunderland, 'Uvedale Price and the Picturesque', *Apollo*, March 1971, p. 201, repr. fig. 7; Herrmann, p. 105; Hayes, pp. 36, 44, 229, repr. pl. 164; Josephine Gear, *Masters or Servants?*, New York and London, 1977, pp. 6, 7, 8, 10, repr. fig. 2; John Barrell, *The Dark Side of the Landscape*, Cambridge, 1980, pp. 66, 67–8, repr. p. 66 (detail); John Ingamells, 'Thomas Gainsborough', *Burlington Magazine*, November 1980, p. 780; Lindsay, pp. 194–5, 199, 201; Christoph Heilmann, 'Thomas Gainsborough', *Kunstchronik*, Munich, March 1981, p. 117.

This canvas, the largest Gainsborough ever painted, is in many ways the grandest and most romantic of all his landscape compositions, and it is recorded as having been completed by candlelight (Whitley, p. 368). A study in which the broad essentials of the composition are fully stated, but the cottage has not yet been included, is in the Mellon Collection at Yale (185a; Hayes, *Drawings*, no. 803). A study from life, one of several studies of woodcutters drawn from the same model that was used for *The Woodman*, painted in the summer of 1787 (Waterhouse, no. 806), was used for the pose of the woodcutter in the Mellon drawing (185b; Hayes, *Drawings*, no. 852). In the finished picture an extra child and dog have been added to the figure group (which is now consciously, though loosely, pyramidal in concept), the woodcutter seated on a pile of faggots has been replaced by a figure (with a jug in one hand and a pipe in the other) seated on the steps of a sequestered cottage, the trees have been varied slightly and added to on the left, and a mounted peasant with pack-horses has been introduced in the middle distance. The dominating diagonal tree is even more vigorous, though rather less integrated, than the similar motif in the Huntington *The Cottage Door* (cat. no. 123), a brilliant sunset effect breaks through the tree-trunks on the left, and the richly modelled, agitated, romantic foliage carries this style of background, first used in the Rutland landscape of ten years earlier (cat. no. 120), to an expressive point unsurpassed in Gainsborough's work. The figures are exceptionally loosely modelled. Sir George Beaumont's somewhat half-hearted purchase of the picture is recorded by Farington (cited above). The painting hung in the Library at Coleorton Hall, along with Wilson's *Niobe* and *Villa of Maecenas near Tivoli* (see Jones, cited above). Also mentioned on pp. 140, 161, 171, 178–80, 181, 182, 183, 191, 192, 228, 237–8; a detail is repr. pl. 215.

DATING Identifiable as a picture painted in the spring of 1788 from Bate-Dudley's descriptions. In May he wrote that Gainsborough 'has painted, during his quiet intervals [the painter was already gravely ill at this time, with his doctors constantly in attendance], a beautiful little *Landscape*,' and continued, 'Another *Landscape*, of larger dimensions, was finished a few weeks since by Mr. GAINSBOROUGH, and exhibits one of those sweet recesses, where the mind never fails to find a source of enjoyment:—'Tis reading *Poetry*, and compressing all its enchantments to the glance of the eye' (*Morning Herald*, 9 May 1788). In August he described this as 'one of the last pictures Mr. *Gainsborough* painted' (ibid., 26 August 1788) and later as 'the finest landscape ever produced, with its rich scenery of a summer evening unsurpassed by the fervid glow of Claude' (Whitley, p. 323).

## 186 Rocky Wooded Landscape with Woman carrying a Pitcher and Youth (Hagar and Ishmael)

Canvas. $30\frac{3}{4} \times 37\frac{1}{4}$  78.1 × 94.6
Painted *c.* 1788

National Museum of Wales, Cardiff (1111)

PROVENANCE Mrs Gainsborough sale, Christie's, 2 June 1792, lot 73; William Petty, 1st Marquess of Lansdowne (1737–1805); Lansdowne sale, Coxe's, 19–20 March 1806, 2nd day, lot 25, bt Sir Watkin Williams Wynn (1772–1840); thence by descent to Sir Owen Watkin Williams-Wynn; Williams-Wynn sale, Sotheby's, 7 July 1965, lot 121 (repr.), bt Agnew, from whom it was purchased by the National Museum of Wales.

EXHIBITIONS BI, 1814 (8); BI, 1853 (162); 'La Peinture Britannique de Gainsborough à Bacon', Galerie des Beaux-Arts, Bordeaux, May–September 1977 (14).

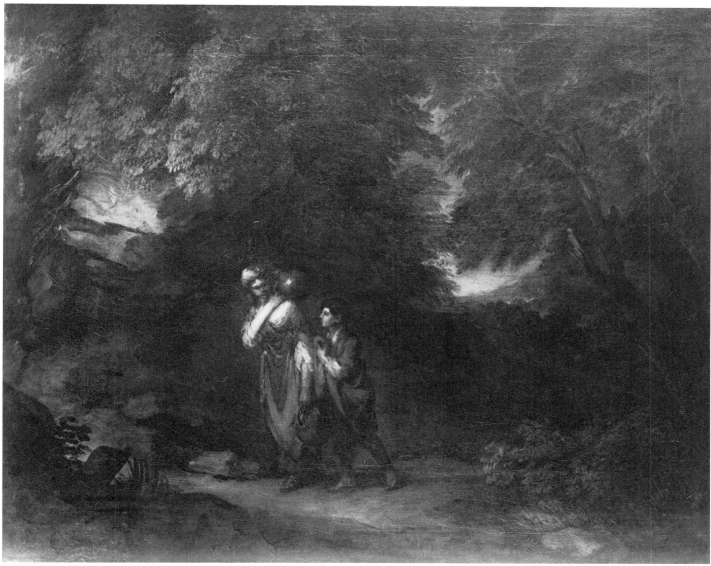

186

BIBLIOGRAPHY Fulcher, p. 197; Armstrong, 1898, p. 208; Armstrong, 1904, p. 290; Waterhouse, no. 929; Mary Woodall, 'Gainsborough Landscapes at Nottingham University', *Burlington Magazine*, December 1962, p. 562, repr. fig. 49; John Hayes, 'Gainsborough's Later Landscapes', *Apollo*, July 1964, p. 22; Paulson, p. 248; John Dixon Hunt, *The Figure in the Landscape*, Baltimore and London, 1976, p. 214; Grand Palais, 1981, p. 43, repr. fig. 41.

Gainsborough copied several religious paintings from originals by Rubens, Salvator Rosa and Murillo (see cat. no. 187), but this, which is in subject a companion to cat. no. 187, is the only original religious work he is known to have painted. The story is taken from Genesis, chapter 21, verses 9–15: Abraham's wife, Sarah, angry at Ishmael's mocking at the birth of Isaac in Abraham's old age, besought her husband to cast out his bondwoman, Hagar, and Ishmael, the child she had born to Abraham, 'And Abraham rose up early in the morning, and took bread, and a bottle of water, and gave *it* unto Hagar, putting *it* on her shoulder, and the child, and sent her away: and she departed, and wandered in the wilderness of Beer-sheba.' The figures are spotlit against a dark mass of rocks and trees, and the darkness of the scene, emphasized by the diagonal tree-trunks and foliage on the right, is only partially relieved by the sunset effect, glowing over the generalized distance. Both the figure of Hagar and the background on the left seem to be derived from Murillo (see cat. no. 187). Paulson (cited above) suggests that the picture is one of Gainsborough's fancy subjects, but there seems no good reason, especially in view of the similarity to cat. no. 187, for doubting the traditional identification of the figures (which goes back to the 1792 sale catalogue and thus, presumably, to the artist) as Hagar and Ishmael.

DATING Closely related to cat. no. 185 in the rich, deep tonality, the windblown treatment and highlighting of the foliage, the motif of the tree arching across the

573

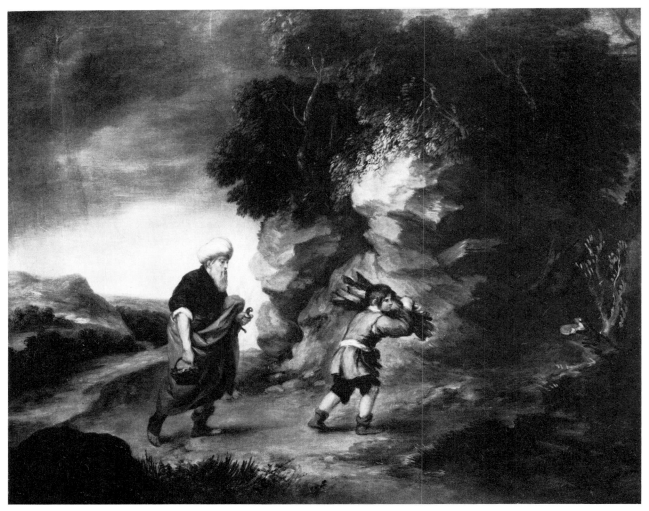

**187** Cat. no. 187, from the copy by Gainsborough Dupont. With C. G. Doward, New York, 1960.

composition, the use of a rich variety of tones in the modelling of the forms, the loose modelling of the figures (compare especially the painting of the highlights in the garments of the youth with the small girl in cat. no. 185) and the sketchy handling of the distance.

### 187*  Open Rocky Landscape with Old Man and Boy carrying Firewood (Abraham and Isaac) (after Murillo)

Canvas. Probably about $33\frac{1}{2} \times 41\frac{1}{4}$  85.1 × 104.8
Painted *c.* 1788

Ownership unknown

PROVENANCE Schomberg House sale, March–May 1789, no. 97, bt Mr Cornewall; P. Hinds; anon. [Hinds] sale, Christie's, 5 April 1856, lot 58, bt Watson; Sir Joseph Hawley (1814–75); anon. [Hawley] sale, Christie's, 14 May 1858, lot 42, bt Waters; with William Cox; William Cox sale, Foster's, 26 February 1862, lot 48, bt in; anon. [Cox] sale, Christie's, 16 May 1863, lot 156, bt in; anon. [Vokins] sale, Christie's, 29–30 January 1864, lot 265, bt in; William Cox liquidation sale, Christie's, 8–18 February 1884, 1st day, lot 76, bt Ward. The copy illustrated above was with C. G. Doward, New York, 1951, and some, or most, of the provenance cited here may refer to this copy rather than to the lost original (but see below).

EXHIBITION Schomberg House, 1789 (97).

BIBLIOGRAPHY Fulcher, p. 192; Armstrong, 1898, p. 209; Armstrong, 1904, p. 290; anon. [Tancred Borenius], 'Gainsborough's Collection of Pictures',

**187a** Bartolomé Esteban Murillo (1617–82): *Abraham and Isaac*. Canvas. 33 × 43 / 83.8 × 109.2. Private collection, England.

*Burlington Magazine*, May 1944, p. 110; Ellis Waterhouse, 'The Sale at Schomberg House, 1789', *Burlington Magazine*, March 1945, p. 77; Waterhouse, no. 1024; Paulson, p. 248.

Copy by Dupont of a lost Gainsborough. Dupont's canvas closely follows the original Murillo, formerly at Aynhoe Park (187a), except on the extreme right. The story is taken from Genesis, chapter 22, verses 1–13, and follows the episode of Hagar and Ishmael, to which it is, therefore, complementary: God tempted Abraham, ordering him to sacrifice his beloved son Isaac, 'And Abraham took the wood of the burnt offering, and laid *it* upon Isaac his son; and he took the fire in his hand, and a knife; and they went both of them together.' Though the landscape on the left is open, and the figure of Abraham is silhouetted against the sunset glow, the rocky landscape is very similar in character to the *Hagar and Ishmael* (cat. no. 186), and it is evident, therefore, that the background for the latter picture was derived ultimately from Murillo. The work was described by Christie's in 1858 as 'Very richly coloured in the manner of Rembrandt' (see above), a remark which must surely refer to the lost original, rather than to the copy illustrated here. Also mentioned on p. 192.

DATING Known only from the copy by Dupont (which is the size given above), from which it appears to have been closely related to cat. no. 186 in the handling of the foliage, the rocks, the figures and the foreground.

# List of Present Owners and of Locations of Works on Loan

The figures refer to the numbers in the Catalogue Raisonné

Anglesey Abbey, Cambridgeshire (National Trust) 126

Anonymous 6, 11, 12, 14, 26, 28, 35, 36, 56, 57, 63, 64, 66, 68, 73, 74, 76, 78, 82, 83, 85, 86, 87, 91, 92, 104, 106, 111, 125 (fragment), 135, 142, 158, 164, 165, 170, 175

Ashcroft, Trustees of the late O.S. 136

Avery, Mr and Mrs R. Stanton 54

Barber Institute of Fine Arts, Birmingham 88

Bayerisches Landesbank, Munich 146

Beckett, Sir Martyn, Bt 182

Beit, Sir Alfred, Bt 4, 84

Birmingham City Museum and Art Gallery 136 (on loan)

Bowes Museum, Barnard Castle 41

British Rail Pension Fund 124

Buscot Park, Oxfordshire (National Trust) 102

California, University of, at Los Angeles 32, 185

Camrose, Viscount 113

Christchurch Mansion, Ipswich 40, 45

Cincinnati Art Museum 9, 98, 121

Clarke-Jervoise, Michael 58

Coolidge, William A. 70

Coram, Thomas, Foundation for Children, London 23

Corcoran Gallery of Art, Washington, D.C. 167

Courtauld Institute Galleries, London 171 (on loan)

Cummer Gallery of Art, Jacksonville, Florida 168

Destroyed or dismembered 37, 125

Douglas-Pennant, Lady Janet 118

Dufferin and Ava, the Dowager Marchioness of 176

Egremont, the Earl of 178

Elvehjem Art Center, University of Wisconsin, Madison, Wisconsin 162

Faringdon Collection, the Trustees of the 102

Fitzwilliam Museum, Cambridge 18, 42

Frick Collection, New York 148

Fry, Dr Lewis S. 171

Gainsborough's House, Sudbury 28 (on loan)

Gardner, Mr and Mrs Rodney T. 7

Green, Richard, Fine Paintings, London, with 71

Grosvenor Estates Company 127

Hemphill, Dr Marie-Louise 30

Houston Museum of Fine Arts 77

Hove Museum of Art 3

Howe, Earl 62

Huntington, Mrs E.C.B. 81

Huntington, Henry E., Library and Art Gallery, San Marino, California 123

Indianapolis Museum of Art 99

Ipswich Museums: see Christchurch Mansion

Iveagh Bequest, Kenwood 95, 124 (on loan), 159

Jersey, the Earl of 109

Kimbell Art Museum, Fort Worth, Texas 67

Kunsthistorisches Museum, Vienna 24

Labia, Dr J.B. 46

Labia, Count Natale 47

Lehigh University, Bethlehem, Pennsylvania 145

Manchester City Art Gallery 161, 163

Mellon, Mr and Mrs Paul 1

Metropolitan Museum of Art, New York 150

Michaelis, C. M. 128

Minneapolis Institute of Arts 33

Montilera, Count Theo Rossi di 103

Montreal Museum of Fine Arts 59

National Gallery, London 17, 117

National Gallery of Art, Washington, D.C. 129, 151

National Gallery of Ireland, Dublin 13, 90, 93

National Gallery of Scotland, Edinburgh 29, 137

National Gallery of Victoria, Melbourne 141

National Museum of Wales, Cardiff 31 (on loan), 118 (on loan), 153, 186

National Trust: see Anglesey Abbey, Buscot Park, Petworth House, Stourhead, Upton House

Nelson Gallery of Art, Kansas City 119

Neue Pinakothek, Munich 146 (on loan)

Norfolk, the Duke of 49

Norwich Castle Museum 10, 72 (on loan)

Ontario, Art Gallery of, Toronto 157

Pennington-Mellor Charity Trust, London 147

Perret, Robert 116

Petworth House, Sussex (National Trust) 115

Philadelphia Museum of Art 22, 79, 94, 143

Plymouth, the Countess of 31

Private collection: see Anonymous

Her Majesty The Queen 160

Royal Academy of Arts, London 138

Royal Holloway College, Egham 107

Rutland, the Duke of 105, 120, 131

St Louis Art Museum 52

San Francisco, Fine Arts Museums of 156

São Paulo Museum of Art 20

Saumarez, Lord de 72

Scudamore, Mrs Henrietta 144, 174

Shelburne, the Earl of 110

Stourhead, Wiltshire (National Trust) 184

# Concordance

| Waterhouse (1958) | Present catalogue | Fulcher (1856) | Armstrong (1904) |
|---|---|---|---|
| 823 | 159 | pp. 195, 198 | p. 291 |
| 826 | 20 | p. 198 | — |
| 827 | 56 | — | — |
| 828 | 17 | p. 197 | p. 283 |
| 829 | 50 | p. 204 | — |
| 830 | 33 | p. 236 | p. 286 |
| 831 | 22 | p. 208 | — |
| 832 | 65 | — | pp. 289, 292 |
| 833 | 51 | p. 204 | — |
| 834 | 52 | — | p. 288 |
| 835 | 72 | — | — |
| 836 | 69 | p. 235 | p. 286 |
| 837 | 57 | — | — |
| 838 | 40 | — | — |
| 839 | Copy | — | — |
| 840 | 29 | — | p. 286 |
| 841 | 32 | — | — |
| 842 | 70 | p. 231 | p. 283 |
| 843 | 73 | p. 235 | — |
| 844 | 59 | — | p. 284 |
| 845 | 62 | — | — |
| 846 | 15 | — | — |
| 847 | 48 | p. 238 | — |
| 848 | 67 | — | — |
| 849 | 35 | — | — |
| 850 | 63 | — | — |
| 851 | 64 | — | — |
| 852 | 41 | — | — |
| 853 | 19 | — | pp. 284, 289 |
| 854 | 47 | — | p. 288 |
| 855 | Copy | — | — |
| 856 | 79 | pp. 201, 207 | p. 288 |
| 857 | 68 | pp. 199, 207 | — |
| 858 | 49 | p. 231 | p. 288 |
| 859 | 24 | — | p. 288 |
| 860 | 42 | — | — |
| 861 | 23 | p. 237 | p. 283 |
| 862 | 54 | — | p. 286 |
| 863 | Imitation | — | — |
| 864 | 43 | — | — |
| 865 | 46 | p. 233 | pp. 284, 290 |
| 866 | 36 | — | — |
| 867 | 12 | — | — |
| 868 | Ibbetson | p. 234 | pp. 290, 291 |
| 869 | 11 | — | — |
| 870 | 13 | — | p. 287 |

| Waterhouse (1958) | Present catalogue | Fulcher (1856) | Armstrong (1904) |
|---|---|---|---|
| 871 | 58 | p. 201 | p. 283 |
| 872 | Imitation | — | — |
| 873 | Almost certainly H. J. Antonissen or B. P. Ommeganck | — | — |
| 874 | 27 | — | — |
| 875 | 18 | p. 236 | p. 286 |
| 876 | 4 | — | p. 285 |
| 877 | 2 | — | p. 286 |
| 878 | Ibbetson? | — | — |
| 879 | 9 | — | p. 283 |
| 880 | 3 | p. 237 | p. 287 |
| 881 | 31 | — | p. 290 |
| 882 | 6 | — | — |
| 883 | 45 | p. 232 | p. 286 |
| 884 | 5 | — | — |
| 885 | 1 | — | — |
| 886 | 37 | — | — |
| 887 | 44 | p. 234 | p. 291 |
| 888 | 61 | — | — |
| 888a | 60 | — | — |
| 889 | 91 | — | — |
| 890 | 108 | p. 238 | p. 284 |
| 891 | Copy (Dupont?) | p. 242 | p. 288 |
| 892 | Imitation | — | — |
| 893 | 16 | — | p. 287 |
| 894 | 8 | — | p. 287 |
| 895 | 76 | — | — |
| 896 | 82 | — | — |
| 897 | 75 | pp. 197, 200, 207 | — |
| 898 | 80 | p. 206 | — |
| 899 | 77 | p. 235 | p. 286 |
| 900 | 87 | p. 185 | p. 283 |
| 901 | Dupont | — | — |
| 902 | Dupont | — | — |
| 903 | Dupont | — | p. 287 |
| 904 | Dupont | — | p. 284 |
| 905 | 111 | — | p. 287 |
| 906 | 89 | — | p. 286 |
| 907 | 88 | p. 199 | p. 283 |
| 908 | 119 | pp. 194, 206 | p. 288 |
| 909 | 90 | p. 197 | p. 290 |
| 910 | 74 | p. 238 | p. 290 |
| 911 | 107 | p. 199 | p. 287 |
| 912 | 95 | — | p. 283 |
| 913 | 84 | p. 234 | p. 285 |
| 914 | 85 | p. 207 | p. 290 |
| 915 | Imitation | — | — |
| 916 | 168 | p. 204 | p. 286 |
| 917 | Imitation | — | p. 287 |

| Waterhouse (1958) | Present catalogue | Fulcher (1856) | Armstrong (1904) |
|---|---|---|---|
| 918 | Hayes, *Drawings*, 740 | — | p. 284 |
| 919 | Dupont? | p. 207 | p. 288 |
| 920 | 112 | — | — |
| 921 | Dupont? | — | — |
| 922 | 113 | p. 199 | p. 290 |
| 923 | Copy | p. 201 | p. 287 |
| 924 | 104 | — | — |
| 925 | 103 | — | — |
| 926 | 102 | — | — |
| 927 | 166 | p. 197 | p. 285 |
| 928 | 167 | p. 196 | p. 285 |
| 929 | 186 | p. 197 | p. 290 |
| 930 | 158 | p. 207 | — |
| 931 | 109 | p. 195 | p. 287 |
| 932 | Dupont | p. 237 | — |
| 933 | Dupont | — | — |
| 934 | 118 | — | p. 288 |
| 935 | Copy | — | p. 289 |
| 936 | 122 | — | — |
| 937 | 117 | pp. 187, 198 | p. 284 |
| 938 | Copy | — | — |
| 939 | 135 | p. 189 | p. 287 |
| 940 | 121 | p. 200 | p. 283 |
| 941 | 123 | pp. 188, 196 | p. 283 |
| 941a | 156 | — | — |
| 942 | 125 | p. 188 | — |
| 943 | S. W. Reynolds | — | — |
| 944 | 124 | pp. 188, 201 | p. 283 |
| 945 | 94 | p. 208 | p. 284 |
| 946 | 176 | p. 200 | — |
| 947 | 98 | — | p. 289 |
| 948 | 144 | p. 199 | — |
| 949 | 145 | pp. 200, 204 | p. 284 |
| 950 | 161 | — | — |
| 950a | Imitation | — | — |
| 951 | Copy | — | p. 290 |
| 952 | 115 | p. 200 | — |
| 953 | 110 | p. 198 | p. 287 |
| 954 | 129 | p. 198 | — |
| 955 | 127 | pp. 189, 198–9 | p. 284 |
| 956 | 126 | pp. 189, 208 | pp. 284, 290 |
| 957 | 142 | p. 201 | — |
| 958 | 130 | p. 200 | p. 289 |
| 959 | 128 | pp. 189, 234 | p. 289 |
| 960 | 105 | p. 231 | p. 289 |
| 961 | 106 | — | — |
| 962 | 120 | p. 231 | p. 289 (twice) |
| 963 | 131 | p. 231 | p. 289 (twice) |
| 964 | 141 | p. 190 | p. 284 |

| Waterhouse (1958) | Present catalogue | Fulcher (1856) | Armstrong (1904) |
|---|---|---|---|
| 965 | 149 | p. 208 | — |
| 966 | 137 | pp. 190, 194 | p. 286 |
| 967 | 136 | — | p. 286 |
| 968 | 143 | — | — |
| 969 | 150 | — | p. 289 |
| 970 | 133 | — | — |
| 971 | 134 | — | — |
| 972 | 173 | — | — |
| 973 | 172 | — | — |
| 974 | 139 | — | — |
| 975 | 177 | — | — |
| 976 | 140 | — | — |
| 977 | 155 | — | — |
| 978 | 154 | — | — |
| 979 | 132 | — | — |
| 980 (as imitation) | Imitation | — | — |
| 981 (as imitation) | Imitation | — | — |
| 982 | 153 | — | — |
| 983 | 175 | p. 207 | p. 286 |
| 984 | 169 | — | p. 286 |
| 985 | 170 | — | p. 285 |
| 986 | Dupont | — | p. 288 |
| 987 | 148 | p. 194 | p. 284 |
| 988 | Genre painting | — | — |
| 989 | 96 | — | — |
| 990 | 97 | — | — |
| 991 | 116 | pp. 194, 204 | — |
| 992 | 146 | p. 193 | — |
| 993 | 157 | pp. 193, 233 | p. 283 |
| 994 | Dupont | — | — |
| 995 | 181 | p. 207 | — |
| 996 | 180 | p. 207 | — |
| 997 | 179 | pp. 194, 206 | p. 284 |
| 998 | 162 | — | p. 285 |
| 999 | 178 | p. 238 | p. 287 |
| 1000 | 152 | — | — |
| 1000a | 125 | — | — |
| 1001 | 174 | p. 208 | — |
| 1002 | 183 | p. 206 | p. 284 |
| 1003 | Copy | p. 204 | — |
| 1004 | Imitation | — | — |
| 1005 | Fragment of a portrait | — | — |
| 1006 | 114 | pp. 206, 239 | p. 286 |
| 1007 | 138 | p. 200 | — |
| 1008 | 151 | — | — |
| 1009 | 184 | pp. 194, 198 | — |

| Waterhouse (1958) | Present catalogue | Fulcher (1856) | Armstrong (1904) |
|---|---|---|---|
| 1010 | Dupont | — | — |
| 1011 | 185 | p. 194 | p. 283 |
| 1012 | 160 | — | p. 291 |
| 1024 | 187 | p. 192 | p. 290 |
| 1029 | 92 | pp. 197, 207 | — |
| 1030 | 93 | — | p. 285 |
| — | 7 | — | — |
| — | 10 | — | — |
| — | 14 | — | — |
| — | 21 | — | — |
| — | 25 | — | — |
| — | 26 | — | — |
| — | 28 | — | — |
| — | 30 | — | — |
| — | 34 | — | — |
| — | 38 | — | — |
| — | 39 | — | — |
| — | 53 | — | — |
| — | 55 | — | — |
| — | 66 | — | — |
| — | 71 | — | — |
| — | 78 | — | — |
| — | 81 | — | — |
| — | 83 | — | — |
| — | 86 | — | — |
| — | 99 | — | p. 289 |
| — | 100 | — | — |
| — | 101 | — | — |
| — | 147 | — | — |
| — | 163 | — | — |
| — | 164 | — | — |
| — | 165 | — | — |
| — | 171 | — | — |
| — | 182 | — | — |

Of the 187 works included in the present catalogue, 81 are recorded in Fulcher, 84 in Armstrong (oddly, after nearly half a century, only three more than in Fulcher) and 160 in Waterhouse.

## Authors cited

## Portraits

## Copies

## Drawings

## Past owners of landscapes and fancy pictures by Dupont

## Present owners of landscapes and fancy pictures by Dupont

## Engravers of landscapes by Thomas Gainsborough

## Exhibitions including landscapes by Thomas Gainsborough

exhibitions including works by artists other than Gainsborough: Barret: London, Royal Academy (1781)  21; Bigg: London, British Institution (1818)  288; John Crome: Norwich, Society of Artists (1806)  267; Dupont: London, British Institution (1814)  190, Royal Academy (1792)  189, (1793)  195 (no. 16), (1794)  190, 195 (and nos 16, 19), 247, (1795)  196, 257, Arthur Tooth's (1948)  235(n25), Milan, Palazzo Reale (1975)  235(n37); Virginia, Richmond Museum of Fine Arts (1963)  235(n43); Hayman: London, Iveagh Bequest, Kenwood (1960)  124(n90); Ibbetson: London, Royal Academy (1771)  269; Lambert: London, Iveagh Bequest, Kenwood (1970)  27(n60), 57(n6), 58(n33); de Loutherbourg: London, Iveagh Bequest, Kenwood (1973)  158(n78), Royal Academy (1784)  22; Misses Maskall: London, British Institution (1818)  297(n151); George Morland: London, Society of Artists (1790)  291; J. M. W. Turner: London, Royal Academy (1812)  25; C.-J. Vernet: London, Iveagh Bequest, Kenwood (1976)  26(n1), 126; Vispré: London, Society of Artists (1764)  158(n74); Richard Westall: London, Royal Academy (1793)  288; Richard Wilson: London, Society of Artists (1767)  19

OTHER EXHIBITIONS: 'Devon painters', Exeter, Royal Albert Museum and Art Gallery (1932)  296(n115); 'English Drawings and Watercolours', London, Colnaghi's (1972)  297(n143); 'The French Taste in English Painting during the first half of the 18th Century', London, Iveagh Bequest, Kenwood (1968)  58(n25); 'Painting from Nature', Cambridge, Fitzwilliam Museum, and London, Royal Academy (1980–81)  123(n35)

fancy pictures 155–6; *see also under* Dupont,

## Exhibited and other recorded landscape paintings at present unidentified

## Mythological paintings

## Portraits

## Topography relating to Gainsborough and Gainsborough's Landscapes